mise-en-scène

The Painted Word

THEATER: Theory/Text/Performance

Enoch Brater, Series Editor

Recent Titles:

The Painted Word

Samuel Beckett's Dialogue with Art

Lois Oppenheim

Ann Arbor

THE UNIVERSITY OF MICHIGAN PRESS

2003 2002 2001 2000 4 3 2 1

A CIP catalog record for this book is available
from the British Library.

Library of Congress Cataloging-in-Publication Data

Oppenheim, Lois.
 The painted word : Samuel Beckett's dialogue with art
/ Lois Oppenheim.
 p. cm. — (Theater—theory/text/performance)
 Includes bibliographical references and index.
 ISBN 0-472-11117-5 (alk. paper)
 1. Beckett, Samuel, 1906—Knowledge—Art. 2. Art and
literature—Ireland—History—20th century. 3. Art and
literature—France—History—20th century. 4. Beckett,
Samuel, 1906—Aesthetics. 5. Art, Modern—20th century.
6. Art in literature. 7. Postmodernism. 8. Modernism.
I. Title. II. Series.
PR6003.E282 Z7855 2000
848'.91409—dc2 99-050634

For Sarah and Keith

*Art has always been this—pure interrogation,
rhetorical question less the rhetoric . . .*
 —Samuel Beckett

Acknowledgments

The challenges associated with the writing of any book are recompensed by the pleasure of thanking those who, in one way or another, helped beget it. I am extremely grateful to H. Porter Abbott and Enoch Brater for their very worthwhile commentaries on the manuscript. Jacques Garelli's critique of the chapter on Beckett and Merleau-Ponty was also eminently useful. But I thank him most of all for his superb erudition, which, for some thirty years, has been for me an immense source of enlightenment. A number of people deserve my appreciation for much needed information they provided. These include Pierre Alechinsky, Avigdor Arikha, Georg Baselitz, Edward Beckett, Andreas Brown, Ruby Cohn, Paul Cornwall-Jones, Stan Gontarski, Edward Gorey, Désirée Hayter, Jasper Johns, Rémi Labrusse, Louis le Brocquy, Luigi Majno, Simone Merleau-Ponty, Elinor S. Miller, Astrid Myers, Barney Rosset, Robert Ryman, Benjamin Shiff, and Toni Zwicker. I am especially grateful to Vivien Igoe, formerly of the Irish Museum of Modern Art, an indefatigable source. Claude Duthuit and Wanda de Guébriant of the Héritiers Matisse are to be thanked for giving me prolonged access to, and greatly facilitating my study of, Beckett's correspondence with Georges Duthuit. The extraordinary expertise of LeAnn Fields, of the University of Michigan Press, was once again invaluable, and I am indebted to her as well.

Economic support was consistently provided by Montclair State University in the form of the Distinguished Scholar Award, which initially allowed me to undertake this study, and Separately Budgeted Research and Global Education grants, which permitted its completion. I wish also to thank Rachel Fordyce, dean of the College of Humanities and Social Sciences, for her continued financial support.

A few people contributed in uncommon ways: Breon Mitchell went to great lengths to procure several of the reproductions. I thank him most sincerely for his efforts. As teachers we are sometimes blessed with students whose intellectual curiosity greatly enriches our own. Léone Seltzer was

such a student. I am exceedingly grateful to her for the number of hours we spent in ardent discussion, for her general assistance, and for taking on the lion's share of the translations of Beckett and Duthuit's letters and other writings on art. Finally, but most important, this book would not have seen the light of day without the remarkable wit and intelligence of Sidney Feshbach and Toby Zinman—empathetic and perceptive beyond the call of friendship—the patience and encouragement of Ellis Oppenheim, and the visual awareness of JoAnne and Norman Schneider. I extend an immeasurable expression of gratitude to them all. The dedication to my children, Sarah and Keith, is for their spirit and daring, of which I will forever remain in awe.

Grateful acknowledgment is made to the following for permission to reprint previously published materials.

G. H. J. Burrows and The Board of Trinity College Dublin for permission to quote from the notes of Rachel Dobbin (Burrows). Luigi Majno for permission to quote from the correspondence of Luigi Majno. Claude Duthuit for permission to quote from the letters and unpublished writings of Georges Duthuit. The Board of Trinity College Dublin, Edward Beckett, and Jérôme Lindon for permission to quote from the unpublished letters of Samuel Beckett.

Contents

Introduction

"*Reductio ad obscenum.*" Any effort to situate and analyze the work of Samuel Beckett risks the epithet of one who bears a marked resemblance to Beckett himself, Jean du Chas, the founder of Concentrism. Such a threat notwithstanding, this book aims to do both, for it is undertaken in the very spirit of Concentrist thought—no less fictive than the movement's leader, both inventions of Beckett—and the belief that a critical exegesis may be just nonreductive enough to respect an art as, at once, "perfectly intelligible and perfectly inexplicable."[1]

Over and above the attempt at elucidation that defines any such endeavor, my purpose in the present volume is to rethink Beckett's place on the twentieth-century cultural horizon. This I propose to do in view of the principal forms taken by his dialogue with art and, more specifically, painting: the function of art in his narrative and theatrical writing, his critical writing on art, and, however briefly, his "collaborations" (either direct or indirect) with painters.

It is not that these areas have not previously been considered: Ruby Cohn rendered the scholarly community an inestimable service in collecting under the same cover a "miscellany of [Beckett] criticism"[2] that includes previously unpublished or published, but with greatly limited availability, texts on art. Others, most notably John Pilling, have used these and other writings[3] as a point of departure to delimit what many call Beckett's aesthetic thinking (a notion with which I take issue throughout this book). Various critics, such as Dougald McMillan and Vivian Mercier, have explored the visual arts in Beckett's fictive oeuvre. And articles by Renée Riese Hubert, Breon Mitchell, Marjorie Perloff, Jessica Prinz, and Carol Shloss have dealt with Beckett's inspiration in the plastic arts. In addition, H. Porter Abbott, Herbert Blau, and Enoch Brater have contributed immeasurably to delineating Beckett's narrative art on the horizon of the specular. I am greatly indebted to the work of these and other critics who have unknowingly made this book possible.

To my knowledge, however, there does not yet exist a volume that treats comprehensively all three areas in question. Indeed, as I had not uncovered any full-length work on Beckett and art, let alone one on Beckett and painting[4] (though numerous are the journal articles and book chapters that pay testimony to the subject's importance), I began this study with the idea of simply filling a conspicuous gap. It was clear that the neglect stemmed, in large part, from Beckett's deprecation of his own critical writings: Were it not for a "special plea of Dr. James Acheson" and, no doubt, that the ensemble of critical pieces was to be edited by Ruby Cohn, it is unlikely that Beckett would ever have consented to "the publication of material," to cite Cohn, "which he [belittled] as mere products of friendly obligation or economic need."[5] Yet, as Pilling has claimed with respect to the breadth of reference and the strangeness of style which render Beckett's criticism difficult, "Behind the erudition [was] an intense interest in the theory and practice of art in general."[6] This interest, which his teaching,[7] letters, and creative as well as critical writing affirmed, was the preliminary justification for my efforts.

It was immediately apparent, as expected, that Beckett's concerns had little to do with the idea of what art qua art *is* and even less to do with its meaning. On the contrary, for his appreciation of certain art (whether literary or visual) over other art (whatever it is that one deems "art") derived from an intuition of its essential meaninglessness: "The time is not perhaps too green for the vile suggestion that art has nothing to do with clarity, does not dabble in the clear, and does not make clear."[8] They had rather to do with process—the means of discovery, the disclosing of a relation of human to world prior to its falsification by the limits of cognition and the representational modes of consciousness. The "work" of art, for Beckett, was interrogatory, the experience of the artist perceptual and innovative. And both his writings on art and the play of art within his nondiscursive writing attest to a kind of enthusiasm for the imaginative transposing or rendering of human need that belies the fundamental nihilism all too often attributed to him.

Also apparent, however, was a less anticipated link between Beckett's thinking on art and his aims as a creative writer. Intrigued by his contextualization of dramatic fiction with the real, the congruence of the play as text with the actuality of its performance that Cohn has eloquently dubbed his "theatereality,"[9] I found in the criticism a phenomenon strikingly similar. It seemed, in fact, the same kind of aesthetic indifference that had tied art to philosophical self-reflection from Duchamp to Warhol and on. Consideration of its origin revealed not only a preoccupation with the specular but

with the specular as paradigm of any truly creative enterprise, a notion that quickly and forcefully supplanted the earlier motivation for this study.[10] For not only did the classic Beckettian themes—language (its expressivity or lack of), identity (its, at best, tenuous link to a fragmented self), and the ego-world relation—appear modeled on the sensory perspective of the eye and the verbal figuration of reality within the visual field constitutive, whatever the genre, of the Beckettian drama, but painting materialized (both in the creative and the critical work) as emblematic for Beckett of the creative process itself.

The history of painting in the twentieth century reveals the problematics of representation as its primary concern. This is also true of Beckett, for whom depiction is intimately related to, if not ultimately thwarted by, the primordial Being-in-the-world. Nevertheless, it is difficult to say that he developed any real aesthetic, in the sense of a theory of artistic expression. Despite valiant attempts to situate his prose and theater pieces in relation to the cultural movements of this century and those to situate his art criticism in a theoretical relation to his prose and theater pieces, the notion of a general philosophy of art as such, discernible within the Beckett literary and critical corpus, remains hard to defend. As is well documented, Beckett was opposed to the unpacking of any sort of consistent Weltanschauung from within his works by means of analogy to the philosophical analysis of existential issues. So, too, though he maintained a clear position with respect to the specificity of literary as opposed to philosophical discourse, what would constitute an aesthetic (no matter how vague or ambiguous the term is permitted to be) would be anathema to him.

"Indeterminacy" (as used by Marjorie Perloff), "decreation" (the term is Ruby Cohn's), and "a literature of the unword" (to cite Beckett himself) remain among the most significant vantage points from which to explore the singular stylistic and narrative characteristics of his work. Yet the effort to draw from them a true visual or even literary aesthetic is undone by the very ambiguity of the frame of reference that would give rise to it. Moreover, such an effort harbors a danger, for it may well provide the means to the canonization, the "endgame," of a creative effort impelled precisely by the lack of resolution or closure such terms imply.

A theory of art suggests not only a problem (what is art?), one that Beckett never really addressed head on, but a solution (what art is), a mode of thinking any reader of Beckett knows to be antithetical to his. Hence, though this book's thesis is that the unifying force of all Beckett's work is a preoccupation with the visual as paradigm and that painting sanctioned the preoccupation, *The Painted Word* will not attribute to Beckett a problem-

atic not his own and will aim to avoid reducing his views on and thematic uses of painting to a topology of art that would defy, by its very coherence, the "crises of negation"[11] that are the sine qua non of all his work. It is hoped that the more discrete context of a dialogue with art will accommodate the slippery nature both of Beckett's writing and the categories within which some have tried to set it.

The starting point of this volume is the current debate over Beckett's place with regard to modernism and postmodernism. This is a controversy that derives quite naturally from the intensity of Beckett's obsession with identity and the self: Insofar as subjectivity is at the origin both of modern epistemological thought (the Cartesian cogito) and of modernism (as perspectivism) in art and insofar as Beckett continually throws into question the viability of a pure subjectivity, exposing consciousness as an entity in and of itself while simultaneously renouncing it through the repeated dissolution of the ego, the dispute is unremarkable.

In addition, much said about Samuel Beckett may be at once true and untrue. Situating him within the arena of cultural change has thus, for some, become a critical imperative. For, just as ordering—periodization, systematization—appears an antidote to the chaos and, in a sense, immorality of our technological age, the classification of so ticklish a writer, one whose art is at once exceedingly indeterminate yet extraordinarily precise, is thought to ease the anxiety such apparent incongruity provokes. Hence, the effort to label his work modernist, late modernist, high modernist, or post-more-of-the-same is currently in full swing.

As I have yet to see any real consensus of opinion about what exactly a postmodernist is, for the term covers far too broad an aesthetico-historical domain, I do not see how there could be serious agreement about why Beckett should be called one. Nor do I see any real reason for the dialogue in which he is engaged with cultural history to be reduced to the subversive practices of modernism, early or late, neo or post (or high!). For the opposition to universalism that postmodernism erects in the name of cultural specificity essentializes culture in much the same way that modernism sought to purify art. Neither accounts for the hybrid reality of their interrelation.

More important, though the claims for each are seductive and not entirely unconvincing, my argument against such taxonomy derives from the idea that the visual paradigm itself—Beckett's concretizing of ontological indeterminacy on the specular horizon—would preclude it. To the extent that the unity of Beckett's endeavor is to be found in an allegoriza-

tion of seeing, in other words, the modernist/postmodernist discussion would appear to be invalid: The visual process revealed by Beckett results in an ontological expression that surpasses the subject/object dichotomy that is the very point of departure of that polemic.

"Always historicize!" Frederic Jameson's "'transhistorical' imperative," has its place in a millennial evaluation of Beckett's contribution. And the value of the modernist/postmodernist arguments lies therein. The "traditional dialectic" that "the historicizing operation" must follow, however, renders it self-defeating. For the distinction between "'objective' structures of a given cultural text (the historicity of its forms and of its content [. . .]) and something rather different which would instead foreground the interpretive categories or codes through which we read and receive the text in question"[12] impedes elucidation of the subtle but undeniable relation between thinking and seeing as manifested in Beckett's art. The modernist "division of wholes into parts" (as Mary Ann Caws puts it) and the postmodernist derision of referentiality are consequences of the historico-cultural conditions that beget art. As interpretive devices, however, they offer insufficient explanations of ways of looking, structures of seeing—in short, visual praxis.

My opposition to the debate stems, then, from a fundamental unwillingness to view either Beckett's own art or his thinking on others' art in terms of any supposed autonomy of art as distinct from what he calls "the issueless predicament of existence,"[13] an unwillingness that subtends this book in its entirety. It also derives from the writer's personal antipathy to such absolutist theorizing: "The danger is in the neatness of identifications. The conception of Philosophy and Philology as a pair of nigger minstrels out of the Teatro dei Piccoli is soothing, like the contemplation of a carefully folded ham-sandwich." And: "Must we wring the neck of a certain system in order to stuff it into a contemporary pigeon-hole, or modify the dimensions of that pigeon-hole for the satisfaction of the analogymongers? Literary criticism is not book-keeping."[14]

The argument that Beckett's oeuvre is neither early nor late, neo- nor post-, modernist, yet in some sense all at once, is further supported by the notion that in seeking to overcome a number of dualisms (mind/body, internal/external, ego/world among them), in seeking to resolve the fundamental dichotomies that are the primary manifestations of the visual paradigm, Beckett's art became increasingly self-conscious. And, I would argue, it is this self-consciousness that resulted in the minimalist writing, and the collapse of genre, characteristic of all the late work.

This is to say that the figuration of seeing wherein lies the unity of

Beckett's art, the visual paradigm that allows his art to be, is ultimately responsible for this art's progressive undermining of itself. Indeed, reductionism in Beckett fulfills, in a way, the Hegelian prediction of the "end" of art whose demonstration against the background of mid-twentieth-century American painting by critic/philosopher Arthur Danto has been so controversial in recent years. Hence, my discussion of art's "end" in Beckett, its "philosophical disenfranchisement" (to borrow from a Danto title), is meant to take the visual argument yet a step farther: For it is in art's visualization of itself (such as it occurred from Duchamp to Warhol and Beckett) that, in accordance with Danto's thinking, it became post-historical and stopped. This discussion, moreover, is also meant to quicken the demise of the Beckett as modernist/postmodernist polemic and to illustrate the need for re-posing many of the same questions that initially gave rise to it on another level of inquiry.

In part 2 Beckett's critical writings are investigated in the framework of the expressive failure of all art condemned to reveal nothing other than the opacity of its own constitution. As allegories of seeing, Beckett's miscellaneous criticism and dramatic and narrative prose follow a similar trajectory away from discourse as the articulation or demonstration of aesthetic theory toward a decisively anaesthetic point of view. Thus, the refutation of a coherent aesthetic discernible within the critical writings is followed by a contextualization of the Beckett/art dialogue with a phenomenological ontology, that of Maurice Merleau-Ponty, which serves to resituate the Beckett as modernist/postmodernist polemic previously considered.

Beckett's sensorial position with regard to art—art as perceptual interrogation—appears exquisitely congruent with this philosopher's conception of art as visible access to the invisible. Indeed, the objectification of self and world, their "visibility," and the interplay of anonymity and individuation that results, are displayed on the horizon of the nonvisual and the visual, the hidden and the revealed, that is the basis for Merleau-Ponty's thinking on painting. While the drawing of philosophical parallels to Beckett's work has been the focus of a number of critical studies (Lance St. John's Butler's book on Beckett and Heidegger, Sartre, and Hegel comes first to mind),[15] none, to my knowledge, has detailed this connection to Merleau-Ponty and linked the great visual force of Beckett's work both with his own deep appreciation of painting and the three important essays on the plastic arts by the French thinker.

On the first page of the introduction to his astute book *The Theory of the Arts* Francis Sparshott claims that "art is a simple matter" for "there is . . . really no problem about what art is and what art is for." Considering

that there follow over seven hundred pages devoted to theorizing about art, the reader is well aware that irony is the operative mode, as it often is, in Sparshott's development of his topic. Indeed, on the very next page one reads of three ways in which "art," not so simple a matter after all, "has become problematic": The first concerns the supposition that poets and painters are engaged in the same kind of enterprise and the difficulty one has in identifying how this is so; the second regards the assessment of the class of activities that includes both poetry and painting, for it has come to "include the most diverse forms of behavior, such as leading cows through a maze or proposing to wrap a countryside in cellophane"; and the third is the importance assigned to such activities over and above the pleasure they may afford.[16]

While Beckett did not for long formally engage in the practice of the art theorist, he did confront the problematics of art described by Sparshott. From *Waiting for Godot* to what has been called his "final fugue,"[17] "What Is the Word," Beckett accounts for the shared province of artistic endeavors, the diversity of expression, and the significance of not necessarily pleasure-related (aesthetic) expression in the correlation of art with life. Each of his creative works is "ready-made" in the subversion of both mimesis (waiting is waiting in Beckett and not an imitation of it) and analogy (no more than Joyce's is his writing "*about* something; *it is that something itself*")[18] in the integration of the aesthetic with the existential or empirical modes.

In the critical essays, tributes, and his correspondence as well, each of these three ways in which art has shown itself to be problematic is pondered: "Is there something paralyzingly holy in the vicious nature of the word that is not found in the elements of the other arts?" he asks, for example, in an oft-cited 1937 letter to an acquaintance, Axel Kaun.[19] Given the significance of Beckett's deliberation on the complexities of art, it is the purpose of the second section of this study to explore, for lack of a better term, the Beckettian "aesthetic" but within the distinct frameworks that follow:

(1) *the belief that the primacy of visual perception (the play of the visible and the invisible) maintains an ontological status consistently overlooked by the imperialist rhetoric of cultural compartmentalizing (viz. modernism/postmodernism) and the institutionalizing of experimental practices of art and (2) that in both theory and practice Beckett negates the conventions of art appreciation[20] rendering his reflections more anaesthetic than not.*

My approach to Beckett's dialogue with art could perhaps best be summed up by the last line of a paragraph Beckett himself wrote, for a 1938 exhibition, about the Dutch painter, Geer van Velde: "Believes painting

should mind its own business, *i.e.* colour. *i.e.* no more say Picasso than Fabritius, Vermeer. Or inversely."[21] This is to say that what is of primary interest in Beckett's writings on painting and in the multiple appearances of painting in his creative work ought not be used to illustrate some sort of transparent thinking on art, a thinking in which art would be viewed as a transcendent object distinguishable from the conditions in which it was created and those of its reception. Proper to a reading of Beckett on art and of art in Beckett is the unveiling of all that is contained therein, the bracketing of all that is not. The final segment of the volume is devoted, therefore, to that concretization of Beckett's dialogue with art that was an allegorical animation of seeing itself.

The last section draws some inspiration from Enoch Brater's eloquent articulation of Beckett's poeticizing of dramatic language and mise-en-scène. Brater's delineation of Beckett's artistry emerges in *Beyond Minimalism* from a careful tracing of the transmission of verbal into stage image, of linguistic into gestural presencing, and his insights are most provocative. While the juncture of the textual and the experiential lies for him, however, in the innovative genre that he calls the "performance poem," it lies for me in the plasticity of Beckett's writing. It will be the purpose of the final two chapters to explore this plasticity as the very structure in which Beckett's artistry, despite its nullifying post-historicism, resides.

I am reminded in this effort of Antoine Roquentin, who wrote in the diary that is Sartre's *La Nausée:* "And suddenly, suddenly, the veil is torn away. I have understood, I have *seen.* [. . .] And then all of a sudden, there it was, clear as day: existence had suddenly unveiled itself."[22] The visual metaphor serves Roquentin well; the incongruity of language with the existential reality, in fact, allows for no other form of utterance. Beckett, however, may be said to take the ontological naming a step beyond: His allegorization of seeing is a reengagement of art with its primary aesthetic impulse. It is in the framework of what I view as a subverted "end," or reaesthetization, therefore, that I consider in part 3, first, Beckett's play on aesthetic problems and the creative depiction of real and imaginary art and, second, how a number of painters have visualized in their "collaborations" with Beckett the visual sensibility that was his.

The critic's privileging of the verbal to the detriment of the visual dimension of Beckett's work has perpetuated the assumption of a fundamental opposition between word and image. The notion that Beckett's writing depicts, above all, mental and perceptual figuration, however, implies a writing that can be read iconographically. The *livres d'artistes* created by painters seeking to "illustrate" Beckett's written word offer a kind of icono-

graphic "reading." Plastic renderings of verbal visualizations, they oblige us to consider as collapsed a number of polarities: subject/object, literary/visual, and illustration/interpretation, to name but a few. Indeed, in questioning the "representations" that constitute the word/image *collaborations,* one is obliged to begin by bracketing any preconceived notion of which art—the verbal or the nonverbal—is the illustration and which the illustrated.

Several artists have found in Beckett the means to further both their own aesthetic and epistemological pursuits. Avigdor Arikha, Georg Baselitz, Edward Gorey, Stanley William Hayter, Jasper Johns, Charles Klabunde, Louis le Brocquy, and Robert Ryman have investigated the process of the mutual animation of verbal and visual meaning with Beckett's texts as the focus. This study of their efforts is in no way meant to be exhaustive but, rather, to afford some sense of how these artists worked with Beckett's words—with a verbal figuration whose paradigm is, precisely, visualization—both to give form and texture to and celebrate an otherwise *in-visible* substance.

Neos and Posts: Situating Beckett

The Endgame of the Modernist/
Postmodernist Controversy

Modern and *postmodern* are among the most consistently used terms in critical and cultural studies. Despite myriad attempts at their clarification, they are also among the most divisive for the ambiguity and imprecision with which they are used lead to endless misinterpretations, many of which derive simply from confusion over their designation of historical periods versus aesthetic sensibilities. Indeed, the confusion surrounding the terms may in itself be deemed postmodern. Listen to Umberto Eco: "I realize, as I say this, that perhaps I use 'modern' and 'postmodern' in a different sense from that in which you and others use it. Well, this seems to me a very postmodern attitude—don't you agree?"[1]

One aim of this book is to resituate Beckett beyond the categorical disposition, for not only does it muddy the waters but significantly reduce the terrain. More often than not, the very problems of structure and style around which the controversy turns assume the subject/object schism (bequeathed by Descartes and bemoaned by Beckett) that deprives art of its ontological weight. But the modeling of Beckett's work on an epistemology of visual perception necessarily throws into question any such supposition of art's objective status and opens word onto world in such a way as to invalidate the labeling.

To appreciate its doing so, I propose to begin by demonstrating, summarily, the kind of ambiguity to which the modern/postmodern tagging continues to lead. This should allow for a fuller articulation of the ontological expressivity of Beckett's critical and fictive efforts and justify, however heuristically, the argument for the specular model. It should also allow for a better understanding both of the minimalist "end" met by Beckett's creative forces and the paradoxical reaesthetization it implied.

Two possible approaches to setting the equivocating consequences in relief seem valid: Either one situates oneself within the "end of modernity" debate to better illustrate the hazards of positioning Beckett on either side,

or one situates oneself resolutely outside it. But how? The controversy, inaugurated by Jean-François Lyotard and Jürgen Habermas and perpetuated by Gianni Vattimo and others, assumes in "modernism" a critical project that itself may be challenged. We could, in other words, go so far as to hypothesize, with sociologist Bruno Latour for example, that the revolutionary idea, "the idea of a time that passes irreversibly and annuls the entire past in its wake," is distortive. We could argue, as he does, that "no one has ever been modern," that "modernity has never begun,"[2] and thereby necessitate a rethinking of "modern" as mere potentiality and of its high, late, post, and other qualifiers as over-anticipations.

Or, with philosopher Richard Rorty, we could call for an end to the postmodern: "It's one of these terms that has been used so much that nobody has the foggiest idea what it means. It means one thing in philosophy, another thing in architecture and nothing in literature. It would be nice to get rid of it. It isn't exactly an idea; it's a word that pretends to stand for an idea. Or maybe the idea that one ought to get rid of is that there is any need to get beyond modernity."[3]

Extending Latour's conjecture or Rorty's plea to Beckett would not minimize in quantity or quality the impact of his innovations. Rather, so decisive a deflation of the binary disposition to his work might simply afford an emancipation from which Beckett studies could profit. For reinserting Beckett within a larger, far more relativist historical sphere from which the entire notion of modernity or that of its aftermath would be absent would restore to our appreciation of his play with language a humanist primordiality that the (post)modernist division between the material world and that of speaking subjects has devalued.[4] But this must be the subject of another volume. Hence the more limited view from within the debate that follows, one whose skepticism is purposeful and brevity hereby acknowledged. As Latour himself reminds us, "Nietzsche said that the big problems were like cold baths: you have to get out as fast as you got in."[5]

Of the principal tendencies discernible in classical modernism, the style in art and literature that, for all intents and purposes, simultaneously bears the mark of both historicity and taste, two are definitive: an oppositional spirit and a totalizing (or utopian) vision. Beckett's writing clearly exhibits both, greatly simplifying the task of designation. The problem is solved: Beckett is a modernist.

Yet the oppositional penchant in Beckett is not restricted to a rupture with literary (narrative or theatrical) convention. It extends as well, if not more significantly, to a self-resistance from which a profoundly dramatic

tension ensues. And the totalizing force does not embody the idea of progress (in either the aesthetic or humanistic realms) that modernism presupposes. Is Beckett a postmodernist, after all?

It is generally agreed, in talking about Western painting, that the modern epoch dates, roughly, from Courbet and Manet to Cézanne, Picasso, and on. In literature the break with convention that *our* modernity represents (for such a notion is hardly restricted to this era alone) can be traced to Flaubert's personalization of the narrative ("Madame Bovary, c'est moi") that paved the way to exposition of the innermost recesses of mind. In art as well as literature the move to the new age meant not merely change in form but change in subject, for the medium itself became the focus of inquiry.

Freud describes the moment in the development of the child when she becomes aware of her own identity as an individual separate from her mother. Jacques Lacan takes this infantile individuation a step further in viewing it as the child's assumption of an identification with her own image ("le stade du miroir," or mirror stage), an identification whose function is the establishment of a concrete relation with reality. In Sartre a comparable process is described in the *pour-soi*'s successful rebuttal of the facticity of the *en-soi* haunting its structure of being.[6] The same sort of realization of self defined the emergence of modern—or, better yet, modern*ist* (to avoid confusion with the term meant only as a demarcator of time)—art.

The history of art may be defined as a history of reactivity, each school or period reflecting both awareness of what preceded and a response that effects change. Art deemed modernist is considered extreme in its reactivity, displaying a faithfulness to the spirit of opposition whose cultivation by Beckett has been identified by some as proof of this writer's specifically late modernist practice. Here, however, is where our troubles begin: Beckett's modernism is said to be late, and not post, precisely for its strategic deviations from, over and above a cultural past, a present self.

"The great challenge," observes H. Porter Abbott in a highly intelligent study, "faced by an art founded on the principle of opposition, is finding ways to resist the neutralizing effect of repetition, whether repetition is imposed *from without* or arises *from within*." Experimentation with form was the principal way in which this resistance to repetition "from without"—"inflicted through the various cultural agencies of appropriation, duplication, and veneration"[7]—manifested itself in Beckett. Play with form was, of course, characteristic of all the early subdivisions of modern art seeking to define themselves in opposition to aesthetic or ideological continuance: from Cubism to Conceptualism via Dadaism, Surrealism, and

Abstract Expressionism, a cohesion of style enhanced individual acts of perception through the refusal to con-form.

Beckett's experimentation with form revealed an opposition to the rules of narrativity that resulted in a crisis of genre unparalleled in literary history. Early on he refused to adhere to the hiatus between narrative voice and character consciousness that was fundamental to the so-called traditional novel of the last century. We have only to think of the dissolution of identity from Molloy to the Unnamable (by way of Malone), the merging of the one into the other that moves from the former's forgetfulness of *how* he got where he is to the latter's forgetting of just *where* and *who* he is, to see how fused the act and content of narration can be. The narrative I and narrated I becoming one and the same (the Unnamable's "I, say I") disrupts the coherence essential to storytelling rendering fragmentation (of identity, of consciousness) of not only the content but the form of the text itself.

Beckett's throwing into question the competency of the narrator that had been essential to the nineteenth-century novel was, in short, at the origin of his experimentation with form. If the very appearance of the text was shaken, sentences increasingly losing their paradigmatic, syntagmatic, and syntactic cohesiveness, it was that the text itself revealed the incomprehensibility that had formerly been restricted to the character alone.

While the French *nouveau roman* with which Beckett was at first associated is not to be understood simply as the monolithic effort of its first-generation practitioners to free the novel of convention, autonomy, and a tradition of narrative equanimity, there were a number of concerns common to these writers that caused their being linked, far more homogeneously than they ought to have been, under this rubric. This congruence of character incompetence and narrative incoherence was one such shared preoccupation (though nowhere is it as evident as in Beckett), and Alain Robbe-Grillet has explained it, with regard to his own work, as a primary element of modernism:

> things must take place within the text itself. It is impossible to write a text which, as a narration, is based on the old established order when its purpose is to show that this order is wavering. On the contrary. Everything must happen within the text so that severances, faults, ambiguities, mobilities, fragmentation, contradictions, holes must be enacted. It is the text which must display them.[8]

The congruence of form and content[9] was not restricted to Beckett's novels alone. In the theater *Waiting for Godot* (1952) revealed the dissolu-

tion of coherence not only linguistically, in Lucky's celebrated speech, most obviously, but in the very act of waiting that is, at once, the subject of the play and the actual theatrical experience, what the actors do on the stage. ("Nothing happens, nobody comes, nobody goes, it's awful.")[10]

Endgame (1957), once again, is a wait for the finish. From the first spoken line ("Finished, it's finished, it must be nearly finished") to the last ("You . . . remain") what is and the performance of it are merged.[11] Beckett's *Play* (1964) begins with a character's response to the faint spot that lights her: "Yes, strange, darkness best, and the darker the worse, till all dark, then all well, for the time, but it will come, the time will come, the thing is there, you'll see it, get off me, keep off me, all dark, all still, all over, wiped out—."[12] In *Breath* (1970) synchronized light and recorded breath controlled by two identical cries of a newborn are all that is left of the dialogue, character, and action that normally make up the theater event, rendering form and content, fiction and actuality, one and the same. And language, the primary vehicle for storytelling, is simply a construct of the visual in the majority of the subsequent plays.

Many of the playwright's other works exhibit this "theatereality": Krapp's time, in *Krapp's Last Tape* (1958), like that of the woman in *Rockaby* (1981), is our time in the theater as much as any other.[13] And in *Not I* (1973), as I have shown elsewhere,[14] Mouth emerges as this "tiny little girl" projected "before her time" into this "godforsaken hole" that is, simultaneously, the fathomless space of our world *and* that orifice whose very presence *is* the dramatis personae herself.

It is this, in fact, that constitutes the crisis of genre, the reevaluation of the play as play (or the novel as novel) that took place within Beckett's writing itself. Of course, the notion of art or literature as a site for experimentation with artistic or literary form was by no means peculiar to Beckett. Another of the shared concerns of the New Novelists, it was made explicit by Michel Butor in an early essay wherein the novel was referred to as "le laboratoire du récit."[15] Beckett, however, extended the notion beyond the question of the novel as genre, diluting the boundaries of both narrative and theater and provoking several directors to adapt certain of his nontheatrical works for the stage. As Enoch Brater has shown in his remarkable study of Beckett's late theatrical style, *Beyond Minimalism*:

The theater event [in Beckett] is reduced to a piece of monologue and the play is on the verge of becoming something else, something that looks suspiciously like a performance poem. All the while a story is being told, a fiction closely approximating the dramatic situation the

audience encounters in the theater. It is no longer possible to separate the dancer from the dance.[16]

If Beckett's oppositional spirit—manifest in the dissolution of narrative unity, syntax, and rhetorical code; in the revolutionizing of novelistic and theatrical genre—qualifies him for the modernist epithet, however, it also legitimizes our situating him on the other front as well. For no less significant than Beckett's resistance, through experimentation with form, to repetition "from without" is the writer's resistance to the threat "from within," a struggle whose problematization is central to postmodern discourse.

Abbott eloquently defines this self-critical impetus as a method of "recollection by distortion," explainable as a "deliberate metamorphosis, a kind of misremembering in successive works of elements from those that went before." *Happy Days* (1961), he relates by way of example, was born in opposition to *Godot*, which preceded it by more than a decade:

> By the fall of 1961, when *Happy Days* was first performed, *Godot* was in serious danger of becoming a classic, having advanced to that status through what could be called the law of retrospective comparative advantage. Beckett had become "the author of *Godot*," the man who wrote the play in which "nothing happens, twice." *Happy Days,* then, creates its effects not simply against Greek tragedy and Protestant devotional practice, nor (to go on) against *Hamlet, Romeo and Juliet, Cymbeline, Paradise Lost,* Gray's "Ode on a Distant Prospect of Eton College," and *the Rubaiyat of Omar Khayyam*—to name a few of the classics against which the play also situates itself . . . but against as well the emerging classic *Waiting for Godot.*[17]

To the extent that modernism represents a self-defining project, Beckett's method of creation through re-creation may be seen, as it is by Abbott, as distinctive of his (late) modernist bent. Nevertheless, what may be defined as a process of *writing against oneself*—that which, I would argue, is a key issue in the Beckett-as-modernist versus postmodernist controversy—also leads in Beckett to a short-circuiting antithetical to the modernist enterprise.

If any single concept pervades the diversity of definitions of the postmodern experience, it is that of indeterminacy, an enduringly complex notion that Ihab Hassan has qualified as "discontinuity" and "deformation." "The latter alone subsumes a dozen current terms of unmaking," he

notes, "decreation," "deconstruction," and "detotalization" among them.[18] If anything, postmodernism is a symptomatic move away from homogeneity and the threat of absolute presence.

Decomposition ("unmaking") in Beckett is a commonplace: The notions of ego and body are continually shattered from one work to the next. Language is forever "unworded." And each and every story is, in fact, another. Textual fragmentation or deconstruction *as a creative process,* however, has less often been a focus of critical inquiry,[19] though it is precisely this that reveals the fundamental inconsequentiality of the modernist and postmodernist rubrics when applied to Beckett.

It is not for nothing that the director Alan Schneider's "Every line of Beckett contains the whole of Beckett" is one of the most often cited remarks about the playwright.[20] As much Beckett scholarship has shown, continuity of theme and image is extraordinary in this oeuvre. And this despite the devaluation of language used, for lack of anything better ("Que voulez-vous, Monsieur? C'est les mots; on n'a rien d'autre"),[21] to convey their meaning. So, too, there is continuity in the structural "less is more" that is progressive from the early to the late work. And, methodologically speaking, autotextuality, or the author's return to his own texts (a variant of the intertextual conscious or unconscious play with works by others), is also a constant.

Yet the dialogue that the autotext perpetuates, a dialogue of Beckett with himself, is as much deformative or detotalizing as constitutive. For it amounts to the endless undoing of every work posited as referent, the making of each a work-in-progress whose ultimate creation is forever thrown into question. *Krapp's Last Tape,* for instance, not only deploys a subtle variation on a previously used name, that of Victor Krap in Beckett's first complete play, *Eleuthéria,* but revives and reworks both the initial dramatic concept and theme of that work as well. Intertextuality already functioned in *Eleuthéria* to call into question the conventions of dramatic method. As Dougald McMillan and Martha Fehsenfeld have demonstrated in *Beckett in the Theatre,* each act of the play relates the impossible employment by Beckett of Shakespearean and Strindbergian theatrical tradition: "indirect presentation through others" is rejected in act 1, "conventional conscious self-revelation" in act 2, and "the method of unconscious self-revelation in the tradition of the expressionistic dream play" is contested in the third and final act.[22] Very much in evidence in *Eleuthéria* was the Beckett credo: "The text as is, the words as is, that's all I know. The rest is Ibsen."[23]

But *Krapp* extends the freedom (suggested by the earlier play's Greek title) from conformity by confronting, theatrically and thematically, the

other work. An autotextual redoubling of the method and conflict of *Eleuthéria*, *Krapp* substitutes the character's own voice on tape (recorded at earlier moments of his life) for the direct and indirect modes of character exposition parodied there. It also reworks the conflict faced by the young Krap, that of *being* versus *nonbeing* (an obvious throwback to *Hamlet*), as defined by the bourgeois household to which he is called to return. The play ends with Krapp's addressing anew the fundamental question answered in the final gesture of Victor Krap:

Krapp's Last Tape:

> Here I end this reel. Box—[*Pause.*]—three, spool—[*Pause.*]—five. [*Pause.*] Perhaps my best years are gone. When there was a chance of happiness. But I wouldn't want them back. Not with the fire in me now. No, I wouldn't want them back.

Eleuthéria:

> He looks perseveringly at the audience, the orchestra, the balcony (Should there be one), to the right, to the left. Then he gets into bed, his scrawny back turned on mankind.[24]

Such "recollection by distortion" is traceable throughout Beckett's writing. Another striking example is to be found in *A Piece of Monologue*, in which a new discourse is constructed from the fragmenting of several works (both novels and plays, from *Molloy* and *Malone Dies* to *Endgame*, . . . *but the clouds* . . . , and *Ghost Trio*, to name but a few), as has been astutely illustrated by Brater.[25] As Ruby Cohn has shown, moreover, with regard to the same work,

> several critics point to three accounts of matches lighting the oil-lamp, but the third description actually replaces the three matches with a spill, and it is therefore ambiguous in the fourth reference, "Lights lamp as described," as to *which* light ghosts the narrated action—match or spill.[26]

In *Footfalls* (1976), to cite yet one further instance, we encounter a play (both senses intended) on infinity that recalls its scenic, textual, mathematical, and philosophical functioning everywhere in the Beckett canon.[27]

I propose, in short, that this characteristic autotextuality may be viewed either as modernist or postmodernist practice insofar as, to cite

Andrew Renton, it is "not simply a stylistic resonance, but a re-negotiation of something altogether more solid."[28] With Abbott we may see it as a refinement of the sine qua non of modernism, a kind of distillation of the prototypical modernist attribute (opposition). As such, it represents a new valuation: through re-imagination, re-authentication.

At the same time, however, we might construe it as distinctly post-modernist, for, despite the imprecision of the term *postmodernism* and its eclectic use, undermining is its legitimizing trait. Lyotard, for one, sees in the postmodern a process strikingly similar to what has just been described, in accordance with Abbott's prefixless definition, as operative in Beckett. Clarifying *post-*, Lyotard writes that it is "not a movement of repetition but a procedure in 'ana-': a procedure of analysis, anamnesis, anagogy, and anamorphosis that elaborates an 'initial forgetting.'"[29] Hence, Beckett's "writing against himself" (or "misremembering") may be said to fulfill both the criterion for modernism as described by Abbott and that for post-modernism as depicted, among others, by Lyotard. Insofar as Beckett's "method of distorted self-recollection"[30] is auto-*ana*lytic, the autotextual elaboration of "an 'initial forgetting,'" it is at once *modernist subversion* and *postmodernist multivalence* and never only either one.

The Sartrean model of the *pour-soi* referred to earlier may again be evoked with regard to modernism but now with respect to the specificity of Beckett's self-resistance and its potential for postmodern qualification: Cru-cial to Sartre's essentializing notion of the individual is the idea that the *pour-soi*, in its infeasible effort to objectify consciousness as an *en-soi*, "thinks against itself." (Such resistance is a concept that has also been used with regard to Sartre, the man: Michel Rybalka has written of Sartre's ten-dency to disregard critical interpretation and to "penser contre soi" [think against himself] from a uniquely "internal point of view.")[31] In Beckett it is precisely the resurrection, alteration, and elaboration of a previous text within a subsequent one that not only defies any possible fixity of art but also renders both works-in-progress, each as temporally resistant to objectification as the *pour-soi* itself.

Robbe-Grillet has described his own need to write against himself. When asked by Rybalka about the development of his work, he responded: "A chaque fois qu'à propos d'un de mes films ou d'un de mes romans j'ai développé moi-même un fragment théorique [. . .], ce que j'ai eu envie de faire (*contre moi* [. . .]), c'est précisément *autre* chose" [Each time that I developed for myself a theoretical fragment concerning one of my films or one of my novels [. . .], what I wanted to do (*against myself* [. . .]) was pre-cisely something *else*].[32]

There is no doubt that the shared vocabulary has its origin in unshared sources. Unlike in Sartre and Robbe-Grillet, the question in Beckett appears distinctly nonconceptual. (Beckett's antipathy to the philosophical systemizing of his literary efforts in no way precluded philosophical praxis and the working through of the relation of subject to object, whether mind to world or to objectified self, was, as it is by now platitudinous to state, the basis of his creative experience.) Nonetheless, in all three, a determination to undo one's subjective rendering of the world so as to better subjectify it, to articulate a less deceptive ordering of the real—an attitude long identified as modernist—is the driving force.

Beckett's subversiveness is, of course, not restricted to the unmaking and remaking of previous writings. As already noted, both linguistic meaning and physical and mental function are sabotaged continually within each work, from the immobility that contradicts every intended departure (that of Vladimir and Estragon at the end of each act of *Godot* or Clov's in *Endgame*) to the leitmotif of "making sense" (as in *Not I* and *What Where* [1984]) in a world where none is to be made. Ruby Cohn has noted a more subtle form of it in the "generic ghosting" of plays such as *Footfalls* and *Ohio Impromptu* (1981): "The one mentions a Reader, and quotes a reading, but we see no book on stage. The other offers prominence to a book, from which a story seems to be read aloud about a reader reading aloud."[33]

Refinement of text through performance is another variation on the subversive theme characteristic of Beckett's compositional method. As Stan Gontarski has shown, it was in the conjunction of the "writing self" with the "directing 'other'" (or the "directing self" with the "writing 'other'")— a conjunction that "occurred some 16 times on the stage and another six times in the television studio"—that Beckett purified and refined his artistic vision. Insofar as publication of a play was hardly the defining moment, but an "interruption in the ongoing process of composition," Beckett's staging of his own work was not just revisional but fundamental to the ever-continuing creative process.[34]

Beckett's self-translations offer a variant of his subversiveness as well. The writer's bilingualism allowed him to write in both English and French, and most of his works were translated by him from one to the other language. In these more accurately termed rewritings (Beckett called them "adaptations"),[35] as Charles Krance has ably demonstrated, translation takes place precisely in the space *between* two Beckett texts, not *within* one or the other. The particularity of this self-translation, to quote Krance, lies in the "insufficiency *and* dependence (in other words, their difference) *vis-à-vis* each other."[36] And it was precisely as a countering of language that Beckett related the task: "I have the consolation [. . .] of sinning willy-nilly

against a foreign language, as I should love to do with full knowledge and intent against my own—and as I shall do—Deo juvante."[37]

In a sense, then, the transtextual (external) process duplicates the auto-textual (internal) interplay of texts within a single work, repeating outside the original and adapted versions of a text the opposition noted earlier. One cannot help but be reminded by both the transtextual and autotextual reconstructive processes, moreover, of qualities operative in Beckett's characters themselves. The dissolution of the ego, like the decomposition of the body that shelters it, is habitually cited as the most identifiable feature (or condition of being) of those who inhabit Beckett's world. As distinctive is the replication, *within its very process of creation,* of the quest for unity that impels—whether through unconscious repetition (verbal or behavioral) or conscious self-objectification—the fragmented ego itself.

The dialectic of "writing against oneself" that is pivotal in the Beckett as modernist versus postmodernist controversy thus reveals the reduction of the work to either arena to be exceedingly problematic. As already noted, opposition is the hallmark of modernism, in which form and structure *are* meaning, not the vehicles of its deliverance, and undoing, or self-effacement, the only protection against the closure of having said. Viewed not as a function of a prescriptive awareness, however, but rather of a self-reflexivity that bears witness, simply, to the arbitrary status of the text, the repetition ("recollection by distortion," or misremembering) from work to work (or within a given work)—whether transcriptive or translative—implies the contrary of the modernist essentializing vision.

This is to say that the reworking of thematic, structural, and philosophic preoccupations in Beckett may or may not be considered a totalizing force. Abbott, for one, is definitive in his consideration of the process as a unifying construction to the extent that he sees it as dependent upon a variation of the Victorian trope of onwardness.[38] In this perspective Beckett's creative practice is revealed as distinctly modernist (or late modernist), and rightly so, insofar as it is reconstructive, or conjunctive, though driven by a movement against what came before.

The very same process, however, may be said to be not modernist at all, for the repetition that we have defined as a "writing against" fragments structure and meaning in a way that not only echoes but undoes textual paradigms and genres and reveals a consciousness exquisitely conscious of its own self-consciousness. As critic Stephen Barker has written, "Beckett's palimpsestic 'system' of writing affords this invitation to the erasure of the archi-trace. The reversals and qualifications one finds so pervasive in Beckett's texts have their roots in this strategy of erasure."[39]

That Beckett's position with regard to modernism and postmodernism

is nothing if not ambiguous is due not only to differences in definition. It is true that the semantics in question reflect aesthetic and cultural forces (leaving aside the political for our present purposes) without any real consensus as to their mutual implication. It is for this reason that modernity has come to reveal, as Latour has shown, a kind of schizophrenia: While insisting in theory on essentializing and the ultimate in purification, in practice it delivers "hybrids of nature and culture" that provoke the prepositional qualifications.[40] But also increasingly apparent is the extent to which opposing views of Beckett may simultaneously be on the mark. Unintended reinforcements of one camp (the modern or postmodern) by the other are not, in fact, uncommon.

Does not the breakdown of genre associated with deconstruction and thus postmodernism, for instance, clearly, if paradoxically, result in Beckett in an accentuation of genericity, a preoccupation of modernist discourse itself?[41] *Beyond Minimalism* is devoted in its entirety to that extraordinary "epic adventure" that is Beckett's minimalist work. And what Brater successfully demonstrates there is, precisely, how the playwright's exploration of drama as genre realizes, in the poeticization of mise-en-scène (particularly in *Not I* and after), a genre all its own. Similarly, does not the breakdown of language—the destabilization of meaning in repetition and syntactic irregularity, the dissolution of a coherent semiotic function, the problematic rapport of speaking subject to the spoken word—so often cited as a mark of Beckett's postmodernist (as deconstructive) practice, result in a deepened communication reminiscent of both the imagism and musicality of much modernist poetry?

His modernist *nouveau romanesque* opposition to the monolithic and omniscient Western narrative conventions of the preceding century notwithstanding, Beckett may be situated at the postmodern antipode of modernism when one considers that he celebrates the innovative power of art divorced from any cultural—whether appropriative or reactive—determination other than its own. "L'art adore les sauts" [Art loves leaps], Beckett wrote in "La Peinture des van Velde ou le Monde et le Pantalon," attesting to a radical view of art as absolute initiation. And, indeed, the Beckett text is, in many respects, a metaphor of its own initiality:

MUSIC: *Small orchestra softly tuning up.*
WORDS: Please! [*Tuning. Louder.*] Please! [*Tuning dies away.*] How much
 longer cooped up here in the dark? [*With loathing.*] With you!
 [*Pause.*] Theme. . . . [*Pause.*] Theme . . . sloth.

(*Words and Music*)

w1: Yes, strange, darkness best, and the darker the worse, till all dark, then all well, for the time, but it will come, the time will come, the thing is there, you'll see it.

<div align="right">(Play)</div>

v: Good evening. Mine is a faint voice. Kindly tune accordingly. [*Pause.*] Good evening. Mine is a faint voice. Kindly tune accordingly. [*Pause.*] It will not be raised, nor lowered, whatever happens. [*Pause.*] Look. [*Long pause.*] The familiar chamber. [*Pause.*] At the far end a window. [*Pause.*] On the right the indispensable door. [*Pause.*] On the left, against the wall, some kind of pallet. [*Pause.*] The light: faint, omnipresent. No visible source. As if all luminous. Faintly luminous. No shadow. [*Pause.*] No shadow. Colour: none. All grey. Shades of grey. [*Pause.*] The colour grey if you wish, shades of the colour grey. [*Pause.*] Forgive my stating the obvious. [*Pause.*] Keep that sound down. [*Pause.*] Now look closer.

<div align="right">(Ghost Trio)</div>

a: [*Finally.*] Like the look of him?
d: So. so. [*Pause.*] Why the plinth?
a: To let the stalls see the feet.
 [*Pause.*]
d: Why the hat?
a: To help hide the face.
 [*Pause.*]
d: Why the gown?
a: To have him all in black.
 [*Pause.*]
d: What has he on underneath? [a *moves towards* p.] Say it.
 [a *halts.*]
a: His night attire.
d: Colour?
a: Ash.
 [d *takes out a cigar.*]
d: Light.

<div align="right">(Catastrophe)[42]</div>

Opening onto a fictive world, *Words and Music* (1962), *Play* (1963), *Ghost Trio* (1976), and *Catastrophe* (1984) are, in the act of revelation, that which is itself revealed. So, too, reproducing no other reality than that of its own

origination, the narrative *Company* (1980) begins: "A voice comes to one in the dark. Imagine."[43]

Topologically, then, Beckett's texts *progress* as they *regress*, to displace, at once, both fictive and linguistic foci. The fiction is elusive, in other words, insofar as the object, its own constitution, is fundamentally non-objectifiable, or is so only *en abyme,* referring to itself referring to itself ad infinitum. Just as the specular identification with self that Lacan envisaged as requisite to individuation precludes stasis, the infant's assumption of his mirror image already transporting him to the next stage of development, writing (or speaking) oneself into existence simultaneously implies the reverse. Expressiveness is "fatal," the Unnamable tells us, knowing full well that, as soon as something is named, it is no longer as it was.

Despite the hermeneutical implications of this self-reflexivity, there is a sense in which Beckett is no more postmodern than that first literary modernist Flaubert. For the same pull toward a solipsistic center (author in pursuit of himself not as authorial voice but as *persona principalis*) impels them both. Their obsessively scrupulous use of the word (*le mot juste* being no more Flaubertian than Beckettian) is also telling, rooted as it is in the shared belief that one *is* one's language and, in desperation, we seek *the* word through which we can *be*. This is a far cry from the postmodernist assumption of the necessarily subversive workings of language.

But there is also a sense in which Beckett is no more modern than, say, Balzac (foremost practitioner of the novelistic norms Beckett—like those other "high modernists" of his generation in France, Robbe-Grillet, Nathalie Sarraute, Michel Butor, Claude Simon, and Robert Pinget—was typically said to be challenging). Despite his break with the representational thought that had dominated narrative tradition, Beckett is no less fiercely realistic, naturalistic even, than his predecessor. The titles alone—*How It Is* no doubt best of all—suffice to tell the story. And his enormous cosmic galaxy, though peopled by increasingly nonindividuated subjects, is no less perspicacious a Human Comedy.

As a modernist, Beckett was no doubt heir to the precedents set by those literary and visual artists whose disregard for accepted standards of the well-made work was at once provocative and liberating. Deformation and decomposition (from the maimed bodies of Molloy and the Unnamable: "perhaps I had left my leg behind in the Pacific, yes, no perhaps about it"[44] to Mouth's total disembodiment) reflect various inspirations of the modern tradition, Freud's privileging of the unconscious not least among them. Verbal explosiveness ("quaquaquaqua") recalls the irrational energy of the Dadaists and Surrealists as much as the Cartesian legacy parodied.

Existential angst is the landscape upon which are constructed the figurations of universality. And irony, cynicism even, reproduces the disbelief that, twice, was the basis of postwar artistic expression.

Beckett's de-essentializing (of the mind) and de-materializing (of the human body), however, situate him well beyond the pale of classic modernist practice. Indeed, the unwording of language to which Beckett aspired, that language that appeared to him "like a veil that must be torn apart in order to get at the things (or the Nothingness) behind it,"[45] bears the mark of a distinctly postmodernist modernism, one that has been described by Lyotard as follows:

> The postmodern would be that which, in the modern, puts forward the unpresentable in presentation itself; that which denies itself the solace of good forms, the consensus of a taste which would make it possible to share collectively the nostalgia for the unattainable; that which searches for new presentations, not in order to enjoy them but in order to impart a stronger sense of the unpresentable.[46]

Where, then, does calling Beckett's modernism postmodern and his postmodernism modern leave us on the spectrums that extend from early to late, neo to post? In a word, Beckett's own, "At bounds of boundless void. Whence no farther."[47] For in the first place we have yet to come to terms with the notion of postmodernism as an extension versus rejection of the modernist project, as something other than a crude estimation of periodization. And in the second it is the nature of Beckett's writing, and herein resides its singularity, to defy, despite the quantity of engaging criticism to the contrary, such classification. In summary, then, the modernist/postmodernist distinction simply cannot set Beckett's work as a moment in cultural time. Only in abandoning the binarism will we achieve some understanding of what places him outside the contingent or provisional mode. To situate Beckett ("Three pins. One pinhole")[48] we must try otherwise.

Hegel . . . Duchamp . Warhol . . Beckett

The title of this chapter plays on Beckett's critical essay "Dante . . . Bruno . Vico . . Joyce," a study of the latter's *Work in Progress* first published in 1929. My inspiration here is both the "distillation of disparate poetic ingredients into a synthetical syrup" that the suggested lineage implies and the initial caveat offered by Beckett in his opening paragraph: "There is the temptation to treat every concept like 'a bass dropt neck fust in till a bung crate', and make a really tidy job of it. Unfortunately such an exactitude of application would imply distortion."[1] As I aimed to show in chapter 1, the identification of Beckett's work as modernist or postmodernist—though apparently neat ("soothing," even, "like the contemplation of a carefully folded ham-sandwich")—is a case in point.

Hence, I will seek now to situate Beckett's achievements beyond the "party game" (the term is Breon Mitchell's) of classify the author, beyond the present "turf war" (to use one by Abbott), on a level of inquiry that both contextualizes Beckett's practice of art with his thinking on art and illustrates the following thesis: The ever increasing minimalism that characterizes the evolution of Beckett's fictive and dramatic style is a paradoxical result of his preoccupation with the visual as prototype. The specular model, in other words, while allowing his art to be, is precisely what subverts it, causing "failure" (a term to which I will return shortly) to be more than a persistent threat. In this sense Beckett's reductionism confirms the conjecture—derived from Hegel and demonstrable, via Duchamp and Warhol—that art has reached an "end."

I

I begin with the visual paradigm, the specular concretizing of ontological indeterminacy. It was not for nothing that, with the canonization (or what might be called, after Marjorie Perloff after Gertrude Stein, the "classiciza-

tion") of the New Novel, Beckett was cited as an immediate precursor of this "école du regard." From the time of his earliest writings, the short stories collected in *More Pricks than Kicks* (1934) and the novels *Murphy* (1938) and *Watt* (1953), an expressly reduced but finely tuned narrative vision substituted for the panoramic descriptive realism that had defined the Western novelistic techniques of the preceding century. And an effort to think representation nonmimetically, in accordance with the ontological authenticity that springs straight from the perceptual field, replaced the more arbitrary circumscription of the "real."

If Alain Robbe-Grillet, Nathalie Sarraute, Michel Butor, Claude Simon, and Robert Pinget—those writers bound from the 1950s more by their affiliation with Jérôme Lindon's publishing house, Les Editions de Minuit, than by any shared theory of the novel—found in the specular a means for the phenomenological bracketing of all but the here and now, Beckett, some two decades earlier, relied on the visual not only to divorce the narrative from any a priori construct of reality but, somewhat ironically, to defame the very ideal of verisimilitude itself.

This privileging of the look, over the more conventional reaching for metaphysical heights or probing for psychological depths, served, from the start, the new narrative realism that first Beckett, then the others, each in his or her own way, would deploy. If the novelistic revolution that *Molloy, Les Gommes, Martereau, La Modification,* and other early *nouveaux romans* represented insisted on the objective, it did so precisely to reunite the object of perception with a visually perceiving subject. From this intentionality the innovative novelistic expression arose. In Beckett, however, the visual dynamic would increasingly evolve toward a self-reflexivity—an imaging of the perceptual process itself—that was to defeat its own condition of being.

Yet, before we can evaluate this subversive process and consider how it might exemplify the notion that in Beckett art, in a sense, has reached an end, we would do well to identify those constructs that not only allow the specular to predominate in his writing but also give it a paradigmatic value. I distinguish four.

First, there are the explicit references to art, many specifically to painting; verbal representations of visual representations; and implicit allusions to and employment of art forms and techniques pervasive throughout the work. As ekphrastic description; the practice of still life, seascape, portrait, and so on; and the relation of iconography to pure abstraction will be considered in chapters 5 and 6, I will not elaborate on them here. Rather, I will simply suggest that they reveal not only both the extent of Beckett's engagement with the visual arts and the magnitude of painting's influence on his

writing but also a valorization of art as prototype whose consequences are profound.

Beckett did not acquire his formidable knowledge of painting from reading (he was highly skeptical of most art criticism) as much as from his museum and gallery visits. Although widely read in art history, it was primarily the many hours spent before the paintings themselves and his extraordinary memory of what he had seen that were the source of this extensive knowledge. The unpublished German Diaries to which James Knowlson had access in the preparation of his authorized biography yield a great many insights into those artists who interested Beckett (and those who disappointed him as well). But the allusions in his fiction also allow us to trace his paths through the galleries and museums of much of Western Europe.[2]

The explicit references to painting are of two kinds: those that mention specific art works or artists and those that allude to imaginary art. Both are paradigmatic insofar as it is on the *referent,* whether material object or fictive image, *as visual form* that Beckett's entire investigation of language, whether as epistemological or communicative tool, is modeled.

Indeed, the referentiality of language is problematized first and foremost by Beckett on the order of the tableau. For consciousness, of self or other, and its ultimate articulation are fundamentally related in visualization. The dilemma confronted by the Beckett character is universal: How is one to *know* what is not *seen?* And particularization underscores aspects of the problem: Consider, say, the Unnamable, who perhaps best appreciates the irony of our one-sided physiognomy. For him the question becomes: How am I to know who I am when destined to look not at but away from myself? The Unnamable's difficulty in voicing something of himself ("Me, utter me"; "Say of me that I see this, feel that, fear, hope, know and do not know?") is intimately linked to his peculiar situation of having to "remain forever fixed and staring on the narrow space" before his eyes that "can no longer close as they once could." It is not for nothing, then, that his identity is retrievable from a visual image: "Look, this is you, look at this photograph [. . .] come now, make an effort, at your age, to have no identity, it's a scandal, I assure you, look at this photograph."[3]

In *Film* Beckett's visual rendering of Bishop Berkeley's *esse est percipi* (to be is to be perceived), the protagonist is again dependent on the ocular for proof of himself. E's (eye's) pursuit of O (object) is not only the camera's (and hence the spectator's), as Beckett advises in the original filmscript, but his own: Although it will not be clear until the end, "pursuing perceiver is not extraneous, but self."[4]

This dependence of identity (or self-awareness) on the visual explains

the continual effort of Beckett's characters to, quite literally, catch sight of themselves. The narrator of *Texts for Nothing* (1958) seeks himself "in all those places where there was a chance of [his] being": "I'm in earnest, as so often, I'd like to be sure I left no stone unturned before reporting me missing and giving up."[5] *Stirrings Still* (1988) recounts a subject's visual objectification of himself: "One night or day then as he sat at his table head on hands he saw himself rise and go. First rise and stand clinging to the table. Then sit again. Then rise again and stand clinging to the table again. Then go. Start to go."[6] And in Beckett's first published novel Murphy must picture his mind itself, "the mental fact," to distinguish it from "the physical fact, equally real if not equally pleasant": "Murphy's mind pictured itself as a large hollow sphere, hermetically closed to the universe without." The distinction, however, is not so simple, and the picture is expanded:

> Thus Murphy felt himself split in two, a body and a mind. They had intercourse apparently, otherwise he could not have known that they had anything in common. But he felt his mind to be bodytight and did not understand through what channel the intercourse was effected nor how the two experiences came to overlap. He was satisfied that neither followed from the other. He neither thought a kick because he felt one nor felt a kick because he thought one. Perhaps the knowledge was related to the fact of the kick as two magnitudes to a third. Perhaps there was, outside space and time, a non-mental non-physical Kick from all eternity, dimly revealed to Murphy in its related modes of consciousness and extension, the kick *in intellectu* and the kick *in re*.[7]

Hence, cognition, whether of self or other, hinges on depiction. And Beckett plays with a distinctly visual vocabulary to drive home the point. Thinking that those who shut him up are coming to get him, the Unnamable says, "What can they be hatching anyhow, at this eleventh hour? Can it be they are resolved at last to seize me by the horns? *Looks* like it. In that case *tableau* any minute."[8] Even the end, his own concomitant with that of the discourse with which he is one, is "*in sight.*"

To return to the references to art, then, the naming of both real and imaginary works, they may be said to concretize as visual referent the referentiality of language. Not merely metaphorical expansions of narration, these allusions illustrate (in the most literal sense of the word) the dependence of meaning, both the making of meaning by a writer and its interpretation by a reader, on specular association. This, as we shall see, is true of explicit references to art and those that more implicitly recall a given

work—the narrator's minutely choreographed journey through the mud in
Comment C'est (1961), for instance, which evokes the illustrations by Bot-
ticelli for Dante's *Paradiso*.[9]

If music for Beckett continued where words could no longer tread (as
evidenced in the radio play *Words and Music*), visual art offered him a
means of exploring language as the appropriation of imagistic representa-
tion. While the making of verbal images is endemic to the literary process,
it is the evocation of specular *topoi*—be they specific works of art or depic-
tions of what might as well have been a painted image, such as those from
Malone Dies that follow—that reveals the implication of seeing in saying:

> It is such a night as Kaspar David Friedrich loved, tempestuous and
> bright. That comes back to me, those names. The clouds scud, tattered
> by the wind, across a limpid ground.

> this window that sometimes looks as if it were painted on the wall, like
> Tiepolo's ceiling at Wurzburg.[10]

Beckett precisely articulates this appropriation of the visual as para-
digm, the modeling of linguistic reference on specular imaging, in *Watt*, in
which a picture found hanging in a bedroom becomes the focus of a number
of questions. Watt wonders, for one, whether the black circumference of the
circle and the blue dot inscribed therein belonged to his coworker, Erskine, or
another, or whether it was "part and parcel of Mr. Knott's establishment":

> Prolonged and irksome meditations forced Watt to the conclusion
> that the picture was part and parcel of Mr. Knott's establishment.
> *The question to this answer was the following, of great importance*
> *in Watt's opinion. Was the picture a fixed and stable member of the*
> *edifice, like Mr. Knott's bed, for example, or was it simply a manner of*
> *paradigm, here today and gone tomorrow, a term in a series, like the*
> *series of Mr. Knott's dogs, or the series of Mr. Knott's men, or like the*
> *centuries that fall, from the pod of eternity?*
> A moment's reflexion satisfied Watt that the picture had not been
> long in the house, and that it would not remain long in the house, and
> that it was one of a series.[11]

The question, which I italicize, allegorizes the paradigmatic, albeit
ephemeral status of the visual (note Beckett's own use of the word *para-*
digm): "Not long in the house," the picture will yield to the next in the

series (of art, like the series of dogs, men, or centuries), much as the specular referent yields to its verbal successor in Beckett's own narrative production.

The contradiction in the answers that precede and follow the question, it might be added, is more apparent than real, for, as Beckett is quick to add, "nothing changed, in Mr. Knott's establishment, because nothing remained, and nothing came or went, because all was a coming and a going,"[12] which brings us to the second construct in which the visual functions as prototype.

Inconsistency and incongruity are, of course, among the most salient features of Beckett's work. Much has been written on the fragmentation of self that results in the fractured syntax and disparate content of the increasingly disembodied narrative voice. And much has been made of the estrangement that is the fate of Beckett's divided or disintegrated characters, profoundly isolated not only from others but from themselves. Less attention has been paid, however, to the gestalt, or *vision of the whole*, that is Beckett's metafictive point of departure.

This second motif of the visual paradigm might best be described as the substitution of an ontological for an objective (or descriptive) vision. That "nothing came or went" in Mr. Knott's establishment "because *all* was a coming and a going" (emphasis added) is emblematic of Beckett's narrative universe where objects, like the subjects perceiving them, have lost their separateness. Yet the dissolution of the ego that plagues the Beckett character also frees him to envisage the world in all its fullness as the "over all" place of his being. Abandoning his empirical stance, he assumes a transcendental posture that has been delineated by J. Mitchell Morse as the malady "of seeing everything whole, under the aspect of eternity."[13]

In the first volume of the trilogy Molloy acknowledges the liberating aspect of his isolation: "And once again I am I will not say alone, no, that's not like me, but, how shall I say, I don't know, restored to myself, no, I never left myself, free, yes, I don't know what that means but it's the word I mean to use."[14] Abdicating his psycho-social singularity, opting for the freedom of a kind of non-being, he surrenders will, thereby avoiding disappointment (for Molloy is not the "unhappy consciousness" of many of his counterparts), and resides in the total acceptance of his nothingness. At one with the world from which he forgets to differentiate himself ("Yes, there were times when I forgot not only who I was, but that I was, forgot to be"), his ontological vision is reflected in an intuition of the inexplicability of his being as a "Being-in-the-world": "To restore silence is the role of objects."[15]

For his part, the Unnamable also rids himself of what philosopher Jacques Garelli has called "la contrainte du regard objectif" [the constraint of the objective gaze] in favor of "la vision ontologique de l'*In-der-Welt-sein*, qui n'est autre que la transcendence du Dasein dans l'immanence de l'être"[16] [the ontological vision of the *In-der-Welt-sein*, which is but the transcendence of Dasein in the immanence of being]: "People with things, people without things, things without people, what does it matter, I flatter myself it will not take me long to scatter them, whenever I choose, to the winds."[17] Unable to be articulated *as he is*, the Unnamable forsakes his multiple individualities ("The essential is never to arrive anywhere, never to be anywhere, neither where Mahood is, nor where Worm is, nor where I am") in resigned acceptance of the annihilation this indetermination implies: "Nothing to do but stretch out comfortably on the rack, in the blissful knowledge you are nobody for all eternity."[18]

The ontological (or totalizing) vision, then, is one in which the "infinitesimal lag between arrival and departure"[19] is pictured neither on the order of the rational nor its opposite, the absurd, two sides of the same intellectualizing coin, but metaphorically—in the visualization of being's emergence in nonbeing. Such figuration of the ontological gestalt, in fact, is the first mark of this writer's work, the second being the persistent throwing into question of the metaphor's legitimacy. As Beckett himself admonishes, "Every word is a lie,"[20] for the ubiquity of being is fundamentally unrepresentable.

Indeed, the Unnamable's despair before the unrepresentability of the world, of life (a despair born of his determination to "say himself") culminates in the most profound deception. For his journey through space has been one through language, from the lies of others—"I am deceived, they are deceived, they have tried to deceive me"[21]—to the lie that is expression itself, whence the *fallor ergo sum* that is the Beckettian cogito.

The ontological vision is thus paradigmatic insofar as it is a primary source of the metaphorical figuration characteristic of Beckett's literary philosophizing. Beckett repeatedly stressed the distinction between artistic and philosophic discourse: "I wouldn't have had any reason to write my novels if I could have expressed their subject in philosophic terms."[22] Nevertheless, if his effort was not to articulate being in accordance with any philosophical logic, it was to depict what he called "the mess" and metaphorical figuration accommodated the "chaos" that is the perception of the *In-der-Welt-sein* prior to its abstraction in philosophical theory.

In the list of rhetorical figures in Beckett included in his essay "A Rhetoric of Ill-Saying," Bruno Clément notes an absence of metaphor in

Beckett's work and claims that "this absence tells us more about the work than does the presence of many other figures."[23] I would argue, however, that those critics who persist in seeing in Beckett an impoverishment of such figuration fail to recognize, on the one hand, that the ontological language used by Beckett to depict the immanence of being is, of necessity, metaphorical and, on the other, that the site of a metaphor need not be discursive.

Lance St. John Butler's comparison of "Beckettian man and Heidegger's concept of *Geworfenheit*, 'Thrownness,'" is telling: "There is no question but that this is a metaphor: Heidegger does not intend us to conceive of man as 'thrown' into Being literally. And when the actor in *Act without Words* is literally flung onto the stage we automatically grope for the meaning of that flinging in just the same way as we try to seize the philosopher's concept."[24] Beckett's 1969 play, *Breath*, with its thirty-five-second interplay of light, the cry of a newborn, and recorded breath, offers an equally dramatic example for, again, the metaphor is not linguistic but the simple visual (and aural) enactment of life experience. The event is so condensed that any portrayal of character, to say nothing of speech, is excluded. And the whole is but a metaphorical imaging, the mise-en-scène of the ontological vision itself.

This is not to say that metaphor is not a primary rhetorical mode in Beckett. On the contrary. Political metaphors (in *Godot*, *Catastrophe*, and other texts); existential metaphors (such as *Godot*'s celebrated "Astride of a grave and a difficult birth" and its many variants in the trilogy, *Rough for Radio*, *Not I*, *Stirrings Still*, and elsewhere); and metaphors of the creative process are privileged forms of articulation in his narrative and dramatic work. Even the possibilities of metaphor are metaphorically figured—as in these lines from *Company*: "A voice comes to one in the dark. Imagine" and "What visions in the dark of light!"—and its limits, the *ill said*, are as well.

My point, rather, is that the perception of existential immanence, as an immediate source of the metaphorical figuration, is effected both linguistically and non-linguistically. I find in the very phrase cited by Clément as proof of the absence of metaphor, in fact, evidence of the kind of monologic metaphorizing most typical of Beckett: "Here is my only elsewhere."[25] And throughout this novel (as throughout the oeuvre) it is as visual metaphor that the ontological reflection is continually articulated:

> Well I prefer that, I must say I prefer that, that what, oh you know, who you, oh I suppose the audience, well well, so there's an audience, it's a public show, you buy your seat and you wait

that's the show, you can't leave, you're afraid to leave, it might be worse elsewhere, you make the best of it, you try and be reasonable

in the anguish of waiting, never noticed you were waiting alone, that's the show, waiting alone.[26]

The mimes *Act without Words I* and *II* (1957 and 1959), like *Breath* and the silent *Film*, on the other hand, reveal nonverbally the primacy of art as metaphor and proclaim both the visual motivation and visionary sensibility that delimit Beckett's art. As Paul Ricoeur defined it, and Beckett demonstrated it in works such as these, "the 'place' of metaphor, its most intimate and ultimate abode, is neither the name, nor the sentence, nor even discourse, but the copula of the verb *to be*. The metaphorical 'is' at once signifies both 'is not' and 'is like.' "[27]

What I am claiming, therefore, is that the ontological (as opposed to objective) vision is not only further evidence of Beckett's obsession with the specular, but that it is a dominant paradigm of Beckett's characteristic and highly creative play with metaphors of existence. His most consistent metaphorical referent, in other words, is a visual gestalt, a seeing of everything, for all eternity, whole. What he claimed to have found most worthwhile in the Belgian Cartesian philosopher Arnold Geulincx, in fact, was the very "conviction that the *sub specie aeternitatis* vision is the only excuse for remaining alive."[28]

The third instance of the specular model is again a figurative source: What in this case amounts to a nontranscendental, and necessarily fissured, worldview is configured thematically in the focalization of seeing itself. As seeing is never a perception of the world independent of oneself within it, and one can never see oneself seeing, a kind of perceptual blind spot is part of every vision. This provokes the dichotomous focus within and without (as in *Endgame* or *Not I*, e.g.), the search for parameters of internal and external visual fields, that constitutes the dramatic tension of so much of Beckett's writing.

Unlike the metaphorical figuration of the ontological vision that is structured on the totalizing force of resemblance, Beckett's thematic figuration of seeing is constructed on the opposition of self and non-self antithetical to it. The recurring images of closing and opening (of eyes, windows, blinds) like those of refuge (of shelter, cylinder, jar) reveal the rupture that separates the inner and outer domains, the quintessential I from the nonessential not I, while the motif of "looking" ("looking at" and, by extension, "looking for") marks the quest for a unity between them.

Hence, the eye denotes the separation of inner and outer worlds and

the potential for their integration as well. Projecting at once outward and inward, it is a window on reality and an access to the soul:

> I asked her to look at me and after a few moments—(*pause*)—after a few moments she did, but the eyes just slits, because of the glare. I bent over her to get them in the shadow and they opened. (*Pause. Low.*) Let me in.[29]

> One is enough. One staring eye. Gaping pupil thinly nimbed with washen blue. No trace of humour. None any more. Unseeing. As if dazed by what seen behind the lids.[30]

If, as David H. Helsa has claimed, "the shape of Beckett's art is the shape of dialectic,"[31] it is that the visual theme replicates this dichotomous structure.[32]

In *Waiting for Godot* (in which polarized worlds offer numerous interpretive options) the link of Vladimir and Estragon to Godot is nothing other than the boy's having observed them: In act 1, in response to his "What am I to tell Mr. Godot, Sir?" Vladimir replies, "Tell him . . . (*he hesitates*) . . . tell him you saw us," which is reiterated, though with a change of pronoun, in the second act: "Tell him . . . (*he hesitates*) . . . tell him you saw me and that . . . (*he hesitates*) . . . that you saw me."[33]

Already in *Watt* observation had played (quite comically) on the I / not I bifurcation, prefiguring the metamorphosis of identities occasioned by search in the trilogy written not long thereafter:

> Mr. Fitzwein looks at Mr. Magershon, on his right. But Mr. Magershon is not looking at Mr. Fitzwein, on his left, but at Mr. O'Meldon, on his right. But Mr. O'Meldon is not looking at Mr. Magershon, on his left, but, craning forward, at Mr. MacStern, on his left but three at the far end of the table. But Mr. MacStern is not craning forward looking at Mr. O'Meldon, on his right but three at the far end of the table, but is sitting bolt upright looking at Mr. de Baker, on his right. But Mr. de Baker is not looking at Mr. MacStern, on his left, but at Mr. Fitzwein, on his right. Then Mr. Fitzwein, tired of looking at the back of Mr. Magershon's head, cranes forward and looks at Mr. O'Meldon, on his right but one at the end of the table.[34]

Here, as elsewhere, Beckett's positing of observation evolves into a positing of the need, often intense, to be observed oneself. As we know

from *Film,* in which avoidance of the eye is self-annihilation, being has meaning in proportion to its perception. Murphy perhaps best exemplifies this craving. His pain is palpable when he comes to realize that he is but "a speck in Mr. Endon's unseen": "The relation between Mr. Murphy and Mr. Endon could not have been better summed up than by the former's sorrow at seeing himself in the latter's immunity from seeing anything but himself."[35] Hamm, in *Endgame,* shows a similar yearning:

HAMM (*his hand on the dog's head*): Is he gazing at me?
CLOV: Yes.
HAMM: (*proudly*): As if he were asking me to take him for a walk?
CLOV: If you like.
HAMM (*as before*): Or as if he were begging me for a bone. (*He withdraws his hand.*) Leave him like that, standing there imploring me.[36]

And, as Knowlson has so clearly demonstrated, it is the same "pressing compulsion" that motivates the second woman in *Play* to ask, "Is anyone looking at me? Is anyone bothering about me at all?"; the man in the same play to inquire, "Am I as much as being seen?"; and Winnie, in *Happy Days,* to conclude, in Knowlson's words, "by adopting the Cartesian *ergo* from the 'cogito, ergo sum' formula, that, since she, Winnie, needs to continue to have a witness to her own existence, therefore, *ergo,* he, Willie, must still exist."[37]

Examples objectifying observation are everywhere to be found in Beckett's work. (The cameras in the television play *Eh Joe* and *Film* are not least among them.) The many instances of search (*Molloy, The Lost Ones, Rockaby,* and so on) pose an identical problematic. But Beckett's phenomenology of seeing often calls into question sight itself. Several characters, both real and imaginary (characters in Beckett's stories and characters in Beckett's characters' stories), are blind or "half blind." There are the Galls in *Watt,* for instance, the piano tuning blind father and devoted son; *Endgame*'s Hamm; and the old beggar woman in *Company;* to name but a few. Yet the thematic significance of sight is so closely associated in Beckett with the figurality of language—what Carla Locatelli calls "the issue of the translatability of the said into the seen, and vice versa"[38]—that the question of visual perception as such, and the paradigm of the fissured world view from which it derives, yields to a restructuring of the world over and above the horizon of the visible real. It is then that the transcendental or ontological again comes into play.

So it is that "outer meaning" has a "bad effect" on Watt:

Some see the flesh before the bones, and some see the bones before the flesh, and some never see the bones at all, and some never see the flesh at all, never never see the flesh at all.[39]

and that, despite her disembodiment (and hence visionlessness), Mouth, in the congruence of her narration with the reality of the spectators' view of her, still "sees" herself as seen:

. . . till she saw the stare she was getting . . . then die of shame.[40]

Beckett's texts, in other words, demonstrate on the order of visualization (whose spectrum ranges from seen to ill seen to unseen) an interplay of the totalizing vision of a pure subjectivity and the dichotomous perception imposed on the ego by its investment in-the-world. The most striking example is no doubt *Ill Seen Ill Said,* in which seeing seeks to exceed the binary in saying and "the two zones" (of stones and pastures) "form a roughly circular whole."[41] Here the visual theme is very clearly self-reflexive for the dialectical eye figures the saying-in-progress, the tension between "things and imaginings," that is the creative act itself reproduced as a *mise en abyme* in Beckett's imaginative work.

Locatelli has suggested, with regard to this text, that "the complexity of seeing is literally portrayed as the modeling of the world, and the actual seeing, inextricably linked to saying, is shown to be the only means apt to establish a world, even when the borders and structure of seeing are problematic."[42] Indeed, it is this "worldifying" process (*Verweltlichung*), repeatedly described by Garelli in Hegelian terms of a poetic *Aufhebung,* or restructuring, that is Beckett's primary focus. And it is precisely this focus, as we will soon discover, that is at once the sine qua non of the novel and its ultimate undoing, or failure.

Such thinking is fundamentally incompatible with the notion of representation underlying the semiotic and deconstructive practice of much current Beckett criticism. Although it is now far more fashionable to set Beckett within the poststructuralist context of Derridean and Deleuzian thought than that of the phenomenological tradition, it seems to me that only in viewing this text in terms of its opening onto a nonobjectified or prereflexive horizon can the reciprocity of the verbal and visual that is both means and outcome of Beckett's oeuvre be truly accounted for. How else are we to interpret Beckett's invitation, in *Ill Seen Ill Said,* for example, to enter the aesthetic site? "Let the eye from its vigil be distracted a moment. At break or close of day. Distracted by the sky. By something in the sky. So that when it resumes the curtain may be no longer closed."[43]

Let us move on, however, to the visual effects that constitute the fourth

and final construct of the visual paradigm. These range from extraordinary plays of color to subtle interactions of light and darkness and images (real and imaginary) such that John Calder would call Beckett's work "more painterly than literary."[44]

The early prose, more often than is generally acknowledged, can be vibrant. Eoin O'Brien has described Beckett's first novel, *Dream of Fair to Middling Women* (written in 1932 but published posthumously), as "a book of colour, pervaded by Samuel Beckett's technique of invoking colour to heighten mood with a unique chromatic intensity."[45] "Vivid lemon" is Murphy's "lucky colour," and, also in *Murphy*, Neary's thoughts are of "a wild evening's green and yellow seen in a puddle," while Mr. Endon is depicted as "an impeccable and brilliant figurine in his scarlet gown," with "purple poulaines" on his feet, and a "little blue and olive face."[46]

Even more striking is the play of colors in *Watt* in which there are numerous mentions of red floor; red hair; ashes alternating red and gray; an apron of green baize; blue days; blue sky; red screen; red, brown, yellow, and grey leaves; green grass; blue flowers; and so on and so forth. Indeed, "past trials and errors glow" with "sudden colors," and day breaks with "first the grey, then the brighter colours one by one, until getting on to 9 A.M. all the gold and white and blue [. . .] fill the kitchen."[47] Even with the greying of Beckett's prose in the trilogy, there are references, in *The Unnamable* for instance, to eyes "as red as live coals," for this is a grey "shot with rose, like the plumage of certain birds."[48]

Thus, despite Beckett's indulgence in "that colorlessness which is such a rare postnatal treat,"[49] color plays a far from negligible role in the early work, in which the blues, pinks, greens, and yellows are often very vivid. As far as the subsequent writings are concerned, however, as Stanton B. Garner has observed with respect to the theater, "when color threatens in Beckett, it is carefully muted, its singularity of hue strictly minimized."[50] The costumes in *Come and Go* provide a good example: "Full-length coats, buttoned high, dull violet (Ru), dull red (Vi), dull yellow (Flo)."[51]

Nevertheless, if Beckett's theater is characteristically gray, from the distinctly gray light of *Endgame* to the gray hair and gowns of many of the late plays, such as *Footfalls* and *What Where*, it too is not entirely drab. Mouth's red lips in *Not I*, like the yellow wheat, rust rails, green greatcoat, and blue sky of *That Time*, for instance, do not significantly offset the intended austerity—achieved by the interplay of light and dark, an often discreet half-lighting, and the striking contrast of white and black—of the late plays. But they do serve as a reminder of a better place, a colorful world that once was, recalling vitality where debility has become the norm.

Color in Beckett also, however, and herein lies its paradigmatic value,

renders concrete the otherwise invisible dimension of the world, its nonobjective or experiential constitution by which are individuated both people and things. Merleau-Ponty notes in *Le Visible et l'Invisible* that, while we subscribe to the thesis that the world is what we see, problems arise as soon as we ask the meaning of *we, see,* and *world.*[52] Beckett uses color, and particularly the contrasts of black and white and light and dark, to delimit the praxis that these terms represent, to express our encounter with the universe, the nature of and phenomena that constitute it.

This is evident in *Murphy,* where what Knowlson calls a "confrontation with colours in the physical world" may be said "to echo or anticipate [. . .] inner states"[53] and also, repeatedly, in *Watt,* where nature and man are mutually accommodating:

> The sensations, the premonitions of harmony are irrefragable, of imminent harmony, when all outside him will be he, the flowers the flowers that he is among him, the sky the sky that he is above him, the earth trodden the earth treding, and all sound his echo. [. . .] With what sudden colours past trials and errors glow, seen in their new, their true perspective, mere stepping stones to this![54]

In one sense black and white, and the grays that lie between, suffice to render the nonvisible visible, touching the reader or spectator more deeply than might the whole spectrum of primary colors. Light and dark comingle in a slow transformation of one into the other (*Breath*), in the constancy of a dimly lit stage (*What Where*), in the polysemy of the word *dim* itself (*Worstward Ho*). Or they contrast in set and costume (*Ohio Impromptu*), in narrative line (*Company, Ill Seen Ill Said*), in internal monologue ("The Calmative," "The End"). But in each instance it is either their interaction, or the reduction of one to the other, that allows the invisible to enter the perceptual field. Note the following examples from *Company:* "In dark and silence to close as if to light the eyes and hear a sound. [. . .] To darkness visible to close the eyes and hear if only that" and "You lie in the dark and are back in that light";[55] and this one from *Ill Seen Ill Said:* "For an eye having no need of light to see."[56]

In another sense, however, it is the very absence of primary color (rather than the presence of black, white, and gray) that spatializes the existential dimension of Beckett's solipsistic world. Giving form to thought, structure to being, and rendering consciousness inhabitable, color succeeds, by virtue of its lack, in arranging zones of visibility. Such is the function of the blueless sea and sky, greenless grass, and colorless flowers that lie

"beyond the unknown" in *Ill Seen Ill Said*. And such is the function of the reduction of color to white in this same work:

> How whiter and whiter as it climbs it whitens more and more the
> stones
>
> All dark in the cabin while she whitens afar.[57]

in *Ping:*

> Traces blurs light grey almost white on white. Only the eyes only just
> light blue almost white. Given rose only just bare white body fixed one
> yard white on white invisible.[58]

and elsewhere.

Light and darkness, color and the lack of it, in sum, are constructs of the visual paradigm to the extent that they concretize the play of the visible and the invisible, more precisely, the rendering of the invisible visible. Of this making visible, the image of the human eye, certainly one of Beckett's favorites, is emblematic. Indeed, in its capacity to open and close, see and not, the eye mirrors the revelatory quality of Beckett's writing at the same time that it is the source of much of its visual imagery and appeal. Thoughts, memories, and imaginings operate through visualization, but they are fluid, changing as they do in their relation to time and space. Setting them within a permanent field of vision is the aim of every artist and the predominance of the image of the eye in Beckett articulates this mission.

The preceding discussion of those constructs that reveal the specular as paradigm assumes a belief in a dialectic of referentiality generally ignored by theorists of language for whom the referent is conceived as a representable thing-in-itself. This is to say that the visual prototype is not restricted to the reproductive notions of mimesis and semiosis, notions inherited from the medieval metaphysical concept of truth as *adaequatio intellectus et rei* and the no less metaphysical Cartesian dualism of the *res cogitans* and the *res extensa*.

Rather, the transformation of seeing into saying in Beckett may be said to emanate from a referential function whereby the literary text is at once revelation and that which is itself revealed. If the visual is paradigmatic in this work, it is in the sense that what is visible is not only the result of figuration, but both the means and object of figuring as well.

Garelli has described the phenomenon with regard to poetry:

There is a paradox of poetic activity which is the measure of its very condition. Opening onto the world, the poem, in the act of unveiling, is that which is unveiled. Looking, it makes itself seen. Enlightening, it illuminates itself. Revealing, it reveals only in being itself revealed. (Translation mine)[59]

And Locatelli has studied it in the specific context of Beckett's *Ill Seen Ill Said*. Where her emphasis is on the transference of saying into seeing, "the fact that saying is responsible for visibility,"[60] however, mine has been on the primacy of the visible as model for the linguistic constitution of the fictive world. After all, Beckett's title is not "ill said ill seen" but the reverse.

Either way, it was Beckett's profoundly visual disposition that resulted in the often cited narrative precision and exactitude of staging unparalleled in other writers. If he was painstaking in his scenic indications (*Breath*'s "If o = dark and 10 = bright, light should move from about 3 to 6 and back" is typical), it was that as he wrote he visualized the entire play-in-progress in performance.

Edward Albee has spoken of the affinity he feels with Beckett in this regard. When asked during an interview whether he is aware of his audience while writing his plays, Albee replied:

No, I don't think about the audience. I just think about the experience of the play being done onstage. The audience is implied, of course. I see the play as a performed piece, obviously before an audience, certainly before the audience of me. I have discovered, to my amazement, that when some playwrights are writing a play, while they're writing it, they don't see it being performed on the stage.

He went on to say that some playwrights see the play "as some kind of amorphous reality. They don't see the necessary artifice of the stage at work." "And you do and Beckett did?" Albee was asked. "Yes," he said, "very specifically onstage. That distancing, that removal."[61]

Beckett's extraordinary visual sense made him feel, as Martin Esslin has written, "more at home in the company of painters than that of writers."[62] He preferred *Endgame* to *Waiting for Godot*—"I suppose," he is reported to have said in 1978, "the one I dislike the least is *Endgame*"[63]— precisely because, as he told Gottfried Büttner, it was "better visualized."[64] And this visual acuity is the reason that so many of his non-theatrical writings have inspired directors to stage and artists to illustrate them. Yet, if the visual is the primary paradigmatic force of his work—the sine qua non of

the configuration, in words, of time, space, and the self's dwelling therein—it is also the cause of its defeat, an irony to which I now turn.

II

I began this chapter with the visual paradigm to demonstrate the materialization that is Beckett's art. For it concretizes in allusions to painting the referentiality of language, figures both in metaphor and theme the empirical boundaries of seeing, and realizes in visible form the indeterminacy of the invisible. What is problematic in this presencing, however, is the paradox that subverts it.

I wish now to explore what in the visual sine qua non of Beckett's writing undermines its production and, quite literally, defeats it. Much critical attention has been paid to the importance of "failure" in this oeuvre, a notion reducible neither to a perverse aesthetic strategy nor to a sublimation of a nihilistic (or even pessimistic, to say nothing of depressive) nature. Failure in Beckett originates within the visibility of expression (verbal as well as visual) in which a struggle ensues from an internal or dialectical opposition to expression itself. This opposition, which reflects the resistance of the real to representation (what Beckett calls an object's "indifference" to aesthetic reproduction), spawns a self-reflexivity that, in thwarting the "power to express," provokes an obsession with continuance that vies with the impossibility of "telling" to impel the work "on." Art for Beckett is limited in its capacity to supersede the dialectic and hence is subject to the persistent threat of the "end." What amounts to its actualization in his celebrated minimalism is thus, paradoxically, forever a driving force. When examined in conjunction with the overall evolution of his writing, I would argue, this itinerary—which begins with Beckett's awareness of the failure of expression, proceeds to the self-awareness of his art, and results in its provisional "end"—reveals an astonishing exemplification of the Hegelian model of the philosophy of the history of art.

The word *end* needs clarification. I do not use it here in the sense of a stoppage but, rather, in the sense that it is used both by Hegel and philosopher/critic Arthur Danto when they write of the perpetuation of the making of art beyond the completion of art's history. Danto's thesis (which draws heavily on Hegel's, though it does not place Christian and Romantic art at its center) claims there is a post-historical production of art, not that there are no more artworks. For me, then, the end of Beckett's writing is not meant to describe a putting down of the pen but the kind of writing that took place in response to its own self-consciousness. This is *not* the end to

which Beckett's characters typically aspire, though it *is* the end that results from their projection—and here they are true analogues of Beckett's own thinking on art—of the difficulties endemic to creation.

My discussion of the visual as prototype was meant to show that writing for Beckett is a way of seeing. That the real (as referent) does not give itself to art, but rather depends on perception (and hence interpretation) for its depiction represents for him (as for Molloy, the Unnamable, Mouth, and all his other storytellers) art's inherent failure. This antagonism between subject and object has been thoroughly studied elsewhere. I mention it briefly here only for the meaning it had for Beckett with respect to the creative process: That art could not grasp reality as independent of the interpretive process in which perception is necessarily immersed, and thereby reproduce it, implied a deficiency of expression itself.

Not only because Beckett seldom spoke of his work, but because it is so overt an acknowledgment of his "fidelity to failure," the "Three Dialogues" has become the most often cited of Beckett's art criticisms. In it he wrote that "to be an artist is to fail, as no other dare fail"; that "The history of painting [. . .] is the history of its attempts to escape from this sense of failure"; and that "there is nothing to express, nothing with which to express, nothing from which to express, no power to express, no desire to express, together with the obligation to express."[65]

One must not see in these or any other of his statements on art or, for that matter, in any of his myriad characters haunted by failure, proof of an ethical imperative (the obligation to speak out against moral indifference), proof of an existential imperative (the necessity of facing with courage an essentially meaningless world), or proof of the writer's succumbing to the absolutism of nihilism. We know from the role he played in the Resistance and the evocations in his work of World War II and the Holocaust, as well as from the preoccupation with authority and subservience that runs throughout his oeuvre, that Beckett was not apolitical. Among the most moving lines he wrote, in fact, are those uttered by Vladimir in his plea in act 2 of *Godot:*

> Let us do something, while we have the chance! [. . .] To all mankind they were addressed, those cries for help still ringing in our ears! [. . .] Let us represent worthily for once the foul brood to which a cruel fate consigned us! What do you say?[66]

We know also the extent to which he probed in his work problems of consciousness, time, and other motifs of the existential ontologies that domi-

nated the intellectual and cultural scene during Beckett's most prolific years. Nevertheless, there is nothing, to my thinking, to support the notion of failure—either as it appears in the "Three Dialogues" and the other writings on art or as it appears in the creative texts—as anything other than what he so openly claimed it to be: the *interference* of words in their own saying.

It was precisely this failure of expression, this interference or stress on the projection or representation (whether verbal or not) of the objective in art, that led to Beckett's conceiving of a "literature of the unword." In their excellent work *Arts of Impoverishment* Leo Bersani and Ulysse Dutoit raise the possibility, with regard to the painting of Mark Rothko, of "an invisible art, an art in which there is nothing to see."[67] Beckett's preoccupation with the unwording of literature—an obsession that derives from the failure of language to manifest, rather than circumscribe—is an obvious parallel. Beckett describes it best in the letter to Axel Kaun in which he asks,

> Is there any reason why that terrible materiality of the word surface should not be capable of being dissolved, like for example the sound surface, tornby enormous pauses, of Beethoven's seventh Symphony, so that through whole pages we can perceive nothing but a path of sounds suspended in giddy heights, linking unfathomable abysses of silence?[68]

As characterized by Ruby Cohn, the letter to Kaun is "a declaration of creation through decreation,"[69] for Beckett yearns, in his own words, "to bore one hole after another [in language], until what lurks behind it—be it something or nothing—begins to seep through."

Contrasting his program for an unwording of literature with the latest work of Joyce ("There it seems rather to be a matter of an apotheosis of the word"), Beckett defines the irony that is the use of words to arrive at their undoing: "On the way to this literature of the unword, which is so desirable to me, some form of Nominalist irony might be a necessary stage." From the necessary participation of language in what is all but its elimination comes the possibility of "[feeling] a whisper of that final music or that silence that underlies All."[70]

In certain of his paintings, as Bersani and Dutoit explain, Rothko subverted the visuality of his art in the avoidance of subjects (whether narrative or abstract) that could distract, in their readability, the viewer from the act of seeing itself. He opted instead for the presencing of the *prerequisites* of visibility—the framing of space, for example, in shape and color. Works from the 1950s, like "Number 18" and "Blue over Orange," are exemplary.

Comparable was his focus on what Dore Ashton calls "the light within the canvas itself," that light "that could never be associated with the hard objects picked out by the 'everyday' light of day."[71]

Similarly, Beckett seeks the subversion of language in the display of its *potential* to mean. The late prose works, particularly *Ill Seen Ill Said* and *Worstward Ho*, offer the richest examples. In both these works Beckett is more interested in the possibility of narrative to unveil an external a priori than in a realization of it. The first line of *Ill Seen Ill Said*, "From where she lies she sees Venus rise,"[72] provides a stunning clue to the suspension of mimesis achieved in the succession of images of origination that constitutes the novel. The "on" that follows, and that reappears as a leitmotif throughout, furthers the invitation to enter the empirical space that counters, in the maximum reduction of narrative forms, an authoritative construction of meaning. Perception, as opposed to the object perceived, in other words, is continually projected as the source of forever latent meaning:

> Let the eye from its vigil be distracted a moment. At break or close of day. Distracted by the sky. By something in the sky. So that when it resumes the curtain may be no longer closed. Opened by her to let her see the sky.[73]

The same virtuality or diminution of the autonomy of meaning is evident in *Worstward Ho*, in which intratextual recapitulation or reiteration prevents the tracing of a linear or anecdotal (and hence representational) progression. From "somehow on" to "nohow on," it is language as representation that is tried and that consistently fails. In the first of these two works, language is utterly insufficient to express the world beyond, and the struggle of words with life itself is played out against the silence that, of its own, offers nothing more: "Look? Too weak a word. Too wrong. Its absence? No better."[74] In the second, language again is a mere "missaying," the repetition of utterance that, in continually missing its ontical mark, makes of the text a reaffirmation of absent meaning.

Beckett's unwording of literature resembles Rothko's invisible art, the painting of nothing to see, insofar as it is precisely, if paradoxically, the visual paradigm—what I have defined as the concretization or figuration of seeing itself—that is the impediment of sight. Just as the visible subject, for Rothko, conceals, it is words themselves that, for Beckett, dim the view: "Less. Less seen. Less seeing. Less seen and seeing when with words than when not." And again: "Blanks for when words gone. When nohow on. Then all seen as only then. Undimmed. All undimmed that words dim."[75]

Claude Simon's 1987 novel, *L'Invitation*—an amusing if somewhat ironic commentary on the bringing of some fifteen "guests" to the now-former Soviet Union for the purpose of rehabilitating the chaotic world order—reveals a remarkably similar problematic. There the visual as impediment to seeing is rendered all the more obvious by a deliberate skirting of focus. As I have shown elsewhere,[76] this is a narrative of interminable speeches *never heard by the reader,* a narrative of limitless dialogues *never spoken before the reader,* a narrative of unending tête-à-têtes *never articulated for the reader.* And it is a narrative of communication in foreign (which, in this novel, is to say incomprehensible) languages, of communication by interpreters, of communication between persons, each responding, indirectly, "to a river of words with a river of his own."[77] The subject of this incessant flow of words is thus a discursive though virtually unarticulated language. And its achievement is the collapse of those barriers—traditionally maintained by representational thought—between the real and the imaginary, words and things, man and the objective world.

The deconstructing of the subject/object schism and its replacement with what Heidegger, for one, referred to as a pre-cognitive awareness circumvents the limits of representation and allows the reader of *L'Invitation* to enter a realm of linguistic materiality (what Lucien Dällenbach calls "*l'être-là* des mots" and Jacques Garelli "le champ de présence verbal") unencumbered by the visual failure in question. For a congruence of what may be termed "aqueous speech" with "aqueous imagery" (as, e.g., in the conjunction of "that fabled—orgiastic, so to speak—capacity for discussion" with the "sound of the torrent thrown back in echoes")[78] is continually perceptible to the pre-conscious or pre-reflexive minds of the characters in the very same way that the "river of words" never uttered within the text remains for the reader the unspecified focus of the novel.

Like Beckett's second trilogy—the late, short novels *Company, Ill Seen Ill Said,* and *Worstward Ho*—emphasis on the potential for, as opposed to accomplishment of, meaning is *L'Invitation*'s most distinctive feature. For Simon's text delineates the site of a nonpositional awareness revealed both as an *hors-lieu*—that of the state of being *elsewhere* (outside one's proper milieu, outside one's country, beyond the familiar)—and as an *hors-temps*—that of *waiting* (for departures, meetings, ceremonies). In a word, the text posits, with the support of the official visit which enframes the narrative, not a "being there" so much as an awareness of being invited to "be there."

As it was for Simon, language was Beckett's nemesis from the start: "Grammar and Style. To me they seem to have become as irrelevant as a

Victorian bathing suit or the imperturbability of a true gentleman," he wrote to Kaun as early as 1937.[79] Already in *Waiting for Godot* it was the impotence of words that Beckett mocked ("quaquaquaqua"). And their failure to re-present either the relation of language to the self or that of the self to the world was the focus of the first trilogy, particularly its final work.

Even in *Watt* the world was "unspeakable":

> [Watt] desired words to be applied to his situation, to Mr. Knott, to the house, to the grounds, to his duties, to the stairs, to his bedroom, to the kitchen, and in a general way to the conditions of being in which he found himself. For Watt now found himself in the midst of things which, if they consented to be named, did so as it were with reluctance.

and the failure of representation a source of anguish:

> Looking at a pot, for example, or thinking of a pot, at one of Mr. Knott's pots, of one of Mr. Knott's pots, it was in vain that Watt said, Pot, pot. Well, perhaps not quite in vain, but very nearly. For it was not a pot, the more he looked, the more he reflected, the more he felt sure of that, that it was not a pot at all. It resembled a pot, it was almost a pot, but it was not a pot of which one could say, Pot, pot, and be comforted. It was in vain that it answered, and with unexceptionable adequacy, all the purposes, and performed all the offices, of a pot, it was not a pot. And it was just this hairbreadth departure from the nature of a true pot that so excruciated Watt.

Here, as in the trilogy to follow, the "need of semantic succour" defined a search for the facticity of things and a search for the confirmation of self within an apprehension of all that it was not:

> Then, when he turned for reassurance to himself, who was not Mr. Knott's, in the sense that the pot was, who had come from without and whom the without would take again, he made the distressing discovery that of himself too he could no longer affirm anything that did not seem as false as if he had affirmed it of a stone. [. . .] And Watt was greatly troubled by this tiny little thing, more troubled perhaps than he had ever been by anything, and Watt had been frequently and exceedingly troubled, in his time, by this imperceptible, no hardly imperceptible, since he perceived it, by this indefinable thing that prevented him from saying, with conviction, and to his relief, of the object that was

so like a pot, and of the creature that still in spite of everything pre-
sented a large number of exclusively human characteristics, that it was
a man.[80]

Like the narrators of the trilogy, Watt "would set to trying names on
things, and on himself, almost as a woman hats,"[81] for words continually
failed to yield the facticity of things or self by impeding a *saying* of them. It
is significant that what relieved Watt of his despair before the inadequacy of
language to confirm either the I or the not-I (or any knowledge of
them) was precisely a deliverance from words ("rats") altogether, the very
unwording that concerns us here:

> there were times when he felt a feeling closely resembling the feeling of
> satisfaction, at his being so abandoned, by the last rats. For after these
> there would be no more rats, not a rat left, and there were times when
> Watt almost welcomed this prospect, of being rid of his last rats, at
> last.[82]

The word as impediment, then, derived for Beckett from the visual
paradigm—from the materiality of the verbal utterance—to the extent that
its presencing, or making visible, was a misappropriation of the world as an
object of representation. In *Dream of Fair to Middling Women*, published
posthumously though written some five years before the letter to Kaun,
Beckett wrote (albeit tongue in cheek) of the need to undo *the seeing of say-
ing that impedes the saying of seeing:*

> Without going as far as Stendhal, who said—or repeated after some-
> body—that the best music (What did he know about music anyway?)
> was the music that became inaudible after a few bars, we do declare
> and maintain stiffly (at least for the purposes of this paragraph) that
> the object that becomes invisible before your eyes is, so to speak, the
> brightest and best.[83]

In a sense Beckett's project of unwording implies, and herein lies its
irony, a deliberative breach of the imaginative effort. As with Rothko's
invisible painting, there is in the unwording of literature a loosening of the
boundaries between art and the outside world, a kind of recontextualizing
of art to life. This is seen in the enactment (as opposed to reenactment) of
life experience characteristic of Beckett's plays, what Cohn refers to as their
"theatereality." And it is evident in the undoing of narrative time that ear-

marks the prose. Vladimir and Estragon have no allegorical significance; as Matti Megged has said, "only the waiting is important and real."[84] Molloy and the Unnamable tell stories not to re-present their lives but, in effect, to create them.

Further glimpses of contextualism are gleaned, albeit more discretely, where fictive characters are free to resist enclosure within the literary form, such as in *Dream of Fair to Middling Women,* and nonfictive personages, like the author himself, may be said to intrude therein (Mr Beckett in *Dream* and Sam in *Watt*). The substitution of the second or third for the first person pronoun (in *Company* and *Not I,* e.g.) also perverts narration in causing it to function outside the prescribed perimeters of the text. In *Watt* Erskine's song is represented (or not represented) thus: "?"[85] again opening the discourse beyond the borders of the literary structure that the Unnamable, for one, solicits: "Yes, we must all have walls, I need walls."[86] Examples abound, the interplay of "art" and "con" (an exposé on the art of artifice) also in *Watt,* not least among them. Indeed, contextualism is the driving force of many of the middle and late plays, in which the actuality of the theater merges with the inventiveness of the drama.

The balance between contextualism—the nonrepresentational intrusion of reality into the text—and figuration in Beckett is delicate. For, while contextualism signals the referential break between word and world that is the source of expressive (which is to say representational) failure, it is also the condition for the fusion of consciousness and things peculiar to Beckett that causes the speaking subject (whether Molloy or the Unnamable, Lucky, Krapp, or Winnie) to become lost in nondifferentiation. While objects, in other words, leak reality into the text, they do not necessarily allow for the location of self that the character's visual awareness of them might presuppose. Rather, Beckettian sameness is most often enhanced by their contingency and by the obsessive need to confirm one's own existence by that of the material world: Winnie's persistent tallying of her possessions is no less an inventory of self than Krapp's play with his tapes, no less an extension of self than Molloy's bicycle or crutches.

The protagonist in *Company* is yet another example: Like so many of Beckett's figures, he is neither a traditional (objective) characterization nor a pure (subjective) consciousness, but a unification of subject and object in the "mental activity" (as it is called in the text) that constitutes the fundamental reality of human perception. As such, he inhabits an ambivalent text, one that is neither fully transcendent nor entirely conditional on the world as we know it.

Contextualism (like "theatereality"), then, results from the admitted

failure of the expressivity of art. Born of the impossibility to represent, of the fatal and "incoercible absence of relation" between artist and world, it consists in making of this failure what Beckett calls "a new occasion, a new term of relation."[87] Although an "impossible desideratum" (the term is Megged's), for subject and object will remain forever antagonistic, art assumes its defeat in the contextual opening onto the world, and only in this appropriation (or reconstitution) of the real does failure become success.[88]

In its testing of both aesthetic convention and the limits of expression, Beckett's contextualism necessarily achieves the kind of devaluation of art associated with the Duchampian "readymade," whether bicycle wheel, snow shovel, bottle rack, or urinal. Exploiting the very contrasts between "stasis and flow, design and story, repetition and narrative" that Wendy Steiner has outlined in her study of pictorial narrative and literary romance,[89] Beckett resists anecdotal progression in much the same way that Duchamp did in reconnecting art with objects of everyday life. Indeed, Beckett's suspension of narrative closure in favor of a metanarrative and metalinguistic opening onto the real, like Duchamp's valorization of the commonplace, poses the same fatal epistemological questions that de-aestheticized that artist's work. To the extent that he impacted on all of the subdivisions of modernism, participating as he did in Cubism, Mechano-morphism, Dadaism, Surrealism, and Conceptualism, while never really belonging to any of them (it was he, after all, who initiated the postmodernist critique of the modernist aesthetic),[90] Duchamp emptied twentieth-century art of the value system that had previously defined it. And, in his problematizing of its expressive (as opposed to formal) qualities, Beckett waged on the literary front the very same war.

The comparison with Duchamp is not without further significance. It is true, as Jessica Prinz has noted, that Duchamp's "deconstructive" art called into question not only the beauty and value of art, but its "retinal" aspect as well,[91] whence his preoccupation with words. From the titles and rubrics for his earliest cartoons, and their adaptation to the readymades, to the verbal games found in his paintings, to say nothing of his prose fantasies, notes that both inspired and were inspired by his art, the semantic twists of *Rrose Sélavy,* and so on, Duchamp aimed at something more than cerebral play and punning: language as a means of undoing the hegemony of sight. He said so himself when he wrote: "One important characteristic was the short sentence which I occasionally inscribed on the 'Readymade.' That sentence instead of describing the object like a title was meant to carry the mind of the spectator towards other regions more verbal."[92]

But Duchamp's use of language, to which Conceptual art, on the whole, is indebted, also harbored a fundamental distrust of the word not dissimilar from Beckett's. The pun itself, his privileged device, couples economy of language and sonorous or orthographic slippage with the semantic ambiguity that typified for Beckett the inadequacy of expression. Duchamp's misgivings about language became part and parcel of the visual art he made. In a profound sense this is the same paradox operative in Beckett (above all in the first trilogy), in which the focus is the insufficiency of language, but words pour forth nonetheless.

On the periphery of the early *nouveau roman* Beckett was not alone in his effort to contextualize the failure of *the seeing of saying* and to seek, if not a truly unworded literature, a similar deconstruction. Simon's celebrated use of pictograms, for example, where pictures themselves substitute for words inadequate to image reality, revealed an identical preoccupation. So, too, the proliferation in Simon's texts of character doubles, the open-ended depictions of pictorial art, and the persistent disrupting of fictional continuity meant to disturb the most basic assumptions on the rhetoric or practice of reading.

Michel Butor was another for whom avoiding, in contextualism, the interference of art—the word as stressed image[93]—in its rendering of the real became primary. His works characteristically schematize all kinds of extraliterary material, by which I mean that they incorporate things and places in ways that do not overtly further the text as a literary work of art. Enumerations of the most (intentionally) banal sort serve to contextualize in the recent narrative, *L'Embarquement de la Reine de Saba,* for instance, fundamental premises of art (verbal and pictorial) to the commonplace. Indeed, repeated references to twentieth-century technology (telex, refrigerators, and the like), in this "animation" (as Butor calls it) of the seventeenth-century painting of the same name by Claude Lorrain, arise from the very indifference of which Duchamp spoke with regard to his own innovative efforts: "A point which I want very much to establish is that the choice of these 'Readymades' was never dictated by esthetic delectation."[94]

Butor's passion for totalization—he interrogates, explores, and integrates works, genres, persona, and cultures (his own and others') within each of his writings—has led numerous critics to focus on deconstructing the architectural design. I would submit, however, that what appears to many as purely formalist concerns is rather the manifestation of a haunting perspectivism born of the need, comparable to Beckett's, for a new relational model. Proof lies, as it does for Beckett, in the evolution of his work: A novelist of international renown, Butor ceased writing novels at roughly

the same time as the advent of Pop Art in the United States and its French counterpart, *Nouveau Réalisme*. Following the publication of his last novel *Degrés* in 1960, he opted for a more conceptualist, dialogical, and collaborative point of departure at that time when art as a quintessentially aesthetic form could no longer be considered and the philosophic quest, such as it was inaugurated by Duchamp, for the essence of art as distinguished from the common object culminated in the mixing of high art with popular culture. *Mobile: etude pour une représentation des Etats-Unis* (1962), *Réseau aérien* (1962), and *6 810 000 litres d'eau par seconde* (1965), which followed, all define the limits of art conceived either as abstraction from life or its representation.

In transcending itself—for the refusal to acquiesce to the self-containment of words is, as I have said, what provokes the opening of language—the contextualized text, whether Simon's, Butor's, or Beckett's, reveals something of its origination and, in dilating its source, it posits the referentiality that is the very antithesis of art as autotelic entity. This is to say that in the undoing of the art/reality schism (that prolonged the Platonic aesthetic tradition), the work paradoxically becomes undeniably self-reflexive.

Self-reflexivity is what shields the reader of *L'Invitation* from the banality of the ipso facto ineffective ceremonies Simon describes. For the continual *mises en abyme* of the fiction that is but is not one, achieved through the suspension of any temporal progression comprehensible on the order of reflexive thought, is what renders the work literary as opposed to reportage. And self-reflexivity is what renders Beckett's art, particularly the late work, minimalist, for the limitations of seeing, hearing, and speaking that constitute the dramatic conflict of each of his works are those of art itself. Beckett's "unwording of the word," like his "drama stripped for inaction" (as Edith Kern has described it), displays, in other words, art's consciousness of its own expressive failure.

Like Paul Valéry's Monsieur Teste, whose too lucid consciousness prevents his incarnation (he remains but thought seeing itself seeing itself ad infinitum) and, sooner rather than later, is the cause of his demise, the many transcendental mirrorings, or *mises en abyme,* characteristic of the Beckett work aspire to an absolute, the work of art, that it recognizes as unrealizable. All the stories that Beckett's protagonists tell themselves, for instance, are fictions that are both cause and effect of a larger fiction that can never fully be. As metaphors of the writing to which they themselves give rise, these stories reflect their own incompletion. For, as Lucien Dällenbach has attested, "A metaphor of origin will not reveal all its meaning until it is put back into the series to which it belongs."[95] Watt's many musings on the

series of dogs, men, pictures, and the like in the novel that bears his name; the picture hanging on the wall of Erskine's room emblematic of this text's own decentering; and the intertextual, Dantesque structure of the novel are all superb reflections of the reciprocal mirroring of metaphors of origin and narrative.

What is of particular importance as far as self-reflexivity in Beckett is concerned is, first, that it is a paradoxical subversion of the visual paradigm and, second, that it results in a short-circuiting of expression. The subversion consists in the visualization's making a spectacle of itself. *Not I* is a clear example. Enoch Brater explains:

> Although *Not I* focuses our attention on Mouth, not eye (costarring Auditor as ear), the piece is a far more ambitious exercise in dramatic perception than this unruly trinity might seem to imply. Although Mouth speaks, Auditor hears, and audience *sees,* Beckett establishes for the viewer of his work a visual horizon as well as an aural stimulus closely approximating the "matter" of the monologue itself. The "buzzing" in the ear is in fact the strange buzzing in our ears; the spotlight on Mouth becomes the "ray or beam" we ourselves see.[96]

The spotlight in Beckett's 1963 *Play* illuminates (pun intended) the process: As what Ruby Cohn calls "a fictional inquisitor,"[97] the light is a sort of eye incarnate. "Mere eye. No mind. Opening and shutting on me," the male character says of it.[98] It is also, however, and this first and foremost, that theatrical device which allows *the audience* to see the play. *Film,* to offer but one more illustration, similarly records the dichotomized vision. It is "a movie," as Brater describes it, "about the experience of our eyes watching other eyes watching us."[99]

As for the short-circuiting of expression, I would contend that it is Beckett's progressive minimalism that is the most dire consequence of his work's auto-elucidation. The decrease in length, number of characters, and physical space circumscribed by Beckett's dramatic work, like the reductionism of his prose (in which, as has so often been said, more is also increasingly made of less), is a topic virtually exhausted by the extensive critical commentary devoted to this writer's oeuvre. And it is not my purpose to explore either its means or merits here. I wish, instead, to relate what has been variously interpreted as a "running down" of material, a purification of dramatic time and space, and a kind of perfectionism[100] to a larger evolutionary process in which art is limited by its inability to escape the fulfillment of its own historical drive. I refer, of course, to Hegel and,

more specifically, to Arthur Danto's endorsement of his thinking on the historicism of art.

"Art is and remains for us, on the side of its highest possibilities, a thing of the past,"[101] proclaimed Hegel in one of his best-known statements on the development of art history. As the end of history is identical with the advent of Absolute Knowledge—the coincidence of knowledge with its object—so, too, the end of art is the internalization in self-consciousness of its own developmental history. In his hotly debated essay, "The End of Art," and elsewhere, Danto reflects on this conjecture, applying it to his assessment of the history of modern art as a movement toward philosophical self-understanding. Danto finds in Hegel's thought support for the idea that the works and movements of the art of this century are connected only by our reflection on them and concludes, in his own right, that philosophy has aggressed against and overtaken art.

Danto's philosophy of art is a philosophy of the history of art, historical location being for him more essential to the identity of the art work than anything aesthetic. Having internalized in self-consciousness its own historical trajectory, art has overcome the subject/object dualism to become, in essence, philosophy. Transported from its "superior place in reality" to "our world of *ideas,*" per Hegel's claim, "disenfranchised" by self-knowledge, per Danto's confirmation of it, art has simply run its course.

If we concur with this idea of art's dependence on its own developmental history, it appears reasonable that what amounted to the reproduction *within art* of its most fundamental dilemma, representation, was what caused art to come to a halt. This self-consciousness in Western painting reached its apogee in Pop where the mechanical duplication of images gave a new twist to art's age-old thematization of itself. Taking a step further the distinction between art as atemporal object (complete in itself) and sociohistorical contingency, the artists associated with this 1960s movement dramatized the irrelevance of conventional definitions of art, displaying not only the powers of institutionalization (the museum) and aesthetic theory, as Duchamp had done before them, but a consciousness of this consciousness as a landmark in art's transfigurative history. In reproducing the ready-made images of comics, news photos, or publicity stills, Warhol, Rauschenberg, Lichtenstein, and others pushed art over the philosophical edge, for dominant in their work was the absence of any real aesthetic telos save the problematization of imaging itself.

Thus it was, above all, Pop Art's resistance to narrativity—accomplished, as Wendy Steiner explains, "by repeating identical instances of a crucial scene (as in Andy Warhol's *Five Deaths Eleven Times in Orange*) or

by isolating parts of narrative sequence (as in Lichtenstein's paintings of single comicbook frames"[102]—that upset the balance between representation and self-reflection that preceded art's demise. It would not, therefore, be reckless to extend the notion of art's historical end to the literature of the period showing a similar opposition to narrative purpose. Indeed, the temporal proximity of Butor's abandonment of the novel form to Warhol's first exhibit of his Brillo Boxes (in 1964 at the Stable Gallery in New York) is telling. As is that of Beckett's own gentle discarding of the genre. (The post-trilogy *Comment C'est,* in a sense more epic poem than prose, appeared in 1961.) But I would contend that a more profound case is to be made for a link with Beckett's progressively minimalist style.

In an early assessment of *Waiting for Godot* Edith Kern wrote, "by all traditional standards *Waiting for Godot* is not a play. It has no action and thus completely lacks what Aristotle considered the most essential element of a successful play." She also claimed, "There is within the play no character development: One is what one is. Nor is there any plot or any kind of suspense."[103] Vivian Mercier and Hugh Kenner agreed: "nothing happens, twice," wrote the former; it is "a non-play [that] comments on itself," complied the latter.[104] While *Godot* was a far cry not only from conventional theater but also from the playwright's own first full-length play, *Eleuthéria* (though that play already made a statement on the limitations of dramatic tradition), it did not yet tell the whole reductive story. By 1969, however, the year in which Beckett composed *Breath,* the multi-character play of two-hour duration would be both null and void.

Beckett never deviated from the reductionist impulse, whether that extending from one work to the next or that within a given text. The economizing strategies that escalate both from *Godot* to *What Where* and from start to finish of the individual plays[105] increasingly reduce his literary and theatrical pieces to the visual inspiration that initially set them in motion. With the increased undermining of language, his growing fascination with electronic mass media allowed the visual imagery to predominate more than ever: *Ghost Trio* and . . . *but the clouds . . . ,* plays written for television in 1975 and 1976 respectively, use a minimum of words, while *Quad* and *Nacht und Träume,* both of which premiered in 1982 on German television, have no dialogue at all.

My point is the following: The visual element that I have until now considered the prototype of the verbal is itself dramatized in the minimalist condensations of *Breath* and the post-*Breath* works to reveal a magnitude of self-consciousness comparable to that in Pop. In Beckett's theater the image outweighs the word: The two tramps of *Godot,* Winnie in her

mound, heads peering from within trash cans and funerary urns in *Endgame* and *Play* have a force more enduring than the scripted text. Indeed, a number of visual sources reverberate in a play like *Not I*: Caravaggio's *Decollation of St. John* in Valetta Cathedral, a djellaba-clad figure observed in North Africa, and the "many old crones, stumbling down the lanes, in the ditches, beside the hedgerows" of Ireland.[106] As Beckett said with regard to *Footfalls*, "The walking up and down is the central image [. . .] The text, the words, were only built up around this picture."[107]

The Pop movement's multiplication of images, Warhol's silkscreened photographs of Marilyn Monroe and Campbell's soup cans, for instance, with their overdetermination and absence of emotional depth, provoke an undoing of psychosocial meaning similar to that in Beckett. The outward focus on the world, as opposed to an affective response to it; the challenge to the modernist institutionalization of the purity of art; and the drawing of inspiration from the ordinary—these are the evident links between Beckett and Pop.[108] But I would deepen the association by saying that, with the predominance of the visual (whether the centrality of the image in Beckett or its overproduction in Pop), an ambivalent role is assigned by both to thought. "If you take a Campbell soup can and repeat it fifty times," said Duchamp, "you are not interested in the retinal image. What interests you is the concept that wants to put fifty Campbell soup cans on a canvas."[109] At the same time, however, the overly focused image is not a conceptual site; rather, as Jean Baudrillard has noted, what the proliferation of images projects is the very "*disappearance* of meaning and representation."[110] In fact, we can say with Calvin Tomkins that "American Pop artists were not much interested in ideas."[111] Like Beckett's, Warhol's image is conceptual only to the degree that its preoccupation is with itself.

Hence I would qualify the comparison by saying that where the visual not only predominates but is the paradigm of creativity and, as such, the subject of a work, as in Beckett's mid- to late theater and the best-known images of Pop, the result is a self-reflexivity that impedes expression in both. Already in Beckett's fiction, self-reflexivity meant impediment: the Unnamable cannot really *say* (or even be) anything for, as a voice seeking to undo the language that he speaks, the articulation of undoing prevents it from taking place. His narrative is a persistently thwarted or depleted fiction, the representation of the representational process, the dramatization of the creative effort itself.

In the theater, however, the consequences are even more acute. Beckett clearly tells us as much in *A Piece of Monologue*, written in 1979 for the late actor David Warrilow: The speaker's very first lines—"Birth was the death

of him. Again. Words are few"—turn the drama against itself in equating the tale of a life to be told with that life itself. For the life in question is no more human than it is linguistic. Birth—

> Waits for first word always the same. It gathers in his mouth. Parts lips and thrusts tongue forward. Birth.

and death—

> The dead and gone. The dying and the going. From the word go. The word begone.[112]

are indeed the dramatic sources, but the theatrical tension arises not from the synecdochic re-presentation of the succession from one to the other. Rather, as with *Not I* and other of the late plays, the audience bears witness to a live production in the truest sense: the birth *and death* of language. As dramatis persona, language tells its own tale, and in so doing it subverts its own exposition. The story to be told thus becomes the story of a story, which, in turn, is another story. And so on, with each story short-circuiting the one being told.

Ohio Impromptu (written in 1980) further exemplifies the linguistic betrayal. A "tale within a tale within a play," as Cohn describes it, "the refracted images of old men resonate toward reflection within the tale that is read from the book" to end with the two men, heads raised, looking at each other, devoid of any expression. "*Ohio Impromptu*," Cohn percep- tively concludes, "almost drains a story *of* experience in order to theatri- calize the reading/writing itself *as* experience."[113]

What Beckett's late plays have in common with Pop, then, is their pre- occupation with referential illusion and, more importantly, their self-con- scious recognition of the historical significance of that concern. The dia- logue of an actor has always been more than representation of character; its pronouncement is real. What distinguishes Beckett's minimalist plays, how- ever, is that they tend to be *about* the making of that reality. In *Not I*, *Foot- falls*, *A Piece of Monologue*, and *What Where* the image itself (as opposed to a narrative extension of it) is enacted. *Catastrophe* goes so far as to show us how it is done.

Warhol's Brillo Boxes can be said to dramatize the visual, and specifically the methodology of painting, in much the same way. For the painter is asking what in the rendering of an image that is but the exact duplication of a real object makes that image art. Why, in other words, did

one pay the Stable Gallery some two hundred dollars for a replica of a commercial design worth almost nothing at all? The answer, of course, lies in the fact that the interest of Pop, from the start, was never the copying, but the hermeneutic imitation implied.

Consider for a moment Jasper Johns's exploitation of targets, flags, numerals, and maps. As Danto reminds us, anything sufficiently like one of these objects *becomes* one and "the dream of Pygmalion to use art as an avenue to the creation of reality appears logically assured of fulfillment."[114] Johns's numerals *are* numerals and his pictures of the maps *are* maps. The letters S-A-V-A-R-I-N on the painted bronze effigy *Savarin Can* are indeed every bit as genuine as those they are meant to depict. Inasmuch as Johns's experimentation revealed mimetic representation of the real to be one and the same with its subject, the link to Beckett is striking: iconoclasm in its most literal sense. In the subversion of mimesis by mimesis, the image becomes the real.

No matter how much Beckett's "theatereality" puts reality on the stage, however, like Warhol's reproduction of celebrity images or commercial products, Rauschenberg's transfers and photographic doublings, and Lichtenstein's borrowings from romance and war comics, it remains irreducible to it. The Brillo and Heinz Ketchup Boxes are pictures. Beckett's staging of the image is staged. Rauschenberg is reported to have said, "Painting relates to both art and life (I try to work in that gap between the two)."[115] Beckett's effort is to be situated in that self-conscious opposition as well.

Beckett's kinship with the evolution of the painting of this period is, in a sense, not at all remarkable. The modernist notion that the validity of art no longer resided in the conventional ideas of Beauty to which art had previously subscribed and the persistent need of modern art for self-revolutionization[116] had eventually to give way to an examination of the legitimacy of modernism itself. And this pursuit was not to be limited to any particular medium of expression, but would instead be culture wide.

What *is* extraordinary is what may be said of Beckett's minimalism—beyond its reductive qualities—in the light of Danto's prognostic for post post-historical painting. In the preface to *The Philosophical Disenfranchisement of Art* Danto writes:

> In a sense, the post-historical atmosphere of art will return art to human ends. The fermentation of the twentieth century will prove to have been terminal, but exciting as it has been to live through it, we are entering a more stable, more happy period of artistic endeavor where

the basic needs to which art has always been responsive may again be met.[117]

Considering the extent to which his plays both approximate the artistic and fulfill the aesthetic conditions of music, choreography, and painting, Beckett's minimalism would appear to offer ironic evidence of this essentialism. For the progressive diminution of words, gesture, and movement that, as Gerhard Hauck has observed in *Reductionism in Drama and the Theatre*, brought the rhythm, tone, color, and melody of a play to center stage was precisely what was responsible for the crossing of boundaries from drama to something else.

Art's "end" resides in its consciousness of its self-consciousness, in the postmodernist explication of modernist self-definition. The reduction of genre in the conflation of subject and object, the result of the dramatization of the self-awareness at hand, though, is precisely what defeats the "end" to make of Beckett's minimalism something more and not something less. To the extent that Beckett's is a totalizing art—a synthesis of sight and sound, poetry and drama, literature and choreography—within its very minimalism art as manifestation of the concrete universal has been revived. Its itinerary from a historical to a post-historical effort accomplished, the afterlife of Beckett's painterly writing may thus be said to lie—"beyond minimalism" (to borrow from Brater), beyond the historicity of Hegel-cum-Danto's philosophical analysis—in its re-essentializing, which is to say rehumanizing, of art.

An/Aesthetic: Beckett on Art

Critical Interrogations

The modernist/postmodernist controversy surrounding Beckett's oeuvre is a polarization that presupposes on the part of this writer a coherent aesthetic project: Most often, those in the modernist camp assume a project that substantiates, in what is deemed Beckett's radical exposition of existential absurdity, ontological universality. Those on the postmodernist side presume aesthetic coherence to lie in a declaration of the bankruptcy of modernism's philosophical foundationalism. Even within the same camp, the presupposition breeds opposition: Where one critic finds in Beckett a modernism of formalist or abstract conception, another sees a modernist practice imbued with the rhetoric of lived experience.

In the belief that the notion of a preoccupation with the visual as paradigm dismantles the either/or in displacing the question, I turn now to Beckett's writings on art to demonstrate that the same visual (as opposed to conceptual) thinking that led in the creative oeuvre to a self-reflexivity precipitative of an "end" is operative there. More significantly, I will show that what results is a persistent undermining of any cohesive notion of the function or meaning of art. In this chapter and the next, in short, the idea to be contested is that in his writings on art Beckett developed some sort of unified theory. For in his miscellaneous critical pieces, I will argue, the work of art is simultaneously celebrated and bemoaned as an "appropriation" (Heidegger calls it "Ereignis"; Beckett calls it "occasion"), a process of origination or actualization rather than an object of *aisthēsis,* and criticism itself deteriorates before its own, as any other, representational effort.

The nature of art, whether or not an essence may be ascribed to it, is at best a highly controversial matter. Over and above the multiplicity of genres, to say nothing of cultures, the idea of art as access to knowledge of reality differs in all respects from the notion of art as expression of feeling, in turn distinct from art's conception as a fundamentally spiritual phenomenon.

Beckett is unconcerned in his writings on art with any of these perspectives. Rather, it is a defense against a rational apprehension of the aesthetic that impels his investigations. An honest appreciation of his critical efforts, therefore, necessarily impedes the reductive application of them to his own creative endeavors.

This is not to say that Beckett's fiction, poetry, and plays are no better understood in light of his thinking on literature and painting. On the contrary. For the critical pieces, along with much of his personal correspondence, do provide prophetic insight into the evolution his work would follow: References to "the principle of disintegration," "irreparable disassociation," and "dissolution," such as they appear in a 1934 review of Sean O'Casey's *Windfalls,* for instance, are startling prefigurations. Beckett's "discovery" of Bram van Velde's painting of impossibility, to cite another example, surely stimulated his own privileging of abstraction over figuration (beginning with the trilogy) rendering the critical commentaries on the painter's artistic practice extremely pertinent to his own literary achievement. And to the extent that criticism, literary or art, provided above all a forum for the discussion of language in relation to thought, it yields insight into the linguistic and philosophic preoccupations of his noncritical work.

But any serious effort to explicate the creative by the critical oeuvre necessarily distorts the writer's critical objective. While recent efforts (and there have been many)[1] to wrench from the writings on literature and painting a cohesive Beckettian credo—despite the author's antipathy to such a notion—have shed light on the questions of influence and obsession, in other words, they have clouded Beckett's primary motivations and misrepresented his intentions in writing criticism. While these need not be altogether reduced to the "mere products of friendly obligation or economic need" by which he disparaged his miscellaneous essays, critiques, and other forms of homage, neither can his distaste for the critic's task be entirely overlooked: "I am not a critic and have to express publicly no judgement of a literary (or other) order."[2]

From the 1937 letter to Axel Kaun, in which he writes of his desire for "a literature of the unword," to the best known of his writings on art, "Three Dialogues with Georges Duthuit" (first published in *Transition* in 1949) and the short tributes paid to his artist friends in the 1950s and 1960s, Beckett remains true to art as rhetorical interrogation ("less the rhetoric"!) as opposed to illusionist representation. It is in this regard, and only in this regard, I believe, that we can speak of a Beckettian aesthetic. Otherwise, the search for a however implicit artistic credo in Beckett's critical miscellany is

futile. There is, however, coherence of another sort: Just as in his practice of art, where self-reflexivity led to defeat (a defeat that was but of course was not one), an increased awareness within the critical writings of the insufficiencies of the critical task significantly reduced, and ultimately aborted, the entire critical effort.

What I mean is the following: Beckett's critical writings trace a chronology not unlike that of the fictive and dramatic prose. Just as we follow progressive reductions in time, place, character, plot, and language itself from the early novels and plays to the mid and late, a similar movement away from the discursive defines the critical itinerary. As is well documented, a certain consistency of thinking on aesthetic experience is discernible in "Dante . . . Bruno . Vico . . Joyce" (1929) and "Proust" (1931), the most important of Beckett's prewar critical commentaries. And his earliest postwar articles, with their shift in focus to painting, advance some of the ideas expressed in those earlier essays. Yet in "La Peinture des van Velde ou le Monde et le Pantalon" (1946) and "Peintres de l'Empêchement" (1948) a distinctly deconstructive process comes into play. Later critical pieces will not be identifiably discursive at all, but dialogic and honorific.[3] In a sense, they will be anti-texts in much the same way that the novels became anti-novels and the plays anti-plays.

What I aim to demonstrate here, however, is that the evolution outlined by the critical commentaries is far less a dismantling of the essay genre or the deconstructing of a theory or theories of art than the relinquishing of any real belief in the aesthetic qua aesthetic perspective. The opacity of art—the idea that art can reveal only its own revelatory process and not a reality beyond it—was responsible, in part, for what I would term Beckett's *anaesthetic* point of view. Responsible as well was the startling proliferation of paradoxes to which the iteration of seeing—the verbal enactment (as opposed to description) of visual experience—gave rise. For, as the paradigm of creative discovery, seeing rendered art as organic, inconstant, and inexplicable as life itself.

We need not restate the equation of Being with Chaos evident everywhere in Beckett, but its articulation on the order of the visual cannot be overstressed. Therein, in fact, as Beckett would explain in 1961 to Tom Driver, lay the only hope for innovation in a post-historical art: "The confusion is not my invention. . . . It is all around us and our only chance now is to let it in. The only chance of renovation is to open our eyes and see the mess."[4] Similarly, to Lawrence Harvey he said, "If anything new and exciting is going on today, it is the attempt to let Being into art."[5] It is my contention that Beckett moved in his criticism and in his correspondence on

painting toward a kind of exposition which paralleled the chance for reno-
vation in art he described. If his writing on art became as minimalist as his
creative corpus, it was that a deference to seeing (the setting of visibility in
art—written, painted, or staged) defined the ontological drive. Whether as
collapsed distinction between the imaginary representation of reality and
reality itself—the "theatereality" that became increasingly important in
Beckett's middle and late dramatic works—or as diminished critical com-
mentary on a painter's oeuvre in favor of an unqualified glimpse at the
work itself, such as we have in the homage to Jack B. Yeats (1954) and three
for Avigdor Arikha (1966, 1981, and 1982), the anaesthetic and atheoretical
impulse is very much the same.

Giving voice to the visual was Beckett's nemesis before he began writ-
ing on painting per se. We find it couched in *Proust* in the description, for
example, of the Narrator's introduction to Albertine, related as a *plastic*
(the emphasis is Beckett's), if transformational process:

> He is introduced to her by the painter Elstir, and proceeds to her
> acquaintance by a series of subtractions, each fragment of his fantasy
> and desire being replaced by an infinitely less precious notion. [. . .]
> Thus is established the *pictorial* multiplicity of Albertine that will duly
> evolve into a *plastic* and moral multiplicity, no longer a mere shifting
> superficies and an effect of the observer's angle of approach rather
> than the expression of an inward and active variety, but a multiplicity
> in depth, a turmoil of objective and immanent contradictions over
> which the subject has no control.[6]

As the difficulty of uttering the experience of looking—and looking at art,
in particular—intensified, as Beckett increasingly perceived the verbaliza-
tion as a betrayal of the art in question, he would defer to art's immanence
by withdrawing, in both critical texts and letters, from the position of mid-
dle man. From the "verbal defiguration[s]," "assassination[s]" even (the
terms are Beckett's own), perpetrated in the first essays on painting, he
would move to a writing that eliminated the barriers to art erected by think-
ing itself: "In images of such breathless immediacy as these there is no occa-
sion, no time given, no room left, for the lenitive of comment," he wrote in
the homage to Yeats. Indeed, "Merely bow in wonder" is the conclusion he
arrives at there.[7] It is precisely this deference—which I qualify as anaes-
thetic and deem intimately related to the playwright's "theatereality"—that
is utterly ignored in the effort to excise from the criticism a unified concep-
tual thinking on art.

In *Beckett l'abstracteur* Pascale Casanova debunks any but the most formalist readings of Beckett. Her claim that Beckett's literary corpus is unified by a singular aesthetic purpose—to emulate in literature the abstraction central to modernism in the plastic arts—is supported not only by examples from the fiction where Beckett empties words of meaning, debilitates syntax, and diminishes the value of ordinary narrative constructs. It is justified as well by an interpretation of the critical writings said to overtly favor painting that replaces a more conventional aesthetic undertaking—realist representation—with a preoccupation with abstraction alone. Beckett's admiration for the work of the van Veldes (in particular Bram's), for example, derives from the triumph of order over disorder, Casanova claims, from the mathematic-like achievement of art that is the successful refinement of form. A passage from a 1948 letter from Beckett to Georges Duthuit drives home Casanova's point:

> I remember a painting at the Zwinger, a Saint Sébastien of Antonello of Messina, wonderful, wonderful. It was in the first room, it would grab me each time. Pure space of mathematical force, tiling, flagstones rather, black and white, with long foreshortenings enough to draw moans from you, [. . .], all invaded, consumed by the human. Before such a work, such a victory over the reality of disorder, over the pettiness of heart and spirit, one nearly gets lost.[8]

If the unity of both Beckett's critical discourse and creative practice lies for Casanova in the abstraction of the word from reality, as opposed to its materiality, a favoring of formal relations and visual effects such as is found in nonfigurative painting, for Lawrence Harvey it resides in the elimination not only of content from the work of art but form itself: "The form of the work of art, in any traditional sense of the word 'form,'" Harvey writes in his excellent study *Samuel Beckett Poet and Critic*, "is obviously in jeopardy in such an aesthetic." In fact, Harvey locates the unity of Beckett's views on art at the antipodes of Casanova's thesis, in the depths of ontology that Casanova claims Beckett to have purged from art in his deliberate pursuit of abstraction: "At the heart of all is being. The further from it we move the less authentically human we become. Art is closest (after seeing), especially the new art."[9]

This kind of opposition, endemic to scholarly assessments of Beckett's critical and non-critical writings, is, I would venture, of dual origin: The first reason for it concerns our tendency to lose sight of the distinction between aesthetics as thinking on art and aesthetics as creative praxis.[10]

When George Steiner refers to an "aesthetic of abstention" with regard to Beckett, he only means the latter.[11] Richard Begam's "aesthetics of play"[12] similarly accounts for an attribute, irony, of Beckett's literarity. But not all uses of the term are so clearly derivative; "aesthetics of failure," for instance, which shows up again and again in studies of Beckett, is so loosely used an expression as to provide the best case in point. Given, on the one hand, the self-conscious and reductive direction taken by his critical writings and, on the other, their focus on the dilemma of representation, where it should be used to define not a conceptual thinking *on* art but a creative manipulation of deception (*"Fallor, ergo sum!"*) before its expressive limitations, the preoccupation with failure has all too often been made to stand for a philosophy of art.

Needless to say, narrative correlatives of an aesthetic of failure are everywhere to be found in Beckett's creative works. Numerous are the failures to find oneself:

> Did I try everything, ferret in every hold, secretly, silently, patiently, listening? I'm in earnest, as so often, I'd like to be sure I left no stone unturned before reporting me missing and giving up[13]

the failures to assume oneself:

> who? . . . no! . . . she![14]

the failures to express oneself:

> my life last state last version ill-said ill-heard ill-recaptured ill-murmured in the mud brief moments of the lower face losses everywhere[15]

the failures to silence oneself:

> And all these questions I ask myself. It is not in a spirit of curiosity. I cannot be silent.[16]

and the failures to succeed less well at failing:

> Ever tried. Ever failed. No matter. Try again. Fail again. Fail better.[17]

Indeed, it is by now a commonplace to speak of the morose, fragmented egos that populate Beckett's works as failures, in and of themselves, in their

inability to defend against the onslaught of the not so light (pace Kundera) unbearableness of being. After all, isolation is their primary abode; an inability to couple renders the mind (with its feeble attempts at remembrance) their only available refuge; and compulsive speech is their *activité du jour.*

As critical key to the narrative and dramatic works, a doctrine of failure serves to intellectualize the disturbing affect—terminal misery—so closely associated with them. For the intellectualization protects against the morbidity and angst. Yet, while the desire to achieve a "literature of the unword," to abort the "terrible materiality of the word surface," was Beckett's only real expression of a conceptualized aesthetic project, the expressive failure that led to the formulation has swelled to proportions that Beckett, in renouncing writing on art, made the sincerest effort to avert.

Like his fiction and drama, Beckett's critical commentary records his struggle to reconcile artistic form and technique with the resistance of the real to its expression. But his critical writings, as we shall see, constitute far more an invitation to contemplate the struggle with him than a consistent theory of art. In fact, they have a good deal less to say about what art is than what it is not. Beckett's skepticism concerning man and the nature of the world in which he resides is indisputable. And it is therein that the unity of his thinking is perhaps to be found. But the rhetoric of failure (the inability to say, to know, to cohere, to imagistically represent), however frequently it may appear in both the creative and critical work, must not be attributed either a prescriptive. or proscriptive function (no theory where none intended, to paraphrase the ending of *Watt*) and this not because of, but despite, the expressive boundaries shared by writer and painter alike.

The second reason for the kind of critical controversy noted earlier more directly concerns Beckett's antipathy for conceptual thinking on art. If I cannot subscribe to the view that there emerges from Beckett's critical writings, however unintentionally, a consistent aesthetic theory, it is precisely that such a view ignores Beckett's insight into the closure that inevitably results from speculation that posits art in objectivity. In *Samuel Beckett's Artistic Theory and Practice* James Acheson comes close to respecting Beckett's anaesthetic (which is not to say anti-aesthetic) position in an insistence on the Schopenhauerian dimension of his critical writing. But "the relationship between art and the limits of human knowledge"[18] Acheson effectively establishes ultimately compromises Beckett's fundamental effort: The problem for Beckett lies neither with the mind in its limited capacities nor even with aesthetic experience itself, but with the objectification that thetic thinking necessarily imposes. Insofar as writing

on art meant for Beckett its virtual undoing (for criticism inflicts on art an objective status not inherent within it), he had ultimately to renounce its practice.

The temptation to locate even within this very renunciation an aesthetic is strong. But Beckett's hyper-lucidity requires in and of itself that we resist: He was all too aware that the opposition implied, in a sense, its own theoretical stance, and the damned-if-I-do-damned-if-I-don't dilemma was responsible for the impediment to writing (both creative and critical) of which he often despaired. Outlining the supposed cohesiveness of Beckett's thinking on art, on the one hand, and the creative exercise of it, on the other, thus falsifies the problem at hand. It is only when we situate Beckett beyond the notion of a unified theoretical perspective (a notion that can no longer be substantiated once his rejection of the intellectualization of art is rendered its due), on the horizon of aperception or seeing, that the need for polarization (Casanova's abstraction versus Harvey's ontology, e.g.) becomes less compelling. A look both at Beckett's critical writings and his unpublished correspondence with Georges Duthuit should prove the point.[19]

Most of Beckett's art criticism was composed between 1945 and 1954. The major texts are (1) "MacGreevy on Yeats" (1945); (2) "La Peinture des van Velde ou le Monde et le Pantalon" (1946); (3) "Peintres de l'Empêchement" (1948); (4) "Three Dialogues" (1949); (5) "Henri Hayden, homme-peintre" (1955); and (6) "Hommage à Jack B. Yeats" (1954).

During these years Beckett also translated a number of important texts on painting.[20] To make ends meet he translated material for nearly every issue of *Transition* between 1948 and 1953.[21] It was not economic need alone, however, that prompted Beckett's entry into the art world. As he made clear on several occasions, his critical writing was motivated, in part, by the desire to do right by his artist friends: "There is at least this to be said [. . .] for art-criticism, that it can lift from the eyes, before *rigor vitae* sets in, some of the weight of congenital prejudice."[22]

Numerous are the artists with whom Beckett was personally acquainted. Since late 1930 he knew Jack B. Yeats, whom he first met through Tom MacGreevy in Dublin and with whom he remained close until the painter's death in 1957. Through relatives in Germany (his father's sister, Aunt Cissie, was married to the art and antiques dealer William ["Boss"] Sinclair), he knew many artists there.[23] But it was in Paris that he had the widest circle of painter friends. Even before his regular postwar outings with Duthuit and Nicholas de Staël, Jean-Paul Riopelle, Bram van Velde and others,[24] to say nothing of the late-night/early-morning jaunts

with Alberto Giacometti, he had come to know many painters in the French capital. He had known Giacometti (who would design with him the set for the Odéon Theater's revival of *Waiting for Godot* in 1961), for instance, since the late 1930s and the brothers Bram and Geer van Velde and Marcel Duchamp since 1937. Knowlson tells us of others from this period:

> the forty-two-year-old Polish artist Jankel Adler; the founder of "Atelier 17," Stanley William Hayter; the New Zealander John Buckland-Wright and his wife; and he also knew Otto Freundlich and a German Surrealist, Wolfgang Paalen, who gave him an "automatic picture." He saw and played chess occasionally with Marcel Duchamp, for Beckett knew Duchamp's companion, Mary Reynolds, well through Peggy Guggenheim. He also met Francis Picabia and his separated wife, Gabrielle Buffet-Picabia, and their daughter, Jeanine. At the end of 1939, he at last met Kandinsky, whom he described as a "sympathetic old Siberian."[25]

It was not long thereafter that Henri Hayden, Robert Pikelny, and Marthe Kuntz would be added to the list.[26]

The many friendships with painters and the impulse to lend a few a helping hand by way of his critical acumen and increasingly celebrated name pay testimony not only to the value Beckett placed on these relationships but to the seriousness of his interest in art. Indeed, his engagement with painting was passionate and long-lasting. These friendships followed years of visits to galleries, museums, and private collections in many European cities, including, in addition to his native Dublin, Florence (which he first visited for a month in the summer of 1927), Paris (where he lived from 1928 to 1930 before the definitive move of 1937), London (the site of a prolonged stay from 1933 to 1935), and several in Germany (where he traveled widely in 1936 and 1937). (He even applied in 1933 for a post as assistant curator at the National Gallery in London.) An avid reader of the history of art, he purchased many exhibition catalogues and he kept lists of titles of paintings important to him and extensive notes on particular paintings. We know from his close friend, the painter Avigdor Arikha, that, as Knowlson puts it, "He could spend as much as an hour in front of a single painting, looking at it with intense concentration, savoring its forms and its colors, reading it, absorbing its minutest detail."[27]

The work of a number of painters, moreover, is known to have had special meaning for him at this time: Rembrandt, Caravaggio, Adam Elsheimer, and Gerrit van Honthorst among the Old Masters; Ernst Ludwig

Kirchner, Emil Nolde, and others associated with the Die Brücke group; Paul Klee, Lyonel Feininger, Wassily Kandinsky, and other German Expressionists;[28] along with Yeats, Georges Braque, Karl Ballmer, the van Veldes and other twentieth-century favorites. The pictorial inspiration for some of Beckett's writings can, indeed, be traced to certain of them and I will briefly consider the question of sources later in this volume. What interests me here, however, is less the influence or even Beckett's appreciation of painting than the determination that writing on it, his own or others', was fundamentally irrelevant to, and indeed a falsification of, art.

"La Peinture des van Velde ou le Monde et le Pantalon," Beckett's first published work in French, appeared in *Cahiers d'art* just after World War II. The most important of his writings on the Dutch van Velde brothers, this essay—though commissioned by the journal—occasions attacks on the insincerity of artists and critics alike and applauds the efforts of those he favored: Kandinsky, Yeats, and Ballmer, on the one hand, MacGreevy and Willi Gröhmann, on the other. It also, however, offers clear evidence of Beckett's anaesthetic thinking with its overt denial of both the objectivity of painting: "There is no painting. There are only paintings," and the validity of aesthetic judgment: "These, not being sausages, are neither good nor bad."[29] A second essay on the van Veldes, "Peintres de l'Empêchement" (commissioned by *Derrière le Miroir* for publication in 1948), confirms the anaesthetic purpose.

In question in "La Peinture des van Velde" is the presumed autonomy of the work of art. Prior to particularizing the art of the van Veldes, which is never very fully explored, Beckett offers a generalized parody of aesthetic experience. At issue, as might be expected, is the subject/object relation— with all its perceptual, referential, and representational implications—to which, in his creative work, he continually returns. Here, however, despite the ludic tone and often contradictory insights, he is explicit in his depiction of the dependence of art on the viewer: "The work considered as pure creation, and whose function ends with its genesis, is doomed to nothingness."[30]

Perception is required for the activation of the work beyond its objective status: "As it is still only a painting, it lives only a life of lines and colors, offering itself only to its author. Take note of its situation. It awaits removal from there. It awaits eyes."[31] But the actualization of art beyond its materiality hardly suffices to justify the aesthetic rubric. In the first place viewer judgment is insubstantial insofar as the artist alone can assess how well the work corresponds to the forces of tension that produced it. (More often than not, even she or he knows nothing of such valuation, dismissed

by Beckett, in any case, as little more than an uninteresting "coefficient.")
And, in the second, insofar as art's innovativeness lies precisely in its decreative function—its destruction of the received forms that "justify the existence of painting as a public thing"[32]—it defies the appellation.

More important, however, it is the dialectical interplay of the visible and the invisible—the indeterminacy of our visual apperception of the world—that, as Beckett clearly shows in this essay, impedes the designation of art as aesthetic object. Writing of the elder of the two brothers, Beckett deems Bram's art an "apperception purement visuelle," so purely visual in fact that the mere attempt to describe it as such is distortive:

> To write purely visual aperception is to write a phrase devoid of meaning. As is well understood. For each time one wants to make the words do a genuine act of transfer, each time one wants to have them express something other than words, they align themselves so as to cancel each other out mutually.

And Beckett is insistent: "For it is not at all about a sudden awareness, but a sudden visual grasp, a sudden shot of the eye. Just that!"[33]

The "objectivité prodigieuse,"[34] then, wherein this artist's originality may be said to lie, is far from re-presentational. Rather than a duplication of the object perceived a priori, it is a suspension, a spatiotemporal fixing of it as, in reality, it is: "It is the thing alone, isolated by the need to see it, by the need to see. The thing, motionless in the void, here, finally, is the visible thing, the pure object. I see no other."[35]

With regard to Geer, however, Beckett notes the opposite, a painting that is "excessively reticent, [that] impacts by way of radiancies one senses defensive, [that] is endowed with what astronomers call (if I'm not mistaken) an escape velocity." His is a world "without weight, without strength, without shadow,"[36] where everything is fluid and evanescent—testifying to a distinctly different sensibility. While the object is abstracted from time in Bram's work, its surrender to temporal flow is at the heart of his brother's effort. Indeed, while the one paints "l'étendue," or spread of time, the other paints its characteristic element of succession.

Yet the two orientations are conjoined at the very heart of the artistic dilemma: the spatial representation of change. The van Veldes thus present two sides of the same optic coin but a single diabolic task: "To force the fundamental invisibility of exterior things till the very invisibility itself becomes a thing."[37]

Here we approach what critics persist in naming Beckett's aesthetic

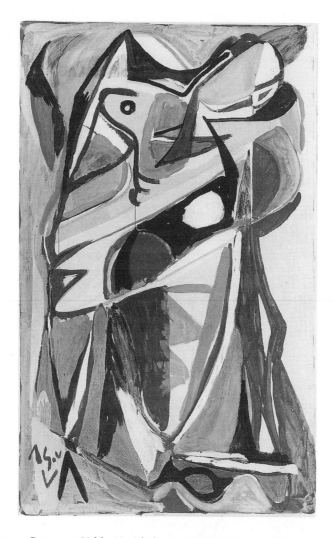

FIG. 1. Bram van Velde, Untitled (1941). Collections du Centre Georges Pompidou, Musée National d'Art Moderne (Paris). Courtesy Musée National d'Art Moderne (Paris). Previously owned by Samuel Beckett.

position: Insofar as the plight of humankind is the inability to penetrate the substance of existence, despite the need to do so, any attempt to represent the real, plastically or in words, is necessarily doomed to failure. As noted earlier, it would be useless to deny the significance of this thesis for it dominates the author's critical and creative work. Its expansion to a theory, however, disavows both the ontology in which it is rooted and what con-

stitutes for Beckett the interrogative status (or irreducibility to meaning) of every creative effort. When we consider that the impossibility of expression does not definitively obstruct it, we are obliged to reflect on the dialectic that allows the incongruity to be.

Beckett writes, in his first van Velde essay, that in the economy of art what is not said is the light of what is said and that every presence is absence.[38] In the second of these essays he more closely targets the dialectic as process—painting as an endless unveiling of the unveilable, a seeing of what cannot be seen. While I will explore the problematic in greater detail later, in the context of the profound similarity between Beckett's and Merleau-Ponty's approach to art, what I wish to point out here is that, in both "La Peinture des van Velde" and "Peintres de l'Empêchement," the contradiction inherent in creative expression—the visible rendering of what cannot be seen—stems *not from a conflict of semiotic origin (the incongruity of sign and what it designates), but the transparency and opacity of the world itself.* It is precisely in their projection of this paradigm, of the world as phenomenon of disclosure and resistance at once, that the essays (1) initiate the undoing of critical discourse that will culminate, not long after, in Beckett's admission of the irrelevancy of his discourse on art to art itself and (2) reveal their anaesthetic orientation comparable to the parity of Beckett's theater art with lived space and time.

A previous essay, "Les Deux Besoins" (written in 1938 though not published before *Disjecta*), already set the artist as visionary apart: "It is without a doubt only the artist who ends up seeing."[39] And there Beckett identified art as interrogation: "The artist poses questions, poses himself as a question, resolves himself in questions, in rhetorical questions without oratorical function."[40] But it is not until the two subsequent articles that Beckett fully develops the contradiction that the specifically ontological and interrogative nature of art presents: "Finished, brand-new, the painting is here, a non-sense" confirms painting's accommodation of the inexplicable "mess" or chaos of existence. "Ignorance, silence, and the motionless azure," however, offer the only possible solutions before the conundrum the accommodation may be said to pose.[41]

Beckett's phenomenology of painting, for these metacritical essays are nothing if not that, bears a resemblance to Heidegger's. Both in form and content "La Peinture des van Velde," for instance, is highly reminiscent of "The Origin of the Work of Art," where the art "object" is similarly located outside the aesthetic domain—in the totalizing movement of the concealment and disclosure of Being—and the problem of art is rethought in such a way that the finish is a return to the start. Heidegger's focus is the work

at work, the unveiling of a thing in truth. For him art transcends the aesthetic valorization precisely in the revelation (as opposed to representation) through which it speaks. So, too, Beckett situates art on the level of the primordial (visual) apprehension of the real. And it is this, I believe, that accounts for the incongruity at hand: Art fails for the impossibility of expression; yet—as the creative counterpart of the existential "I can't go on, I'll go on" at the crux of every Beckett work—its failure is not its end. Rather, art originates precisely therein. This is to say that, to the extent that it is the prerational or antepredicative seizure of the elemental ("On la montre ou on ne la montre pas"),[42] art, by its very failure to represent, is authentically innovative and retains its potential to be.

The van Velde essays display another stunning paradox that, in questioning whether a coherent aesthetic is discernible within Beckett's commentaries on art, we are certainly obliged to consider: They do not aim at an elucidation of art (the van Veldes's or any other) so much as a clarification of the difficulty endemic to writing about it. At the very antipodes of the conceptual order of thought, art defies conceptual explication, yet it is in expounding on what opposes the critical task that Beckett succeeds in articulating those qualities intrinsic to art itself.

Such contradiction, at the heart of all Beckett's writing, critical and creative, has hardly gone unrecognized. As we have seen, more than any other feature, it was semantic self-resistance—in the form of the cancellation of one word or group of words by others on the page or by a discrepant act on the stage—that first caused Beckett to be so closely scrutinized by scholars of literature in the early 1960s. Need it be said, yet again, that each of Beckett's texts belies, by its mere existence, the futility of the communicative effort professed within it? My point is simply this: As the foundation upon which these essays are constructed—explication of art by way of a demonstration of its inexplicability—incongruity is the means by which aesthetic unity is eluded.

Beckett's mockery of the critical project, then, takes him farther than his penchant for irony would have us suppose. As a rhetorical strategy, it allows for the exegesis of art in the same way that Rothko's invisible painting, referred to previously, subverts the visible (as a distraction from seeing) to make for the visual art. Beckett refutes interpretive commentary on the creative process only to elucidate thereby the life forces of art. In "Les Deux Besoins," for example, he states the impossibility of a true iteration of art: "This center, around which the artist can be aware of turning, [. . .] obviously one cannot speak of it, no more than of other substantial entities, without falsifying its very idea," only to achieve it: "The two needs, the two

essences, the being that is need and the necessity of its being there, inferno of unreason out of which arises the blank cry, the series of pure questions, the work."[43]

What he is getting at here is the closure, brought by the application of reason to art, that menaced consideration, in his first published essay, of James Joyce's *Work in Progress:* "There is the temptation to treat every concept like 'a bass dropt neck fust in till a bung crate,' and make a really tidy job of it." Critical analysis, with its search for symbols, distorts the organicity, the "inner elemental vitality," of the work at hand: "Here words are not the polite contortions of 20th century printer's ink. They are alive."[44] This is precisely his point in the letter to Axel Kaun where he pleads for the unwording of literature that will divest language of its surface materiality and allow its organic charge to ring through: "I know there are people, sensitive and intelligent people, for whom there is no lack of silence. I cannot but assume they are hard of hearing."[45]

And this is his point in the 1938 review of Denis Devlin's *Intercessions,* in which art is defined as the "approximately adequate and absolutely non-final formulation" that is, more than anything else, "pure interrogation."[46] What gives art its interrogative status is precisely its ontological foundation which manifests as need. Need explains both the artist's drive and his doom to failure when understood as the ultimate formulation and questioning of human identity, its universality and its concretion in individuality.[47] Indeed, the specification of need is the critic's sole respectable job:

> The only suggestions therefore that the reviewer may venture without impertinence are such as have reference to this fundamental. Thus he may suggest the type of need (Braque's is not Munch's, neither is Klee's, etc.), its energy, scope, adequacy of expression, etc.[48]

"Les Deux Besoins" makes its case against the reductive closure of interpretive analysis by graphically illustrating, as opposed to verbally articulating, the interrelation of the two needs in question. Two triangles, one inverted and placed atop the other, create six points that Beckett labels *A, B, C, D, E,* and *F.* Lowercase letters (*a, b, c, d, e,* and *f*) label the exterior angles between these vertices. What Beckett aims to show are the limits in accordance with which the artist questions as he himself is thrown into question:

> Need to have need [DEF] and need which we need to have [ABC], awareness of the need to have need [ab] and awareness of the need that

we need—that we *needed* [de], exit from the chaos of wanting to see [Aab] and entry into the nothingness of having seen [Dde], release and end of the creative autology [abcdef].[49]

The geometric circumscription of art's existential origin (the needs to know and to need to need) and impossible completion (whence its expressive failure) is meant to demonstrate the insufficiency of critical language to apprehend the ontological chaos (the "enfer d'irraison") from which art arises. A similar correlation between art's illumination of the unintelligible and mathematic cognition of the incomprehensible is made in the August 4, 1945, review "MacGreevy on Yeats," Beckett's sardonic humor notwithstanding: "[Yeats] is with the great of our time [. . .] because he brings light, as only the great dare to bring light, to the issueless predicament of existence, reduces the dark where there might have been, mathematically at least, a door."[50] The art as mathematics metaphor is of interest here, however, over and above its illustrative value, for its substantiation of Beckett's nonaesthetic vision. For, to the extent that it serves to represent art as, purely and simply, a process of making, it situates it very precisely outside the aesthetic arena.

Let me explain. "Les Deux Besoins" develops the idea that art is the product of need. Insofar as the need to know and the need to need impel the artist to create, art as a fundamentally interrogative pursuit is not after beauty but knowledge. It is not in the nature of man to know, though. And it is not in the nature of the artist to give up trying. Hence, Beckett is led to see the artist as remaining delicately balanced, as Lawrence Harvey put it, "between the need for privation and the need for fulfillment," whence "the synthesis of thesis and antithesis" in "the need to make."[51]

Duchamp and Hegel again come to mind. More than any other visual artist of this century, it was Duchamp who unloaded from art the conventional checks on both what it should look like and how it should be regarded: "Duchamp's private mission with its attendant public repercussions," to cite Anne d'Harnoncourt, "was to strip the word 'Art' bare of all its accumulated paraphernalia and return it to one of its etymological meanings—simply, 'to make.'"[52] We recall Hegel, of course, for the historicity the triadic structure—"Deux besoins, dont le produit fait l'art"—implies.

It is "Peintres de l'Empêchement," however, that will delineate the historical process more precisely. If this essay reiterates and consolidates much of what was said in "La Peinture des van Velde" with regard to representation, it also plays on the subject/object schism in a chronographic way. In

describing the stages through which the relationship between artist (as subject) and his "occasion" (or object) has passed, it reveals a remarkable similarity with Hegel's idea of the historicity of art. The essence of Beckett's claim in this essay is as follows: "The history of painting is the history of its relations with its object, these evolving, necessarily, first in the direction of breadth, and then in that of pervasion." In an initial evolutionary phase, painting negotiated a growing awareness of its representational limits to be all the more restricted by the object itself; secondarily, it moved from the object as surface toward the object as substance, "towards the thing that hides the thing."[53] Ultimately, painting would renew itself in a complete lack of negotiation with the impediments to it (the "impediment-object" and the "impediment-eye") as a visual art: The resistance to representation, not its "accommodation," is what would be painted by the van Veldes.

Hegel allots a comparable maturation to painting whose self-reflexivity he describes in the following terms: "It is the effect and the progress of art itself which, by bringing before our vision as an object its own indwelling material, at every step along this road makes its own contribution to freeing art from the content represented."[54] What is remarkable is the similarity in outcome of the historical accounts: Beckett's Dantoesque interpretation of the role played by reflexive painting—specifically, the van Veldes's impediment art—is anaesthetic in the same way as Hegel's, and it was so some one and a half decades before the Brillo Box that put an end to the history of art.

Also extraordinary is the definitive link Beckett's own creative output establishes between his originality (his renewal, or "reaestheticizing," of art) and that of the painters he esteems. That his deepest engagement with art criticism was concurrent with his greatest period of innovation in drama and the novel is significant. That its culmination in the less-is-more minimalist reflexivity of the mid to late works traces the very historical evolution he used to register admiration for the van Veldes is even more so. How fully it justifies the admonition that serves as point of departure for the first van Velde essay: "With words, we do no more than tell of ourselves. Even the lexicographers unbutton themselves. We inform on ourselves all the way to the confessional."[55] But I will look more at the self-reflexive quality of his criticism shortly. I wish now to turn to Beckett's correspondence with Duthuit to see how it, in turn, substantiates the essays' denial both of painting's aesthetic status and the validity of aesthetic judgment, in short, Beckett's anaesthetic thinking on art.

Georges Duthuit, art critic and editor of *Transition* magazine from 1948 to 1950, was, as James Knowlson portrays him, "a very cultured,

extraordinarily brilliant man, with enormous charisma, who impressed Beckett with his wide knowledge of art and the exuberance and intelligence of his talk."[56] Duthuit's critical writings illustrate the exceptional breadth of his art interests,[57] and his letters show the depth of his intellectual engagement with and very real friendship for Beckett. The correspondence dates, for the most part, to the years when Beckett and Duthuit saw each other often (either in the company of other writer and painter friends or, on occasion, with Duthuit's wife, Marguerite, daughter of Henri Matisse, and Suzanne Deschevaux-Dumesnil). Begun in 1948, the letters continued (with diminished regularity after 1949) until 1951, at which time they became considerably less frequent to cease almost entirely thereafter.

The Beckett/Duthuit correspondence, an outgrowth of their many conversations on painting, leads to what I believe are three important points. First, the letters and related documents (primarily Duthuit manuscripts and notes) reveal that Duthuit played a far greater role as catalyst in Beckett's thinking than is generally attributed to him. Made to function as what Anthony Cronin calls "a sort of straight man or Socratic interrogator"[58] in the "Three Dialogues," Duthuit has been relegated to a position of secondary importance with regard to his oral and written exchanges with Beckett on art. In fact, his contribution was prolific, insightful, and invaluable to Beckett's own.

The correspondence obliges us, even, to consider just how accurate it is to say, with Deirdre Bair, Cronin, and others,[59] that the "Three Dialogues" are predominantly, if not entirely, written by Beckett. The material contained in the Duthuit Archives gives ample evidence that there was considerably more collaboration, that Duthuit had a much more active part, than has heretofore been assumed. On the one hand, it reveals that the published text is really a synthesis (albeit one largely diminished) of the Beckett/Duthuit letters themselves. Entire passages, in fact, were extracted to appear in print. On the other, it offers a kind of historical proof: "I am incapable of rethinking our debate," Beckett wrote Duthuit, "incapable of restating the more or less acceptable things already said. I cannot replace your voice: the one that reminds me that I am not the only one involved here." Indeed, he then alludes to the possibility (probability?) of their soon having to meet to put the text in place.[60] Similar references to the collaborative effort are too numerable to cite.

Second, Duthuit's writings to Beckett validate the anaesthetic view of Beckett's thinking on art. No more "meaningful" than the existence it is made to project—"Impossible to valorize or devalorize being: it is what it is. Absurd to ask if existence has a meaning, as such: it is what it is."—art

solicits engagement in Beckett and not an analytic or evaluative response. Duthuit specifically praises him for this: "Your studies on van Velde cannot be compared to anything else known in [art] criticism. They are questions of life and death, no more no less."[61]

Third, the letters confirm that what might be taken for Beckett's characteristic modesty cannot be made to account for his resistance to writing on art. It is true that in a 1954 letter to MacGreevy, Beckett would qualify his homage to Yeats, no doubt intending full well the double entendre, as "nothing more than an obeisance." Similarly, responding to a request from Trinity College Dublin's library for a new play, he would write in 1959 that he had never been "able to manage anything in the way of occasional writing—since the little book on Proust," composed some thirty years prior "when writing was a game."[62] There is no denying Beckett's belittling of himself. But, as the correspondence with Duthuit reveals, his reluctance to writing on painting cannot be attributed to that. Neither is the insufficiency of language to render color and form adequate to explain it.

In a letter dated July 17 (1948?) we read: "All that is thought is not from me. Thought is quickly tired, quickly extinguished, while I go out repenting, stumbling." Note, however, what follows immediately thereafter: "Ditto for taste."[63] Beckett was well aware of the imperiling of mind by the inconstancy of passion. Writing of the paintings of Bram van Velde, he admits, in a letter of May 27, 1948, "Me, with my wire-cutter, I easily lose my head."[64] And in a letter of March 2, 1954, he again allows:

> Having believed I discerned in Yeats the only true value that still remains somewhat real for me, a value I do not want to attempt to circumscribe and for which the very respectable considerations of country and execution cannot account, I become literally blind to all the rest. It was already that way when it was about Bram.[65]

More important, however, the reluctance stems from the ontological indeterminacy of art and I believe we need to give greater credence to the idea that Beckett's dislike of criticism was a protest against the ideation of art, the distortion of art as fully autonomous presence, whence the distinction between *peinture* with *tableaux* made in the first van Velde essay. At issue here is not the decontructionists' focus on the absence of meaning in which the fullness of signification had been thought to lie. Rather, what Beckett is continually grappling with (both in his correspondence with Duthuit and in the "Three Dialogues") is an image of an imageless art, an art so utterly nonobjective (a notion to which I will return in chap. 4) as to

be inevitably modified by any attempt to describe it. This indeterminacy (likened by some to Werner Heisenberg's principle of uncertainty in physics)[66] was recognized by Duthuit as the search for an absolute, on a par with the unworded word: "Reread everything you wrote about Bram [van Velde], my dear friend, and tell me if, in ten places, it is not this search for this absolute, by way of procession and not by conversion, which haunts and torments you,"[67] he would perceptively advise.

Indeed, it was Duthuit's own notion of art as something other than objective replication, a process whereby the world itself was shaped and colored by the visual image rather than reconstructed, that from the start captured Beckett's attention. Duthuit was committed to Byzantine art, and likewise Fauvism, precisely for the inaugural (which is not to say expressive) value of its imagery. This was an art that opened onto the world without seeking to bridle it, an art that relinquished the illusionist fantasy in favor of what Rémi Labrusse calls "an immediate coloration of real space":[68] "A painting has value," Duthuit wrote to Beckett, "only by virtue of the state of mind it induces in you, the orientation it gives your thinking, the impulse it drives into your actions."[69] Duthuit remained true, in short, to a predilection for Bergsonian empiricism: "The world a flux of movements partaking of living time, that of effort, creation, liberation, the painting, the painter."[70] And, apparently, he recognized a similar penchant in his correspondent:

> You reassure me in saying that we can at least say of a painting that it translates, with greater or fewer losses, some absurd and mysterious thrusts toward the image, that it *** more or less adequate vis-à-vis obscure internal tensions. But since we are from the start the tonsured rather than the taut, the question becomes one of knowing how far our hair grows, and its attendant strength since the story of the sacked temple, to the degree that the painting enters our skin or we enter its own. A story of tension, perhaps, communicated by the taut, received by the tonsured. We shift tension together. Together we enter the time of creation.[71]

But if Beckett, like Duthuit, valorized the image for its enlightenment (if nonmimetic) potential, any faith in the imagery of abstract art, which he claimed to be the "only hope"[72] for painting, soon diminished along with the prospect of a new critical discourse that could articulate the originary force of abstraction. Already in May 1949 Beckett renounced discussion of the image with Duthuit, claiming, "the fact is that the question does not

interest me."[73] Indeed, what Beckett could no longer partake in was precisely what Duthuit was doing simply in writing on art. A letter, dated March 2, 1954, hints at an explanation:

> There is no bone of contention between us. It simply may be that we don't manage to define, before attempting to speak of it, our concern. For this there are obviously too many reasons for me to have the courage to deal with them. I think that in the end our preoccupations are of two very different orders and as though separated by a dark area where, exiled both of us, we stumble in vain toward a meeting point.[74]

The problem was previously discernible in "La Peinture des van Velde," where criticism—senseless in its attempt to give form to what is but is also not already that—is said to be hindered by exactly the same obstacle impeding creativity itself.

The dilemma can only resolve itself outside the expressive paradigm, as Beckett's praise of Bram van Velde will in the "Three Dialogues" be made to show. There Bram is said to be the first "to submit wholly to the incoercible absence of relation," to work, in essence, outside the semiotic where painting succeeds by virtue of its very impoverishment. But if painting that is " 'authentically fruitless, incapable of any image whatsoever,' " if painting that remains utterly "unresentful of its insuperable indigence and too proud for the farce of giving and receiving,"[75] is an ideal to which Beckett aspires, it is also a solution that self-destructs.

As I remarked earlier, there is a very real sense in which Beckett, when writing on others, is conscious of writing of himself. ("So you can't talk art with me; all I risk expressing when I speak about it are my own obsessions," he wrote Duthuit in 1954.)[76] This was particularly true of his writing on Bram van Velde. In conversation the two men persistently echoed each other.[77] For the disassociation of art from will or the intellect, art as "vital necessity" (the term is van Velde's) or "inner elemental vitality" (this one is Beckett's) and the preoccupation with the primordial as revelation of the very immediacy of vision itself, are deeply rooted in both. Listen to Bram van Velde:

> I paint to kill off the word

> My painting is bound up with the phenomenon we call seeing. What do we mean by seeing, since we never do see?

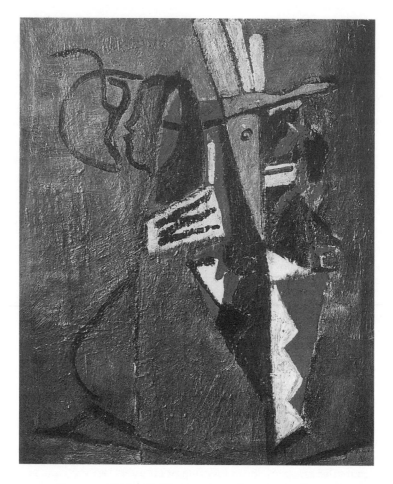

FIG. 2. Bram van Velde, Untitled (1937). Collections du Centre Georges Pompidou, Musée National d'Art Moderne (Paris). Courtesy, the Lilly Library, Indiana University, Bloomington. Previously owned by Samuel Beckett.

A painting is an instant of vision

The canvas allows me to make the invisible visible.[78]

Much more than "a visual counterpart for the futility of expression he encountered in his own writing," as Bair has reasoned,[79] what Beckett found in Bram was an endorsement of his own anaesthetic purpose. And

therein lay the particular danger of writing on his work: "I'll tend irre-sistibly to bring Bram's case back to my own, since that is the condition for being able to be there and speak of it."[80]

At the center of Beckett's determination to write no longer on art, then, is his decision to write no longer on the painting of Bram. He was unam-biguous in expressing his resolve: "I will make a few more efforts, but these will be the very last. I have done all that is in my power to do for Bram, it's over."[81] The motivation, however, remains puzzling: We can, with La-brusse, relate it to Beckett's abandonment of an earlier optimism as expressed to Duthuit: "Yes, we will do something else, something other than groping where the findings suffice, something other than just search-ing."[82] Or we can, with Beckett's painter friend Louis le Brocquy, limit it to an "eventual modification" or reassessment of van Velde's "stoic endeavour of the impossible."[83] Beckett wrote as much to Duthuit:

> Bram and I, it seems to me, are not talking about the same thing. He wants to conquer, he comes back to this all the time. These splendors where I hear the hymn of being boring against the grain and free at last in the forbidden quarters, these may be splendors like so many others, relative to the species of course, that of the tight rope where we wal-low.[84]

And further:

> But I am beginning to think that it is too late, and that it will be till the end these formidable restorative attempts at a furiously dreamed sum-mit, and with him [Bram], till the end it will be just the beauty of effort and failure, instead of the calm and even gay one by which I have the pretention of letting myself be haunted.[85]

Labrusse is no doubt right to see in the "affaire van Velde," as Beckett referred to it, "la blessure d'une utopie originelle."[86] And, indeed, I myself have stressed chronology in likening the transition from the first van Velde essay of 1945 to the short honorific pieces of 1955 and after to the decon-structing of the novels and plays. But too great a reliance on historical evo-lution can be misleading. Let's not forget a key declaration of the 1945 essay: "Avec les mots on ne fait que se raconter" (With words, we do no more than tell of ourselves). In renouncing writing on the painter, Beckett also renounces, as he did in everything he wrote, a verbal affixing of self. It is clear, moreover, that Beckett felt the critic sullied the painting on which

he wrote and to desist in doing so was to preserve its authenticity as art. Any devalorization his decision implied, therefore, was not uniquely that.

We cannot but see in this context the nobility of the renunciative act: His letters to Duthuit attest to the deep kinship he felt with van Velde[87] and the great difficulty he had in relinquishing his critical support. His fear, however, as Claire Stoullig has noted, was that "the reader not only didn't seek to see painting but attempted to recover 'some Beckett' in a text on painting."[88] His determination to make known "all the wrong I think of the role I played in the van Velde affair," then, reveals the integrity of the man.[89]

But one also senses a more fundamental *crise de conviction:* To the extent that Beckett continually struggles against Cartesian dualisms, that he identifies himself through opposition to them and positions himself precisely in their in-between, he cannot play a role constructive of the very relation (the subject-object dichotomy) he is fighting to reject. In other words, he attributes not being able to do what Duthuit does, namely, write on art, to the presumption of art's autonomy the critic is obliged to make. "I also read about painting, with your notes, but could add nothing," he wrote on March 1, 1949, to Duthuit. "I think it is the descriptive aspect that paralyzed me, or rather did not un-paralyze me."[90] He cannot endure the defining relation of critic to art any more than he could "the definition of the artist as one who never ceases to be *in front of.*"[91]

In a letter dated some three months later Beckett goes so far as to group Duthuit himself with those painters (Matisse and Tal Coat among them) who believe in the triumph of the possible over the impossible, of richness over the impoverishment of an inexpressive art:

> I take advantage of a (passing) moment of lucidity to tell you that I think I see what separates us, what we always end up stumbling against, after many useless locutions. It is the possible- impossible, richness-poverty, possession-deprivation, etc. etc. opposition. From this perspective, the Italians, Matisse, Tal Coat and tutti quanti are in the same sack, of superior fiber, along side those who, having, want more, and, being able to, still more. More what? Neither beauty nor truth, alright, if you wish, it isn't so clear, these are catchall concepts, but more of a self-the rest relation which, in other times, expressed itself in terms of beauty and truth, but which now seeks other respondents, and does not find them, despite deliberate airs of capharnaum, void and periclitation.[92]

And, in what is arguably the most valuable testimony Beckett ever paid to the only imaginary horizon he considered valid, that veritably new horizon where aperception may be said to render painting an immediate communication of nothing but its own indeterminacy, he admonishes:

> You oppose a quotidian, utilitarian time to a vital one of tripes, privileged effort, the true. All this comes down to wanting to save a form of expression that is not viable. Wanting it to be so, working for it to be so, giving it the air of being so is giving in to the same plethora as always, the same theatrics. Apoplectic, bursting arteries, like Cézanne, like van Gogh, that's where he's at, the pale Tal Coat, and that's where Masson would be, if he could. No need to speak of details. Does there exist, can there exist or not, an impoverished painting, useless without camouflage, incapable of any image whatsoever, whose obligation does not seek to justify itself?[93]

Even the complete absence of subject/object relation—as achieved in the imageless image or the wordless word, an absolute that Bram van Velde's painting receives the highest praise for approaching—succumbs before the critic's reiterative act. This is most evident in the "Three Dialogues," a discussion of the painting of Pierre Tal Coat, André Masson, and Bram van Velde that is certainly the most cited of Beckett's critical writings for its supposedly explicit "position statement." In lauding van Velde for being the first real revolutionary (Tal Coat and even Matisse are of "a value cognate with those already accumulated"), Beckett speaks of a true art that turns "in disgust" from "the plane of the feasible" toward an admission of failure, "an expressive act, even if only of itself, of its impossibility, of its obligation."[94] But the notion that Bram was unconcerned with expression at all had necessarily to be retracted: What he writes in the third dialogue— "I suggest that van Velde is the first whose painting is bereft, rid if you prefer, of occasion in every shape and form, ideal as well as material, and the first whose hands have not been tied by the certitude that expression is an impossible act"—is replaced at the end of the text by a not entirely ironic admission of error. For reflection alone on the pleasures afforded by this art, as he told us previously in "La Peinture des van Velde," suffices for them to collapse in an "éboulement innombrable."

What I claim, then, is the following: An effort must be made to redirect toward Beckett's struggle to disavow his Cartesian penchant the argument that he maintains a consistent aesthetic position. If writing (hence

thinking) on art was fundamentally incongruous with art as imaginative experience, and extricating himself from criticism was thus to become increasingly urgent, it was that the duality (art/world; critic/art) was, ontologically speaking, intolerable. Rendered cleverly in the opening joke of the first van Velde essay:

THE CLIENT: God made the world in six days and you, you're not fit to make me a pair of pants in six months.
THE TAILOR: But Sir, look at the world, and look at your pants.[95]

or more enigmatically in the "Three Dialogues":

> All that should concern us is the acute and increasing anxiety of the relation itself, as though shadowed more and more darkly by a sense of invalidity, of inadequacy, of existence at the expense of all that it excludes, all that it blinds to.[96]

the true and invariable issue is "the obliteration of an unbearable presence," that of the transparent or opaque but always sovereign object[97] in its alterity from a perceiving subject—not art as beauty or truth, not an aesthetic theory.

There is a sense in which Harvey is right to see in the critical writings evidence that for Beckett "the *oeuvre d'art* is a closed world," that "Beckett argues consistently for an aestheticism that isolates the work of art from all extrinsic considerations," and that what matters is "the wholeness and autonomy of the work of art."[98] The dualism of the title "La Peinture des van Velde ou le Monde et le Pantalon" is not without meaning. The very desire to articulate Bram's painting outside of a system of relations, in fact, led to the notion of art as ontological indivisibility that Beckett described to Duthuit as of "such density, that is to say, simplicity, of being, that only eruption can prevail over it, bring movement to it, in raising it all of a piece."[99]

But Beckett's as consistently clear negation of the autonomy is simply not to be overlooked. It permutates the play on aesthetics in *Dream of Fair to Middling Women*, Beckett's first novel written in 1932, in which, as Cohn succinctly describes it, an "anonymous narrator fabricates a *chinoiserie* that attempts to confine fiction in a closed system, only to find that his characters refuse enclosure."[100] It filters through the protagonist's meditations on art that anticipate other of Beckett's narratives: Belacqua thinks of "the dehiscing, the dynamic décousu, of a Rembrandt, the implication lurking

behind the pictorial pretext threatening to invade pigment and oscuro";
and of canvases in which he has "discerned a disfaction, a désuni, an Unge-
bund, a flottement, a tremblement, a tremor, a tremolo, a disaggregating, a
disintegrating, an efflorescence, a breaking down and multiplication of tis-
sue, the corrosive ground-swell of Art."[101] The negation of an aestheticism
that makes a case for the wholeness of art figures blatantly in the 1945 *Irish
Times* review of MacGreevy's account of Yeats, in which Beckett ranks the
painter "with the great of our time" precisely because he "brings light, as
only the great dare to bring light, to the issueless predicament of existence"
from which painting cannot survive abstraction. "There is no symbol" he
told us previously, in a 1936 review of Yeats's *The Amaranthers,* but "stages
of an image."[102] For making art is giving life to vision and has not to do, as
material objects ("tableaux") do, with autonomy and self-sufficiency.
Rather, as he said in the 1938 Denis Devlin review, art is but an "approxi-
mately adequate and absolutely non-final formulation,"[103] what Harvey
himself legitimately terms "a destruction of surfaces, an unveiling."[104] We
cannot ignore that at the heart of Beckett's struggle with the material pres-
ence of art is the narrator's claim in *Dream* that "the object that becomes
invisible before your eyes is, so to speak, the brightest and best."

In short, Beckett was well served by Duchamp's discovery that the dis-
tinction between the work of art and an ordinary thing of the world is not
one of aperception. The difference cannot be apprehended visually. It is for
this reason that the critic's task is no more viable than the artist's assays at
expression; art, in a word, is "uniquely self-pervaded," as Beckett wrote in
his homage to Yeats, and "not to be clarified in any other light" but its own.
Nonetheless, both he and Duchamp appear to have benefited from Hegel's
findings that the work is not self-contained but exists for the perceiver who
ultimately completes it:

> By displaying what is subjective, the work, in its whole presentation,
> reveals its purpose as existing *for* the subject, for the spectator, and not
> on its own account. The spectator is, as it were, in it from the begin-
> ning, is counted in with it, and the work exists only for this point, i.e.,
> for the individual apprehending it.[105]

Paradox, ambiguity, and reversal characterize Beckett's writings on art.
Hardly a weakness, therein lies their greatest strength: "Negation is no
more possible than affirmation," he told Charles Juliet. "You have to work
in an area where there are no possible pronouns, or solutions, or reactions,
or standpoints . . . That's what makes it so diabolically difficult."[106]

Although the antipathy to writing on art reached a peak in Beckett's "deeply courageous" (as le Brocquy referred to it)[107] decision to renounce his support of van Velde, it did not originate in his association with the painter but in the very nature of his rapport both with painting and the written word. No less than his fictive voices, he found that words simply decompose. What caused him to renounce writing on art, to resist publication of his "miscellany of criticism," and to persist in a uniquely perceptual (which is to say, entirely nonconceptual) view was the conviction that a barrier was erected through reason to the authentic experience of art. Beckett continuously sought to thwart the kind of systematization of his thinking that, in and of itself, his thinking on art defied. Referring to conversations he had with the writer in 1962, Harvey explains that Beckett "felt that 'Being is constantly putting form in danger,' and conversely that he knew of no form that didn't violate the nature of being 'in the most unbearable manner.'"[108] The equation was clear: Art as (aes)thetic object is to Being as critical conjecture is to art—in essential conflict.

Justification for avoiding the temptation to tease an aesthetic credo from his criticism and letters is to be found, then, in Beckett's ultimate refusal to participate in the objectifying act, the thetic act of critical writing which disregards art's ontologically eruptive force. He openly renounced theory—"I don't want to prove anything," he told Duthuit[109]—and mocked it more subtly in references to "aesthetic safety" ("Peintres de l'Empêchement") and "a charming game" ("La Peinture des van Velde"). He was only half-tongue-in-cheek when, in the "Three Dialogues," he threw into question Bram's innovative art: "For what is this coloured plane, that was not there before? I don't know what it is, having never seen anything like it before. It seems to have nothing to do with art, in any case, if my memories of art are correct."[110] Indeed, the admission in the "Three Dialogues" that he made a mistake, that his speculation on Bram's art has nothing much to do with it, for the art, as Daniel Albright has noted, "is the aliment to the dispatch of the 'Three Dialogues' and therefore unrelated to it,"[111] is a direct throwback to the caveat with which he ended, eleven years prior, "Les Deux Besoins": "Until further notice." Both achieve their ultimate confirmation in the startling honesty of the correspondence with Duthuit: "Here's where we're at, or rather where I feign to solidly hold ground," the critic wrote Beckett, "which is not at all the case, in order to push the dialectic as far as possible, a simple matter of an article to be done. You will see in the end that I am by no means bound to my position."[112] And here is Beckett to Duthuit: "This miserable composition, that was arse-licked out

of me, at a time when already I couldn't have cared less about Geer than about my last jock-strap, is neither within reach nor in my head. I just seem to remember that I let myself go, the faster to be done with it, to some antithesis of which I am the first to have sensed the absurdity, while recognizing in it a certain explicative value, which is far from comforting."[113]

In summary, I would substitute for the notion of a Beckettian aesthetic a more properly *anaesthetic* perspective, a nonconceptual approach to art wherein the need for its definition is undone not only by the very inadequacy of expression Beckett continually addresses (as in what he terms the "compromises" of Tal Coat and Masson) but by the futility of attempting to give form to what already is meant to exist as such. Duchamp's remark that "there is no solution because there is no problem"[114] could have been Beckett's own. "There is no communication because there are no vehicles of communication" was. Insofar as for Beckett art as imaginary re-presentation of the world's surface simply cannot be, this exploration of his commentaries on painting was meant to affirm that the authentic aesthetic experience is nothing other than the visible rendering of the impossibility to make seen. It was also meant to show, however, that criticism, like painting, is vitiated by its very effort to represent art.

The claim, finally, that the opposition between a formalist reading of Beckett (such as Casanova's) and one that seeks philosophical (Harvey's) or even psychological depths loses ground when the question of aesthetic unity is dispelled appears justified not only by the correspondence and critical writings in question. The plurality of interpretive perspectives Beckett's work inspires is also supported by the more prudent application of the term *aesthetic* for which I would plead. We cannot but concur with Porter Abbott when he writes, "There is no denying Beckett's aestheticism," for it is true that Beckett had an "overriding concern for shape and for the music of what he wrote."[115] Indeed, in Beckett's creative work this aestheticism extends so far into the concerns of formalism, while touching so nearly both the immanence and ineffability of Being as to delineate the unattainable in artistic practice, that it achieves a singular undoing of itself to become an anaesthetic art.

Similarly, Beckett's critical writings—in their absence of ideology or sustained judgment, in their disclosure of the paradoxes that seeing as the prototype of creativity implies—both reiterate and validate this anaestheticism. Refusing to submit to the descriptive task of the reviewer, aiming more at a defense of art against the intellect, they propose to rescue art's

legitimacy from aisthesis and its function from expression. Offered in their stead is the only true pleasure art inspires: the immediate apprehension of the world, and the situation of the human being within it, through innovation all the more valid for its inexplicability.

In-Visible World

I have argued, in the preceding chapter, for an appreciation of Beckett's writings on art as a defense against a rational apprehension of the aesthetic. For his indifference to art as anything but a projection of the indeterminacy of experience is antithetical to the kind of reductive theorizing that scholars—in their focus on an "aesthetics of failure," an "idealist aesthetics," or any other—have all too often ascribed to him. Beckett's novels and plays, in their preoccupation with the fundamentals of existence and renunciation of a rational interpretation of them, have long been associated with modern continental philosophies. In their articulation of the connection of art to ontology, the critical writings further support the association. My aim here, however, is not to explore how the primacy of perception renders the fictive and dramatic texts parables of the philosophical postulates. That has been competently done by others.[1] Nor is it to uncover in the commentaries on art further compatibility with certain of these theses. Rather, I propose a shift away from the Heidegger/Sartre hermeneutical camp, not in compliance with the alternative displacement toward Derrida and Deleuze that others have recently advanced,[2] but toward that of a second-generation phenomenologist, Maurice Merleau-Ponty, whose thinking on art reveals a resounding congruence with that of Beckett and might well move us beyond the modernist/postmodernist impasse—perpetuated by stylistic analyses of a positivist nature—described above.

Beckett's degree of familiarity with the philosophers with whom his work is most often linked may never be accurately assessed. From his biographers—Deirdre Bair, Anthony Cronin, and, most important, for his is the authorized life of the writer, James Knowlson—we have a sense of who Beckett was reading and when. We know, for example, that, in his second year at the Ecole Normale Supérieure (1929–30), he determined to make up for not having studied philosophy while at Trinity College, Dublin, mostly by reading Descartes and Arnold Geulincx (Descartes's Belgian follower

and, arguably, a strong influence on Beckett).[3] And we know that the late 1930s found him reading, in addition to Descartes and Sartre, Kant and Schopenhauer.[4] Perhaps from the eventual publication of his correspondence, we will gain further insight into what he thought of Spinoza, Malebranche, Leibnitz, Hegel, Kant, Kierkegaard, Schopenhauer, Heidegger, Wittgenstein, and others who provided his work with significant philosophical sources. But even then much will be surmised as we remember how far he went to refute the significance of philosophy for him and the transcription of philosophical into literary discourse:

INTERVIEWER: Have contemporary philosophers had any influence on your thought?

BECKETT: I never read philosophers.

I: Why not?

B: I never understand anything they write.

I: All the same, people have wondered if the existentialists' problem of being may afford a key to your works.

B: There's no key or problem. I wouldn't have had any reason to write my novels if I could have expressed their subject in philosophic terms.[5]

Taking Beckett at his word, we are obliged to believe that at the time of this conversation, in 1961, he was not reading philosophy and had not for some years. But a certain knowledge of the philosophies in vogue in Paris has, of course, to be supposed. Sartre, moreover, had been at the Ecole Normale (pursuing an *agrégation*) while Beckett held the position of English *lecteur* there, from 1928 to 1930. And Merleau-Ponty was there then as well. While his acquaintance with Sartre is documented,[6] whether or not Beckett had much, if anything, to do with Merleau-Ponty is not. It would be of interest to know how much of Merleau-Ponty's thinking was known to Beckett, particularly later when certain of his critical pieces were written, his homage to art paid. For the affinity I aim to establish appears to be profound. While no direct relationship between the two men can be substantiated,[7] it goes without saying that Merleau-Ponty's phenomenology was very much in the air and that the philosopher was a strong presence in the intellectual and artistic milieus of mid-century Paris.

What can be said with certainty is that Merleau-Ponty knew Beckett's work well. His library contained many of Beckett's books and it is reasonable to presume that his readings included the available critical as well as noncritical writings. It is not inconceivable, moreover, that Beckett's friendship with Duthuit, publisher of certain of his essays and translations on art

and his primary interlocutor on the subject, provided a conduit, for Duthuit and Merleau-Ponty knew each other well.[8]

Merleau-Ponty's first two essays on painting were published while Beckett was writing (and translating others) on art: "Cézanne's Doubt" dates to 1945, "Indirect Language and the Voices of Silence" to 1952. "Eye and Mind" appeared in 1960. Situating, as they do, aesthetic experience beyond the reach of rational analysis and interpretation within the primacy of perception, it is plausible that they would have been of some interest to Beckett. But a recontextualizing of Beckett's thinking on art in no way requires the kind of familiarity that one might, for the sake of neatness, wish to establish. This is all the more true given that Beckett's reading of philosophy had less to do with achieving greater intellectual understanding of life than with sanctioning his affective view of it:

> I am reading Schopenhauer. Everyone laughs at that. Beaufret and Alfy etc. But I am not reading philosophy, nor caring whether he is right or wrong or a good or worthless metaphysician. An intellectual justification of unhappiness—the greatest that has ever been attempted—is worth the examination of one who is interested in Leopardi and Proust rather than in Carducci and Barrès.[9]

As he wrote of Schopenhauer to Tom MacGreevy, furthermore, "It is a pleasure also to find a philosopher that can be read like a poet."[10] Thus Beckett would not have looked to Merleau-Ponty, more than to any other philosopher or aesthetician, for insight into the meaning of art or the perceptual conditions of artistic experience. Yet the affinities he might have uncovered there could well have impacted (directly or indirectly) his thinking and confirmed his accommodation of the paradigmatic value of the visual. The continuing poststructuralist condemnation of phenomenology notwithstanding, therefore, it is these affinities that I will now explore.

I

The need to situate Beckett beyond the modernist/postmodernist controversy is threefold: As we have seen, it derives, first, from an incongruence both with the modernist's drive to extend to the aesthetic the Enlightenment values of truth and reason and with the postmodernist's belief in their complete obsolescence. It ensues, second, from the collapse of any consistent differentiation in Beckett between the aesthetic (as the domain of imaginary representation) and the real. And it results, third, from the reductivism to

which such formalist problematizing invariably leads. (The focus of this kind of materialist and normalizing thinking, the work as object is made to replace the intersubjective structure that constitutes the organicity of art.)

If I offer phenomenology—and, specifically, the phenomenological approach of Merleau-Ponty—as a preferred context in which to situate Beckett's creative and critical contributions, it is that it attends to a dimension of language virtually ignored by those engaged in the modernist/postmodernist debate: an ontology of the word and of the perceptible within it, an antepredicative or precognitive experience of language, that supersedes Beckett's assignment to either plain. To the extent that it is an approach *to* art or a way of thinking *about* art that is at the center of the controversy, a subject-object dualism is implied by the modernist and postmodernist epithets that it was precisely the aim of both Merleau-Ponty and Beckett to be free. Indeed, any real theory of art is as fundamentally inconceivable for the one as for the other to the extent that aesthetic experience, in engaging the beholder in an active encounter with both self and world, defies cognition.

Beckett's anaesthetic thinking on art, not unlike Duchamp's, is best understood, as I have said, as a nontheory of art. I do not mean this only in the sense that Beckett disputed the theoretical value of his own miscellaneous criticism. (What Cohn refers to as his articulation, in the 1937 letter to Axel Kaun, of "a virtual credo," e.g., Beckett would later dismiss as mere "German bilge.")[11] Nor do I mean this only in the sense that his writing on art offers no affirmative theses systematically argued from one critical work to the next. I mean, as well, that art for Beckett is quite literally nothing (no-thing) and any "idea" of art, therefore, anathema to him.

Consider, again, the following statements from "La Peinture des van Velde":

> Finished, brand-new, the painting is here, a non-sense.

> The work removed from the judgment of men ends up dying, in dreadful agony.

> The work considered as pure creation, and whose function ends with its genesis, is doomed to nothingness.

The phenomenologist's insistence on the intentionality of perception (the fusion of subject and object in the projection of consciousness, Husserl's "All consciousness is consciousness of something") rings loud and clear: The work of art does not exist outside of the reader or spectator's percep-

tual animation of it. But Beckett's "negative" characterization of art, I would argue, takes the subject's implication of object and vice versa beyond the Husserlian premise, to a realm not, so far as I know, heretofore acknowledged.

Husserl's notion of consciousness as the correlation of an object's representation (*noema*) and an individual's perception of it (*noesis*) has provided some critics with a way into Beckett's fictive depiction of the reality that surpasses conceptual reason. More commonly, Heidegger's Dasein, and its primordial state of Being-in-the-world, has served to render metaphorically the writer's struggle with the Cartesian dualist legacy, man as *res cogitans*. And, insofar as he operated within the Hegelian framework of both Husserl and Heidegger, Sartre has also been made to shed light on Beckett's imaginative inquiry into the nature of existence and the mind-body problem. It would seem, however, that of the modern Continental philosophers it is Merleau-Ponty who offers the most suitable model for depicting, within the critical oeuvre, Beckett's distinctly atheoretical understanding of art.

For Heidegger never really exceeds the transcendental subjectivity that is the basis of Husserlian phenomenology. His Being-in-the-world describes the "basic state" of Dasein, its mode of existence, as the primary reality. And he has little to say, if anything at all, on perception. To the limited extent that he addresses the question of Dasein's awareness, Heidegger does so within the context of its ipseity or selfhood, and what he recounts as the facticity of Dasein's being perpetuates, however ironically, the kind of objectivist thinking that Husserl, with his theory of intentionality, had specifically sought to deflate.

Sartre, as well, remains fixed in an absolute subjectivity of consciousness, in his case one that falls prey to a duality of "I" and "Self" that succumbs to the same objectifying conceptualizations. Sartre has been useful for explaining, as Lance St. John Butler has eloquently done, the failure of the Beckettian pursuit of the Self: "there is any amount of stuff in his narrators' worlds that qualifies as 'mine' but none of it is 'I'; there is plenty of objective Self but it is always 'Not I.'"[12] This division between consciousness and Self, however, prevents any real escape from the relation of exteriority, the basis for Husserl's own scientific rationalism to which Sartre, like Heidegger, objected.

Merleau-Ponty, however, did succeed in challenging the transcendental subject, and in refuting thereby the dualisms of modern or Cartesian thought, and he did so by articulating our apprehension of reality on an entirely other order of thinking. Indeed, his entire philosophical career was

devoted not to the primacy of perception as such, but to perceiving as an active or lived reality and to purging ontology of the polarities of mind/body, self/world, thought/language, and so on. While the notion of intentionality unites all four phenomenologies, Merleau-Ponty's most successfully eludes the autonomies of consciousness and its surroundings.

First, he viewed perception not according to the objectivist models of pure exteriority or pure interiority—whereby perceiving subject and perceived object are conceived as separate in and of themselves—but, rather, in accordance with the nonobjectifying model of "chiasm," the intertwining, overlapping, or reversibility of the perceiving organism and its environs. This reinsertion of the mind within its world depended upon the reinsertion of the mind within its body—"The perceiving mind is an incarnated mind"[13]—and the ambiguous nature of this corporalized consciousness whose boundaries he sought to define.

Second, particularly in his later writings, *The Visible and the Invisible* and "Eye and Mind," he reformulated his thinking on ambiguity—the necessarily polymorphous profile of a subjectivity for whom "To perceive is to render oneself present to something through the body"[14]—in terms of visibility, the relation between the visible and the invisible, and that between seeing and the seen. It is, of course, this account—in which the visual work of art comes to be revealed not as object or thing, but *agent* of both artist and spectator's seeing—that is of particular interest to us here. For it is a comparable resolution of the subject-object dichotomy in the play of perception and perceptibility that in Beckett becomes the paradigm of art.

Like Husserl, Merleau-Ponty "de-Euclidized" space in intentionality. Like Heidegger and Sartre, he existentialized Husserl's essentialized "real" world, previously "bracketed" from consideration in the practice of the phenomenological reduction or *épokhè*. Unlike all three, however, he abandoned the objectifying schism bequeathed by Descartes precisely in resituating perception beyond the conceptual, on the horizon of bodily sensation, and in rendering account of the ambiguity of the corporeal infusion. Remarkably reminiscent of this effort is Beckett's own positing of consciousness, in both his creative and critical work, as a distinctly sensorial, and specifically visual, corporeality.

Director Pierre Chabert has written: "One must understand [Beckett's theater] as a deliberate and intense effort to make the body come to light, to give the body its full weight, dimension, and its physical presence . . . to construct a physical and sensory space, filled with the presence of the body, to affirm . . . a space invested by the body." Critic Stanton Garner describes Beckett's theater similarly: "Beckett's drama is a theater 'of the body,' both

in the traditional sense that its characters are bodied forth by actors for spectatorial consumption and in a more deeply phenomenological sense in which Beckett foregrounds the corporeality of actor and character within his stage's exacting field."[15] It is my contention that the same notion of an incarnated perceptuality is operative in the critical writings where appreciation of the haunting physicality, the concrete humanistic quality of a painting conflicts with the metaphysical or utopian idealism to which Beckett, at once, aspires: The smallest particle of a van Velde, for instance, is said to contain "more true humanity" than all other "processions towards a happiness of sacred sheep."[16] The point, however, is that this perceptuality incarnate is neither objectified nor subjectified by Beckett; the work of art, in a sense, is thing-less and the perceiving consciousness as pure mentality is everywhere proven false. Such purist thinking, in other words, abdicates in the critical texts, no less than in the creative oeuvre, before a bodily possession of the world in which perception is above all visual and the artist that carnal instrument by which the world, in all its visibility, is rendered.

All the more reason to maintain that judgments such as "Everything is happening [. . .] as though Beckett had said to himself: since it is impossible to be an artist, let's at least attempt to be a good theoretician of art"[17] are foolish. They presuppose an objectivist thinking that Beckett, like Merleau-Ponty, was dedicated to proving false. It is true that in his essays on Joyce, Proust, and any number of painters he reveals more of himself and his own reflections on literature and art than of the work in question. But too much has been made of the theoretical uniformity of these writings and too little of their purposeful dissonance and counterpoint. Their real homogeneity, in fact, is to be found in the anti-objectivism that enframes the undoing of perception itself as either empirical or intellectual event.

Both empiricism and intellectualism objectify perception to the extent that the former views it as a naturalistic event occurring within an autonomous world while the latter considers it the process by which the transcendental ego takes hold of that world.[18] Beckett's perceiving subject, however, may be said to exist ambiguously in the link between the two. For Merleau-Ponty, "The perceiving subject or the lived body (two different ways of saying the same thing)," to cite Gary Madison, "is a philosophically bizarre mixture of being-in-itself and being-for-itself."[19] This same mediation is at play in Beckett's curiously populated fiction in which neither the absence nor the fragmentation of a cohesive physical presence yields to the purity of consciousness, but to an antepredicative or preconscious gestalt. It is operative as well in his drama in which, by virtue of performance, the bodily nature of intentionality can most naturally be brought to

the fore. And it is operative in the critical writings to undo any presupposition of art's objective status.

Neither the "simple result of the action of external things on our body" nor rooted in "the autonomy of consciousness," as the Sartrean or Heideggerian would have it, perception for Merleau-Ponty implicates the grounding of mind in both a body and a world.[20] The same may be said of Beckett and thus, I propose, there is no real perceiving subject, in the sense of an autonomous presence, to be found in either the creative or critical work. Although many parallels exist between Beckett and the other continental philosophers, the notion of perceiving subject as pure mentality is essentially, with regard to this writer, an erroneous supposition. Molloy, Malone, and the Unnamable, no more and no less than any of their near or distant relations in the dramatic oeuvre, incarnate a complete identification of self with world comparable to that of the painter through whom the spectator will "see" the real. In so doing, they require our resituating Beckett's fiction and drama on Merleau-Ponty's sensibilized horizon of intentionality where "Inside and outside are inseparable. The world is wholly inside and I am wholly outside myself."[21]

Beckett's criticism is more accurately a phenomenology of vision and a return to the etymological sense of the word *aesthetics* in its relation to the Greek *aisthēsis*—sensation—affords a better understanding of his Merleau-Pontyian orientation.[22] Indeed, it offers a way in to what is sometimes a very obscure assessment of a painting—Tal Coat's, for instance, which he characterizes in the "Three Dialogues" as "a thrusting towards a more adequate expression of natural experience, as revealed to the vigilant coenaesthesia."[23] On the order of this sensorial interiority, Beckett's definition of nature in his conversation with Duthuit as "a composite of perceiver and perceived, not a datum, an experience," becomes all the more meaningful.

Beckett's anti-objectivism (articulated as opposition to either a pure empiricism or intellectualism) is founded on the same quasi-Hegelian dialectic that, in Merleau-Ponty, is a deepening—in the notion of chiasm or reversibility—of the modification of consciousness by the object of perception and the modification, in turn, of the object by the already modified consciousness. Does he not tell us as much when he writes, for Arikha, "Siege laid again to the impregnable without. [. . .] By the hand it unceasingly changes the eye unceasingly changed"?[24] Yet, neither Beckett's nor Merleau-Ponty's phenomenology of vision is fundamentally idealist in the Hegelian sense of the term. As Michael B. Smith explains, "Vision cannot be the *intuitus mentis* of idealism, because vision is movement. Therefore it requires a body. [. . .] It is the intertwining of our sensorimotor projects."[25]

And so it is that the body's embrace (however ironic the term's use here) of the world in vision is the paradigm of Beckett's unique form of writing on art in which, mostly, an effort to image the image at hand, to clarify by no other light than its own (to paraphrase a line from his homage to Yeats) substitutes for a more customary critical appraisal.

Each of the dramatic and narrative constructs outlined in chapter 2—the modeling of the referentiality of language on the specular; the figuration of the ontological gestalt; the focalization of seeing (as related to the vision of self as a visual entity); and the visual effects that render Beckett's prose so extraordinarily "painterly"—attests to the mediation of self and world that defies their conceptualization on the order of objectifying thought. It is precisely Beckett's Merleau-Pontyian circumscription of their intertwining, interweaving, or reversibility that negates vision as anything but an antepredicative or pre-objective experience of the world. The critical writings similarly contest any attempt to reduce the self-world to ideation or representation. "Henri Hayden, homme-peintre" provides a striking example.

Published in 1955 in *Cahiers d'art* (though written in 1952), Beckett's short text begins with a reference to Gautama's[26] claim "that we are mistaken in affirming that the self exists, but in affirming that it does not exist we are no less mistaken." The paintings of Hayden are said to be corollaries of this nonobjectivist thinking on the self, and, indeed, Beckett extends the notion beyond the self to Hayden's art as a whole. If the self cannot be reified, neither can the landscapes and still lives whose recognizable forms are "fragile" in their quasi-humorous immateriality:

> No trace of the great periclitations, of the shaping up under the iron rod of reason, of the exploits of the exclusive temperament, of the quintessentialisms in the cold, of all the recourses and subterfuges of a painting at a loss for references and which no longer aims deep down to render more beautiful, as beautiful, otherwise beautiful, but simply to salvage a relation, a disparity, a couple however dimished its components, the self in its possibilities for acting, for receiving, the rest in its docilities of the given. No trace of one-upmanship, either in excess or deficiency. But the acceptance, as little satisfied as bitter, of all that is immaterial and paltry, as among shadows, in the shock from which the work emerges.

Hayden's art is no less than a "double erasure" at work: "Barely the presence of one who makes, barely the presence of what is made. Impersonal

work, unreal work." While Beckett appears not to confer on this artist a
victory over Cartesianism as he did with Bram van Velde, in whose inno-
vativeness he initially located a decisive step for art—"It is not at the close
of its happy days, the subject-object crisis," he writes of Hayden—in actu-
ality, he does just that: "But it is different and to the benefit one of the other
that we are used to seeing them weaken, this clown and his side-kick. While
here, confused in an identical inconsistency, they withdraw in unison."[27]

Interestingly, Beckett's anti-objectivist attitude was already apparent,
strange as it may seem to those at all acquainted with his work, in an early
association of poetry with prayer. In "Humanistic Quietism," a short piece
on poems by Thomas MacGreevy published in *Dublin Magazine* (July–
September 1934), he made the connection in the context of a movement
toward the lighting, clearing, awareness that is the recognition of truth[28] in
art: "It is from this nucleus of endopsychic clarity, uttering itself in the
prayer that is a spasm of awareness, and from no more casual source, that
Mr McGreevy evolves his poems."[29] A similar, if more general, connection
of prayer to art was again made in the unpublished German Diaries, which
contain the following entry for November 1936: "The art (picture) that is a
prayer sets up prayer, releases prayer in onlooker, i.e. *Priest:* Lord have
mercy upon us. *People:* Christ have mercy upon us."[30] Anthony Cronin has
suggested that such a correlation fulfilled the need, not uncommon in the
young, for a surrogate to replace a forsaken religious faith. It may "have
been the product of an intensive two-year association with MacGreevy," he
writes, "whose own pronouncements on literature and painting are cer-
tainly not free from devotional fervour" or of the influence of James Joyce,
"whose habits of thought and to some extent modes of feeling remained
Catholic to the end."[31] But this assessment is not only inconsistent with the
developmental history of Beckett's attitude toward religion. The commis-
sion of the art/prayer association to the spiritual or ideal is utterly incon-
gruent with the struggle against the subject/object, mind/body, ego/world
dichotomies—the conflict, in sum, with objectivist thinking—already oper-
ative in Beckett at this time: The poem "Whoroscope" certainly posed the
issue of Beckett's anti-objectivism in the form of an anti-rationalism, if not
an anti-Cartesianism, as early as 1930. We can ask, with Sidney Feshbach,
whether Beckett, in preparing for his Joyce essay of the preceding year, was
"moved by Vico's rejection of Descartes."[32] He certainly addressed the
"breakdown of the object" in another 1934 text, this one on recent Irish
poetry, that appeared in the *Bookman* in August of that year, in which the
"breakdown of the subject" was described as "com[ing] to the same
thing—rupture of the lines of communication."[33] And in the same magazine

some months later he located the "energy" of Sean O'Casey's theater in "the principle of disintegration" that the playwright discerns "in even the most complacent solidities"; it was the "impulse of material to escape and be consummate in its own knockabout" that Beckett admired in his compatriot there.[34]

My point is that Beckett's encounter with objectivist thought, the basis for the representationalist notion of art, has been largely misunderstood: As instances of an autonomous perceiving consciousness, the voices that populate Beckett's fictive world would ever be fully present, distinct in their subjectivity both from the body (or parts thereof) and the cogitized world they are made to transcend. Comparably, Beckett's own critical voice would confine the work under scrutiny to "le vieux rapport sujet-objet" (the old subject-object relation), which for him it was the particular task of art to undo. But, as Merleau-Ponty told us, the "I can never say 'I' absolutely,"[35] and both Beckett's creative and critical writings show us the insufficiency of any such attempt.

How, then, is the resolution, the breakdown of the dichotomy to be understood? Not, I would argue, as that failure that, as we have seen, serves all too often as the basis for a supposed aesthetic credo, that failure that results from the binary oppositions characteristic of representational thought. It is, rather, as an embodiment of consciousness, as an ambiguous contouring of the coincidence of mind and body in the simultaneity of seeing and being seen, that the new relation may be grasped. Was it not precisely for the emergence, unveiling, or disclosure of this ambiguity that Beckett praised the brothers van Velde: "An endless unveiling, veil under veil, level upon level of imperfect transparencies, an unveiling towards the non-unveilable"?[36] Was it not, in fact, precisely for the emergence, unveiling, or disclosure of the unseen as seen that Beckett valued the potential of art:

> To force the fundamental invisibility of exterior things till the very invisibility becomes itself a thing, not just awareness of limits, but a thing that can be seen and make seen [. . .] on the canvas, this is a work of diabolical complexity and which requires a skill of extreme versatility and levity, a skill which insinuates more than it affirms, which is positive only with the transient and incidental proof of the great positive, the only positive, time that carts away.[37]

In obliterating the materialist distinction between consciousness and world, Merleau-Ponty distinctly compares the body to art:

The body is to be compared, not to a physical object, but rather to a [work] of art. . . . A novel, poem, picture or musical work are individuals, that is, beings in which the expression is indistinguishable from the thing expressed, their meaning, accessible only through direct contact, being radiated with no change of their temporal and spatial situation. It is in this sense that our body is comparable to a work of art. It is a nexus of lived meanings.[38]

Seeing neither an object when he looks at the work of art nor an investment of meaning in matter to be projected back onto a viewer, he sees something indivisible from the perceiver him- or herself: "The thing is inseparable from a person perceiving it, and can never be actually *in itself* because its articulations are those of our very existence . . . a coition, so to speak, of our body with thing."[39]

Beckett also proclaims the absence of consciousness as a for-itself and the absence of object as an in-itself in favor of a field of reversible interaction, one that is unfathomable on the order of either intellectualist or empirical conceptualization. Apprehensible only on the order of the interchange of visibility with visual apperception, it is there that the bodily relation of human to world is defined. Eyal Amiran is right to remark the erasure of the mind-world division in Beckett's fictive geography:

In several places Beckett describes the body in terms of the world, as in *From an Abandoned Work,* where a pregnant belly is a cavernous mountain (34), and in *Malone Dies,* where Malone is the world, with his arse in Australia (235). More often, this superimposition of figure and ground takes the opposite form—the world is endowed with human features. One may fine oneself lost "on the face of wind-swept wastes" (*Malone Dies,* 227), a road is "blind" (*Malone Dies,* 182), the terrain has "folds" like skin or a cloak (*Molloy,* 11), and the world is "corpsed" (*Endgame*).[40]

I propose that the mutual implication of self and world is comparable in Beckett's critical writing where, in the absence of the sustained metaphor of narrative or drama, it is revealed in the opposition that Beckett erects to objectivism in the visualizing-visibility model.

Hugh Silverman has written that "modernist mentality seeks to elaborate an ego-based subjectivity (or self-constitution) from a position that elaborates its own rules, its own formations and then seeks to regard them

at the same time as elaborated in the 'objective' world." Postmodernism, on the other hand, throws such a Weltanschauung into question: "Postmodernism seeks to enframe a dualist, subject-object based account of human experience, human enterprises, or human activity."[41] In the light of the similarity of Beckett's antepredicative thinking on art to that of Merleau-Ponty, Beckett may be said to conform neither to one nor to the other.

II

"Silence at the eye of the scream":[42] A fitting commentary on Edvard Munch's *The Cry,* this phrase from *Ill Seen Ill Said* bears even weightier relevance to the "impediment" painting of Bram van Velde.[43] This becomes clear when we consider what exactly Beckett means when he writes of the resistance to representation of the object of representation and why the work of this particular painter so appeals to him. A brief look at the imaged "silence" in question, what Beckett considers van Velde's inexpressive painting—in its implicit relation both to his other writings on painters and his own "decreative" project—should further attest to the visual thinking that overrides his conceptual or rational thought. And it should confirm Beckett's nontheoretical stance in its likeness to Merleau-Ponty's phenomenology of art.

Beckett's struggle with objectivism, and with the representational notion or copying idea of art, is most evident in his writings on van Velde. In the "Three Dialogues" and certain of his correspondence with Duthuit, he defines modern painting as the first assault on the object apprehended in its indifference to perception. He lauds van Velde for being the first to recognize on the canvas that any relation between subject and object (dichotomized à la Descartes or fused à la Husserl) is illusory, the first to submit in his work to the "incoercible absence" of relation[44] that impedes expressivity in art. Van Velde, he claims, succeeds not in liberating painting from the object (as Kandinsky "absurdly" spoke of doing), but in rendering visually the impossibility of both expression and representation—in painting, in other words, precisely what it is that prevents painting that refuses to acknowledge this from being an entirely honest act.

Beckett's effort, then, is to articulate van Velde's achievement outside systems of relations assumed requisite to philosophical understanding, on the one hand, and to creative function, on the other. In a letter to Duthuit dated March 9, 1949, he locates van Velde's innovativeness in a refusal of relation in any imaginable form: "It is not the relation with such and such

an order of vis-à-vis that he refuses, but the state of just being in relation and, purely and simply, the state of being in front of."[45] Outside of the binary how, Beckett deliberates, can the painter at work be described?

> Whatever I say, I will appear to be enclosing him again in a relation. If I say that he paints the impossibility of painting, the denial of relation, of object, of subject, I appear to be putting him in relation to this impossibility, this denial, in front of it. He is within, is this the same thing? He is them, rather, and they are him, in a full way, and can there be relations within the indivisible? Full? Indivisible? Obviously not. Yet this lives. But in such a density, that is to say, simplicity, of being, that only eruption can prevail over it, bring movement to it, in raising it all of a piece.[46]

The problematic he outlines is remarkably akin to that articulated by Merleau-Ponty in *Le Visible et l'Invisible,* in which all conventional categories of thinking about the relation of man and world—whether derived from the order of transcendental subjectivity, that of dialectics, or of scientific objectivity—are abandoned in favor of an entirely other kind of affirmation: namely, that the human being is not in the world, but *of* it.[47] For Heidegger there is in the work of art a confluence of beauty and truth in the emergence of the meaning of Being. In the process of disclosure (in appropriation or *Ereignis*) "worked" by the work of art, this confluence is a clearing, an illumination, or showing of the authentically human in art's opening onto the world. Merleau-Ponty also problematizes art as a revelatory act but from an entirely other perspective: It is from *within* the world's interior, rather than as an opening onto it, that Being comes to be seen. From this perspective, the question of how one "views" the world assumes a different sort of urgency. Space and time are now to be conceived beyond the framework of the "real" and the notions of seeing and seer rethought in completely new terms. Merleau-Ponty suggests the following: "instead of saying that I am in time and in space, or that I am nowhere, why not rather say that I am everywhere, always, by being at this moment and at this place?"[48]

This ubiquity of Being to which the philosopher subscribes is the implied focus of all three of his essays on painting. In "Cézanne's Doubt" he speaks of the depiction of world primarily in terms of the artist's use of color: "If the painter is to express the world, the arrangement of his colors must bear within this indivisible whole." As a colorist, however, Cézanne forsakes contour, perspective, and pictorialism to display a sensorial expe-

rience of the natural world: "In giving up the outline Cézanne was abandoning himself to the chaos of sensation."[49] Merleau-Ponty's nonformalist interpretation (he was not interested in Cézanne's geometricalization of the two-dimensional canvas) accounts for a uniquely perceptual apprehension of the plenitude or fullness by which we define the real; it is a pre-objective hold on a totality Cézanne himself described as his "motif":

> He would start by discovering the geological foundations of the landscape; then, according to Mme Cézanne, he would halt and look at everything with widened eyes, "germinating" with the countryside. The task before him was, first, to forget all he had ever learned from science and, second, *through* these sciences to recapture the structure of the landscape as an emerging organism. To do this, all the partial views one catches sight of must be welded together; all that the eye's versatility disperses must be reunited [. . .]. "A minute of the world is going by which must be painted in its full reality." His meditation would suddenly be consummated: "I have a hold on my *motif* [. . .]."[50]

Once again, reversibility comes into play, for it is in the chiasmic structure that Merleau-Ponty locates the illumination of nature that occurs through Cézanne's apperceptual act. It is the overlapping of visible landscape with seeing artist that allows for the arrestation, in other words, as opposed to re-presentation, of the real. "Words do not *look like* the things they designate; and a picture is not a *trompe-l'oeil*," Merleau-Ponty explains. Rather, "The painter recaptures and converts into visible objects what would, without him, remain walled up in the separate life of each consciousness: the vibration of appearances which is the cradle of things."[51] The world's indivisibility and depth radiate (are "seen"), therefore, by virtue of the vibrations of "lived" form; landscape and still life are the shaping of matter within the instantaneity of apperception to disclose the ubiquity of Being: "The landscape thinks itself in me," Cézanne claimed, "and I am its consciousness."[52]

As a response to ideas on art expressed by André Malraux and Sartre, "Indirect Language and the Voices of Silence" is a transitional piece situated between two more explicit expressions of the author's phenomenology of painting. Less topological in approach than the previous essay and less ontological than the one to come, it too features the primacy of perception (the sensorial implication of the body) and the opposition to objectivism (the positivist abstraction of art from the lived world) from which the ubiquity of Being emerges. While the most intriguing part of the work concerns

language's mute expressivity in its relation to the in-visible that painting projects, a connection I will return to later, it is Merleau-Ponty's complete identification of the physical work of art with its pervasive structure of world that is relevant here.

Consider what he says of linguistic meaning:

> For the speaker no less than for the listener, language is definitely something other than a technique for ciphering or deciphering ready-made significations. Before there can be such ready-made significations, language must first make significations exist as available entities by establishing them at the intersection of linguistic gestures as that which, by common consent, the gestures reveal.

There is no cognitive text, to put it another way, "no language prior to language," that an author sets out by his use of words to transform: "Language is much more like a sort of being than a means," and

> Language does not *presuppose* its table of correspondence; it unveils its secrets itself. It teaches them to every child who comes into the world. It is entirely a showing. Its opaqueness, its obstinate reference to itself and its turning and folding back upon itself are precisely what make it a spiritual power; for it in turn becomes something like a universe, in which it is capable of lodging things themselves—after it has transformed them into their meaning.[53]

The same case is made for painting which happens perceptually and gesturally in vision and in time. The brush grapples with intention to execute what does not yet exist; with each stroke the painter utters "an unformulated power of deciphering"[54] within the self that simultaneously unveils the origin or imminence of a world.

The omnipresent self-world again finds expression in "Eye and Mind," an essay Merleau-Ponty would have expanded in *Le Visible et l'Invisible* had his untimely death not prevented the book's completion. At the heart of his engagement with modern art, ontological ubiquity is shown here to amount not only to an anti-formalist appreciation of modernist painting, but to a paradoxical deepening of the formalist perspective. For it acknowledges form as the configuration of the mutual implication of seer and seen. This auto-visibility, a function of the "overlapping" central to Merleau-Ponty's meditations on creativity, discloses what is *in* the visible to expose still other chiasmata—that, for instance, as exemplified in Beckett, of the

imaginary and the real. There is no sense in any of the three essays in which painting is mimetically conceived precisely because ubiquity (understood as *lived* spatiality) renders art an unfolding of the world wherein the revelation of the artist to him/herself is integral to what is visually perceived.

At the intersection of body and world, painting—as celebration of the vision of the world's visibility—is inscribed not only in the spatial ubiquity of Being but in its omnitemporality as well. As Merleau-Ponty explains in "Eye and Mind," the world is transfigured in painting by the connection of vision to movement; it is a moving body that sees and the visual landscape emanates from the body's changes of place. Thus, vision makes painting the carnal enactment of the primordial spatiotemporal functioning of the world and Merleau-Ponty's resolution of the Cartesian impasse may be said to reside therein: "At one swoop, then, Descartes eliminates action at a distance and relieves us of that ubiquity which is the whole problem of vision (as well as its peculiar virtue)."[55]

To the extent that Merleau-Ponty resolves in the chiasmic relation of seeing and the primacy of its access to Being the conflict (subject-object, ego-world) that Beckett continually deplores, his ontology responds to the need for a nonobjectifying order on which to rethink Beckett's writings on art. Indeed, in light of this phenomenology both Beckett's choice of painters and the "decreation" of which he wrote to Axel Kaun manifest the very solution—the visual as paradigm—that I maintain is the basis of his literary and theatrical oeuvre.

To see how, we need to look more closely at Beckett's admiration for van Velde whose origin lies less in any perceived separateness of human and world in his art than in a holistic inspection that surpasses them. The seeds of this veneration were already sown in Beckett's 1934 commentary on Cézanne. In an enthusiastic letter to Tom MacGreevy, written following a visit to the Tate Gallery in London, he contrasted Cézanne's impassive landscapes with the overly invested *paysages* of other painters:

What a relief the Mont Ste. Victoire after all the anthropomorphised landscape—van Goyen, Avercamp, the Ruysdaels, Hobbema, even Claude, Wilson and Crome Yellow Esq., or paranthropomorphised [*sic*] by Watteau so that the Débarquement seems an illustration of "poursuivre ta pente pourvu qu'elle soit en montant," or hyperanthropomorphised by Rubens—Tellus in record travail, or castrated by Corot; after all the landscape "promoted" to the emotions of the hiker, postulated as *concerned* with the hiker (what an impertinence, worse than Aesop and the animals), alive the way a lap or a *fist* is alive.[56]

Clearly he esteemed the artist for his projection of the world's indifference, his resistance to what he calls in the same letter the "itch to animise." Yet, when we consider Beckett's view alongside Merleau-Ponty's idea, as expressed in the first essay referred to above, that this landscape painting achieves its fullness, reaches its maturity, precisely in its rendering of the painter's most intimate participation (as seer) within the world, the holism comes to light. In distinguishing the indifference from any affective register on which it might be imposed, Beckett neutralizes in an absence of relation the self as, simply, of the world. What appears is an omnipresence: the ubiquity of Being the philosopher describes.

Beckett's letter continues: "Perhaps it is the one bright spot in a mechanistic age—the deanthropomorphizations of the artist." What Beckett opposes to the affect of solitude is an isolation, an alienation, more ontologically primary. It is what Alain Robbe-Grillet, among the first to appreciate it as such, defined in an early essay on *Godot* as distinctive of Beckett's own creative work: a vision of the human condition, as expressed by Heidegger, of simply being present.

The contradiction, in other words, between Beckett's deep appreciation of Cézanne's depiction of the insensibility of the world and Merleau-Ponty's respect for Cézanne's interweaving of world and self in vision and visibility is far more apparent than real. Human alienation from an uncaring landscape is also the focus of commentary on another painter greatly admired by Beckett, Jack B. Yeats. In his 1945 review of MacGreevy on the artist Beckett writes,

> The being in the street, when it happens in the room, the being in the room when it happens in the street, the turning to gaze from land to sea, from sea to land, the backs to one another and the eyes abandoning, the man alone trudging in sand, the man alone thinking (thinking!) in his box—these are characteristic notations having reference, I imagine, to processes less simple, and less delicious, than those to which the plastic *vis* is commonly reduced, and to a world where Tir-na-nOgue makes no more sense than Bachelor's Walk, nor Helen than the apple-woman, nor asses than men, nor Abel's blood than Useful's, nor morning than night, nor inward than the outward search.

Here again, when we avoid, on the one hand, attributing to the painted world the very anthropomorphism Beckett condemns in the citations above and, on the other, objectifying it on the reductive order of the more common "plastic *vis*," on the rationalist order of the pursuit of clarity in the

"inward" or "outward search," we see that Beckett does not look schismatically at Yeats's work. Rather, he sees it, as he tells us, "in quite a different way."[57]

The nature of the decreative project Beckett would delineate in his celebrated letter to Kaun proves the point. The nucleus of the "decreative" program is given there as follows: "To bore one hole after another in [language], until what lurks behind it—be it something or nothing—begins to seep through; I cannot imagine a higher goal for a writer today."[58] "Decreation" has impelled the Beckett-as-aesthetician argument ever since the 1937 letter was translated by Martin Esslin and published in 1983. But what has been consistently overlooked is *how* the "something or nothing" in question quite literally figures at the crux of the expressivity issue.

Rupert Wood has written that "Beckett's works bear tribute to the fact that words can never undo themselves and turn into a 'literature of the unword,' however desirable this may seem."[59] In a sense, to speak of the undoing that Beckett has in mind as an impossible aspiration is to perpetuate the tradition of the ontic treatment of the text.[60] A more legitimate understanding of Beckett's "decreative" project requires abandoning the concept of word as entity, indeed, the object model of textuality in its entirety. It requires resituating literary language, and all artistic expression, on the more fundamental level of Merleau-Ponty's antepredicative or precognitive apprehension of the real, whence the opening of art onto world that is the very process of which Beckett writes.

To fully appreciate the "decreative" process in the context of the affinity with Merleau-Ponty, therefore, we need to weigh the relation of language to silence (audible in the way that the invisible is visible) as the philosopher describes it. The following statement, attesting to the opacity of words, appears early in Merleau-Ponty's first essay on painting: "[Language] is always limited only by more language, and meaning appears within it only set in a context of words."[61] Another follows shortly thereafter:

> Now if we rid our minds of the idea that our language is the translation or cipher of an original text, we shall see that the idea of *complete* expression is nonsensical, and that all language is indirect or allusive—that it is, if you wish, silence.[62]

Are we to understand these observations as paradox, inconsistency, or ambiguity of another sort? The answer lies in the way words mean, comparable to the way images in painting do, insofar as they too signify by being both eloquent and mute.

Merleau-Ponty aims to "uncover the threads of silence with which speech is intertwined."[63] This entails considering the word prior to its articulation, alongside others rejected in its favor, and against that silent background without which it would remain meaning-less. The situation is that of the expression of the in-between of words as much as of the words themselves, the signifying of the unsaid as well as of the said. This is also true of painting: What is progressively approached in the visual art is the specificity of an encounter, that of the artist's glance with whatever it may be that solicits it. As "the sign has meaning only in so far as it is profiled against other signs" and speech "is always only a fold in the immense fabric of language,"[64] painting signifies as a gathering in the enormous matter of all that is *in* (the) visible.

No more expressive of the thing-in-itself than language, painting, as Beckett would relate some fifteen years after his comments on Cézanne, "fails" to express precisely for the world's indifference similarly conceived. Beckett's remarks to MacGreevy candidly prefigure those in the "Three Dialogues": If van Velde would be praised there for depicting the total absence of relation, Cézanne had already been honored for being the first to see landscape as "something unapproachably alien."[65] Although it was Merleau-Ponty who wrote that "Language speaks peremptorily when it gives up trying to express the thing itself,"[66] it could as well have been Beckett on Cézanne, Yeats, or van Velde.

My point is that Beckett's struggle to free literary language from the "terrible materiality of the word surface" is a return to the humanistic elementarity or primordiality virtually eliminated by Descartes. In "Eye and Mind" Merleau-Ponty explains that for the Cartesian, rather than an opening onto Being, painting is "a mode or variant of thinking."[67] It stimulates thought to conceptualize what, like the object of a sign, is designated. "Decreation," like Merleau-Ponty's nonthetic, or thoughtless, opening of painting *within* the world's visibility, however, is an actualization of "mute meanings"[68] (Merleau-Ponty), of the "Silence à l'oeil du hurlement" (Beckett), that concretizes the ubiquity of Being. As such, it offers a kind of solution to the "impediment" problem, to the resistance of the real to its representation. Possibility for its realization lies not in the achievement of silence, but in that "Logos of lines, of lighting, of colors, of reliefs, of masses"[69] wherein painting, as the prerational opening of the world as seen, can make of expressive failure success. There, I would argue, lies the key to Beckett's admiration for van Velde.

In likening what Beckett calls "that final music or that silence that underlies All" to the ubiquity espoused by Merleau-Ponty, the "alien"

nature of the painting he esteems, Cézanne's, Yeats's, or van Velde's, takes on new meaning. It is the indifference appropriated by the painter that allows for a configuration of the world's visibility, a configuration that seems strange not merely for its kaleidoscopic nature, but for its elementarity. Indeed, both Beckett and Merleau-Ponty attest to the estrangement— the *Unheimlichkeit* spoken of by Freud and Heidegger alike—with which Cézanne's depiction of landscape endows Being and world. Here is Beckett:

> What I feel in Cézanne is precisely the absence of a rapport that was all right for Rosa or Ruysdael for whom the animising mode was valid, but would have been fake for him, because he had the sense of his incommensurability not only with life of such a different order as landscape, but even with life of his own order, even with the life . . . operative in himself.[70]

And this is Merleau-Ponty: "Only one emotion is possible for this painter— the feeling of strangeness."[71]

In his 1954 homage, Beckett again shows strangeness, above all else, to defend against any attempt at undoing the specificity and integrity of an art:

> High solitary art uniquely self-pervaded, one with its wellhead in a hiddenmost of spirit, not to be clarified in any other light. Strangeness so entire as even to withstand the stock assimilations to holy patrimony, national and other.[72]

While, in "Indirect Language and the Voices of Silence," Merleau-Ponty goes so far as to term "strange" the entire creative process insofar as its prototype is the expressivity of each and every gesture of the human body:

> There is no doubt that this marvel, whose strangeness the word *human* should not hide from us, is a very great one. But we can at least recognize that this miracle is natural to us, that it begins with our incarnate life, and that there is no reason to look for its explanation in some World Spirit which allegedly operates within us without our knowledge and perceives in our place, beyond the perceived world, on a microscopic scale. Here the spirit of the world is ourselves, as soon as we know how to *move* and *look*.[73]

Estrangement, of course, is the unifying affective register of Beckett's fiction and plays. But it is in his critical focus on alienation in painting that

the link to Merleau-Ponty is most profound. For in the disaffection he describes Beckett locates an authentically natural order, one free of any imposed animism and utterly inexpressive for being utterly unreproducible:

> Cézanne seems to have been the first to see landscape and state it as material of a strictly peculiar order, incommensurable with all human expressions whatsoever. Atomistic landscape with no velleities of vitalism, landscape with personality à la rigueur, but personality in its own terms, not in Pelman's, *landscapality*. [. . .] How far Cézanne had moved from the snapshot puerilities of Manet and Cie when he could understand the dynamic intrusion to be himself and so landscape to be something by definition unapproachably alien, unintelligible arrangement of atoms, not so much as ruffled by the kind of attentions of the Reliability Joneses.[74]

What the shared province, however strange it may be, of Beckett's and Merleau-Ponty's neutralized and unobjectified order of ubiquity puts squarely into relief is art's historicism. All too often ignored in the myopic focus on the "aesthetics of failure," painting, in its inexpressivity, is a reworking of previous attempts (the painter's own or others') to advance what must forever, by virtue of its link to ontology, remain incomplete. "Painting fulfills a vow of the past,"[75] Merleau-Ponty tells us, by which he means that it shows the insufficiency of what came before while foreshadowing the painting to come as evidence of its present frustration:

> If no painting completes painting, if no work is ever absolutely completed, still, each creation changes, alters, clarifies, deepens, confirms, exalts, re-creates, or creates by anticipation all the others. If creations are not permanent acquisitions, it is not just that, like all things, they pass away: it is also that they have almost their entire lives before them.

This, I would argue, is how we must comprehend Beckett's remark in the "Three Dialogues" that "The history of painting [. . .] is the history of its attempts to escape from this sense of failure."[76] As though directly addressing Beckett's deception before painting's persistent defeat, Merleau-Ponty protests that "this disappointment issues from that spurious fantasy which claims for itself a positivity capable of making up for its own emptiness. It is the regret of not being everything, and a rather groundless regret at that."[77]

Bram van Velde's appeal for Beckett, he says so very conclusively, resides precisely in the painter's fulfillment of this historical impulse. Unrestrained by the certainty of impossible expression, van Velde paints the inexpressibility of matter itself. If Tal Coat and Masson were lacking for Beckett in originality, as the "Three Dialogues" makes clear, it was that their work, compromising evocations of the profane, remained within the realm of the possible, rather than rendering, however incompletely, the ontological texture that lies silently and in-visibly within it. As Beckett wrote to Duthuit, the only relation revealed by painting situates itself precisely within the folds of invisibility: "It can therefore turn away from the immediately visible without it being of consequence."[78]

Merleau-Ponty's displacement onto silence and the in-visible of the positivist identification of word and thing, what constitutes the ontological advancement of the historicity of art, has led some to qualify him as postmodern, but the presumed resemblance to deconstruction is superficial. For it overlooks the humanistic substance of the argument falsifying the thinking in the very same way, I believe, as the erosion of meaning in Derridean *différance* distorts Beckett's own. Deconstruction examines opposing drives to signification; it decomposes the logic of expectation and reveals a play of intertextual forces. But the incompletion of which Merleau-Ponty and Beckett write derives not just from a deficiency of expression (verbal or plastic) to fix signification, a view that presupposes objectification of the world as an "object" of knowledge. Instead, it is from within the ontology of art that, to cite the philosopher, "painting as a whole presents itself as an abortive effort."[79] Given the spatial and temporal limits of perception, and that painting projects an encounter with things rather than their copy, a work of art can never be expressively complete. There will always be the intertwining with silence or invisibility. And the artistic venture will always be progressive in its movement toward fullness, while regressive in its attempt to better the failure to achieve it. In short, where Merleau-Ponty and Beckett affirm the painter as of an indifferent world, deconstruction denies the link.

My argument, therefore, is that ontological ubiquity is what Beckett turns to in his "decreative" project, whether described as the unwording of literary language, the linking of musical sounds in "unfathomable abysses of silence," or the accommodation within the painted image of the indifference of the visible world. Indeed, in the letter to Kaun Beckett equates breaking through the "terrible materiality of the word surface" to that of the "sound surface, torn by enormous pauses, of Beethoven's seventh Symphony."[80] Similarly, in his correspondence with Duthuit, he locates his

interest in the visual imagery of van Velde in "l'au-delà du dehors-dedans" ("the beyond of the without-within").[81] Is he not articulating in each instance the desire to displace across the arts the illusory spatiotemporal borders of our conventional a prioris, as when he situates van Velde's art beyond the framework of any and all positioning?

> [I] do not at all see how such work bears any connection to considerations of time and space, or why, in these paintings that spare us these categories, we would be inclined to reinstate them, as being of more pleasant sorts than those, division, extensibility, compressibility, measurability, etc., familiar to infinity.[82]

I do not mean to ascribe here any congruence between the arts to one for whom, outside of their struggle with expressivity, there was virtually none.[83] I mean, rather, to say that, though words, brush strokes, and the musical discourse of notes seek expression in incomparable ways, Beckett's "decreative" focus is the shared experience of that immeasurable "whereness," that amorphous space, to which any artist strives to give form.

Merleau-Ponty's description of the way vision "speaks" reveals a distinctly interrogatory process: The painter asks by his gaze how the world makes itself world to us. Light, shadows, color contribute to making the visible seen. For the moderns, no less than for their predecessors, painting is a recreation of visibility, for what is at stake is not reproduction, but the genesis of creation itself. The process, moreover, is reflexive to the extent that the painter as seer is visible and here the philosopher's aesthetics give way to an ontology proper: "Being is *that which requires creation of us* for us to experience it."[84] From a phenomenology of vision, in other words, we pass through the "reflexivity of the sensible" to an ontological account of the creative subject incarnate as seer seen.

In light of this it becomes all the more evident that to view "decreation" as an entirely idealist program, as countless critics are wont to do, is to miss the point completely. No idealist model—from Berkeley to Kant, from Plato to Schelling—bears witness to the reversibility of vision that Beckett and Merleau-Ponty both recognized in art as our principal access to Being. Insofar as "Every theory of painting is a metaphysics,"[85] as Merleau-Ponty claims in "Eye and Mind," Beckett's nontheory of art is simultaneously of another order.

Beckett said so everywhere in his criticism (not only in "La Peinture des van Velde" and "Peintres de l'Empêchement") and, also, in his disdain

for writing on art, a disaffection far more significant than the belittling of his critical pieces as "mere products of friendly obligation or economic need" would have us believe. He disliked playing the valorization game for the objectification it presupposed: " 'There is no painting. There are only paintings. These, not being sausages, are neither good nor bad.' " Like Robbe-Grillet ("But the world is neither significant nor absurd. It *is*, quite simply"),[86] he denied an ethical basis to art for the value judgments that would assume. As he said to Charles Juliet: "Negation is no more possible than affirmation. It is absurd to say that something is absurd. That's still a value judgement. It is impossible to protest, and equally impossible to assent."[87]

From the start he spoke "anaesthetically." In 1937 he wrote to Mac-Greevy that "the real consciousness is the chaos, a grey commotion of mind, with no premises or conclusions or problems or solutions or cases or judgments."[88] Indeed, it was such equivocating that led to the end of his writing on art. Knowlson tells us that "Beckett was bowled over by Yeats's paintings, going to the February 1954 exhibition himself five or six times and encouraging all his friends and correspondents to go to see it."[89] Nevertheless, he had to force himself to write a homage to Yeats for this exhibition at the Wildenstein Gallery; and he described writing it as "real torture."[90] His continuing correspondence with MacGreevy reveals that the earlier van Velde pieces were already a struggle:

> I have a kind of joint study on him with Duthuit in a coming Transition [*sic*], dragged out of me, as the articles for Zervos and Maeght were dragged out of me. Each time I say never again and each time I am told it is for the sake of Bram. But what I write on him will do him more harm than good, as I have told him.[91]

The conflict stemmed, however, not only from an abhorrence to the affixing of aesthetic judgement. As I hope to have made clear in the previous chapter, whatever he might write gave Beckett the feeling of imprisoning van Velde in a relation the work denied. His writing on the painter had thus to come to an end. But not merely because it martyred his friend in a "fidelity to failure,"[92] and an impossible expressive act. It is all too easy to forget that Beckett negated the negation and attributed to van Velde success: The "new occasion," even if an expression of its own inexpressivity, is ultimately not denied. But Beckett's writing on painting had, generally, to come to an end. For "decreation" was not a call to silence, but to a more

profoundly creative impulse to which theory was not ever a serious threat: "I can no longer write in a coherent manner about Bram or about anything whatsoever. I can no longer write *about*," he wrote Duthuit in 1949.[93]

It has been my aim in this chapter to show that the deep attention Beckett pays to the visual is not restricted to the pictorial strategies of his fiction or to the privileged situation of theatrical mise-en-scène. But that, like Merleau-Ponty, Beckett also bears witness, and this in his critical writings, to the subordination of the self-world to the sensible, and to vision, in particular, as our primary perceptual access to Being. Beckett's critical writings are, in fact, almost wholly uncritical. In no way do they call up the conventional ideologies or value systems by which we judge the worth (hardly a fact of nature!) of any given artist. Instead, they constitute a meditation on the commonality of the imaginary and the real. Indeed, like his more properly creative efforts, Beckett's writings on painting, in much the same way as Merleau-Ponty's, reveal this shared domain as the origin of the work of art.

What I maintain, moreover, is that Beckett, though decidedly not a philosopher, betrays an interest and sensibility more distinctly philosophical, phenomenological even, than critical in his "critical" writings, few though they may be. Entirely unconcerned with art's granting of "jouissance esthétique," his preoccupations are restricted to the lived dimension of the visible world as projected on the canvas. His critical writing is anaesthetic insofar as it is fueled by skepticism of reductive (as objectifying) thinking on the world, by resistance to authoritative norms of any sort, and by the view that writing on art had, in the end, to yield to the art itself. "Zur Sachen selbst"—to the things themselves—was Husserl's call that Beckett, in his own way, heeded. His brand of critical writing is comparable to the phenomenological *épokhè* insofar as it brackets all that is not part and parcel of the art itself—the value systems, ideologies, or other social constructs by which we judge it. Utterly paradoxical and wonderfully unpredictable, his criticism, nevertheless, affirms that, as he wrote to Kaun, "in the forest of symbols, which aren't any, the little birds of interpretation, which isn't any, are never silent."[94]

Part 3

"FALLOR, ERGO SUM!"

Chapter 5

The Agony of Perceivedness

An alternate title for this chapter might be "Beckett's Un-doing of the Hegelian Legacy," for the claim (in chap. 2) that the evolution of Beckett's creative work was analogous to the itinerary outlined by Hegel, exemplifying the mortality of art in its post-historical phase, also implied, as I have noted, a renewed aesthetic vision. To the extent that the term *anaesthetic* describes Beckett's inquiry into the incarnation of perception from which art (for Beckett as for Merleau-Ponty) derives its life, "reaesthetic" would appear to account for the allegorization of this incarnation—specifically, that of vision as predominant in the whole of human perception—and the consequent overcoming of art's threatened demise.

We have seen how, in the fusion of life and art that accompanied the collapse of the entire notion of the sanctity of Art, Beckett's reductiveness was closely allied to Pop. Other significant interart relationships come into play in Beckett's creative oeuvre and it is these that will form the basis for this chapter. As already stated, my assessment that the unifying force of Beckett's work lies in a visual as opposed to conceptual thinking is substantiated by the number of perceptual models apparent throughout the creative work. The referential model (images of real and imaginary art), the gestalt model (ontological visions of the whole), the figurative model (the thematic focalization of seeing), and the visibility model (the play of color and interactions of light and dark) of visual perception were previously cited. Each supports the dialogue with painting insofar as it confirms the ideal mode, as defined by Hegel (above all in *The Philosophy of Fine Art*), in which painting, in its liberation of art from the spatial condition of architecture and sculpture and the temporal condition of music, manifests on the plane surface those very qualities endemic to it. Thus, however ironically, it is Hegel's own notion of painting as "visibility in its pure nature"[1] that leads us beyond the post-historical "end" of Beckett's minimalist oeuvre.

This is to say that the nature of painting as a process of "making

apparent," as it is characterized by Hegel, distinctly parallels the paradigmatic function of the visual I have ascribed to Beckett's literary language. Not only do we find in Beckett's minimalist style an exemplification of the Hegelian post-historicism outlined by Danto, in other words, but situate (over and above the superfluity assigned by Hegel to post-Romantic art) within Hegel's notion of art's self-determining function of visibility Beckett's "more painterly than literary" writing.

I

Enoch Brater defines Beckett's surpassing of minimalism as an intergeneric doing more with less. I have chosen the visual paradigm—the specular concretizing of ontological indeterminacy—as the perspective from which to view what impels this work past the reductive impulse. But my overall question remains: In what, precisely, does the visual quality of Beckett's writing reside? Do we mean by this a pictorial writing? Or is the visual component something more or other than that?

To summarize Jean Hagstrum's discussion in *The Sister Arts* of the conditions for "pictorialism" in verbal form, the writing must, first, be translatable into or imaginable as a painting or sculpture; second, consist in visual detail "ordered in a picturable way"; third, involve a diminution of motion toward stasis; and fourth, limit meaning primarily to that which derives from the "*visibilia* present." Unconfined to school or method, it may relate to imitative or abstract, representational or symbolic art.[2] Is Beckett's "painterly" writing limited to the conditions of pictorialism? Indeed, does it fulfill them in any significant way?

Beckett's struggle to express verbally a visual reality took many forms. I will limit myself here to two: the play on aesthetic problems and the depiction of real and imaginary art. It will be my purpose to show that, in each, his visual studies become studies of vision insofar as representation continually collapses before the epistemological constraints of art itself.

Numerous critics have attested to the power of the image that, particularly in the playwright's late drama, "tends to override the words."[3] Jessica Prinz, for instance, has commented on the number of late works in which "Beckett produces a single image or picture that captivates the audience and moves them."[4] Ruby Cohn has observed that "in his television plays, Beckett comes close to painting still lives in movement, so visually are the works conceived."[5] And Martin Esslin has argued that the visual takes precedence over the verbal so that what is remembered is two figures waiting on a lonely road; a blind master centered in his circular room, his aged

parents peering from dustbins; an old man bent over his tape recorder; a woman sinking ever more deeply into a mound; three faces protruding from funerary urns; a disembodied mouth suspended in the dark; a woman pacing to and fro; an old man's white-haired face listening to its own thoughts; an old woman rocking herself toward death; and so on.[6]

Others have written of the predominance of the visual as achieved through Beckett's skillful management of the stage. Brater, for one, has shown that Beckett so restricts space that "the audience's vision of the play is as controllable as the lens of a camera, constantly switching from wide angle to close focus."[7] There is a comparable restriction of light: "If o = dark and 10 = bright, light should move from about 3 to 6 and back" (*Breath*) and "Thirty seconds before end of speech lamplight begins to fail" (*A Piece of Monologue*) are typical. The exactitude of all Beckett's scenic directions, of course, is a commonplace of critical commentary on his drama. So scrupulously does he define his vision by his craft that just how one Beckett director distinguishes him/herself from another remains a question not easily answered.[8]

As director himself—he directed his own work to ensure the most faithful realization of his vision—Beckett also played painter on the stage. His actors commonly attest to that: "In evoking the exact angle at which the head is to be lowered, a hand raised," Esslin writes, "Beckett, in Billie Whitelaw's words, uses the actor's body to create a painting."[9] Whitelaw has written that when doing *Footfalls,* she sometimes felt "as if he were a sculptor and I a piece of clay. At other times I might be a piece of marble that he needed to chip away at. He would endlessly move my arms and my head in a certain way, to get closer to the precise image in his mind." And "Sometimes I felt as if I were modelling for a painter" or "I felt I was being painted with light."[10]

The point I wish to make, however, is not simply this. In the progression from the early to the late work, as reductionism enhances the visually evocative power of the text, Beckett's writing not only becomes more analogous to painting. It also brings epistemological limits of art into play that render the narrative and theatrical picture making an increasingly tangible study of plasticity. The rudimentary, organizational quality of painting becomes visible, in other words, as a phenomenon apart from the painterly picture.

In the earliest texts, indeed as far back as the short story "Assumption" of 1929, the problematization of art constitutes the cornerstone of Beckett's creative writing. As Daniel Albright has rightly noted, "Many of Beckett's fables are meditations on aesthetic problems, extrapolations of

theories of art."[11] Both Albright and Cohn have definitively traced Beckett's mockery of art qua Art through the "awkward, comic artist-heroes" of what are, in a sense, narrative and dramatic correlatives of the "Three Dialogues," and I will not repeat them here. I refer to the telling of stories, those of author and character alike, as a fabulation of the making of art only to situate within narrativity itself (whatever the genre) Beckett's first means of positing the aesthetic.

Beckett's narrative meditations on art in both his fiction and drama had bearing on his style. As he said to Duthuit:

> There are many ways in which the thing I am trying in vain to say may by tried in vain to be said. I have experimented, as you know, both in public and in private, under duress, through faintness of heart, through weakness of mind, with two or three hundred.[12]

His reorganization of familiar concrete realities into the bizarre cosmology that was uniquely his own set up a tension between abstraction and iconography of which he spoke in an interview with John Gruen:

> I think perhaps I have freed myself from certain formal concepts. Perhaps, like the composer Schoenberg or the painter Kandinsky, I have turned toward an abstract language. Unlike them, however, I have tried not to concretize the abstraction—not to give it yet another formal context.[13]

That effort notwithstanding, the freedom from concept (specifically, that of narrative and dramatic form) was to some degree contextualized by the stylistic affinities discernible in his work. Space permitting, much about Beckett's Expressionist, Cubist, and Surrealist tendencies, in fact, could be said.

Many of the best-known practitioners of Expressionist painting, such as it was in Germany in the early part of this century, were greatly admired by Beckett. He delighted in the likes of Kirchner, Feininger, Kandinsky, and Nolde,[14] and, particularly in his work for television and theater, the similarities are profound: From *Le Kid* (the 1931 collaborative burlesque undertaken with Beckett's friend Georges Pelorson) to *Ghost Trio* German Expressionist techniques of distortion, extremes of light and dark, fragmentation, spectrality, and isolation are everywhere to be found.[15]

Even in the fiction, however, a quasi-Expressionist undertone comes into play: The intensity of Beckett's characters' unrealized flight from the

agony of articulation, the fervor of their chronic summoning of silence, often takes the form of a grotesque celebration (however surreptitious) of precisely what is fled. "Assumption" is an obvious instance of the reversal.[16] And, in what Knowlson calls its "anguished contrast between the repressed scream and 'the storm of sound' that appears to lead to death"[17] (viz. its evocation of Munch's *The Cry*), the relation to the Expressionist sensibility is more explicit still. The curious physical appearance, general delirium, and incongruous discourse of the Beckett character all display a powerful dynamic of deformation that recalls it as well.

Beckett's minimalist impulse, in and of itself, suggests a likeness with the geometrization that was the defining element of Cubism. For it was the same modulation of form that led him beyond the confines of genre to the reductive, if increasingly abstract, mode. But the mathematized content, cosmological and ontological—measured world and measured selves distanced from their selves—also bears a relation. It takes on a distinctly Cubist quality in, for instance, *Imagination Dead Imagine* (1965):

> No trace anywhere of life, you say, pah, no difficulty there, imagination not dead yet, yes dead, good, imagination dead imagine. Islands, waters, azure, verdure, one glimpse and vanished, endlessly, omit. Till all white in the whiteness the rotunda. No way in, go in, measure. Diameter three feet, three feet from ground to summit of the vault. Two diameters at right angles AB CD divide the white ground into two semicircles ACB BDA. Lying on the ground two white bodies, each in its semicircle. White too the vault and the round wall eighteen inches high from which it springs.[18]

and *Lessness* (1970), in which a specifically geometric structure and geometric content are fused: "Four square all light sheer white blank planes all gone from mind. Never was but grey air timeless no sound figment the passing light. No sound no stir ash grey sky mirrored earth mirrored sky."[19]

The cosmic autonomy of *The Lost Ones*, with its "flattened cylinder fifty meters round and sixteen high," reveals even more striking similarities to the formalist integrity of Cubist (if not Tubist) style. There dense construction, lack of color, sculptural effect, and two-dimensional fragmentation render a harsh judgment of our mechanistic age. Many and varied, however, are the cases to be made for Beckett's Cubist affinity: the dismembered and otherwise geometricized bodies; the overlapping configuration of "I's"; the discourse patterned by serial, repetitive, and contradictory syntax; the cycles of time (before, with, after) and existential plight (isolation,

coupling, isolation); and the formulaic choreography of, in particular, the two *Quad* teleplays that premiered in Germany in 1981. No less than the Cubists, Beckett could flatten the world squarely against the picture plane as indeed he did in his making of "peephole art,"[20] as he referred to work for television. In fact, the telescoping of image, as we shall see, extended far beyond that medium to a dramatization, both in the late prose and drama, of the plastic dimension of art.

Dadaism and Surrealism, of course, also had their turn in Beckett. In his "destabilization of cultural habits of sign production" Beckett targeted the "crystallized associations" (the terms are Carla Locatelli's) that it was the Dadaists' and Surrealists' primary goal to destroy.[21] He opposed the superior reality of experience to its filtering by the mind, the seminal principle of Surrealism, and was explicit about the opposition in his comments on memory in *Proust*.[22] Indeed, he denigrates intellectualization there, in what amounts to an overt prioritizing of the perceptual over the conceptual, as explicitly as he had in the earlier essay on Joyce.

Moreover, though he aimed not to give his abstract language "yet another formal context," and he never made any sort of appeal for the practice of automatic writing, both Dadaist and Surrealist effect issue from his work. The roll of the existential die, on the one hand, and of the creative die, on the other, emanate visually and verbally in the truncated bodies, motifs of psychic turmoil, and disordering of space and time. (Although unique, the purely arbitrary construction of *Lessness* can be cited in this regard.) Beckett's connections to these movements—through *Transition* and *This Quarter* (to which both he and Tristan Tzara contributed), Roger Blin (a student of Antonin Artaud), avant-garde film (like the collaborations of Buñuel and Dali, *Un Chien andalou* and *l'Age d'or*), and photography that he must have known—are documented.[23] But over and above the question of sources (for *Endgame, Happy Days, Film,* or *Not I,* to name but four works in which they are most in evidence) lies a propensity for the kind of literary and pictorial gesture associated with Dadaist and Surrealist impulse. Had he not been susceptible to its working on his imagination, in fact, no modernist style could have contextualized by any measure what Beckett called his turn to abstraction.

In a way, then, without ever really being so, Beckett was an Expressionist, a Cubist, and a Surrealist—though never a Conceptual artist. And, though a bird's-eye view hardly suffices to make the point, the splendid uniformity of his critical and creative writings lies precisely therein: The former, in allowing the painting under review to, as Beckett said it should, "mind its own business," is resolutely anti-Conceptualist in its repugnance

for the ideation of art; the latter, with its aversion to the symbolic, is doggedly anti-Conceptualist in referring, above all, to itself.

The second form taken by Beckett's meditation on the aesthetic is the deployment, particularly in the early and middle work, of a number of genres from painting: still life, portrait, nocturne, landscape, seascape, and more. *Murphy* and *Watt* are virtual mindscapes in which the symmetries of composition (chronological and structural) rival the best of the *paysagistes:* The descriptions of Murphy's three zones render every contour of the mental motif as visual as Lorrain's idyllically rendered motifs of nature. And with *Watt*, we run our eyes up and down the hedges and ditches of unbroken highway, much as we do before a Turner or a Corot, though what we are observing is the ultimate disintegration of a mind. The land scene, as visually powerful as that in which Rastignac gazes out on (and symbolically seizes hold of) "tout Paris" at the end of *Le Père Goriot,* precipitates an equally arresting still life: In Mr. Nolan's looking at Mr. Case looking at Mr. Nolan, and so on, a final narrative moment is held in check—it, too, to be made "pretty as a picture."[24]

In so many of the texts written prior to the last twenty or so years of Beckett's life, painterly genres are juxtaposed in chaotic imitation, rather than figuration, of the inescapable existential "mess." Landscape (forest and plain) and seascape (the most striking of which contains the celebrated sucking of stones) are everywhere to be found in *Molloy.* The dimly perceived muddy substratum of *Comment C'est* is no less a scape for its demi-obscurity and lack of sky than the "ruinstrewn land" of "Afar a bird." And much could be said, space permitting, of the verdurous "beyond the hills" suggested, if not fully articulated by Hamm. Even the works for radio, and *Embers* is a case in point, prompt visual images of land and sea through the "soundscape" that combines silence with simulated and nonsimulated variants of noise.[25]

Krapp's nocturnal "vision" at the end of the jetty—with its stormy high drama of "howling wind," "great granite rocks," "foam flying up in the light of the lighthouse," and "wind-gauge spinning like a propeller" preceding the "light of the understanding and the fire"—is as visually memorable as a tormented Géricault or Delacroix, its Romantic turbulence made all the more visible against the fading of memory in which the night scene is enframed. The blustery nocturne also stands out against the bleak half-portraits of women. The end of the French story "La Fin" (written in 1945) also bears mention, if only in passing, for the nocturnes within a nocturne meticulously inscribed.

Parody of figuration—in the description of sites, objects, and charac-

ters that deflect our visual grasp by continually changing form or even disappearing entirely from view—constitutes yet another problematization of art. Examples abound. And not only from the narrative and theatrical works: As Marjorie Perloff has eloquently shown, sound combines with the indeterminacy or absence of the disembodied voice, in Beckett's radio dramas after *All That Fall,* to effect a "dialectic of disclosure and obstacle"[26] that pays ample testimony to figurative failure. In pointing to the insufficiency of the figural to preserve its figurality,[27] the parody in *Embers,* for example, achieves greater authenticity than realist illusion insofar as the admission of mimetic failure carries its own verisimilar success.

As Perloff indicates, the reality (or verifiability) of the story is, from the start, thrown into question with Henry's admonition that the sound of the sea we hear is "strange." "If *Embers* were staged or televised," she argues, "the seashore setting would be so designated, whether more or less abstractly. But when sound is our only guide and the narrator tells us that the sound we hear is 'unlike the sound of the sea,' we cannot be sure where we are."[28] Respecting the radio play as a play uniquely for radio, then, allows for the ambiguity necessary to depict what cannot be depicted figuratively: the psychic drama inside Henry's head. As in the trilogy, in which instability—of the transmigratory characters and of the transformational or vanishing objects—gives rise to a similar "realism," the figurative is parodied precisely to the extent that it refuses to indulge the reader in his or her cravings for the sustained objectified image.

Images are made to rapidly come and go on the intricate surface design of these texts. Brief and abundant, they achieve an elusive quality that says much about the alterability of appearance. Those relevant to the identity theme alone continually undermine the possibility of figurative coherence: Recognition of self and others, and all the object paraphernalia that Beckett brings into play in this regard (most notably, the bowler hats), place significant stress on figuration as the giving of determinate form. Albright observes: "The Unnamable describes himself with such a ceaseless abundance of images—a talking bull, a hairless wedgehead, a skull made of solid bone, a tympanum, a red-mouthed half-wit—that no single image is held longer than an instant; each image drives out the image before it, as if the imagination's perfection consisted not in creating images but in extinguishing them."[29] All the spatial and temporal inconsistencies, like other semiotic and semantic contradictions with which any reader of Beckett is familiar, further stress the visual cohesion that figuration is meant, quite literally, to represent.

Additional means of debunking the figurative ideal are in evidence

throughout the early and mid-career work. Often, figuration bre;
on the level of reader participation in the text, as in *Watt,* where t
is made to experience directly the character's metaphorical myopi

> [Watt] realized that he could not be content with the figure's draw-
> ing near, no, but that the figure must draw very near, very near indeed.
> For if the figure drew merely near, and not very near indeed, how
> should he know, if it was a man, that it was not a woman, or a priest,
> or a nun, dressed up as a man? Or, if it was a woman, that it was not
> a man, or a priest, or a nun, dressed up as a woman? Or, if it was a
> priest, that it was not a man, or a woman, or a nun, dressed up as a
> priest? Or, if it was a nun, that it was not a man, or a woman, or a
> priest, dressed up as a nun? So Watt waited, with impatience, for the
> figure to draw very near indeed.

As we wait with Watt to "see" what "knowledge" the representation will
yield, we learn that close viewing is not necessary at all, that "a moderate
proximation would be more than sufficient": "For Watt's concern, deep as
it appeared, was not after all with what the figure was, in reality, but with
what the figure appeared to be, in reality."[30] Ultimately, however, the figura-
tion will be revealed, to Watt and reader alike, as a completely empty
vision, a hallucinatory game of the mind. Beckett clearly seems to be saying,
in confirmation of his writing on van Velde, that, despite the impossibility
of the reproductive task, in art as in life, one simply goes on: "The problem
with vision, as far as Watt was concerned, admitted of only one solution:
the eye open in the dark."[31]

Beckett's verse, from the start, was exceedingly imagistic. It was fol-
lowing the trilogy (written between 1947 and 1950) and *Texts for Nothing*
(published in 1955) that the progression from a sequential pictorialism
toward a stabilized or single image projection in the fiction began. Beckett's
post-*Godot* drama of the 1950s followed a similar course to result in the
immobility or stasis prioritizing the scenographic would suggest. We will
return shortly to the implications of Beckett's fundamentally ekphrastic
writing for his "dialogue with art." For the moment, however, I wish to
look at what this evolved pictorialism reveals of plasticity itself.

The whole of Beckett's writing—critical and creative—may be said to
prove what historians of art have long been theorizing, E. H. Gombrich not
least among them: On the one hand, "Representation really does seem to
advance through the suppression of conceptual knowledge. On the other,
no such suppression appears to be possible."[32] In the late work, when the

static impulse comes to the fore, the deflation of representation by "the prejudices of the intelligence," as Beckett calls conceptualist conditioning in *Proust,* is more sharply focused than ever before. The penultimate *Stirrings Still* (1988)—in which the lone image is of one who sees himself seeing his previous comings and goings—is a case in point. In focusing the character's (mental) eyes on himself and, specifically, on a self whose only real activity is (mentally) visual, the narrative, which ends in figural failure, sets the impasse in high relief.

We know from the literature on reading and writing of the last four decades the epistemological constraints that limit art's representational status. Conceptual knowledge (what knowledge of the world we bring to a work of art) is, of course, but one. Others include: (1) intersubjectivity (painter/viewer or author/character/reader); (2) the imaginative ability of both artist and viewer or reader; (3) sociocultural expectations of viewer or reader; (4) habit (individual ways of looking or reading); and (5) optical forces or the physiology of viewing or reading.

The interplay of author, character, and reader is made, in *Stirrings Still,* to reflect that of painter and viewer in the doubling that is the sine qua non of the text: "One night as he sat at his table head on hands he saw himself rise and go."[33] Beckett was continually plagued by a feeling of doubling, and we know how persistent a leitmotif the self's watching of self is in the Beckett canon. Here, however, the objectification is akin to that of visual art insofar as the text is so reduced as to exist only in function of the character's seeing that comprises it. *Stirrings Still,* in other words, recounts the animation of all art by reader or viewer and *is,* in fact, the visual act displayed "within" it. To the extent, therefore, that the formal structure identifying art as art embraces both artistic intention and its interpretation by a reader or spectator (as well as narrative point of view when there is one), this text may be said to project the intersubjective activity that allows the work to exist.

Stirrings Still illustrates the forming of images that engage us, artists all, on a daily basis. "We live in the midst of a whirlwind of light qualities," writes Gyorgy Kepes in *Language of Vision.* "From this whirling confusion we build unified entities, those forms of experience called visual images."[34] Beckett says as much with the "outer light" that, for whatever duration, survives the character's own (inner) illumination. Specifically, however, he renders the dynamic experience that is the plastic image, an experience initiated by the flow of light through the beholder's eye. In the "faint unchanging light" of the sky, a light "unlike any light he could remember," he depicts the very visibility, the coming into view, of "what lay beneath."

But clarity of vision is obscured by the clouded pane of the "one high window" that *could not* or *would not* be opened—by the physiological and psychological limitations to the ideal of adequation in art. The window/eye is found elsewhere in Beckett (*Endgame* being the most obvious example). Here, however, it looks out on the world in the service of visual image formation, the character's psychic imaging that makes up the textual work of art. Yet the vision is eclipsed. Previously, Beckett's motif was, as Cohn maintains, that "words are thoughts are emotions, that fiction is our only knowledge, and all knowledge a fiction written in a foreign tongue."[35] In the late texts, and specifically this one, it is that *images* "are thoughts are emotions," *vision* "our only knowledge," and "all knowledge" a *vision* clouded by impediments to seeing.

All seeing is creative: As a formative process, it consists in organizing or integrating within a visual field the location of things in relation to one's own spatial positioning. In painting, however, the visual field is reduced to two dimensions and if a work like *Stirrings Still* may be said to approximate the very plasticity of that art, it is that it is structured according to the opposition that exists between them and the optical unit projected beyond the picture-plane surface. The image in this text is of a man seated, head on hands, at his table. Against that two-dimensional image, the rising from the table and the journey through the back roads and field of grass become perceptible. "A two-dimensional surface without any articulation," writes Kepes, "is a dead experience."[36] The subordinate images in this text, those secondary to and dependent upon that of the seated figure, emulate the spatial tension that gives painting its organic quality. The seated figure, in other words, is to the perception of virtual movement (the visualized narrative journeys) as the background, or picture surface, of a painting is to the optical forces that play against it.

Kepes explains that "proximity is the simplest condition of organization. [. . .] We articulate a painting, a typographical design, first of all by the law of proximity. Optical units close to each other on a picture-plane tend to be seen together and, consequently, one can stabilize them in coherent figures."[37] Spatial equilibrium, to put it somewhat differently, is the life-giving quality of the plastic image. And it is precisely this that is realized but then defeated in Beckett's final narrative: "So all eyes from bad to worse till in the end he ceased if not to see to look." Undone by the constraints, conceptual and other, endemic to the representational model, proximity, indeed all spatial organization, is ultimately lost: "he moved on through the long hoary grass resigned to not knowing where he was or how he got there or where he was going or how to get back to whence he knew not how he came."

I return to Gombrich's impasse, the certain advance of representation through the suppression of conceptual knowledge and the impossibility of such suppression. This is precisely the stalemate that brings Beckett's narrativity, in the white on white of *Imagination Dead Imagination* and *Ping*, for example, to a stunning visual halt. It is, in the end, what makes it all *almost* the same—being and not being, knowing and not knowing, creating and "decreating" art. The disappearing, in *Stirrings Still*, only to reappear, again and again, at another identical place is not quite the same as *Worstward Ho*'s "Each time unchanged. Somehow unchanged." Yet it is one of innumerable variations on a theme. Late Beckett, like the earlier Beckett, is intent upon showing the making of art. But in *Stirrings Still* we have gone from the Unnamable's not knowing what he wants to say and not being able to say what he thinks he wants to say to not knowing what or how to see or make seen.

II

Beckett's passion for painting is apparent in the sheer number of references, implicit and explicit, to art and artists traceable, mostly, throughout the early fictive and dramatic writings. Although my interest is in a kind of thinking more profoundly visual than that suggested by the mere inventory of such allusions, they do attest to the impact on Beckett of individual works of art. They also afford greater appreciation of the phenomenology of vision that in some sense defines his artistic purpose and subverts the "end" to which his increasingly self-reflexive minimalist style gives rise. In brief, they constitute a unique verbalization of a reality apprehended through the eye.

As we have seen, Beckett, curiously enough, never discusses in any of his critical writings a particular painting, preferring instead to consider the impression left by the artist's work as a whole. Similarly, in the early prose works references to art or artists may remain generalized, serving to reenforce by unadorned analogy what the verbal image allows us mentally to see. In *Dream of Fair to Middling Women*, for example, such references to art visually support our grasp of the narrative line: "At the end of the street they parted. The Alba boarded a tram and like a Cézanne monster it carried her off."[38] The result is comparable when, somewhat later, Beckett enhances by means of a generalized reference an atmosphere or mood, as in the celebrated line from *Malone Dies:* "It is such a night as Kaspar David Friedrich loved, tempestuous and bright."[39] But if a reference as nonspecific as "Botticelli thighs"[40] succeeds in driving home the description of the

Smeraldina-Rima in *More Pricks than Kicks*, it is the more precise mentions of art that achieve greater authority in their illustrative purpose. To these I will return shortly.

Often, the generalized references to art or artists provide ironic commentary on the struggle of the artistic effort itself: "Our excuse must be that we were once upon a time inclined to fancy ourself as the Cézanne, shall we say, of the printed page, very strong on architectonics."[41] Such is the function of the first picture hanging in Erskine's room in *Watt*, an imaginary picture of a broken circle that inscribes, at the center-most point of the novel, a reflection of the text's decenteredness. This *mise en abyme* elicits a flow of tears from Watt's eyes that pays sad testimony to the failure of art to coincide with any reality save that of its own expression.

More typically, of course, Beckett's narrative references to the visual arts—painting, sculpture or architecture—have a real work as the referent. Consider, for instance, "The body was between them on the bed like the keys between nations in Velasquez's *Lances*."[42] This reference not only sums up Belacqua's ultimate victimization, as Dougald McMillan has suggested[43] but, more important, definitively substitutes for a verbal spectacle a distinctly visual one. The simile, in other words, admits to the insufficiency of language in deferring to the pictorial achievement.

Explicit allusions effecting a substitution of visible for verbal verisimilitude engage the reader in a hermeneutical dialogue (in Gadamer's intersubjective sense of the term). Writer and reader look *together* at the visual replacement that, frequently, concretizes, semiotically if not semantically, perception of the character as a living body. Here is an example from "Love and Lethe":

> Those who are in the least curious to know what [Ruby] looked like at the time in which we have chosen to cull her we venture to refer to the Magdalene in the Perugino Pietà in the National Gallery of Dublin, always bearing in mind that the hair of our heroine is black and not ginger.[44]

and another, from *Dream of Fair to Middling Women*, in which Lucien is described as

> a crucible of volatilisation (bravo!), an efflorescence at every moment, his contours in perpetual erosion. Formidable. Looking at his face you saw the features in bloom, as in Rembrandt's portrait of his brother.[45]

But references to precise works of art may also serve a more transcendental purpose, as in *Murphy,* when the character of the same name "recruit[s] himself in the Archaic Room [of the British Museum] before the Happy Tomb."⁴⁶ And again, when, as the end nears, he sees "the clenched fists and rigid upturned face of the Child in a Giovanni Bellini Circumcision, waiting to feel the knife."⁴⁷ It is important to note, however, that these allusions typically assume a familiarity on the part of the reader with the work of art in question. The decrease in the number of specific references to art in the later works was no doubt due, at least in part, to Beckett's awareness that such intimations were wasted on the not so erudite reader.⁴⁸

Critics have documented both the direct and indirect allusions to art and artists that appear, principally, in Beckett's early and middle work. Vivian Mercier, for one, records references in *More Pricks than Kicks* to the twentieth-century Irish academician Paul Henry, to the Musée Rodin (if not the sculptor himself), and to Leonardo, Botticelli, Perugino, Pisanello, Uccello, Benozzo, Velazquez, and Dürer. He cites references in *Murphy* that extend from Periclean Athens to our own time: Parmigianino, Tintoretto, Vermeer, Braque, and the German sculptor Ernst Barlach. And he notes, among others, allusions to Bosch in *Watt* and to Friedrich, Tiepolo, and Watteau in *Malone Dies.*⁴⁹

More recently, James Knowlson has accounted for innumerable sources of inspiration for Beckett's early and late images and, indeed, entire texts. He links, as did Beckett himself, the visual conception of *Waiting for Godot,* for example, to a painting by Caspar David Friedrich; that of the pacing figure in *Footfalls* to Antonello da Messina's *Virgin of the Annunciation;* the central image of *Not I* to Caravaggio's *Beheading of St. John the Baptist;* and *Nacht und Träume* and *Ohio Impromptu* to the schemata of the seventeenth-century Dutch Masters.⁵⁰ He finds in *Rockaby* evidence of paintings that Beckett knew—*Whistler's Mother;* van Gogh's *La Berceuse;* Rembrandt's *Margaretha Trip (de Geer)*—and speculates that "the flashes of light and color from the jet sequins sewn onto the rocking woman's dress may echo the magnificent Giorgione self-portrait that had so captivated [Beckett] in Brunswick in 1936." He also observes that "Jack Yeats's painting of an old woman sitting by the window with her head drooping low onto her chest has something of the ambiguity of *Rockaby*'s closing moments."⁵¹ His sensitive renderings of the visual associations offer tremendous insight not only into Beckett's literary imagination and his deep love of painting but its often startling influence on his writing.

Indeed, several other painters could be cited in this regard. The resem-

blance of certain of William Blake's pictorial images, to name but one—those of heads so deeply bowed that circular bodies become a means of entry within themselves; those of hidden faces (of despair? of fear?) wrestling with the dichotomy of presence and absence—to Beckett's own are exemplary of the most profound sort of inter-art appropriation. *L'Humanité endormie, La Pensée de la mort que seule arrête la peur,* and "Hyle" come first to mind, though other of his more ghostly renderings (such as "The Book of Los") may be said to bear an uncanny likeness (in the vacant eyes and mouth, the vapid expression) to the phantomlike characters of Beckett's late works for the theater.

But my interest in Beckett's expression of the visual lies beyond the question of influence, beyond the references and sources, however invaluable their naming may be. Most intriguing about them are their relation to the problematization of art into which I have, however briefly, inquired above and the connections they harbor to the dialectic of the visible and invisible that constitutes the driving force of Beckett's creative work. What, if anything, do Beckett's references to art reveal of his thinking on art and representation? Is there any consistent treatment of visual representation in his work? Do the allusions embody the stillness of painting or narrativize it in action? And is allegory to be in any way understood as their intention?

What I am getting at, in part, is whether the many references to the visual arts, and painting in particular, have an ekphrastic function or are merely comparative like more ordinary figures of speech. Ekphrasis (whose etymology is Greek for "description") is generally understood in the literary context to mean the verbal representation of a visual work of art. More readily associated with poetry (Homer's shield in the *Iliad* and Keats's Grecian urn are the most commonly cited examples), it is a device that inscribes in the poetic or other discourse a visual moment stopped in time. Wendy Steiner sees it as "the concentration of action in a single moment of energy," a process of signifying "motion through a static moment."[52] Mary Ann Caws concurs:

> The ekphrastic moment, in which visual art is inserted into the art of words, is supposed to stand still and to stand out, to present an especial *stress,* be couched in an especially vigorous style, and to bear witness to both past and future action held in a quintessentially vivid clasp. Such a moment, mimetic in origin, catches action at its crest, preserved in always incipient vigor, as it transports the visual into the verbal.[53]

How applicable is the notion to the kind of references to painting most often found in Beckett's texts? And, if it is, why does it matter? What, in other words, might be the interpretive consequences of the allusions' ekphrastic status? First, it is evident that Beckett valorizes art by his many references to it. Ekphrastic, the reference would particularize the valorization: On the one hand, ekphrasis minimalizes concept (like the Grecian urn that "doth tease us out of thought") and limits meaning to what is visibly present. On the other, it defies temporality and, by extension, closure.

Second, it seems to me that there is a connection to be made between the varied allusions to art in the early work and the animation of the single image that becomes increasingly characteristic later on. As instances of ekphrasis, the initial references might be said to foreshow a narrative enactment, both in the late prose and the late work for the theater, of this rhetorical mode. We associate stasis with Beckett's work from the start: "It was morning and Belacqua was stuck in the first of the canti in the moon. He was so bogged that he could move neither backward nor forward."[54] Later, however, with, say, "L'Image" and "Still," entire texts become illustrative of the ekphrastic stopped moment to result in narrative that draws less on painterly genres having become more painterly itself. Subsequent examples, as cited by Porter Abbott, are even more to the point: "By the sixties, in prose works like 'Imagination Dead Imagine,' 'All Strange Away,' 'Ping,' and 'Lessness,' Beckett had come very close to the stasis of visual art."[55]

Conceptions of ekphrasis have traditionally been severely limited: first, to the genre of lyric poetry; second, to the art object as unique source of the verbal instance; and, third, to the inset, the lines of reference within the text they inhabit. But ekphrasis need not be an "*anti*narrative" figure; on the contrary, it can be used to a distinctly narrative effect. It need not refer to a single object-source, but many, or even the sum of works by an artist, and more: It may even take art, as opposed to a work or works of art, as its model. And it may involve the entire length of the text, not just the segment in which the visual art is cited.[56]

In what I would argue is a fundamentally ekphrastic literature, all this can be shown: Visual allusions in Beckett are most often invested with an indisputably narrative force far more transformative than comparative or descriptive. Single artists are frequently summoned in generalized ekphrases valorizing a totality of pictorial models. (I offer but one example among many: "The vast floor area was covered all over by a linoleum of exquisite design, a dim geometry of blue, grey and brown that delighted Murphy because it called Braque to his mind.")[57] And the whole of art, its visibility

and limited communicability, is repeatedly the model for an entirely ekphrastic work such as we have in *Stirrings Still.*

Let's return to two of the earlier references: "The body was between them on the bed like the keys between nations in Velasquez's *Lances*" and "He saw the clenched fists and rigid upturned face of the Child in a Giovanni Bellini Circumcision, waiting to feel the knife." No real details of the paintings are given and the visual references appear to intrude on the narrative space to effect a simple analogy. Reinserted within the fuller picture, however, the congruence of the object-sources (the keys in Velasquez's and the fists and face in Bellini's paintings) with the dead body of Belacqua and the soon to be deceased Murphy are of another nature entirely. They become magical, almost fetishistic even, in a way consistent with ekphrastic tradition:[58]

> The body was between them on the bed like the keys between nations in Velasquez's *Lances,* like the water between Buda and Pest, and so on, hyphen of reality. "Very beautiful" said Hairy. "I think very" said the Smeraldina.

> He saw the clenched fists and rigid upturned face of the Child in a Giovanni Bellini Circumcision, waiting to feel the knife. [. . .] Soon his body would be quiet, soon he would be free. The gas went on in the w.c., excellent gas, superfine chaos. Soon his body was quiet.

In each of these two instances, moreover, the very act of enframing the art within the mind's eye and within the textual matter is vitalizing. This is to say that the visual object-source is enlivened by its correlation to the narrative action, its embedding within a discursive surround. Above all else, this energizing is what defines the verbal device and what allows the object-source to operate, at once, as vehicle of a more ordinary figure of speech (such as the simile in the first reference above) and of ekphrastic representation as well.[59]

As I have said, there is an important parallel to be drawn between Beckett's imagistic stagings for theater and television and the invigoration of the frozen moment ekphrasis suggests. For, like paintings that come alive on the stage, Beckett's theatrical tableaux are certainly ekphrasis-like. But a brief look at the fictive paintings in Beckett's prose will reveal a more legitimate, if ironic, application of the term. In the two imaginary paintings of *Watt,* for example, the mimetic origin yields to a meta-mimetic imaging illustrative of the very process of making visible itself. I have claimed a sim-

ilarity between Beckett's thinking on art and that of Merleau-Ponty to reside in the notion that art does not reproduce the visible, but makes visibility be. *Watt*'s imaginary paintings ingeniously make the point.

The second picture in Erskine's room that appears in the Addenda to the novel is, in fact, not only an instance of ekphrasis, but a superb mockery of the notion of representation, a mimicry of ekphrastic description even, and thus its own mimetic function too. With its "faint cacophony of remote harmonics" (its "acoustic context,"[60] as Heath Lees describes it), the portrait, by one Art Conn O'Connery of Mr. Alexander Quinn, becomes not only vitalized but, specifically, an absurd play of illusion on the real: Seated at the piano, "With his right hand he sustains a chord which Watt has no difficulty in identifying as that of C major in its second inversion, while with other he prolongs pavilion of left ear."[61] In depicting its subject "naked save for stave-paper resting on [his] lap" the picture plays on the hidden and revealed and, one might argue, pokes fun at the erotics of art the dialectic necessarily implies.

W. J. T. Mitchell has genderized the practice of ekphrasis in poetry: "Female otherness is an overdetermined feature in a genre that tends to describe an object of visual pleasure and fascination from a masculine perspective. Since visual representations are generally marked as feminine (passive, silent, beautiful) in contrast to the masculine poetic voice, the metaphor goes both ways: the woman is 'pretty as a picture,' but the picture is also pretty as a woman."[62] With "Mr. O'Connery's love of significant detail"—which appeared in "beads of sweat, realized with a finish that would have done credit to Heem" and, again, "in treatment of toenails, of remarkable luxuriance and caked with what seemed to be dirt"—Beckett throws both the conventions of (female) Beauty in Art and (masculine) power in ekphrastic description to the wind.

But it is the receding circle, with its "illusion of movement in space, and it almost seemed in time,"[63] in the painting of the circle and the dot, that more obviously decenters aesthetic coherence in evoking the very nature of the visible/invisible rapport. Galen Johnson explains Merleau-Ponty's stress on the inseparability of the visible and the invisible as follows: "The lines of visible things are doubled by a lining of invisibility that is *in* the visible."[64] The imaginary art of *Watt* illustrates the philosopher's thought and, in so doing, Beckett's clever depiction—"Watt wondered if [the point and circle] had sighted each other, or were blindly flying thus"[65]—defies allegorical interpretation in much the same way as another imaginary painting that intrigues us in a play of a slightly later date.

Unlike the imaginary pictures of *Watt* that are not only mimetic in ori-

gin but meta-mimetic in their auto-reflexive gibes at Art as representation, the picture in *Endgame* has no object-source. Facing the wall, this imaginary picture is anything but ekphrastic for, as an aesthetic encounter, it remains not only undescribed, but unseen. It bears mention here, however, insofar as it serves the same non-allegorical and ironic function as the ekphrastic descriptions in *Watt* to support the phenomenology of in-visibility to which, I maintain, Beckett continually subscribes.

Endgame's picture has been interpreted by one critic as a figuration of the visionless world of Hamm[66] and, variously, by another as "an illustration of a biblical scene (perhaps of the creation); as an icon portrait of Christ; as a family portrait of the four characters," and the disgrace of art itself.[67] A third comes closest to my own understanding of Beckett's purpose when he writes:

> What Beckett has done in this instance is really quite clear. He has communicated concealment. Just as Godot is important not because of who he is but because he is not present, so the picture derives its importance not because of what it represents but because it cannot be seen.[68]

I would go a step further in adding that, while Godot is rendered all the more significant by his imperceptibility, the concealment here is not only "communicated" but, in a very real sense, seen. We do see a picture, though it is turned to the wall, and this is not a negligible fact of the play. It is not that a picture is referred to by the characters, but that a picture is, while it is not, in view. Insofar as it is a picture that is hidden—a thing, in other words, meant to re-present—visibility is again rendered the matter at hand. If the imaginary art of *Watt* and *Endgame*, in sum, is remarkably self-reflective, it is that the only real allegory is that of seeing itself.

The consequences of Beckett's ekphrastic writing are many. To the two cited earlier I would now add the following: The narrative thrust of Beckett's allusions to art supports the differences he values between its various forms. The visual work of art is no more reproducible in literature than is any other more worldly domain and what is projected in the interart relation is the animacy of the painting re-viewed. Ekphrasis in Beckett takes a distinctly nonmimetic turn; it dramatizes perception as it points to the unreliability of representation of the (already unreliable) real.

Epistemological weakness, then, is underscored in both Beckett's play on aesthetic problems and in his ekphrastic allusions to art. But another visualizing process continually posited by him underscores it as well: I refer

here to the evocative power of memory, sole contender of seeing for preeminence in Beckett's highly visual world. What I have now to say concerns the relation between Beckett's numerous references to art, more specifically, the extraordinary visual memory from which they derive, and the thematic and methodological focus on remembering that extends throughout his work. In the pages that follow I want to look at this relation as a disparity unmistakable in the interart dialogue that the direct and indirect references imply.

III

The thesis underlying this book is that the unifying force of Beckett's work is a preoccupation with the visual as paradigm. My argument thus far has centered on Beckett's study of vision as the predominant perceptual mode and on its realization in a writing so visual that Billie Whitelaw could observe that "he writes paintings."[69] In linking his critical focus with Merleau-Ponty's idea of art as the overlapping of vision and bodily movement (for the body is both seer and seen), I have aimed to show a complementarity that resides in ontological immanence: inquiry into the creative process as a concretization of the universality of Being.

My attempt to demonstrate the congruence between Beckett's and Merleau-Ponty's efforts to resolve the Cartesian schism derived from the substitution of the model of ambiguity for objectivism in the work of both men. The intertwining, or "chiasmic," relation maintained by the perceiving subject with its environs, a relation wholly dependent upon the ambiguous boundaries erected by the corporalized or incarnated mind, and the consequent emphasis on visibility (the interplay between the visible and invisible) in their writings reveal a deep dissatisfaction with (1) the presupposition of art as aesthetic object and (2) illusory thinking on art as adequation. I would now raise the question, however, whether what amounts, in Beckett's case, not to a philosophy of art but an expression of ontological malaise also betrays a "working through," in the extraordinary creative achievements that were his, of an interference in object representation of an order radically different from the positivism previously called into question.

The peculiarities of Beckett's characters have elicited a number of psychologically informed interpretations since the explosion of Beckett studies in the early 1960s. Before it became quite so fashionable to relegate the alienation, ego fragmentation, and blocked affect associated with the Beckettian character to the deconstructive zone, psychological oddities were the basis for what Bennett Simon, for one, considered the writer's exemplifi-

cation of a thoroughly schizoid age.[70] I do not aim here, however, at a psychohistorical analysis of any sort. It is all too facile to reduce art to biography and I have no intention of minimizing the complexities of the person or the profundity of his creative output by belaboring the possibility of establishing any such congruency. Rather, I wish merely to describe what may further account for Beckett's phenomenology of vision and the obsessive focus on remembrance it entails. For recollection, as theme or creative process, is clearly a preoccupation to which something other than his own highly functional visual memory must have given rise.

If Beckett could draw easily, either consciously or unconsciously, on images that had struck him, no matter how long before, in any number of paintings, it was that he often remained before a painting for an extended period of time to allow its imagery to be securely etched in his mind. But it is also true that his memory was exceedingly sharp. Knowlson goes so far as to suggest that he "almost certainly possessed a photographic memory,"[71] a notion with which a compelling description by Dougald McMillan concurs:

> If he reads about Descartes, he retains an awareness of the Hals portrait, which appears in *Whoroscope*. He reads of the sigmoid "line of beauty" in Hogarth's *The Analysis of Beauty* and assimilates it to the curving line of the Dublin shoreline in "Serena III." He frequents Mt. Geneviève in Paris, and details of the church St. Etienne du Mont appear in "The Calmative." From the Sorbonne he retains the impression not of scholars but of the frescoes of Puvis de Chevannes, to which he alludes in "Sanies II." He lived in the 15th arrondissement, and the undistinguished municipal bust of M. Ducroix from the rue Brancion appears in *The Unnamable*. He walks in Hyde Park, and *Murphy* is filled with accounts of not only Jacob Epstein's controversial sculpture from *Rima* but also George Watt's *Physical Energy* and the statue of Queen Victoria. Murphy looks at the floor and sees in the linoleum pattern a resemblance to a Braque painting. Beckett discusses the problems of the modern writer with Tom Driver and makes his point by contrasting the Madeleine and Chartres cathedrals. Where art is a part of his environment, Beckett perceives it consciously; where the environment suggests art, Beckett is aware of the connection.[72]

Any reader of Beckett is well aware, however, of the roles played by both repetition throughout the novels and plays and the angst continuously associated with almost any given character and memory. Remembrance

and forgetting, in a sense, structure Beckett's texts whose repetitive, lacunary, and contradictory composition matches the ontological plight of many of their narrators: Molloy, who cannot remember how to spell and half the words he once knew and, more important, if ever he had a son, also forgets not only who he is, but that he is; he forgets to be. The narrator of *First Love* takes pride in his ability to remember the date of his birth; with a bit of effort, he can conjure up this proof of a life that living only barely confirms. With "Thought of everything? . . . Forgotten nothing? . . ."—the opening lines of the epic *Eh Joe*—Beckett's tongue is only slightly more firmly in his cheek. Accordingly, the narrative voices evolve.

For the Unnamable, Winnie, Mouth, May, and so many others, "revolving it all" (to cite *Footfalls*) is compensatory; words reverberate from a mind unable to retain of the past much more than a record of its having been, and often not even that. Krapp goes so far as to tape his life for fear that what separates the authentic present from the inauthentic (as inviable) past will prevail as memory fails him: "This I fancy is what I have chiefly to record this evening, against the day when my work will be done and perhaps no place left in my memory, warm or cold, for the miracle that . . . [*hesitates*] . . . for the fire that set it alight."[73]

Ohio Impromptu, perhaps the most Proustian of Beckett's works, again posits discourse, written and read, as access to and means of sanctioning the past. This self-reflexive parody of the Book as vehicle of memory and purveyor of truth, however, is distinctly cathectic, an affective valorization of the word: As an "old terror of night" returns to take hold of Listener who sits "trembling head in hands from head to foot," Reader is sent to comfort him.[74] Making use, once more, of the *mise en abyme*, Beckett relates how, through repeated readings of the tale of a life, Listener's own (Reader's too, for he and Listener grow to be one), the sufferer of "fearful symptoms" is consoled.

The preoccupation with memory (and the many monologues exhibit nothing if not that) in Beckett does not, of course, always take the form of telling or listening to one's own story. Mouth's desperate denial of herself in *Not I*, like O's reckless attempts in *Film* to obliterate his own objectification, is the other side of the same recollective coin. Both the first-person pronounless mouth and the "sundered" perceiving eye (an eye/I severed from its object of perception, a component of the same perceiving self) enact the very struggle of object representation that is the exclusive task of memory. The agony of perceivedness that characterizes these as other of Beckett's works, in fact, would appear to signal a curiously sublimated interference in aspects of memory function.

Let me put it differently. It is true that *Film* and *Not I* depict a Cartesian reality that Beckett continuously lamented. Disembodiment (Mouth) and the highlighting of individual body parts (E or eye) attest everywhere in Beckett to the impossible unification of subject and object that he strove, in his insistence on indeterminacy, the existential "mess," and the Merleau-Pontyian incarnation of consciousness, to overcome. But it is also true that the focus on what is fundamentally a question of self-possession is played out at least as substantively on the recollective front.

In *Krapp's Last Tape* objectification of self is more obviously staged as a specifically evocative effort: Although Krapp seeks not to obliterate but, rather, to reify the perception of self, what Proust immortalized as "voluntary" and "involuntary" memory are the dramatized operative modes. As Jon Erickson puts it, "The content of the tapes, which although created by the will of voluntary memory, drifts into the ramblings of involuntary memory, punctuated by such Proustian tactilities as the feel of the hard rubber ball in his hand."[75] But everywhere in Beckett the nefarious mind-body/subject-object schism is problematized as the struggle to reconnect, which is clearly to say the struggle to re-collect.

The question thus arises as to why, if Beckett's own memory was so outstanding, those who populate his texts demonstrate such apprehension and debility in this regard. It is worth considering, in other words, why a writer endowed with so rich a memory, and so visual a memory at that, would put the anxiety of remembering—whether it be a question of literal or metaphorical recall—and, indeed, the entire question of vision (of the mind or of the eye) at the very forefront of his art.

All too familiar with the horror of deteriorating eyesight from his days, in the late 1930s, of reading to and performing various tasks for James Joyce, Beckett had sufficient reason to become increasingly obsessed with visual perception and visual memory as his own eyes began to fail him. In his sixtieth year a cataract in each eye was detected, a diagnosis somewhat more worrisome in 1966 than today. Certain of his works will, in fact, echo accommodations to his visual loss: In the 1974 short text "Still," for example, the anonymous figure will turn his head ninety degrees in order to watch the sun. Having no lateral vision, Beckett would also have to turn his head ninety degrees before passing through an intersection.[76] But the preoccupation with seeing and its relation to the mind's own recollective eye of course predated by many years both Joyce's and his own ophthalmological difficulties.

I believe we have to look once more to the writer's struggle with aesthetic experience as it relates specifically to his preoccupation with the sub-

ject-object dichotomy for some semblance of an answer. Indeed, the turmoil of Beckett's engagement with art that stemmed precisely from its failure to represent, the fixation on the subject-object dualism that sought resolution in indeterminacy and the "decreative" project, *invites* speculation as to the reason for the anxiety of remembrance as a visualizing process that runs throughout his work.

Thus, I would question whether it is in a disturbance in object representation of the kind some schools of psychoanalysis relate to the internalization of early parenting and primary (human) love objects that an explanation is to be found. Hints of it are everywhere in Beckett's texts. Consider, for instance, this passage from *Murphy*, Beckett's first published novel:

> When he was naked he lay down in a tuft of soaking tuffets and tried to get a picture of Celia. In vain. Of his mother. In vain. Of his father (for he was not illegitimate). In vain. [. . .] He tried again with his father, his mother, Celia, Wylie, Neary, Cooper, Miss Dew, Miss Carridge, Nelly, the sheep, the chandlers, even Bom and Co., even Bim, even Ticklepenny and Miss Counihan, even Mr. Quigley. He tried with the men, women, children and animals that belong to even worse stories than this. In vain in all cases.[77]

Or this one, a description of fictive photographs, from the much later play *A Piece of Monologue:*

> There was father. That grey void. There mother. That other. There together. Smiling. Wedding day. There all three. That grey blot. There alone. He alone. So on. Not now. Forgotten.[78]

Such vacuousness with regard to object and/or self representation, a variation on the *Film / Not I* objectification theme, may signal a dysfunction of the affective (as opposed to cognitive) evocative faculty. In fact, the cosmic void inhabited by so many of Beckett's narrators might indicate a disturbance not limited to human object evocation, but one that extends to his overall representational world.

Not only might the self-cohesion or integration so lacking in his characters—inherent within the persistent need for or denial of objectification—issue from a fault in object representation, but the absence in Beckett's writings of any affect associated with deprivation of the kind his characters endure might be a consequence of it as well. Perhaps, in other words, resignation, apathy, and ennui so consistently take the place of affective

response precisely because there can be no real sense of object loss where there is little object memory. I would not venture so far as to claim with any degree of certainty that Beckett suffered from the kind of affective visual memory disorder that psychoanalysts deem the result of fantasy and/or conflict invasion in the individual's sense of reality. But I would suggest that there is sufficient similarity between Beckett's texts (both their recollective form and recollective content) and the symptomatology this disturbance presents to pose the question.

Although it is commonly the early loss (through death or emotional neglect) of a parent as primary object that leads to this pathology, interference in the ability to evoke important human objects and, more generally, in the evocation of the inanimate world has been documented in individuals who have not sustained such a loss, but repress visual (evocative or recognition) memory for other, though similar, reasons. We know from his biographers of Beckett's complex and, at times, anguished relationship with his mother. Beckett's creative writings, moreover, are full of references to it. *Footfalls, Rockaby, Company,* and *Ill Seen Ill Said* are all reminiscent of the writer's mother (or, as Lawrence Graver puts it, "of [our] mothers or of some archetypal image of *the* mother").[79]

Separation from his mother did pose some degree of difficulty for Beckett, while closeness was also a threat. It has been suggested that May Beckett was of uncertain temper and that she suffered from powerful changes in mood. The silence of depression is often experienced by the children of those so afflicted as rejection (or a similar expression of hostility) and, coupled with the alternate phases of acceptance and warmth, it poses a distinct and painful dilemma for them.[80] Reared in an atmosphere of emotional uncertainty and unreliability, they can respond with profound ambivalence. Even in the last months of his life Beckett's feelings for his mother were turbulent. Knowlson says they struck him in conversations with Beckett then as "still intense, almost volcanic."[81] But the connection is merely speculative and must not be belabored. Suffice it to say that the fact that the psychoanalyst Wilfred Ruprecht Bion, with whom Beckett was in treatment for nearly two years, was an object-relations theorist and that his work with patients centered not on ego psychology, Freudian drive theory, or other psychoanalytic approaches, but specifically on the impact of early disturbances in object-relations, adds to my suspicion.[82]

In and of itself the disorder holds little interest for the critic beyond the ways in which an artist, visual or literary, sublimates it. Viewed in relation to the self-reflexivity and consequent minimalist "end" of Beckett's work, and to what I call the reaesthetization that defies the threatened defeat, its

potential for insight is particularly alluring: The sublimated fixation on object representation runs the gamut from the agony of perceivedness (even the goldfish is banished in *Film* so strong is the need to avoid being seen!) to the longing for objectification or materialization of the self. But it is also tempting to link to this disturbance Beckett's more general despair before the inexpressivity of art.

What I mean is the following: Porter Abbott has written that "the counter tropes of reduction, negation, cancellation, and despair—always part of the Beckett signature—invariably set off the vigor of [. . .] productivity."[83] Similarly, Shira Wolosky has noted that "gestures toward reduction inevitably give way to reproductive and inventive energy."[84] And Enoch Brater, in *Beyond Minimalism*, studies Beckett's late style in the theater within the precise context of his doing "more and more with less and less."[85] Beckett's reductivist impulse and his reaesthetization of art—his making art not despite but from within "the certitude that expression is an impossible act"[86]—may well compensate, just as the preoccupation with object representation within the text may be said to sublimate, for a deficiency in the evocative object representational world.

How might this be so? To answer, let's consider how a visual artist, and one with whom Beckett is often compared, coped with the same obsession and how it might explain the commonly proclaimed affinity between the two. Over and above the concerns Alberto Giacometti and Beckett shared with other artists of their time, beyond their personal relationship and even their professional collaboration,[87] the bond between them lies in a similarity of creative process. For if creation through re-creation (repeating, remembering, reenacting) was both Beckett's method and his focus, it represented at least as extensive and voracious a need in his artist friend.

From an early age Giacometti was haunted by the impossibility of equivalency in art. The story is told that, while working in the studio of his father, Giacometti attempted one day to draw a still life of pears on a table. It soon became clear, however, that his efforts to replicate the fruit continuously resulted in pears of such small size that they had little to do with their known proportions. Despite his father's admonitions to simply draw the pears as he saw them—advice born of the aesthetic convention of equating known with perceived reality—he continued to produce only the same small pears. As his biographer James Lord tells it, "He was more concerned with representing reality than with representing pears, and therefore he identified the edges of his sheet of paper with the boundaries of his field of vision, in which the pears were naturally tiny."[88]

The anxiety provoked by this clash between reality and his art would

become emblematic of almost every attempt to duplicate a visual experience, whether he was working from life or from memory. Lord recounts his own observation of it when he was posing for Giacometti:

> He (Giacometti) reveals first a great deal of anxiety, agony that the encounter generated in him (Giacometti). When I would arrive at the studio for a sitting, Giacometti would disconsolately occupy himself for a half-hour or more doing odds and ends on his sculpture, literally afraid to start on the painting. When he did bring himself to get into painting, the anxiety became severe. At one point, Giacometti started gasping and stamping his foot, "Your head is going away completely!" "It will come back again," I said. He shook his head, "Not necessarily. Maybe the canvas will be completely empty; then what will become of me? I will die of it!" He reached into his pocket, pulled out a handkerchief, stared at it for a moment as though he didn't know what it was, then with a moan threw it on the floor. Suddenly he shouted loudly, "I shriek, I scream!" To talk to his model while he is working distracts him, I think, from the constant anxiety which is a result of his conviction that he cannot hope to represent on the canvas what he sees before him.[89]

It is often said that many of Giacometti's drawings and sculptures appear illustrative of Beckett's creative writings and that, conversely, segments of Beckett's novels and plays are as verbal transcriptions of Giacometti's plastic art. Similarities of purpose and comparable obsessions (with alienation, mortality, and the failure of art) have been skillfully identified in their work.[90] What has not been acknowledged, however, is a trait they share whose source is precisely this anxiety and despair.

What I refer to is the sense of vanishing, the "quality of disappearance,"[91] as it has been called by psychoanalyst Peter Neubauer with respect to Giacometti's work. While trepidation plagues every artist's attempting to copy what is seen, in both Beckett and Giacometti figural defeat places interrogation of, and the deepest skepticism about, the validity of art in full view. Their art is certainly not unique in its self-regard; what is singular, however, and shared by both is, first, the extent to which the anxiety of remembrance—manifested specifically in the overwhelming need to capture vision and the eye—exerts itself to become a constant force and, second, its effect on creative process.

Giacometti comes closest to Beckett when he concentrates, either in painting or sculpture, on the head. Although his heads on a rod, mouths

agape to emit a moan or a cry, remain in the void while the best-known of Beckett's—Nag and Nell (*Endgame*), Winnie (*Happy Days*), and the three heads of *Play*—are encumbered in bins, earth, or urns (even the Unnamable is relegated, all but his head, to a jar),[92] they reveal the same existential concerns: "The first time I saw the head that I was looking at completely closed in, immobilized within an instant," writes Giacometti, describing when he began seeing heads in the abysses of space, "I trembled with terror as never before in my life."[93]

The fascination with the head as the central life force—wherein reside vision, the voice, and the creative imagination—represented for Giacometti a way of reducing the dissimilarity between art and reality. As though illustrating Merleau-Ponty on the visible/invisible relation, interest in the head was to become even more localized, first in the face and then, like Beckett, specifically in the visual agent: "It should be enough to sculpt the eyes," he claimed. "If I could render a single eye correctly, I would have the head, the figure, the world."[94]

It is remarkable, in fact, how frequently and with what intensity the longing to reproduce the eye manifests itself in the artist's work. Although, to my knowledge, it has escaped all critical commentary, one or both eyes recurrently appears partially covered or surrounded by shadow: A shaded area in a small painted self-portrait of 1921 runs directly through the white of the left eye; a 1923–24 penciled self-portrait has lines drawn through the iris of each eye; and in *The Road Mender* (oil on canvas [1921]) the left eye has shading above and below, to cite but three of the earliest examples.

Later portraits and self-portraits are equally extraordinary in this regard. Vacant, deeply inserted eyes give an impression of blindness in a 1955 drawing of the artist himself; a 1954 drawing of Henri Matisse has a vertical line through the center of one eye dividing it into what appear to be seeing and non-seeing halves; and the depiction of Jean Genet from the same year has a more subtle, but equally distinct division of the left eye. In the 1954 pencil on paper drawing entitled *The Artist's Wife*, one eye contains an iris while the other is curiously unpigmented. *Interior with Standing Man* from 1956 is altogether faceless and the sharply defined features of Giacometti's own face appear in 1960 to include eyes, behind attention-drawing glasses, suggestive of the focus that would be were their centers not whited out. The phenomenon is as conspicuous in the sculptures in which shadows are made to form in the grooves of the sockets and vacuous eyes again fix seeing as the primary question at hand.

The relation of vision to memory (the anxiety of representation and evocation) was as much a part of the appeal of the head and eyes to Gia-

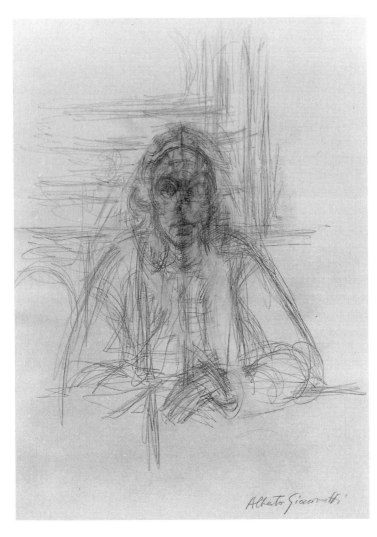

FIG. 3. Alberto Giacometti, *The Artist's Wife* (1954). Pencil on paper,
16⅝ × 11¾″ (42.0 × 29.8 cm) (irreg.). Museum of Modern Art, New
York. Sidney and Harriet Janis Collection (fractional gift). Courtesy
Museum of Modern Art, New York.

cometti as it was to Beckett.[95] Art critic David Sylvester's remarks on the sameness of an artist's working from life and working from memory are apropos:

> The artist can only put down what remains in his head after looking. And the time between the instant when he looks at the model and the instant later when he looks at the paper or canvas or clay to copy what he has just seen might as well be an eternity. [. . .] [A]s soon as we try to copy what is seen, it was seen: it is also because our mind has to get outside the sensation before we can copy it, our very awareness of having a sensation pushes it into the past, for we cannot think about our present thought, it slips away as we try and grasp it, because we try and grasp it.[96]

Clearly, this disappearing reverberates in Giacometti's reductionism: The illusion that he perceived things larger than what he drew eventually gave way to sculptures so minuscule that, for about five years, each of Giacometti's figures, with a single exception, was no greater than an inch in height[97] and he had to fight hard thereafter to keep his figures from growing small. "The more I take away, the bigger it gets," he is often quoted as saying.[98] Similarly, little else remains of the elements of fiction by the end of Beckett's trilogy but a voice. But the dissolution ("Your head is going away completely!") is also something more than what can be accounted for by their minimalist forms of art.

Neubauer attributes the disappearing quality in Giacometti to the inability, such as I have associated with Beckett, to maintain a constant and secure object representation.[99] Giacometti himself attests to the difficulty Neubauer outlines:

> One starts by seeing the person who poses, but little by little all the possible sculptures of him intervene. The more a real vision of him disappears, the stranger his head becomes. One is no longer sure of his appearance, or of his size, or of anything at all. There were too many sculptures between my model and me. And when there were no more sculptures, there was such a complete stranger that I no longer knew whom I saw or what I was looking at.[100]

This perceptual experience of the Other is not unlike that described by Merleau-Ponty for whom "the existence of other people is a difficulty and an

outrage for objective thought."[101] In relating the dimness of the drawings and the elongation and two dimensionality of the sculpture to an insufficient internalization of the world, however, Neubauer outlines a compensatory mechanism that would become the basis of an art. His observation that the uncontrollable shrinking of heads and full-body figures reflects a representational world in endless flux, in other words, reveals a confrontation with reality that had to find expression in sublimated form.

It is true that when Giacometti was most adamant about no longer allowing his sculptures to shrink, they became not only taller, but thinner as well. Indeed, proportion and dimensionality, save the oversized feet that support the sculpted bodies, executed as they were perceived in the fullness of space, were forever in transition. Substituting his fragile sense of reality (both internal and external, that of his own self-representation as well as that of others and the inanimate world) for a more realistic embodiment of the perceived was the primary task the artist set for himself, and it would ultimately be the basis of his ephemeral style.

Interestingly, Jean-Paul Sartre, in an essay on the artist's paintings, provides a comparable link between "the strange paralysis which grips Giacometti at the sight of a fellow creature" and the sense of disappearing characteristic of his work. For Sartre, however, the correlation is best described in terms of the distance issuing, for the artist, from "the innermost nature of the object."[102] A human invention that has "no meaning outside the context of human space," writes Sartre, distance is in itself indicative of a "sense of difficulty," one that he defines as "the product [. . .] of powers of attraction and forces of repulsion."[103] Obsessed by empty space everywhere, Giacometti painted the vacuum that he carried with him and "What he tries to convey are his internal feelings, the boundless void enclosing him, separating him from shelter and abandoning him to the storm."[104]

The psychoanalytic and philosophical perspectives are not so incompatible as might be expected: Where Neubauer depicts a psychic void, Sartre describes a metaphysical one; but, for each, with the paintings of Giacometti, as with the fiction and drama of Beckett, we return to the point of creation ex nihilo. We recall the intention of Mark Rothko to subvert the visuality of his art in the avoidance of subjects that could distract, by their readability, the viewer from seeing. Unlike Rothko, however, who opted for the framing of space in shape and color, Giacometti painted the vacuum itself by ejecting from his canvas the very enclosure along with the material world. The subject, therefore (whether his brother, Diego, who for years sat

regularly for him, a professional model, or any other sitter) is not in relief, but simply there—in all the immensity of Beckett's own terrifying, non-representational void:

ESTRAGON: I tell you we weren't here yesterday. Another of your nightmares.
VLADIMIR: And where were we yesterday evening according to you?
ESTRAGON: How would I know? In another compartment. There's no lack of void.[105]

Neubauer writes of the "derealization" that extends from the artist's external to inner worlds and the elusive boundaries of his figurations that result from the collapsed sense of a cohesive reality. Sartre calls it a "dematerialization," a disintegration that keeps us from knowing where the human body ends and the vacuum begins. The 1946 graphite rendering *Standing Woman*, with its blurred contours and faceless persona, and the 1955 *Standing Female Nude,* for instance, are cases in point. Another is an oil on canvas depiction of Sylvester (1960), in which we are aware of it specifically as a misty intrusion that extends over a part of the right shoulder to a portion of the face. Like a cloud that allows one to see what lies behind it while at the same time obscuring the view, or a floater in the spectator's own eye, a veil of brush strokes hints at a curious dispersal of weight. Here is Sartre on the "game of appearance and disappearance" that characterizes the almost contourless depictions: "These extraordinary figures are so perfectly immaterial that they become transparent, so totally, so fully real that they assert themselves like a physical blow and cannot be forgotten. Are they appearing or disappearing forms? Both."[106]

Whether the obsessive need to capture and recapture the eye verbally or visually is to be explained by a disruption in the psychic organization of the object representational world or by an overwhelming perception of objects (human or inanimate) in the void of their surrounding space, the result was creative processes remarkably alike. Dictated by repetition—continual construction and reconstruction—the persistent metamorphosing of Beckett and Giacometti was an attempt at conciliation in which a primary visual conception was repeatedly lost and found. When, in 1939, Giacometti ceased sculpting heads from life and turned to working from memory, it was "principally so as to see," he wrote Pierre Matisse, "what all this work had left me with." The tiny dimensions to which he continually returned, for only "when small were they like," revolted him and he "kept on beginning again only to end up, a few months later, at the same

point."[107] Like Beckett's reworking of previous texts (as discussed in chap. 1), his method was to start over and over again, for it was never possible to get it just right; as for Beckett, "There was no retouching, changes were made from the inside out, the image had to be indivisible or nothing."[108]

One claim of this book is that art's visualization of itself, extending from Duchamp and Warhol to Beckett, caused it to become post-historical and, in a sense, stop. How far the auto-reflexion and resulting reductionism could advance before a painting or sculpture, a novel or play would no longer be that is of course not possible to determine. This is Giacometti on Duchamp: "Of course a painting exists only in the eye of the beholder; but Duchamp wanted his creations to exist without any help whatsoever; he began by making copies in marble of sugar cubes . . . then it was enough to buy plates and glasses and sign them. Finally he had no other choice but to fold his hands in his lap."[109]

It is clear that in Beckett's case, at least, reaesthetization—in the form of an allegorization of seeing—maintained its hold on the minimalism so that a kind of art, unique in its fulfillment of human need, could ceaselessly emerge. So, too, in Giacometti disappearance and loss resisted defeat to remain a defining "quality" of the work. If paint and clay failed for the one where words failed for the other, the communicative battle was not to be lost for either: The effort was Sisyphean and its very futility affirmed the value of the task. As Lord reminds us, "The bough from which a man can hang himself also bears leaves emblematic of rebirth."[110]

Chapter 6

Worded Image / Imaged Word

In the preceding chapters my effort to resituate Beckett outside the modernist/postmodernist dichotomy derived from the belief that imposing an either/or on that which is not an either/or is fallacious and deceptive. As William Burroughs said, "The data of perception simply cannot be accurately confined in either/or terms,"[1] and, though Beckett shows no interest in some areas of human experience, the primacy of vision is a preoccupation. By aporia Beckett depletes the semiotic of its signifying, if imperialist hold on the literary. In so doing, he rids it of its quality of thingness around which the dichotomy turns. What results is not to be circumscribed schismatically, for it is a continual phenomenological registering of perception as primary creative model, as it has been my purpose to show.

I would add to this that the modernist/postmodernist question is not a useful distinction insofar as we remain historically too close to the Great Divide.[2] Several decades must yet pass before the full impact of modernism and, particularly, that of its aftermath on Beckett's creative output can be, if they can be, assessed. The determination that Beckett was uniformly one or the other, or that he moved from one to the other at some specific moment in time (at the close of the second world war, e.g., or with the writing in 1972 of *Not I*), only returns us to the very impasse Beckett, from the 1930s, sought to resolve. Resituating his art beyond the reductionism the categorical effort implies, beyond the thingness of the work of art as an entity within the world, on the non-objectifying order of the work as world itself, allows it to triumph as a unique visual cognition over the rationalist endgame it abhorred.

The implications of what I call Beckett's visual thinking, his modeling of language on seeing and his distinctly "painterly" use of the word, are several. First, it offers a standard by which other art can be gauged. The narrative pictures (sea, land, and mindscape; portraits; still lifes; and so forth), references to art (real and imaginary), and memories of which his

early and late fiction is composed bear on our modes of perception and make us aware that they continually change. And the imposing theater images, more than those of any other playwright of the twentieth century, continually renew our appreciation for play writing as a far more visual than verbal art.

Second, it allows us to comprehend the quality of sameness that the drama and prose have about them (that quality that led to Alan Schneider's "Every line of Beckett contains the whole of Beckett") much as we "understand," immediately recognize, and esteem the paintings of Mondrian, (late) Rothko, Motherwell and other nonobjectivist painters. For, like theirs, Beckett's art is a visual inquiry into and commentary on the fundamental nature of space: "I wanted to rupture the lines of communication," he once said, "to state the space that intervenes between the artist and the world of objects."[3] Thus, it is not only the nonfigurative but increasingly metaphysical quality of his writing that renders his picture-plane use of space abstract.

Third, the visual thinking implies an experience of space, its inhabitation, that is just as Merleau-Ponty described it:

> Space is no longer what it was in [Descartes's] *Dioptric,* a network of relations between objects such as would be seen by a witness to my vision or by a geometer looking over it and reconstructing it from outside. It is, rather, a space reckoned starting from me as the zero point or degree of spatiality. I do not see it according to its exterior envelope. I live in it from the inside; I am immersed in it. After all, the world is all around me, not in front of me.

Happy Days and *Not I*—in which the body (or a segment of it) and its spatial surroundings are conjoined—are among the most obvious examples. But Merleau-Ponty's conception also appears to be practiced by Beckett in *Breath,* that momentary vision of an opaque realm where inside and outside are but one. And here it is as though the philosopher were writing of *Play:* "No more is it a question of speaking of space and light; the question is to make space and light, which are *there,* speak to us."[4] When he remarks, "We cannot imagine how a *mind* could paint. It is by lending his body to the world that the artist changes the world into paintings," Merleau-Ponty seems to be explicating the singularity of Beckett's creative process in the theater, the very relation of staging and performance to the written text. And when we read, "To understand these transubstantiations we must go back to the working, actual body—not the body as a chunk of space or a bundle of functions but that body which is an intertwining of

vision and movement,"[5] Beckett's narratives as embodied perceptions of the world are also seemingly evoked.

Fourth, the literary achievement of a visual thinking that transcends objectivity and stasis in a perpetually regressive-progressive renovation of text has implications for the tacit expression for which Beckett yearned. His deep regard for painting as silent articulation was, in a sense, transposed into a movement design, a highly stylized choreographic structure, that literally shaped the texts whether written for the stage or not. Certain of them, *Ping* for instance, offer sets of images that expose the creative act as the production of images and nothing more or less than that. *Lessness*, composed by a random process or arbitrary ordering of sentences (sixty repeated for a total of one hundred twenty), makes a similar statement (through the patterning of sentences and paragraphs) about the visual as paradigm of the imaginative effort. The visual apotheosis, of course, is ultimately achieved in the mute *Quad*.

A fifth implication resides in the inaugural dimension of Beckett's imaging, in its virtuality or initiative force, wherein the minimizing or reductive power of his self-reflexive writing is defeated. Beckett's work surpasses the inner historical impulse of art (not to be confused with its external historical circumstances) and the "end" that it precipitates insofar as it allegorizes the function of seeing in the experience of making art. This does not mean that we are to read Beckett as though he were saying one thing while meaning another, as though allegory were the hermeneutical key to an otherwise imperspicuous writing. This would be discrepant with what I have advanced until now and, more importantly, utterly irreconcilable with Beckett's own aversion to allegory, the symbolic, and other intellectualized constructs of meaning in art.

Beckett's negative assessment of the "Crritic" (those "analogymongers" proficient at bookkeeping and little else) derived precisely from the enmity for such constructs that permeated "Dante . . . Bruno . Vico . . Joyce" and most of his other critical pieces as well. In *Proust* we see him struggling with "symbol and substance"; his praise for Jack B. Yeats's *The Amaranthers* in "An Imaginative Work!" centers on the novel's absence of allegory, "that glorious double-entry, with every credit in the said account a debit in the meant, and inversely"; and the antipathy pervades his commentaries on the brothers van Velde.[6]

The idea that Beckett allegorizes seeing as the model for *making* art *does* mean, however, that the tabula rasa of aestheticism (which I have likened to that of Duchamp and his successors in Pop) is reversed in his unification of the real with the ideal. As I have aimed to demonstrate, what

brought his art to its exceedingly minimalist halt was precisely what reaesthetisized it to project it ever on. For his imaging of the perception that in itself is image*less*, his picturing of vision, takes place within a showing of plastic form. This is true not only of the plays, which are in themselves images observed, but of the narratives, particularly the late prose, in which the central image is that of the imaginative act. As Wittgenstein reminds us, "a picture cannot depict its pictorial form: it displays it" much as language exposes its own internal structure in the exposition of something else.[7] Beckett relates the story of visualization as he, himself, envisions the imagination at work. And the process, as prose-real as it is theater-real, is entirely congruent with his critical expression of authenticity in art: "The [Proustian] experience is at once imaginative and empirical, at once an evocation and a direct perception, real without being merely actual, ideal without being merely abstract."[8]

What Beckett specifically dislikes in allegory, as one might well imagine, is its alterity, the notion that language (or any other mode of expression) would be divisible from that of which it speaks. Structuralist and, more recently, poststructuralist critics have sought to normalize (in the split of signifier and signified) allegory as a prerequisite of textuality as a whole.[9] Paul de Man, for one, denied perception as a possible model for literary invention when he argued that the allegorical dimension "appears in the work of all genuine writers and constitutes the real depth of literary insight." He even cited the difficulty Merleau-Ponty would have had in extending his theory of plasticity, as articulated in "Eye and Mind," to literary language claiming "literature bears little resemblance to perception" and "literature begins where the existential demystification ends."[10]

But Beckett succeeded exactly where de Man and his cohorts did not dare to tread: The perceptual plenitude they were intent on devaluing was the very model for the integration of the real and the imaginary Beckett devised both on the stage and the narrative page. His allegorization of seeing, in other words, can not be said to render expression autonomous insofar as it maintains a delicate harmony between verbal eloquence and the presentation of its own iconic form.

This brings us to the sixth and most important implication of my argument: iconography as an essential mode of access to and apprehension of Beckett's work. In his celebrated studies on the topic, Erwin Panofsky distinguished iconology—"a method of interpretation which arises from synthesis rather than analysis" of form—from the iconographic identification and analysis of "images, stories, and allegories" constitutive of meaning in visual art.[11] To the extent that Merleau-Ponty's claim that "painting

speaks," that the painted image has a syntax and rhetoric all its own, has its counterpart in Beckett's painting with words, Beckett's texts command interpretive strategies equivalent to those of the plastic art. His imagery, however, does not define itself either indexically or emblematically. Indeed, mindful of his admonition "No symbols where none intended," we are obliged to abandon any assumption of resemblance between text and world. Thus, I would loosen Panofsky's distinction to speak of the forms engendered by Beckett's allegory of vision in more generalized iconographic terms.

Taking my inspiration from W. J. T. Mitchell's study of the "logos" of icons, in which the concept of imagery restores to "idea" its literal sense of "to see,"[12] I wish to consider four primary icons pervasive in Beckett's work: Confinement, Issue, Anonymity, and Individuation. As they are most accessible in the context of the visual "readings" that are the artists' books (or *livres d'artiste*) that bear his name, I turn now to certain of the "illustrated" texts to see what they reveal of the relation of ideation to visualization and, specifically, Beckett's visual thinking in and of itself. For art's dialogue with Beckett has much to say about Beckett's dialogue with art.

Let me preface my remarks by saying that the iconicity in question sets up a narrative tension that highlights what Mieke Bal calls "recognition-based signification"[13] without diminishing the break up of pictorial space characteristic of non-representational art. An interplay is thus evoked between word and image that radically undermines their conventional opposition and it is this that interests me here. Without entering the *ut pictura poesis* polemic (the debate that pits the Renaissance view of an inherent verbal and visual arts association against a belief in their innate division—a controversy if not initiated, at least perpetuated by G. E. Lessing's *Laocoön*),[14] I would simply argue this: The repetition that sets Beckett's most dynamic images before us as icons "unwords" his literature to invite the illustrated editions with which he was, at least in his later years, in complete accord. And the artists' renderings are "readings" that focalize not only the ensemble of images as icons, but the very metarelation—of figuring to its figuration, of picturing to its depiction—that marks seeing as the prototype of Beckett's verbal structure. By right, therefore, the textual icons should be termed "hypericons"[15]—insofar as their doubling is an imaging of imaging—and the illustrated "readings" hyper "hypericons," but I will refrain from such excess.

In an essay on Max Ernst's illustration of Samuel Beckett's *From an Abandoned Work*, Renée Riese Hubert remarks that "a painter does not ran-

domly select texts for illustration but is guided by an intuitive, if not conscious, awareness of a problematics that he shares with the writer." Ernst stated in an interview, Hubert tells us, that while he differed from Beckett in temperament, he and Beckett did not differ "in artistic pursuits."[16] Beckett's texts have stimulated in painting—to say nothing of sculpture, music, and dance—more numerous and diverse renditions than the work of any other twentieth-century writer. In addition to Ernst, Avigdor Arikha, Georg Baselitz, Edward Gorey, Stanley William Hayter, Jasper Johns, Charles Klabunde, Louis le Brocquy, and Robert Ryman are among those artists who have sought to capture for the eye Beckett's verbally iconic constructs. One wonders how so varied a group could have as a common focus a problematic, the pursuit of an artistry, that was Beckett's own.

Both Beckett's long-lasting affection for painting and his close friendship with a number of artists have been duly noted here. We have seen that the preoccupation with subject and object—the insistence upon and resistance to the dualistic thinking of Descartes—was profoundly linked to his meditations on art; it was also relevant to his admiration for the work of certain of his artist friends. With regard to Bram van Velde, for instance, his esteem centered, initially, on what he thought to be the resolution of that irresoluble dichotomy, on the painter's recognition of art's impossibility, which, paradoxically, made possible his art.

Others have seen van Velde's struggle in an explicitly dialectical light. Rainer Michael Mason, for one, has spoken of painting's appeal and aversion for the artist as evidenced in his work. He has attested to the search for and fear of figuration, particularly in van Velde's most abstract paintings, those of the late 1930s and beyond. And he has described van Velde's artistic adventure as that of one trying to see in a visionless world.[17] Avigdor Arikha has gone so far as to call the dialectical tension—what he refers to as "painting/painting, a sort of ontogenesis by which enclosed forms are liberated giving rise to expression in turn enclosed"—the artist's ideal.[18] Duthuit judged Beckett's idealism, his notion of a resolution or surpassing of all relation in van Velde, nothing less than absurd: "A rhetoric of the irrational is constructing itself before us"[19] (comparably expressed in the "Three Dialogues" in which we read: "D.—You realise the absurdity of what you advance?"). But he rightly identified the source of Beckett's utopian view: "Relation weighs on Beckett. It suffocates him."[20] As Beckett himself would perceive, his own need for liberation from relation was, at least in part, responsible for his empathy with van Velde.

Beckett's deep regard for the paintings of his friend Jack Yeats

(brother of the poet William Butler Yeats and son of the portraitist John Butler Yeats) was of similar origin. Arguably the greatest Irish painter of the twentieth century, Yeats moved in the 1920s from an early objectivist style that demonstrated a profound concern with the sociopolitical environment of modern Ireland to one far more introspective and contemplative. Over time his paintings began to exhibit an observable reality only to play on its structures of immanence. "He sought to exteriorize the twilight area between fact and possibility, experience and illusion," Lois Gordon explains, and "served his own ambivalence toward historical event by rejecting the singularity of statement implied in simple linearity."[21]

Yeats's dispersion or dissolution of the objective into the background against which it is displayed was a process akin to Beckett's own "vaguening" of images and gestures.[22] Certainly in his paintings of the 1940s and 1950s—works like *Humanity's Alibi* (1947), *Each Man's Thoughts Are His Own* (1948), *Meditation* (1950), *The Truth the Whole Truth* (1950), and *His Thoughts Are Far Away* (1955)—Yeats's withdrawal from referential clarity, his favoring, rather, of process, was similar to Beckett's. And Beckett's movement, particularly in the 1960s, toward whiteness and calm—the white on white of *Imagination Dead Imagine* and *Ping*, for example, or the tranquil silence of *Enough*—recalls the painter's increasingly metaphysical attempts at configuration outside the irrepressible dichotomy. Beckett's awareness of this element in Yeats's work, moreover, was by no means subliminal. In his "Homage to Jack B. Yeats" he wrote, "None in this great inner real where phantoms quick and dead, nature and void, all that ever and that never will be, join in a single evidence for a single testimony."[23]

Here is what Beckett wrote in 1952 of the work of Henri Hayden (a close friend since their war days in Rousillon):

> Impersonal work, unreal work. One of the most curious things is this double erasure. And of a quite lofty inactuality at that. It is not at the close of its happy days, the subject-object crisis. But it is different and to the benefit one of the other that we are used to seeing them weaken, this clown and his side-kick. While here, confused in an identical inconsistency, they withdraw in unison.

Eight years later the artist's opposition to the binary would again replace more genuinely aesthetic criteria to earn Beckett's unqualified praise:

From this great solitary painter, we are honored to present today a series of recent gouaches. Their beauty is the doing of an artist who has known, all his life and like few others, how to resist the two great temptations, that of the real and that of the lie.[24]

I would venture that the renderings of the illustrated editions harbor a commonality of this order: Despite great dissimilarities in artistic vision, a dialectical graphic—in the form of either play on or resistance to the dyadic—distinguishes them all. So diverse a group of artists chose the same writer to illustrate because, no matter how hard he fought against it, he had, to cite Alan Schneider, "that Cartesian coordinate kind of mind."[25]

Indeed, its most notable, if paradoxical, iconographic manifestation is an extraordinarily iconoclastic pull. From the start Beckett was preoccupied with the "unthinkable end" and his fidelity to images of movement in that direction is, simultaneously, a working against the fixing of images. It is easily recognized that, in the profusion of "stopped" eyes and "mindlessness," Beckett's "Oh all to end" is metaphorized as a suspension of seeing. What has also to be said, however, is that this "negative" impulse, the progression to whiteness and void, is, above all else, reactive to a relationism perceived by Beckett as a distinctly confining force.

Particularly in the nondramatic pieces written after *How It Is*, Beckett narrativizes the struggle against relation and figures, kaleidoscopically, the antifigural or utopian vision itself. By means of the theme of captivity, he takes what has no iconic form—the existential situation of the human being—and renders it iconic in the form of art. What I mean is this: The subject-object/ego-world relation is an entrapment in Beckett's "theater-real" and "prose-real" world. And art, as imaged in the text, is a metaphor both of that confinement and the effort to escape. Analogous to the human condition, in other words, creativity (continual rewriting or envisioning) becomes an emblem of Being's restriction to the world.

Consider how the spatial dynamic exposes us to this autofiguration in "Fizzle 5":

Closed place. All needed to be known for say is known. There is nothing but what is said. Beyond what is said there is nothing. What goes on in the arena is not said. Did it need to be known it would be. No interest. Not for imagining. Place consisting of an arena and a ditch. Between the two skirting the latter a track. Closed place. Beyond the ditch there is nothing. This is known because it needs to be said. Arena black vast. Room for millions. Wandering and still. Never seeing never

hearing one another. Never touching. No more is known. [. . .] Brilliance of the bright lots. It does not encroach on the dark. Adamantine blackness of these. As dense at the edge as at the centre. But vertically it diffuses unimpeded. High above the level of the arena. As high above as the ditch is deep. In the black air towers of pale light. So many bright lots so many towers. So many bodies visible on the bed. The track follows the ditch all the way along. All the way round. It is on a higher level than the arena. A step higher. It is made of dead leaves. A reminder of bedlam nature. They are dry. The heat and the dry air. Dead but not rotting. Crumbling into dust rather. Just wide enough for one. On it no two ever meet.[26]

Marjorie Perloff has eloquently shown how Beckett's text *is* a "closed place" for its phonemic foregrounding in rhythmic recurrence. Connotative of an open place ("Beyond the ditch there is nothing" and "Brilliance of the bright lots" that, vertically, "diffuses unimpeded"), however, the sound structure of closure is at odds with the text's semantic value. A "process of specification" whose urgency is defeated by ambiguity and our difficulty to envision, "closed place," Perloff observes, is "a paradigm for the mystery of being."[27] To her excellent analysis of the disjunction of sound and meaning, I would add that "closed place" also functions as a model for the mystery of art, that within the ontological paradigm art's reflection on its own figurality is at play.

The captivity of the human being within the restrictive reality of the world, the entrapment of the spirit within the body that decays, the subjection of the individual to a life irreversibly alone—these are familiar Beckettian themes. An ontological reading of "Fizzle 5" is as compelling as that of any other Beckett text. What is remarkable here, however, is how evident the projection of art as the visual analogue to the ontological problem is: Although no reference is made to the relation of the observer to the site (is the voice within it or merely outside?), and no reference is made to a self, an existent is assumed much as one assumes an author's relation, however dissociative it may be, to any given text. As Mitchell reminds us, moreover, "the very idea of an 'idea' is bound up with the notion of imagery,"[28] and Beckett affirms that in the observer's equation of the verbs *to know* and *to say*: "All needed to be known for say is known. There is nothing but what is said. Beyond what is said there is nothing." Phenomenologist of the written word, Beckett verbalizes typography in "dark and bright," the "almost touching" black letters on the white page where "no two ever meet." In the text, in sum, there is no more than literally meets the eye.

If "room for millions"—some who wander and some who do not, millions who never see or hear one another—evokes our chaotic world (likened, perhaps, to an enormous crematorium or Dante's hell),[29] it also elicits the myriad forms from which an author or visual artist must choose. But expression is limited, notwithstanding choice, for the creative "track" follows the "ditch" that is our situation in-the-world "all the way along." Comparable to Being insofar as it, too, is restricted by an unsurpassable relation to the objective world, art remains, nonetheless, "A step higher"— though the landscape is one of "dead leaves"—and transcendence in creation is still a hope.

Like "Fizzle 5," *Ping, The Lost Ones*, the three short narratives of *Nohow On*, the other "Fizzles," and *Stirrings Still* bear witness to art's projection of relationism (the ontico-ontological schema) in the dialectical interplay of mutually defining icons: Confinement and Issue, on the one hand, and Anonymity and Individuation, on the other. Accordingly, the art of Georg Baselitz, Charles Klabunde, Avigdor Arikha, Robert Ryman, Jasper Johns, Edward Gorey, and Louis le Brocquy for Beckett's limited editions also centers on juxtaposition and other kinds of relational tension. Baselitz, in fact, has cited Beckett among the strongest influences on his painting, generally, and, specifically, on his iconoclastic (or "topsy-turvy") approach.[30]

In Baselitz's illustrated *Bing*,[31] bearing the original French title of *Ping* and consisting of twenty-four drypoints and one woodcut (on the front cover), images explode in irreverent deformations or tragicomic inversions. The artist's emphasis, like the author's, is clearly on the body, but its recognition is compromised by a pronounced conflict between form and abstraction. Animating Beckett's solitary white figure are disparate heads and torsos reminiscent of an earlier fascination with anamorphosis and the hallucinatory art of the mentally disturbed.[32] At once ludic and grotesque, they are etched in black ink against a background of gray, red-brown, or blue that accentuates, by its uniformity, both the body's fragmentation and its ultimate isolation.

In liberating "representation from content," as Baselitz has said they are meant to do,[33] the upside down images—like Beckett's contentless words (*ping, quaquaquaqua*, and so on) and wordless content (". . . . out . . . into this world")—attest to the meaninglessness of expression. Assaulting the conventions of painting by destroying its harmony, they underscore the arbitrary nature of art as depiction, its incongruity with the object, and herein lies the illustrations' success relative to Beckett's text: If anything is visualized in Baselitz's contribution to the book, it is that "Utopia, the

FIG. 4. Georg Baselitz, Image 1 of *Bing* (1981). Courtesy Michael Werner Gallery, New York and Cologne.

Nowhere-Land" (the terms are his own) that the creative imagination, in all its non-representational absurdity, uncovers. Similarly, what occurs within the enclosed space of Beckett's narrative is invention, the creative regeneration of sight and sound. Enoch Brater has persuasively described the sonority of *ping*.[34] We have also to recognize that as the text was not written for the theater, *ping* is not actually heard but seen. It is a (typo)graphical image, a written word that we view when we read; "Bing image à peine," *à peine*

but an image nevertheless; "Traces fouillis signes sans sens," *sans sens* but visibility still. Onomatopoeically, as others have alleged, *ping* is perhaps the typewriter carriage's signal and, therefore, both heard and seen at once.[35] Narratively, however, and most important, it is neither, for as a simple "murmure," a prose-real utterance that says nothing, in its imagelessness it is also "une issue."[36]

The Lost Ones (composed by Beckett between 1966 and 1970) sustains the visual analogy: The problem of ontological relativism (the relation world imposes on Being) is that of art (it is the origin, in fact, of its insufficiency or failure) and this fiction, like *Bing* (which derived from early drafts of it), depicts the search for a "way out," a way beyond the subject-object association. It does so even more emphatically: Projecting the confinement of the over two hundred "little people of searchers," the text avoids description of enclosure to *be* it.

Consider, for example, the opening sentence: "Abode where lost bodies roam each searching for its lost one."[37] Syntactically, it obliterates any supposition of a structural affinity of the universe of lost bodies with an a priori reality. As Porter Abbott notes, with this sentence "the reader is constrained to focus entirely on the gratuitous presence of a world." We do not read, he explains, "'There is an abode' or 'Imagine an abode,' but simply 'Abode.'"[38] The restricted focus is further supported by the many subsequent sentences lacking a normal subject-predicate sequence: "One body per square metre or two hundred bodies in all round numbers," for example, or "Omnipresence of a dim yellow light shaken by a vertiginous tremolo between contiguous extremes."[39] Autoconstitutional, the textual world does not initially present itself in relation to a world outside it. Confinement, as the primary visual icon, emanates, rather, from the text's autonomy.

But detailed mathematical specifications of the cylinder (statistical errors notwithstanding)[40] remind us that other world configurations are possible. (Otherwise, such data would be unneeded.) And despite our restriction to this world, ladders, the only objects in the text, allow us to seek "the ideal preying on one and all"—the metaphorical elsewhere. A not quite Dante-esque hell, given the "inviolable zenith where [. . .] lies hidden a way out to earth and sky," *The Lost Ones* impels readers / lost bodies on, with the promise of an out, mythical though the issue may be.

Three limited editions of *The Lost Ones* (two with text in English, one in French), with the complete story or passages from it, were undertaken by Beckett with Charles Klabunde and Avigdor Arikha. These visual interpretations of the verbal iconography have little in common (even where the

FIG. 5. Charles Klabunde, *The Lull*, pl. 5 of *The Lost Ones* (1984). Etching, 44.5 cm × 29 cm, signed, titled and numbered in pencil by the artist. Courtesy, the Lilly Library, Indiana University, Bloomington; reprinted by permission of the New Overbrook Press.

same artist is concerned), except that in each the Confinement/Issue dialectic posed by the writing is dominant. Klabunde's seven intaglio prints, which recall the fantastical imaginings of Bosch and Bruegel, are displayed as loose sheets in a large handmade, embossed portfolio box.[41] Signed, numbered, and hand-pulled by the artist, they are titled in accordance with Beckett's narrative content: "The Myth," "The Consequences," "The Way out," and so on. Envisioned throughout are grotesque yet whimsical figures whose elfin attire, crude smatterings of hair, and various appendages (horns, an antenna, winglike structures, a tail) complement painfully twisted positions and facial expressions of despair. Psychically as well as physically contorted (Beckett himself called them "terrifying images"), they evoke the dialectic in powerfully mystical terms envisioning, as Klabunde described them, "the inner conflicts of man in society where rules hold sway over reason and intuition."[42]

Arikha, on the other hand (about whom more below), initially fashioned his view of Beckett's claustrophobic dominion in pure abstraction.[43] Illustrating a fragment of *Le Dépeupleur* for *L'Issue*[44] (note Beckett's choice of a title), Arikha preferred to subvert cognition of Issue in an instance of art's visual reflection on its own intrinsic process. Divorced from Beckett's narrative content, his six color aquatints, with their mute tones, quiescent forms, and broad brush strokes, appear as antidotes to Klabunde's frenetic web of rhythmic movement and detail. Yet, in the metaphorical link of ontology to art and the quest for self-definition that is the particular domain of abstraction, the motif of emergence is articulated with force.

Arikha had already illustrated other works by Beckett and more such "collaborations" would follow.[45] *The North,*[46] his second rendering of a passage from *The Lost Ones,* reveals a rededication to realism and a concrete use of pictorial space and form. In the segment of text chosen the spatial dialectic is subverted in the shape of a woman in whom deliverance from the crushing "want of space" is a bleak, dark (northerly) liberation at best: "There does none the less exist a north in the guise of one of the vanquished or better one of the women vanquished or better still the woman vanquished."[47] Printed in black, Arikha's etchings only subtly intimate Beckett's descriptive prose. The last of the three, for example, repeats the first—of the squatting woman with head between her knees—with a single refinement: Light is projected over a different part of the pose. But Beckett's verbal iconography is nonetheless visually captured in all its potency: Juxtaposed to our mental configuration of the huddled group that seems "a mere jumble of mingled flesh" is the etched lone female; the spatial "privation" is all the more powerful for her being rendered alone. And repres-

sion—"Of all the scenes of violence the cylinder has to offer none approaches" that of the consequences befalling him who acts on his passion—is concretized in the very repetition of the first faceless illustration, which both structurally and formally secures Beckett's worded image.

Beckett's fecund iconoclasm and dialectical poetics of space are perhaps most obviously revisioned in Robert Ryman's art for *Nohow On*.[48] The author's trilogy of late 1970s and 1980s short novels, which includes *Company, Ill Seen Ill Said,* and *Worstward Ho,* further distills the creative process as ontological analogue and achieves greater proximity than any of the earlier works to an imaging of the "nothing more." In *Company,* for instance, Beckett's foremost narrative strategy views itself as a measure of life: "Another trait its repetitiousness. Repeatedly with only minor variants the same bygone." When obscurity threatens, it is (in)sight into the intuited art-existence parallel that is (almost) lost. For when the eye closes, as "the window might close of a dark empty room," so closes the mind. But "What visions in the dark of light!" With the mind "Unstillable," its "gropings" only *appear* "unformulable," without a shape of any kind. Although the "temptation is strong to decree there is nothing to see," in other words, there will always be "yet another still."[49]

Similarly, "whiter and whiter," what happens when we close our eyes very hard, is *Ill Seen Ill Said*'s reply to the binary nature of world: "What remains for the eye exposed to such conditions? To such vicissitude of hardly there and wholly gone. Why none but to open no more." Merely bracketed like a psychic fix on nothingness, however, blankness is but an approximation, a visually imaged more: "The eyes will close in vain," for where there is "no more to be seen" a "haze" (a "dazzling haze," even) endures.[50] *Worstward Ho,* finally, drives the invisibility the first two narratives make visible to its epistemological core: "What the so-said void. The so-said dim. The so-said shades. The so-said seat and germ of all. Enough to know no knowing."[51]

Ryman has described his images as "illustrative in a very abstract way."[52] With Benjamin Shiff, of the Limited Editions Club, the book's publisher, he chose portions of text to which the art would connect—loosely, but with a certain precision nonetheless. The first and last of the six images (easily missed when the book is first viewed) are virtually blank. Textured sheets, printed in white ink, from which only openness emerges, they enframe the ensemble of texts and thereby confront in a structure of enclosure the purest depictions of Beckett's void. In the other, more illustrative etchings, a degree of realism is obtained that sets up an additional tension, this time with the art's extremely minimalist style.[53] In *Company,* for

instance, a blank white image, indented on all sides of the page, is inserted within the following passage: "You hear again the click of the door pulled gently to and the silence before the steps can start. Next thing you are on your way across the white pasture afrolic with lambs in spring and strewn with red placentae."[54] The synergism of "silence" heard and "white" seen could not be more impressively, if explicitly, interpreted.

Ill Seen Ill Said is accompanied by two illustrations. In the first, an almost imperceptible form suggestive of a ground swell juxtaposes two subtly different ivory tones. As Breon Mitchell has noted, "seen straight on it almost disappears, seen at a slant against the light it stands out relatively clearly, like the boundary of two areas of land viewed from above."[55] The text speaks of "one continuous din. With none to hear. Decreasing as the levels draw together to silence once again." A sound graph is thus also evoked by the nearly identical shades of color and the insinuated shape that ascends from within it. Again, an ivory coloration, but with a distinctly granular texture, is deployed in the text's second image. Here, however, word and visual image no longer coexist in an elusive dialectic; they are but one. Hence, Beckett's descriptive text itself provides the clearest account of Ryman's etching:

> The coffer. Empty after long nocturnal search. Nothing. Save in the end in a cranny of dust a scrap of paper. Jagged along one edge as if torn from a diary. On its yellowed face in barely legible ink two letters followed by a number. Tu 17. Or Th. Tu or Th 17. Otherwise blank. Otherwise empty.[56]

"TH 17," hand inscribed in black ink within the "otherwise blank" plate, arises from below the grainy surface on the right side of Ryman's image. So conjoined, word and image, deconstruct the convention of verbal visual opposition. *Worstward Ho's* single etching—a return to iconoclasm in its imageless depiction of the vacuum, the "all gone for good"—is a visual *mise en abyme:* Like the two aquatints that enclose the book in a frame of empty illustration, it dedicates an internal space for picturing (what would be a picture within a picture) but leaves that space, save its differing shades of ivory, essentially vacant.

Of the visual/verbal connection Shiff has claimed that "the images leave it wide open, yet go deeper than any figurative art could go." In fact, Ryman goes so far as to render it a tactile conjunction by taking the opening and closing plates to the very edge of the page. The reader is thereby obliged to feel the art as a surface while the book is being read (at least at

its start and finish). Beckett showed considerable concern when the project was first proposed to him that the visual renderings not compromise his vision.[57] Given the holistic approach the artist would adopt and, most importantly, his sensitivity to the multiple tensions developed in the narratives, Beckett's apprehension was certainly moot.

In an undated fragment Georges Duthuit made the following notation: "The entire drama will therefore situate itself in this prison of relation and of the limited, limiting space of man."[58] An extraordinary number of references to Confinement and Issue in Beckett's letters to him supports the claim: A vocabulary of entrapment (*trappe, coincement, trou, oubliette*) and liberation (*sortir, émerger, accès, naître, naissance, sperme, frontière, passage*) is a constant reminder to both author and critic that, as Beckett himself wrote, he saw "toujours tout en termes de boîte" (everything always in terms of a box).[59] Duthuit expands on the "drama" in his likening of Beckett to Bram van Velde. In a critical account of the painter, he calls his work a "spectacle" of "engulfment"—similarly, the critic Jacques Putnam has described van Velde as "drowning" in his art[60]—and in an undated typescript says this of both men: "They recommend we attach ourselves to the protoplasm rather than to the individuals who issue from it. Adults, come back to the initial ovum from whence came the constituted organism. Curl up again in this undifferentiated halo where there is no distinguishing inside or outside."[61]

Duthuit's first notation continues: "D'où le mépris de Beckett pour ces peintres qui s'imaginèrent vaporiser les barreaux de la cellule et dissoudre les pans du mur" ("Hence Beckett's scorn for those painters who imagined themselves vaporizing the bars of the cell and dissolving the sections of the wall"). What he is claiming is that Beckett's aesthetic judgment ultimately yields to a spirit as Cartesian as Descartes's own, that his resistance to the dualistic model is ultimately undone. Beckett's assessment of the painting of André Masson, for one, proves Duthuit, again, to be right: We know from the "Three Dialogues" that, so far as Beckett was concerned, though he aspired "to be rid of the servitude of space" and rehabilitate the void, what Masson envisaged was the mere opposite of presence and not, the void at all.[62] Masson fails for Beckett insofar as his notion of space "breathe[s] possessiveness" and remains justifiable solely on the relational plane.

The critical acclaim Beckett accorded the closest of his artist friends was based, as I have said, on their surpassing, or attempts to, of the dyadic structures that wall us in. A variation on the Merleau-Pontyian visible-invisible chiasmic relation, the expressible-inexpressible dialectic (the potential success or failure of art) is, therefore, but a permutation of the

existential theme. And the impossible situation of the artist is a reflection of
the human condition rendering birth synonymous with enclosure or isola-
tion and the end the only release.

As the meaninglessness of language is made visual in the disjunction of
utterance and act (*Godot*) and speech itself is visualized in its very emission
from a mouth (*Not I*), the struggle for and loss of identity also "retinizes"
Beckett's word. Shredded photographs and forgotten faces, no less than the
progressive reduction of proper names, continually vie with the psychic
configuration of self or other so that the question of picturing is everywhere
posed. If art presents itself as a metaphor of Confinement and Issue for
Beckett, it serves as a metaphor of Anonymity and Individuation as well. In
keeping with this second dialectic inherent for Beckett in the creative act,
we are obliged to remember that the artists' renderings of the author's
images never aimed to illustrate but, rather, to animate in nonverbal medi-
ums his visually animated prose. Indeed, Beckett pressed for "respect [of]
the non-image nature of text"; requiring that the type for one illustrated
edition not be enlarged "simply in order to occupy space," he stressed the
need to not ask of text what it is virtually unable to give.[63]

Au loin un oiseau, considered by Arikha to be his "best book with
Beckett,"[64] contains a text originally written in French in the late 1950s[65]
and five aquatints completed for the 1973 publication, in a limited edition
of 120 copies, by the now defunct Double Elephant Press in New York.
Beckett's text begins: "Terre couverte de ruines, il a marché toute la nuit,
moi j'ai renoncé, frôlant les haies, entre chaussée et fossé, sur l'herbe mai-
gre" (Ruinstrewn land, he has trodden it all night long, I gave up, hugging
the hedges, between road and ditch, on the scant grass).[66] Of Arikha's five
prints, entitled *Coat, Ruin, Cane, Stones, Grass,* three were suggested by
this opening passage, while the remaining two depict objects appearing in
the text shortly thereafter. For all five, the artist worked from life: an old
English coat of Arikha's, the walking-stick of a friend, pebbles for the
road's edge, a fragment of turf for the grass.[67] "The coat and cane were
easy," Arikha has revealed. "The hard one was the ruin," a motif for which
he smashed a ceramic pot.[68]

The art that accompanies Beckett's text is strikingly realistic—scrupu-
lously detailed and highly controlled. The concreteness of the images
emanates from the artist's aversion for his previously non-figurative style.
Yet there is a certain abstractness to be noted nonetheless: The coat and
cane are ever so slightly tilted and just off center. Coat, ruin, cane, stones,
and grass are all powerfully juxtaposed to pale grey backdrops projecting a

palpable void. And shadows combine with light greys and deep blacks in an intense play of non-color tones that pay testimony to Paul Valéry's observations that "black and white penetrate more deeply in the soul than colored paintings" and that "a work reduced to light and shadows touches us, makes us more deeply thoughtful than the whole register of colors."[69] The black parts of the stones, for instance, or the richly blackened earth from which springs a few solitary blades of grass suggest the fathomless vacuum within which Beckett's character circulates.

Even more commanding, however, is the existential charge of the five prints that derives precisely from the absence of any human body or consciousness to lay claim to the objects or rubble at hand. First- and third-person pronouns are continuously lost to one another in the text to underscore the renunciation of a coherent subjectivity, one identifiable as a speaking subject nonetheless: "it was he had a life, I didn't have a life, a life not worth having, because of me . . . a life of my own I tried, in vain, never any but his, worth nothing, because of me, he said it wasn't one, it was, still is, the same, I'm still inside, the same."[70] Arikha's motifs, in not giving form to this voice, are all the more poignant for the memory—as opposed to actuality—of the life that dominates the narrative and for the quiet unveiling of the dialectic in question.

Beckett's text is an epic of being, a recounting of the trajectory toward non-being, and Arikha, in the words of critic Duncan Thomson, "has moved in close to the few clear signs on the way."[71] As Thomson has written with regard to other of Arikha's works, his art "is not concerned with whatever information it may contain and insists on its separateness from the facts that provoked it. It cannot be read for anecdote, and yet it lights up a life."[72] Things—a coat, a cane, stones—are the markers by which Arikha's art makes visible the ontological journey. For such are the focal points of the Beckett narrative that concretizes in allegorical figuration the very perception of self as always of the objective world.

In *Au loin un oiseau,* in other words, the eye moves easily between a verbal art of de-objectification: "he is fled, I'm inside . . . I'll be inside, nothing but a little grit, I'll be inside, it is not possible otherwise, ruinstrewn land, he is fled through the hedge, no more stopping now, he will never say I, because of me,"[73] and a visual art that objectifies the invisible metamorphosing of identities. But what at first strikes the viewer as a flagrant realism in direct opposition to the metaphysical preoccupation of the writer evolves, on closer consideration, into a far more discreet codetermination of the hidden and revealed. Although the coat, for example, does not enframe a body, it is suspended as though it does: sleeve in pocket, collar

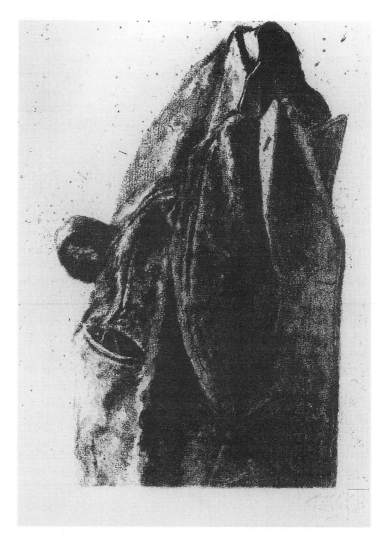

FIG. 6. Avigdor Arikha, *Coat*, pl. 1 of *Au loin un oiseau* (1973). Sugar-lift aquatint, 27 cm × 24 cm, signed in pencil by the artist. Courtesy, the Lilly Library, Indiana University, Bloomington; reprinted by permission of the artist.

erect, gravity defied in the fullness of its pose, it summons the interplay of Anonymity and Individuation to center stage. So, too, the cane that, though unheld, appears very much in use: A solitary object not supportive of human weight, it subtly suggests movement as a first pale articulation of uncertain line yields to a second, more solid depiction of its shape.

While Arikha chose to render the fragile presence of the Beckettian speaking subject through the absence of any imaging of it, Jasper Johns, in *Foirades/Fizzles*,[74] concretizes it in very distinct images of fragmentation. Unlike Arikha, who grounds this voice in the facticity of its surroundings (coat, ruin, cane, and so forth), Johns dismantles the objective world to reveal the struggle for individuation that defines both his own and Beckett's ontology. His images relate less directly to the text than Arikha's and the success of this collaboration derives precisely from the adaptation to each other of independently initiated projects.[75]

Foirades/Fizzles consists of five texts written in French by Beckett in 1972 and rendered in English in 1974 for the undertaking with Johns, and thirty-three etchings by the artist, most of which reworked the imagery that already appeared in the large four-paneled painting *Untitled, 1972*.[76] Thus, both artist and writer contributed preexisting work whose remarkable likenesses in aesthetic sensibility and philosophic preoccupation bear witness to Hubert's hypothesis, as noted above, of the "intuitive, if not conscious, awareness of a problematics" that drives such collaborative efforts.[77] Johns was responsible for integrating the visual with the verbal, though he did meet with Beckett on at least three or four occasions to discuss the layout,[78] and the book was published in New York by Petersburg Press in 1976.

The structure or design of the book fortuitously reflects its extraordinarily rich contents. Each of the five sections displays both the French and English texts and is preceded by a full-page number identifying the narrative, or "fizzle" to follow. Although Johns originally thought that he would incorporate Beckett's texts within his images, he ultimately decided to position the etchings to the left of, and sometimes above, Beckett's writings and to uniformly separate the French and English versions by double-page etchings.[79] The various motifs of *Untitled, 1972*—"stripes," "rocks," and "fragments"—are arranged in black and white, except for the frontispiece and endpage, to show multiple pairings and positionings of the painting's four panels and various combinations of its images.

The obsessive repetitions and interruptions that define the book's overall design undo any sense of linear continuity. Johns's decision to include both the French and English versions of the text, though not favored by Beckett ("I do not much like the bilingual setup, but would not oppose it if

it pleases you"),[80] creates a kind of theme and variations sequence. As such, it reflects at once the syntactic and semantic fragmentation of the narrative and Johns's redoubling of casts and reworking of prints in *Untitled, 1972*. It further reflects Beckett's habitual repetition of images and motifs from text to text and Johns's own from painting to painting. Add to this the fact that the order of the etchings was, for the most part, not determined by the written texts,[81] but largely predetermined by Johns's earlier painting, and the congruence of form and content is all the more stunning.

Like the "fizzle" of *Au loin un oiseau*, those given Johns for *Foirades/ Fizzles* are also renunciations of self. "Fizzle 1"[82] begins: "I gave up before birth, it is not possible otherwise, but birth there had to be, it was he, I was inside, that's how I see it, it was he who wailed, he who saw the light, I didn't wail, I didn't see the light." The impossibility of the narrator's ever having a voice or thoughts of his own is the focus, one falsified of course by the existence of the very words we read. Beckett believed it incumbent upon the artist to remove himself from his art.[83] Johns's own need to disassociate himself from his painting is well-documented: "I have attempted to develop my thinking in such a way that the work I've done is not me," he once told an interviewer.[84] The etching "Face" that anticipates the first text supports the artist's disavowal, particularly the positioning of a strong black X below the image (part of his own face) where a signature might be expected to appear. It further supports the narrative self-effacement in ways that Jessica Prinz has described as follows:

> Like the Beckett text, the etched face is conspicuously fragmentary, and like the fragmented structure of Beckett's prose, the broken image appears from and disappears into blankness. The head has no eyes, just as in Beckett's text the eyes are either blind or not functioning. A black "X" cancels out the image, echoing the narrator of *Fizzle 1*, who voices a distorted and destructive desire for self-annihilation. The "X" marks a nihilistic devaluation of life. It also serves as a sign for the kind of art produced by Beckett and Johns, an art that undercuts and cancels itself out.[85]

The anonymous status of the narrator of the logorrheic text that is "Fizzle 1" (it is composed of a single sentence) is maintained in the subsequent "fizzles" despite hints at individuation that threaten to reveal: "Prison garb," "eyeglasses," "my fortieth year had come and gone," nocturnal visits of one called Horn, even the possibility that it is Murphy who reappears here, hint at identity, but ambiguity, irony, and inaccessibility

FIG. 7. Jasper Johns, *Foirades/Fizzles*. © Jasper Johns, licensed by VAGA, New York, NY. Courtesy, the Lilly Library, Indiana University, Bloomington.

prevail. And if syntactical coherence is illusory in that we simply cannot grasp what the text might "mean," the graphic renderings are as contradictory and similarly deconstruct any potential for unity of voice.

In the first place *Untitled* consists of four unrelated panels that, together, form a kind of "modular" whole.[86] Nothing organic dictates their order and, like the prose texts, they can be rearranged. Johns's numbers (not part of the painting) participate in the fragmenting game, for the notion of numerical sequence is nothing more than a tease. Furthermore, as

Marjorie Perloff reminds us, the very introduction of numbers within the visual field reduces "the power of images to achieve concretion" to the extent that a numeral cannot be re-presented, only given as it is in and of itself.[87]

Secondly, there is the division of physical and psychic self. Johns's etchings fail at identification as well as Beckett's words. In "Fizzle 5" of the illustrated edition, for example, a profusion of labels defines what the image is not. Black and white patterns with the words for body parts ("buttocks," "torso," "knee," and so on) bear no resemblance to what is named; indeed, they are unintelligible as human fragments at all. Were they realigned, they would no more comprise a complete body than the reassembling of memories and perceptions would make of the fragments of consciousness a unified whole.

Despite the highly abstract nature of both the verbal and visual imagery in *Foirades/Fizzles*, however, the iconography is clear. Repetition and distortion, echoes of previous texts and paintings, structure the play on Anonymity and Individuation to give it dialectical form. And once again the dialectical paradigm is nothing other than seeing itself. This is to say that the quest for a determinate subject, for an identifiable *res cogitans*, is enacted allegorically specifically on the visual front. When in "Fizzle 5," to cite one climactic moment, the narrator assumes an intradiegetic role in whatever "story" there may be, seeing Horn becomes a matter of his own visibility, of self-observation and of being seen:

> It was five or six years since anyone had seen me, to begin with myself. I mean the face I had pored over so, all down the years. Now I would resume that inspection, that it may be a lesson to me, in my mirrors and looking-glasses so long put away. I'll let myself be seen before I'm done.[88]

If Johns dismembers the body (strewing buttocks, face, torso, and leg throughout the picture plane), or even cancels it with the *X* reprised in the final etching of the book, and Arikha leaves out the human figure altogether, Louis le Brocquy comes at the problem of depicting Beckett's voices from an antithetical perspective. Le Brocquy's contribution to the illustrated *Stirrings Still* appears considerably less burdened by the difficulties of representation insofar as it appears to project the fragmented persona from within. The original black-and-white brush drawings in the 1989 publication exhibit a process of discovery, or unveiling, akin to Beckett's own wherein a voice or consciousness emerges as a self-reflective presence—a

FIG. 8. Louis le Brocquy, *Stirrings Still*. Courtesy, the Lilly Library,
Indiana University, Bloomington; reprinted by permission of the artist.

pure subjectivity objectifying itself—rather than as a representation of this presence, the object of an external creative force. The artist has explained that "When the publishers first approached me, I was asked to include in the illustrations a portrait head of Beckett. In face of *Stirrings Still,* however, I have preferred to allow the image to form itself, as it were, interiorized, indeterminate."[89]

Each of the images of the collaboration exhibits this interiorization in that they seem rooted directly within the textual matter.[90] All are loosely drawn; several are layered even, onion-like,[91] to suggest the multiplicity of selves and the interiority so endemic to the writing. Those of the ghostlike figure who inhabits the text are relatively formless, lacking delineated features as indicated by the text: "Seen always from behind withersoever he went,"[92] the personage in question remains nondescript, nameless, in the words of Robert Scanlan, "a consciousness reporting on itself, on its perception of a Self (perhaps itself, perhaps a fictional second self, the perennial unsolved, insoluble problem of Beckett's prose)."[93] Hence, as in the Arikha and Johns collaborations, it is once again the identification of self with the anonymity or universality of Being and the differentiation of self, its struggle for individuation, that is the site of the primary verbal-visual connection.

In *Stirrings Still,* however, the visual reading is less dramatic than in the Beckett/Arikha book and less formally determined than in the book by Beckett and Johns. To begin with, le Brocquy's art is not set off from the text. It is neither marginalized by placement alongside the type or on pages separate from it nor encased in any way. Rather, the drawings are frameless black strokes dependent upon the all-white pages of the book in the same way that the lettering of any text is a function of the white against which it appears. The result is an integration of word and image that does not function as a visual contextualization of verbal meaning, as in the Arikha/Beckett project, or as a formalist display of the cycles of displacement and reappearance projected by the consciousness, as in the one by Beckett and Johns. Here the graphic opposition of word and image is transcended and through the intimacy of their interconnection Beckett's visual cognition is exposed.

Secondly, this whiteness serves not only as a means of contrast but as the aesthetic matrix from within which each image emerges.[94] Accordingly, a sense of stillness pervasive throughout the book does not appear to replicate, but rather emanate from the white world of Being inhabited by the solitary Beckettian voice.

Finally, le Brocquy's lithographs reveal only the focus of this con-

sciousness' inner eye: We do not see in the visual art any of what the reader imagines the narrative scene to be but, exclusively, what the speaking subject himself *perceives* while *conceiving* of his own emergence into the outer world. For the text in its entirety is the observation of a man who, "One night as he sat at his table head on hands [. . .] saw himself rise and go."[95] Le Brocquy has said that " 'reality takes place in the mind' "[96] and his art for *Stirrings Still* is guided solely by the Beckettian figure who ceases "if not to see to look"[97] as he turns to thought and sees in cognitive counterpoint what would otherwise be optically viewed.

Like le Brocquy's for *Stirrings Still*, Edward Gorey's drawings for *Beginning to End*,[98] a selection of texts adapted by the author with the actor Jack MacGowran, exhibit a close existential link to the narrative. Characteristically Goreyesque,[99] the pen and ink illustrations depict forms not entirely human though not entirely not: The ontic and ontological are very subtly juxtaposed. Also embedded within the text, these images conjure the transitional moments in which Beckett's voices perceive themselves as existent, though they know not who they are nor whence they came, as both peculiar object and strange subjective force. "It was mostly a mood thing," Gorey replied when asked how he had worked with the written material. "I just sat and stared at the text for a long time." He then added, "I sat around drawing skulls."[100]

In this amalgam of several dissimilar works (the script for Mac-Gowran's one-man show of the same name), one reads, as with so many Beckett works, the story of an "I" whose story is never to be fully told. Implicitly, this "I" recalls the "big talking ball" of *The Unnamable* who wonders "why a ball, rather than something else" and "why big?" Why not an egg, for instance, "a medium egg"? Gorey responds to the narratively predetermined shape with an extraordinary inventiveness, and round—both despite and by virtue of its repetition from image to image—elicits numerous interpretive possibilities. Running the gamut from the organic to the inorganic, though "atomized" all, these include heads (some with faces, some without, and several with limited features), rocks (creviced or not to border more or less on human skulls), and related motifs at once naturalistic (evocative of sun and moon) and abstract (unidentifiable as biologic, inanimate, or bioliths of some unknown sort).

The circular and semicircular are deeply etched in Beckett's iconography and their theatricality and structural implications (repetitiveness, incompletion, and so on), already explored by others, need not be reiterated here.[101] However one "reads" Gorey's quasi-circular figurations, most significant is their relation to Beckett's ceaselessly self-reflective and self-

easons unknown of Testew and Cu

is established what many deny that ma

d Cunard that man in

t that man in brief in sp

mentation and defecatio

vastes and pines and con

sly what is more for rea

ite of the strides of physical culture the p

as tennis football running cycling swimn

ng gliding conating camogie skating te

FIG. 9. Edward Gorey, *Beginning to End*. Courtesy, the Lilly Library, Indiana University, Bloomington; reprinted by permission of Gotham Book Mart.

defining gestalt. Clearly, the visual semantic derives its force from the density or sparseness of the ink lines that mark the extremely small, extremely tight pictorial surfaces: Some depict white spherical enclosures set against impenetrable backgrounds and heavily shaded groundlike surfaces. Others show darkened orbs against all or partially white backdrops. Still others are rotund creatures so conjoined with the horizon on which they rest as to be almost indistinguishable. In several, deep-set eyes projecting a sightless gaze upon the viewer visualize the tale as a game of phantom identification.

As in the illustrated editions discussed above, the intervention of white in Gorey's otherwise monochromatic compositions bears heavily not only upon the Anonymity/Individuation dialectic, but upon the spatial dynamic of Confinement and Issue as well. As a projection of the void wherein the "I" is not "on [his] way anywhere, but simply on [his] way,"[102] the white delimits Beckett's iconographic deployment of space as a metaphoric journey to the end, however undenotable that end may be. One passage of the text (from a poem published initially in *Transition Forty-Eight* [No. 2]),

provides a key to Gorey's visual accommodation of Beckett's verbal treatment of space:

> my peace is there in the receding mist
> when I may cease from treading these long shifting thresholds
>
> and live the space of a door
> that opens and shuts

It is true that the contrast of white against the dark blue (almost black) skulls and related forms is the visual mark of the worded schism between uncertainty and its antithesis ("these long shifting thresholds" and "the space of a door that opens and shuts")—between the imagelessness of Being and hope for momentary issue in the illuminating images of art. It is also true, however, that the opposition affords ironic relief from the deadly (or ghostly) angst and more; doodle-like, the drawings have a humorous edge that matches Beckett's own tragicomic sensibility. As one Gorey admirer so rightly put it, "For Gorey, existential dread isn't the subtext, it's the punch line."[103] Is this not Beckett's saving grace as well?

Beckett's artists speak of the "interesting challenge" (Ryman's phrase) offered by illustrating his texts. Klabunde describes it as follows:

> The challenge lies in making the visual form not only equal to the literary text but actually enriching its content. It must be creative and imaginative as well as descriptive. If it is not, it becomes subordinate to the writing and cannot become a work of art of and by itself. If it does not live independently of the text—as the text does of the picture—it will be a burden to the story. A story and its accompanying pictures must be able to be living reflections of each other if both are to achieve the level of art.[104]

Beckett's willingness to have his texts illustrated, particularly in his middle to late years,[105] reflected this respect for the visual independent of the verbal art. Unlike the tight rein with which he kept his directors and set designers in tow, his attitude toward the illustration of his work was flexible. As Breon Mitchell says, "Artists seemed free to do anything they wished across the page from his words. In granting them this freedom, Beckett was not paying tribute to individual artists, but to the very nature of art itself."[106]

Indeed, most of the "collaborations" were not really collaborative at

all. Often he did not even see the illustrations until the art was complete. One notable exception was Stanley William Hayter's images for *Still*.[107] Although some confusion surrounds the inception of the project,[108] Beckett's continued attention to it is clear. To begin with, he involved himself with the art. As Désirée Hayter (the artist's wife) remembers, "Beckett lived around the corner [. . .] and he came by frequently and followed progress on each plate with acute interest. He was disturbed at one moment by the depiction of a head as it had too much character and he wanted it to be an anonymous head."[109] Additionally, he made minor but numerous corrections to Luigi Majno's Italian translation of the text. With regard to production, pages of the volume had to be reprinted at Beckett's request when he insisted that some dots of black ink, removed by Majno who assumed them to be "superfluous," were intended to appear.[110] He was greatly pleased by the outcome, however, and wrote Majno of liking the proof, called the final reproduction of his manuscript "excellent," and congratulated and thanked the publisher when the book appeared.

Still, like so many of the texts chosen for illustration, dramatizes art as the visual analogue of the binary situation of the human being in-the-world. Once again, the visual focus is clearly the text itself. Brater describes it as an anonymous figure configuring a figure of speech: "The drama is the spectacle and speculum of Beckett's language," he explains, and "the only hero in this *play* is the uncertain word."[111] Peter Black and Désirée Moorhead, in their *catalogue raisonné* of Hayter's work, have confirmed the artist's fidelity to the syntactic and semantic morphology of the figure who repeatedly passes from stasis to stirring as he observes, seated or standing, from west or east, the setting sun.[112]

If Beckett chose to closely supervise the progressive stages of this limited edition, it was perhaps, as Knowlson has suggested, that he "was deliberately providing Hayter with strong visual material with which to construct his three etchings . . . *Still* seems in fact to have evolved out of Beckett's love of painting and his friendship with various painters."[113] So preoccupied was Beckett with the visual form the figuration of tranquility might take that his own drawings appear in the margin of the manuscript facsimile of the M'Arte publication.[114]

Regardless of his degree of involvement in the many *livres d'artiste,* Beckett's privileging of sight as the quintessential ontological metaphor assumes the shape of dialectic in each. Confinement and Issue, on the one hand, Anonymity and Individuation, on the other, play on visibility and invisibility in the artists' renderings to confirm his profoundly visual thought. As icons of figuration, they reveal the significance of his "ocular-

FIG. 10. S. W. Hayter, *Still II*, pl. 2 of *Still* (Milan: M'Arte Edizioni, 1974). Copper plate engraving, 29.5 cm × 21.5 cm, signed and numbered in pencil by the artist. Courtesy, the Lilly Library, Indiana University, Bloomington; reprinted by permission of the publisher.

centrist"[115] writing to lie in a combining of the figural, imagining, with its literal counterpart, empirical acts of seeing, and, hence, in a merging of the creative and the real.

It has been my purpose in this volume to prove that understanding the dominant role played by the visual paradigm in Beckett allows for an appreciation of the self-reflexivity that "stopped" his art. For tensions between the spatial icons and those of identification break the illusion of reference as they figure both perception and its morphic changes to produce what Robert Fletcher calls "a dual movement of creation and feedback."[116] "Theatereality" and "prosereality" have thus been shown to take over where Hegel's historicity leaves off and to be comparable in their nonrepresentational point of departure to the nonconceptual (anaesthetic or atheoretical) thinking in which originate Beckett's critical writings.

It should now be clear that Beckett's preoccupation with vision (with a metaphorical lucidity and blindness) affirms the search for a stable form that neither the human condition nor the situation of Being-in-the-world exhibits. A final extract from Bruno Latour may be cited as a measure of Beckett's endeavor to and respect for artists who surpass in this effort the dehumanizing legacy of Descartes:

> The human is not a constitutional pole to be opposed to that of the nonhuman. The two expressions "humans" and "nonhumans" are belated results that no longer suffice to designate the other dimension. The scale of value consists not in shifting the definition of the human along the horizontal line that connects the Object pole to the Subject pole, but in sliding it along the vertical dimension that defines the nonmodern world. Reveal its work of mediation, and it will take on human form. Conceal it again, and we shall have to talk about inhumanity.[117]

If I have proposed situating Beckett outside the very "neatness of identifications" to which he, himself, was opposed, it is not that I believe recent attempts to conceptualize his modernist versus postmodernist heritage are not of value, but that they risk our neglecting the most significant aspect of his genius. I could not agree more with Sidney Feshbach when he claims, "No matter how reduced Beckett's characters become over the years, no matter how much the self is dissolved into, say, objects or words, there always remains a human factor and warmth; accounting for that quality [. . .] is the primary task for Beckett criticism."[118] It was to that end

I was led to identify Beckett's thinking as primarily visual and art as emblematic for him of the human-world relation. If defending his explicitly anaesthetic thinking on art against the rush to set it as theory appears imperative, it is that Beckett's art speaks to us in ways that defy circumscription in thought transcending life. Readings that reduce the perceptual paradigms (vision is one; sound, as Brater has ably shown, another) to philosophic precept and aesthetic ideology lose sight of the empirical foundation in which his artistic integrity resides. Beckett maintained a dialogue with art whose terms were uniquely his. The very aloofness with which he regarded aesthetics, as such, entices us to regularize them or bring standards to bear that were not. But with the Unnamable we might remember that "it is easier to raise a shrine than bring the deity down to haunt it"[119] and continue to respect the conditions on which the dialogue was based.

Notes

Introduction

1. SB, "Le Concentrisme," in *Disjecta*, ed. Ruby Cohn (New York: Grove Press, 1984), 41, 42.
2. Cohn, foreword to *Disjecta* 7.
3. The unpublished correspondence of Beckett and Georges Duthuit, for example, is the focus of Rémi Labrusse's essay "Beckett et la Peinture," *Critique* (Aug.–Sept. 1990): 670–80.
4. Special mention must be made of Matti Megged's short monograph on Beckett and Giacometti, *Dialogue in the Void* (New York: Lumen Books, 1985), although the focus is the shared preoccupations of Beckett and a single artist, and one who was by no means primarily a painter.
5. Cohn, foreword to *Disjecta* 7.
6. John Pilling, *Samuel Beckett* (London: Routledge and Kegan Paul, 1976), 13.
7. Notes taken by Rachel Dobbin (Burrows) on Beckett's 1931 lectures on Gide and Racine contain references to art throughout. (These notes are housed in the Trinity College Dublin Library.)
8. Cited in Pilling, *Samuel Beckett* 18.
9. Ruby Cohn, *Just Play: Beckett's Theater* (Princeton: Princeton University Press, 1980), 35.
10. Unless otherwise indicated, my use of the word *specular* throughout this volume is not to be identified with Lucien Dällenbach's concept of "self-reflexivity," Michel Foucault's idea of "transparent vision," or Jacques Derrida's "limitless regression." I refer, rather, to a broader notion of that which assists sight.
11. Beckett uses the term with regard to Jean de Chas in "Le Concentrisme," *Disjecta* 37.
12. Frederic Jameson, *The Political Unconscious Narrative as a Socially Symbolic Act* (Ithaca: Cornell University Press, 1981), 9.
13. SB, "MacGreevy on Yeats," *Disjecta* 97.
14. SB, "Dante . . . Bruno . Vico . . Joyce," *Disjecta* 19.
15. Lance St. John Butler, *Samuel Beckett and the Meaning of Being* (New York: St. Martin's Press, 1984).

16. Francis Sparshott, *The Theory of the Arts* (Princeton: Princeton University Press, 1982), 3, 4.

17. Enoch Brater, *The Drama in the Text* (New York: Oxford, 1994), 165.

18. SB, "Dante . . . Bruno . Vico .. Joyce," *Disjecta* 27.

19. Translated from the German by Martin Esslin, *Disjecta* 172.

20. Cf., Sidney Feshbach on the negation of such by Marcel Duchamp in "Marcel Duchamp or Being Taken for a Ride: Duchamp was a Cubist, a Mechanomorphist, a Dadaist, a Surrealist, a Conceptualist, a Modernist, a Post-Modernist—and None of the Above," *James Joyce Quarterly* 26, no. 4 (Summer 1989): 557–58.

21. SB, "Geer van Velde," in *Disjecta*, ed. Ruby Cohn (New York: Grove Press, 1984), 117.

22. Jean-Paul Sartre, *Nausea*, trans. Lloyd Alexander (New York: New Directions, 1964), 126–27.

Chapter 1

1. Umberto Eco, in Stefano Rosso, "A Correspondence with Umberto Eco," *Boundary* 2, no. 12: 5; cited in Breon Mitchell, "Samuel Beckett and the Postmodern Controversy," in *Exploring Postmodernism*, ed. Matei Calinescu and Douwe Fokkeme (Amsterdam and Philadelphia: John Benjamins, 1990), 109.

2. Bruno Latour, *We Have Never Been Modern*, trans. Catherine Porter (Cambridge: Harvard University Press, 1993), 47.

3. Richard Rorty, *New York Times*, November 1, 1997, B13.

4. Cf. Latour 61.

5. Latour 12.

6. Jean-Paul Sartre, *L'Etre et le Néant* (Paris: Gallimard, 1943), 125, 127.

7. H. Porter Abbott, "Late Modernism: Samuel Beckett and the Art of the Oeuvre," in *Around the Absurd*, ed. Enoch Brater and Ruby Cohn (Ann Arbor: University of Michigan Press, 1990), 74; emphasis added.

8. Alain Robbe-Grillet, in *Three Decades of the French New Novel*, ed. Lois Oppenheim, trans. Lois Oppenheim and Evelyne Costa de Beauregard (Urbana: University of Illinois Press, 1986), 24.

9. I am reminded here of Beckett's pungent remarks in "Dante . . . Bruno . Vico .. Joyce" on the congruence of form and content in *Work in Progress*: "Here is direct expression—pages and pages of it. And if you don't understand it, Ladies and Gentleman, it is because you are too decadent to receive it. You are not satisfied unless form is so strictly divorced from content that you can comprehend the one almost without bothering to read the other." And: "Here form *is* content, content *is* form." (*Disjecta* 26, 27).

10. SB, *Waiting for Godot* (New York: Grove Press, 1954), 27.

11. SB, *Endgame* (New York: Grove Press, 1958), 1, 84.

12. SB, *Play, The Collected Shorter Plays of Samuel Beckett* (New York: Grove Press, 1984), 147.

13. See Enoch Brater, *Beyond Minimalism* (New York: Oxford University Press, 1987), 9.

14. See my essay "Female Subjectivity in *Not I* and *Rockaby*," in *Women in Beckett*, ed. Linda Ben-Zvi (Urbana: University of Illinois Press, 1990), 220–21.

15. Michel Butor, "Le Roman comme recherche," *Répertoire* I (Paris: Les Editions de Minuit, 1960), 8.

16. Brater, *Beyond Minimalism* 3.

17. Abbott, "Late Modernism" 75, 76.

18. Ihab Hassan, "Toward a Concept of Postmodernism," in *Postmodernism: A Reader*, ed. Thomas Docherty (New York: Columbia University Press, 1993), 153.

19. The most interesting and comprehensive treatments of fragmentation or deconstruction as a creative process are Abbott's essay and one by Ruby Cohn: "Ghosting through Beckett," in *Beckett in the 1990s*, ed. Marius Buning and Lois Oppenheim (Amsterdam: Rodopi, 1993), 1–11.

20. Alan Schneider in the D. A. Pennebaker Associates film *Rockaby*; cited in Brater, *Beyond Minimalism* 176.

21. Cited in Martin Esslin in *The Theatre of the Absurd* (New York: Doubleday, 1961), 46.

22. Dougald McMillan and Martha Fehsenfeld, *Beckett in the Theatre* (London: John Calder, 1988), 36. See also 32–36.

23. Beckett was said by Alan Schneider to have written this, or words to this effect. See my book *Directing Beckett* (Ann Arbor: University of Michigan Press, 1994), 10.

24. *Krapp's Last Tape, The Collected Shorter Plays of Samuel Beckett* 63; *Eleutheria*, trans. Michael Brodsky (New York: Foxrock, 1995), 191.

25. Brater, *Beyond Minimalism* 116–18.

26. Cohn, "Ghosting through Beckett" 7.

27. See Brater's discussion in *Beyond Minimalism* 61–64.

28. Andrew Renton, "Disabled Figures: From the *Residua* to *Stirrings Still*," in *The Cambridge Companion to Beckett*, ed. John Pilling (Cambridge: Cambridge University Press, 1994), 167.

29. François Lyotard, "Note on the Meaning of 'Post-,'" cited in Docherty, *Postmodernism* 50.

30. Abbott, "Late Modernism" 77.

31. Michel Rybalka, "Alain Robbe-Grillet: At Play with Criticism," in Oppenheim, *Three Decades* 41.

32. Robbe-Grillet, in Oppenheim, *Three Decades* 40–41. (First emphasis added).

33. Cohn, "Ghosting through Beckett" 8.

34. Stan Gontarski, "Revising Himself: Performance as Text in Samuel Beckett's Theater," forthcoming, n.p.

35. Charles Krance, "Traces of Transtextual Confluence and Bilingual Genesis: *A Piece of Monologue* and *Solo* for Openers," in *Beckett in the 1990s*, ed. Buning and Oppenheim 133.

36. Krance 134.

37. SB, letter to Axel Kaun, *Disjecta* 173.

38. Abbott, "Late Modernism" 84.

39. Stephen Barker, "Recovering the *Néant*: Language and the Uncon-

scious in Beckett," in *The World of Samuel Beckett*, ed. Joseph H. Smith (Baltimore: Johns Hopkins University Press, 1991), 129.

40. Latour 10.

41. Cf. Marjorie Perloff: "It is the paradox of postmodern genre that the more radical the dissolution of traditional generic boundaries, the more important the concept of genericity becomes" (*Postmodern Genres* [Norman: University of Oklahoma Press, 1988], 4).

42. SB, *Words and Music, Play, Ghost Trio, Catastrophe, The Collected Shorter Plays of Samuel Beckett* 127, 147, 248, 297–98.

43. SB, *Company, Nohow On* (London: Calder Publications, 1992), 5.

44. SB, *The Unnamable* 41.

45. SB, letter to Axel Kaun, *Disjecta* 171.

46. Jean-François Lyotard, "Answering the Question: What Is Postmodernism?" in Docherty, *Postmodernism* 46.

47. SB, *Worstward Ho, Nohow On* 128.

48. SB, *Worstward Ho* 128.

Chapter 2

1. SB, "Dante . . . Bruno . Vico . . Joyce," in *Disjecta*, ed. Ruby Cohn (New York: Grove Press, 1984), 29, 19.

2. Dougald McMillan cites as the most prominent among them "the National Gallery of England, the British Museum, the Louvre, the Prado, the Schatzkammer, Albertina, and the *Kunsthistorisches* museum in Vienna, the Pinacoteca in Milan, the Uffizi and Santa Croce in Florence, the Sistine Chapel in Rome, the Bishop's Palace in Würzburg, the *Stadtsgalerie* in Dresden, and the Campanella in Pisa" ("Samuel Beckett and the Visual Arts: The Embarrassment of Allegory," in *On Beckett: Essays and Criticism*, ed. S. E. Gontarski [New York: Grove, 1986], 29).

3. SB, *The Unnamable* 16, 17, 125.

4. SB, *Film, Collected Shorter Plays of Samuel Beckett* 163.

5. SB, *Stories and Texts for Nothing* (New York: Grove Weidenfeld, 1967), 107.

6. SB, *Stirrings Still* (New York: North Star Line, 1991), n.p.

7. SB, *Murphy* (New York: Grove Weidenfeld, 1957), 107, 109.

8. SB, *The Unnamable*, 128–29; emphasis added.

9. Noted by Dougald McMillan in "Samuel Beckett and the Visual Arts: The Embarrassment of Allegory" 43–44.

10. Cited in Vivian Mercier *Beckett/Beckett* (New York: Oxford University Press, 1977), 119, 120.

11. SB, *Watt* (London: John Calder, 1963), 128–29.

12. SB, *Watt* 130.

13. J. Mitchell Morse, "The Contemplative Life According to Samuel Beckett," *Hudson Review* 15 (1962–63): 522. Cited in Gottfried Büttner, *Samuel Beckett's Novel Watt* (Philadelphia: University of Pennsylvania Press, 1984), 13.

14. Samuel Beckett, *Molloy*, trans. Patrick Bowles in collaboration with the author (New York: Grove Press, 1955), 16. "Et je suis à nouveau je ne dirai pas

seul, non, ce n'est pas mon genre, mais, comment dire, je ne sais pas, rendu à moi, non, je ne me suis jamais quitté, libre, voilà, je ne sais pas ce que ça veut dire mais c'est le mot que j'entends employer" (*Molloy* [Paris: Minuit, 1951], 17).

15. SB, *Molloy* 65, 16. "Oui, il m'arrivait d'oublier non seulement qui j'étais mais que j'étais, d'oublier d'être" (73). "Ramener le silence, c'est le rôle des objets" (17).

16. Jacques Garelli, *La Gravitation Poétique* (Paris: Mercure de France, 1966), 66.

17. SB, *The Unnamable* 4–5.

18. SB, *The Unnamable* 71.

19. SB, *The Unnamable* 86.

20. Cited in Gottfried Büttner in *Samuel Beckett's Novel* Watt (Philadelphia: University of Pennsylvania Press, 1984), 27. In a letter to LO, dated February 28, 1995, Büttner wrote: "Beckett's remark 'Every word is a lie' was actually said in German: 'Jedes Wort ist eine Lüge.'" Describing an evening he and his wife spent with Beckett in Berlin in 1967, Büttner explained, "The same evening we came back to the so-called 'Nothingness' or 'Naught' and Beckett said again, it is difficult to explain the experience of nothingness. 'This takes place deeply within us where words are not appropriate to express what happens there, where it becomes quiet, simple and still.' Only after this, the moving sentence was said by Beckett: 'Every word is a lie.'"

21. SB, *The Unnamable* 133.

22. SB, interview with Gabriel D'Aubède; cited in Carla Locatelli, *Unwording the World* (Philadelphia: University of Pennsylvania Press, 1990), 14.

23. Bruno Clément, "A Rhetoric of Ill-Saying," *Journal of Beckett Studies* 4, no. 1 (Fall 1994): 39, 47.

24. Butler, *Samuel Beckett and the Meaning of Being* 9.

25. SB, *The Unnamable* 39; cited in Clément in "Rhetoric of Ill-Saying" 39.

26. SB, *The Unnamable* 132.

27. Paul Ricoeur, *The Rule of Metaphor,* trans. Robert Czerny with Kathleen McLauglin and John Costello, SJ (Toronto: University of Toronto Press, 1977), 7. "Le 'lieu' de la métaphore, son lieu le plus intime et le plus ultime, n'est ni le nom, ni la phrase, ni même le discours, mais la copule du verbe être. Le 'est' métaphorique signifie à la fois 'n'est pas' et 'est comme'" (*La Métaphore Vive* [Paris: Editions du Seuil, 1975], 11).

28. SB, letter to Tom MacGreevy, March 5, 1936; cited in James Knowlson, *Damned to Fame* (New York: Simon and Schuster, 1996), 207.

29. SB, *Krapp's Last Tape* 61.

30. SB, *Ill Seen Ill Said* 81.

31. David H. Helsa, *The Shape of Chaos: An Interpretation of the Art of Samuel Beckett* (Minneapolis: University of Minnesota Press, 1971), 215; cited in Mercier, *Beckett/Beckett* 11.

32. The eye is also often valorized by Beckett as a symbol of exchange. In the brief 1950s text appropriately titled *L'Image*, for example, the gaze, if not the eye itself, is emblematic of the engagement of the seer with what he or she beholds. In this text, as elsewhere, the verbal expression is exquisitely conscious of itself as a visually projected image: "j'ai l'absurde impression que nous me

regardons [I have the absurd impression that we are looking at me]" (Paris: Minuit, 1988, 14); translation mine.

33. SB, *Waiting for Godot* 34, 59.

34. SB, *Watt* 173–74.

35. SB, *Murphy* 250.

36. SB, *Endgame* 41.

37. Knowlson, *Light and Darkness in the Theatre of Samuel Beckett* (London: Turret Books, 1972), 37.

38. Carla Locatelli, *Unwording the World: Samuel Beckett's Prose Works after the Nobel Prize* (Philadelphia: University of Pennsylvania Press, 1990), 188.

39. SB, *Watt* 70.

40. SB, *Not I* 222.

41. SB, *Ill Seen Ill Said* 59.

42. Locatelli 191.

43. SB, *Ill Seen Ill Said* 66.

44. Walter James Miller and Bonnie E. Nelson, *Samuel Beckett's "Waiting for Godot" and Other Works* (New York: Monarch Press, 1971), 9; cited in Robert Winer, "The Whole Story," in *The World of Samuel Beckett*, ed. Joseph H. Smith (Baltimore: Johns Hopkins University Press, 1991), 76.

45. Eoin O'Brien, foreword to *Dream of Fair to Middling Women* (New York: Arcade Publishing, 1992), xx.

46. SB, *Murphy* 63, 229, 241.

47. SB, *Watt* 39, 63.

48. SB, *The Unnamable* 17.

49. SB, *Murphy* 246.

50. Stanton B. Garner Jr., *Bodied Spaces* (Ithaca: Cornell University Press, 1994), 71.

51. SB, *Come and Go, The Collected Shorter Plays of Samuel Beckett* 196.

52. Maurice Merleau-Ponty, *Le Visible et l'invisible* (Paris: Gallimard, 1964), 17.

53. Knowlson, *Light and Darkness* 19.

54. SB, *Watt* 39.

55. SB, *Company* 20.

56. SB, *Ill Seen Ill Said* 58.

57. SB, *Ill Seen Ill Said* 59, 77.

58. Cited in Mercier 130.

59. "Il y a un paradoxe de l'activité poétique qui est la mesure de sa condition. Ouverture sur le monde, le poème est, dans l'acte du dévoilement, cela même qui est dévoilé. Regard, il se fait voir. Lumière, il s'éclaire. Révélateur, il ne révèle qu'en étant lui-même révélé" (Garelli, *La Gravitation Poétique* 9).

60. Locatelli 211.

61. In Oppenheim, *Directing Beckett* 88.

62. Martin Esslin, "A Poetry of Moving Images," in *Beckett Translating / Translating Beckett,* ed. Alan Warren Friedman, Charles Rossman, and Dina Sherzer (University Park: Pennsylvania State University Press, 1987), 67.

63. Enoch Brater, *Why Beckett* (London: Thames and Hudson, 1989), 85.

64. Büttner, *Samuel Beckett's Novel* Watt xiii. Jonathan Kalb, in *Beckett in*

Performance, also notes that "Beckett has said he prefers [*Endgame*] to *Godot* because of the greater exactitude with which its physical activity is planned" (Cambridge: Cambridge University Press, 1989), 39.

65. SB, *Proust and Three Dialogues with Georges Duthuit* (London: Calder and Boyars, 1970), 125, 103.

66. SB, *Waiting for Godot* 51.

67. Leo Bersani and Ulysse Dutoit, *Arts of Impoverishment: Beckett, Rothko, Resnais* (Cambridge: Harvard University Press, 1993), 101.

68. SB, letter to Axel Kaun, *Disjecta* 172.

69. Cohn, foreword to *Disjecta* 12.

70. SB, letter to Axel Kaun, *Disjecta* 172, 173.

71. Dore Ashton, *About Rothko* (1983; rpt., New York: Da Capo Press, 1996), 86.

72. SB, *Ill Seen Ill Said* 57.

73. SB, *Ill Seen Ill Said* 66.

74. SB, *Ill Seen Ill Said* 95.

75. SB, *Worstward Ho* 123, 124.

76. See my essay "Narrating Hi(s)story: A Brief Commentary on Claude Simon's *L'Invitation,*" *New Novel Review* 2, no. 2 (April 1995): 19–29.

77. Claude Simon, *The Invitation,* trans. Jim Cross (Normal, IL: Dalkey Archive, 1991), 45.

78. Simon 45, 37.

79. SB, letter to Axel Kaun, *Disjecta* 171.

80. SB, *Watt* 78, 79.

81. SB, *Watt* 80.

82. SB, *Watt* 81.

83. SB, *Dream of Fair to Middling Women* 12.

84. Megged 57.

85. SB, *Watt* 82.

86. SB, *The Unnamable* 173.

87. SB, *Three Dialogues* 125.

88. Cf. Megged 67.

89. Wendy Steiner, *Pictures of Romance: Form against Context in Painting and Literature* (Chicago: University of Chicago Press, 1988), 187. It should be noted that my use of *contextualism* differs somewhat from Steiner's. Whereas I mean the integration of the quotidian within the artwork in ways that do not necessarily further it aesthetically, Steiner intends the dependence of interpretation on the spectator or reader's knowledge of a given reality.

90. See Feshbach's excellent essay "Marcel Duchamp or Being Taken for a Ride . . . ," esp. 548–56.

91. Jessica Prinz, *Art Discourse / Discourse in Art* (New Brunswick: Rutgers University Press, 1991), 13, 22.

92. Marcel Duchamp, *Salt Seller: The Writings of Marcel Duchamp (Marchand du Sel),* ed. M. Sanouillet and E. Peterson (New York: Oxford University Press, 1973), 141; cited in Feshbach, "Marcel Duchamp" 545.

93. I take my inspiration here from Mary Ann Caws's notion of stressed image in *The Art of Interference* (Princeton: Princeton University Press, 1989).

94. Duchamp, *Salt Seller* 141; cited in Feshbach, "Marcel Duchamp" 544.

95. Lucien Dällenbach, *The Mirror in the Text,* trans. Jeremy Whiteley with Emma Hughes (Chicago: University of Chicago Press, 1989), 103. For a full account of the transcendental *mise en abyme,* see 101–6.

96. Brater, *Beyond Minimalism* 19.

97. Ruby Cohn, "Beckett's Theater Resonance," in *Samuel Beckett: Humanistic Perspectives,* ed. Morris Beja, S. E. Gontarski, and Pierre Astier (Columbus: Ohio State University Press, 1983), 8.

98. SB, *Play* 157.

99. Brater, *Beyond Minimalism* 79.

100. See the interpretations of reductionism cited in Gerhard Hauck in *Reductionism in Drama and the Theatre: The Case of Samuel Beckett* (Potomac, MD: Scripta Humanistica, 1992), 70, 73–74; specifically, those of Patrick Murray, Colin Duckworth, Alec Reid, and A. Alvarez.

101. Cited in Heidegger, "The Origin of the Work of Art," in *Poetry, Language, Thought,* trans. Albert Hofstadter (New York: Harper and Row, 1971), 80.

102. Steiner 6.

103. Edith Kern, "Drama Stripped for Inaction: Beckett's *Godot,*" *Yale French Studies* 14 (Winter 1954–55): 41; cited in Hauck 85–86.

104. Vivian Mercier, "The Mathematical Limit," in *Nation* 187, Feb. 14, 1959, 145. Hugh Kenner, *Samuel Beckett: A Critical Study* (New York: Grove Press, 1961), 135; cited in Hauck 86.

105. I refer the reader to Hauck's excellent analysis of the reductions between the plays and those within the plays in his *Reductionism in Drama and the Theatre* 95–142.

106. SB, cited in Brater, *Beyond Minimalism* 24.

107. SB, cited in Hauck 206n. 17.

108. Cf. Calvin Tomkins, *Duchamp: A Biography* (New York: Henry Holt, 1996), 413.

109. Cited in Tomkins 415.

110. Jean Baudrillard, "The Evil Demon of Images and the Precession of Simulacra," in *Postmodernism: A Reader,* ed. Thomas Docherty (New York: Columbia University Press, 1993), 194.

111. Tomkins 414.

112. SB, *A Piece of Monologue* 268, 269.

113. Cohn, "Beckett's Theater Resonance" 14–15.

114. Danto, *The Transfiguration of the Commonplace* (Cambridge: Harvard University Press, 1981), 84.

115. Cited in Danto, *Transfiguration of the Commonplace* 12.

116. See Danto, *The Philosophical Disenfranchisement of Art* (New York: Columbia University Press, 1986), xv.

117. Danto, *Philosophical Disenfranchisement of Art* xv.

Chapter 3

1. If John Pilling could write in 1976 that "the most important neglected part of Beckett's total *oeuvre* to date is undoubtedly his criticism" (*Samuel Beck-*

ett [London: Routledge and Kegan Paul], 13), fortunately this is no longer so. As the defining point of departure for almost every study of it I am aware of, however, the attempt to locate a cohesive aesthetic substantially undermines the fundamental role played by negation and paradox in what was never meant to harbor a rational exposition on art.

2. "Je ne suis pas critique et n'ai à exprimer publiquement aucun jugement d'ordre littéraire (ou autre)." SB, letter to Jacoba van Velde; cited in Truusje van de Kamp, "Weinig talent voor geluk: De congenialiteit tussen Samuel Beckett en Jacoba van Velde," *BZZLLETIN* 193 (1992): 83. Unless otherwise indicated, all translations from the Beckett-Duthuit correspondence and Beckett and Duthuit's other writings on art, in this chapter and those that follow, are by Léone Seltzer in collaboration with me.

3. The reader is referred to Rupert Wood's fine analysis of this deconstructive process, "An Endgame of Aesthetics: Beckett as Essayist," in *The Cambridge Companion to Beckett,* ed. John Pilling (Cambridge: Cambridge University Press, 1994).

4. Cited in Pilling, *Samuel Beckett* 22.

5. Lawrence E. Harvey, *Samuel Beckett: Poet and Critic* (Princeton: Princeton University Press, 1970), 435.

6. SB, *Proust* 46–47.

7. SB, "Homage to Jack B. Yeats," *Disjecta* 149.

8. "Je me rappelle un tableau au Zwinger, un saint Sébastien d'Antonello da Messina, formidable, formidable. C'était dans la première salle, j'en étais bloqué chaque fois. Espace pur à force de mathématique, carrelage, dalles plutôt, noir et blanc, en longs raccourcis à vous tirer des gémissements, [. . .] tout ça envahi, mangé par l'humain. Devant une telle oeuvre, une telle victoire sur la réalité du désordre, sur la petitesse du coeur et de l'esprit, on manque de se perdre" (cited in Pascale Casanova, Beckett l'abstracteur [Paris: Seuil, 1997], 162–63).

9. Harvey 434, 441.

10. It is the latter that Ruby Cohn no doubt has in mind when, in her remarkably succinct introduction to *Disjecta,* she refers to "Beckett's radical esthetic of failure" (foreword to *Disjecta* 15).

11. George Steiner, "Leastness," *New Yorker,* September 16, 1996, 92.

12. Richard Begam, *Samuel Beckett and the End of Modernity* (Stanford: Stanford University Press, 1996), 9.

13. SB, *Stories and Texts for Nothing* 107.

14. SB, "Not I," *Collected Shorter Plays of Samuel Beckett* 217.

15. SB, *How It Is,* trans. by the author (New York: Grove Press, 1964), 7. "Ma vie dernier état mal dite mal entendue mal retrouvée mal murmurée dans la boue brefs mouvements du bas du visage pertes partout" (*Comment C'est* [Paris: Minuit, 1961], 9).

16. SB, *The Unnamable* 7.

17. SB, *Worstward Ho, Nohow On* 101.

18. See James Acheson, *Samuel Beckett's Artistic Theory and Practice* (London: Macmillan, 1997), esp. 1–16, 81–83.

19. I am enormously grateful to Léone Seltzer for her many insightful com-

ments regarding this correspondence. Much of what I will go on to say here was inspired by her thinking.

20. Beckett's association with the influential magazine, published first by Eugene and Maria Jolas and beginning in 1948 by Duthuit, was not new: His essay on Joyce, "Our Exagmination Round His Factification for Incamination of Work in Progress," had appeared there in 1929, along with his first short story, "Assumption." And a poem, "For Future Reference," was published there in 1930. Subsequently, the short story "Sedendo et Quiescendo" (1932), the review of Denis Devlin's *Intercessions* (1938), his translation of Apollinaire's "Zone" (1950), and additional poems of his own would appear in the magazine as well.

21. Deirdre Bair, *Samuel Beckett* (New York and London: Harcourt Brace Jovanovich, 1978), 391.

Among the translated texts on art are Paul Eluard's seven poems on Picasso; René Char's poem "Courbet: Les Casseurs de caillou" ("Courbet: The Stone-Breakers"); "Picasso Goes for a Walk" by Jacques Prévert; Alfred Jarry's "The Painting Machine"; Francis Ponge's "Braque, or Modern Art as Event and Pleasure"; and Duthuit's own eminent essay, "Matisse and Byzantine Space." All six appeared in *Transition 49*, no. 5 (Knowlson, *Damned to Fame* 689n. 58). Several translations, at Beckett's request, went unsigned, and, as his correspondence with Duthuit indicates, there were many more of them than has previously been acknowledged. (See Knowlson, *Damned to Fame* 334 and 689nn. 57–58). Interestingly, Mary Ann Caws, the critic and Char's Anglo-American translator, has told me that there was an "enormous amount" of Char poetry translated by Beckett. She knows this from Tina Jolas, the poet's wife, and Eugene and Maria Jolas's daughter. Other essays by Duthuit were translated or revised by Beckett for publication elsewhere: "Vuillard and the Poets of Decadence," for example, and "Sam Francis ou l'Animateur du Silence" (Sam Francis, or the Animator of Silence). And Beckett assisted Ralph Mannheim with the translation of Duthuit's book *The Fauvist Painters*.

22. SB, "MacGreevy on Yeats," *Disjecta* 95.

23. Beckett visited his father's family in Germany a number of times (his relationship with his cousin Peggy Sinclair is well documented), and he benefited not only from his uncle's knowledge of contemporary German painting but from the artistic/social milieu. He also met a number of German artists through the art historian Willi Grohmann, whom he met in Dresden in 1937; through the son of critic, gallery director, and collector Max Sauerlandt; and others. They included, most notably, Karl Kluth, Willem Grimm, Karl Ballmer, Hans Ruwoldt, Paul Bollmann, Gretchen Wöhlwill, and Eduard Bargheer (Knowlson, *Damned to Fame* 222). My sources for all of this biographical information are Knowlson, *Damned to Fame* 222, 266, 334–35; Mercier 90–91, 95–96; and Bair 391–92.

24. Bair describes Duthuit's long lunches with his painter friends at "a small restaurant bar" across the street from his office at which Beckett was "usually present" (391–92). Knowlson writes of gatherings around a big stove at Duthuit's office that took place "most days at half past five to smoke and talk" and were followed by drinks at the Café des Trois Maronniers across the road. He claims, however, that Beckett "only came occasionally" (*Damned to Fame* 335). In an article in *Arts Magazine* Alan Jones adds to the list of those most often

in attendance at Duthuit's lunch table Sam Francis, Tal Coat, André Masson, Giacometti, and, "on occasion, Duthuit's father-in-law, Henri Matisse" and notes that "Beckett joined them each day, and drank them under the table each night" (66, no. 2 [Oct. 1991]: 28).

25. Knowlson, *Damned to Fame* 266.

26. Knowlson, *Damned to Fame* 352.

27. Knowlson, *Damned to Fame* 186.

28. Knowlson, *Damned to Fame* esp. 187.

29. SB, "La Peinture des van Velde," *Disjecta* 123.

30. SB, "La Peinture des van Velde" 119–20.

31. SB, "La Peinture des van Velde" 119.

32. SB, "La Peinture des van Velde" 120.

33. SB, "La Peinture des van Velde" 125.

34. SB, "La Peinture des van Velde" 127.

35. SB, "La Peinture des van Velde" 126.

36. SB, "La Peinture des van Velde" 124, 128.

37. SB, "La Peinture des van Velde" 130.

38. SB, "La Peinture des van Velde" 123.

39. SB, "Les Deux Besoins," *Disjecta* 55.

40. SB, "Les Deux Besoins" 56.

41. SB, "La Peinture des van Velde" 119, 125.

42. SB, "La Peinture des van Velde" 127.

43. SB, "Les Deux Besoins" 55, 56.

44. SB, "Dante . . . Bruno . Vico .. Joyce" 19, 28.

45. SB, letter to Axel Kaun, *Disjecta* 172.

46. SB, "Intercessions by Denis Devlin," *Disjecta* 91.

47. Cf. SB, "Dante . . . Bruno . Vico .. Joyce" 22.

48. SB, "Intercessions by Denis Devlin" 92.

49. SB, "Les Deux Besoins" 56.

50. SB, "MacGreevy on Yeats" 97.

51. Harvey 433.

52. Anne d'Harnoncourt, introduction to *Marcel Duchamp*, ed. Anne d'Harnoncourt and Kynaston McShine (New York: Museum of Modern Art, 1973), 38. "The Large Glass," for instance, may be viewed, as it is by Calvin Tomkins, as a response to the question Duchamp had asked himself, two years before beginning it, in a 1913 note: "Can one make works which are not works of 'art'?" (*Duchamp: A Biography* [New York: Henry Holt, 1996], 5).

53. SB, "Peintres de l'Empêchement" 135. Interestingly, Beckett apparently made a similar distinction in literature. The notes of Rachel Dobbin (Burrows) on Beckett's 1931 lectures at TCD contain the following: "Balzac's greatness—*power of transcribing surface—cataloguing. Detail apprehended—but whole interest on surface—makes one impatient. Not interesting.* Proust—baffled by surface—wants to get below."

54. G. W. F. Hegel, *Aesthetics: Lectures on Fine Arts*, trans. T. M. Knox (Oxford: Oxford University Press, 1975), 604.

55. SB, "La Peinture des van Velde" 119.

56. Knowlson, *Damned to Fame* 335.

57. Duthuit's publications are wonderfully diverse. His subjects range from Byzantine art and Coptic sculpture to Renoir, the Fauves, and contemporary American art.

58. Anthony Cronin, *Samuel Beckett: The Last Modernist* (New York: HarperCollins, 1996), 396.

59. In her preface to *Trois Dialogues,* the French translation of the text published by the Editions de Minuit in 1998, Edith Fournier states unequivocally that "Georges Duthuit n'a pas du tout collaboré à la rédaction des *Trois Dialogues*" (Georges Duthuit did not at all collaborate in the writing of the *Three Dialogues*) (9). In my article "Three Dialogues: One Author or Two?" I address the accuracy of this statement and of the omission of Duthuit's name from a title, which, originally and in several subsequent publications, contained it (*Journal of Beckett Studies* 8, 2 [Spring 1999]: 61–72).

60. "Je suis incapable de repenser notre débat, incapable de reprendre des choses plus ou moins acceptables dites déjà. Je ne peux remplacer ta voix: celle qui me rappelle qu'il ne s'agit pas que de moi" (SB, letter to Georges Duthuit, June 1949[?], Duthuit Archives). Rationalizing, in March 1949, his joint undertaking of yet another piece on Bram, moreover, he told MacGreevy that "this time Duthuit is there to mollify my generalisations" (SB, letter to MacGreevy, dated March 27, 1949, TCD Library).

61. "Impossible de valoriser ou dévaloriser l'être: il est ce qu'il est. Absurde de demander si l'existence a un sens, en tant que telle: elle est ce qu'elle est" and "Tes études sur van Velde ne peuvent se comparer à rien de connu en critique. Elles sont question de vie ou de mort, ni plus ni moins." From unpaginated and undated typescript documents of Georges Duthuit held in Duthuit Archives. (Accents have been added where missing in all citations from these documents.)

62. SB, letters to Tom MacGreevy, dated April 15, 1954, and to Robert Butler Digby (lecturer in English, TCD), dated October 24, 1959, TCD Library.

63. "Tout ce qui est pensée n'est pas de moi. c'est la pensée vite lasse, vite éteinte, c'est alors que je sors, répentant, trébuchant. Idem pour le goût [. . .]."

The year, absent in the letter, has been given by Rémi Labrusse in his transcription of the correspondence. In the discussion that follows all letters cited are housed in the Georges Duthuit Archives, maintained by his son, Claude, at the Héritiers Matisse in Paris.

64. "Moi avec mon coupe-fil je perds facilement la tête."

65. "Ayant cru discerner chez Yeats la seule valeur qui me demeure encore un peu réelle, valeur que je ne veux essayer de cerner et dont les si respectables considérations de pays et de facture ne peuvent rendre compte, je deviens littéralement aveugle pour tout le reste. C'était déjà la même chose quand il s'agissait de Bram."

66. Heisenberg's principle describes the impossibility of simultaneously measuring the position and velocity of electrons in motion. See, for example, Gordon S. Armstrong, *Samuel Beckett, W. B. Yeats, and Jack Yeats* (Lewisburg: Bucknell University Press, 1990), 29. It might be noted, however, that, when asked by William York Tindall if he had read Heisenberg, Beckett replied, in correspondence dated 1963, that, if he had, he "succeeded in repressing it" (Bair 560). Similarly, other critics have begun to address the complexities of Beckett's inde-

terminacy through chaos theory. See, for example, John L. Kundert-Gibbs, "Continued Perception: Chaos Theory, the Camera, and Samuel Beckett's Film and Television Work," in *Samuel Beckett and the Arts: Music, Visual Arts, and Non-Print Media,* ed. Lois Oppenheim (New York: Garland Publishing, 1998), 365–84.

67. "Relis tout ce que tu as écrit sur Bram, mon cher ami, et dis-moi si, en dix endroits, ce n'est pas cette rechereche de cet absolu, par la procession et non par la conversion, qui t'obsède et te désespère" (undated fragment by Georges Duthuit, Duthuit Archives).

68. Rémi Labrusse, "Beckett et la peinture: le temoignage d'une correspondance inédite," *Critique* 519–20 (Aug.–Sept. 1990): 671.

69. "Un tableau n'a de valeur qu'à travers l'état d'esprit où il vous place, par l'orientation qu'il donne à votre pensée, par l'impulsion qu'il communique à vos actes" (undated letter from Georges Duthuit to SB; cited in Labrusse, "Beckett et la peinture" 671). Labrusse offers 1948 as the probable year of this letter.

70. Georges Duthuit, in SB, "Three Dialogues" 101.

71. "Vous me rassurez en disant qu'on peut du moins dire d'un tableau qu'il traduit, avec plus ou moins de pertes, d'absurdes et mystérieuses poussées vers l'image, qu'il *** plus ou moins adéquat vis-à-vis d'obscures tensions internes. Mais puisque nous sommes au départ des tondus et non pas des tendus, la question devient de savoir jusqu'à quel point nos cheveux poussent, et la force y attenante depuis l'histoire du temple déboulonné, à mesure que le tableau entre dans notre peau ou que nous entrons dans la sienne. Histoire de tension peut-être, communiqué par le tendu, reçue par le tondu. On change de tension ensemble. On entre ensemble dans le temps de la création" (undated letter of Georges Duthuit to SB, Duthuit Archives).

72. SB, letter to to Georges Duthuit, August 11, 1948; cited in Labrusse, "Beckett et la peinture" 673.

73. "Le fait est que la question ne m'intéresse pas" (SB, letter to Georges Duthuit, May 26, 1949; cited in Labrusse, "Beckett et la peinture" 672).

74. "Il n'y a pas de litige entre nous. Il y a simplement peut-être que nous n'arrivons pas à dégager, avant d'essayer d'en parler, ce dont il s'agit. Il y a à cela visiblement trop de raisons pour que j'aie le courage de les aborder. Je crois finalement que nos préoccupations sont de deux ordres très différents et comme séparées par une zone d'ombre où, exilés l'un et l'autre, nous trébuchons vainement vers un point de rencontre" (SB, letter to Georges Duthuit, March 2, 1954, Duthuit Archives).

75. SB, "Three Dialogues" 125, 113, 112.

76. "Ce n'est donc pas avec moi qu'on puisse parler art et ce n'est pas là-dessus que je risque d'exprimer autre chose que mes propres hantises" (SB, letter to Georges Duthuit, March 2, 1954; cited in Knowlson, *Damned to Fame* 248; translation by Knowlson).

77. Cf. Adriaan van der Weel and Ruud Hisgen: "The dialogues recorded by Juliet are full of echoes. Van Velde echoes himself; Beckett echoes himself; Van Velde echoes Beckett and Beckett Van Velde" (introduction to Juliet, *Conversations with Samuel Beckett and Bram van Velde,* trans. Janey Tucker [Leiden: Academic Press, 1995], 3).

78. Bram van Velde; cited in Juliet 110, 123, 84, 25.

79. Bair 394.

80. "Je tendrai irrésistiblement à ramener au mien le cas de Bram, puisque c'est là la condition de pouvoir y être et en parler" (SB, letter to Georges Duthuit, March 9, 1949). This letter is printed in *Bram van Velde: 1895–1981*, catalogue ed. Rainer Michael Mason (Geneva: Musée RATH, 1996), 45–48. (This citation on 45.)

81. "Je vais encore faire quelques efforts mais ce seront les tout derniers. J'ai fait tout ce qui est en mon pouvoir de faire pour Bram, c'est fini" (SB, letter to Georges Duthuit, Summer 1949?; cited in Labrusse, "Beckett et la peinture" 677).

82. "Oui, nous ferons autre chose, autre chose que chercher là où ça suffit les trouvailles, autre chose que rechercher tout court" (SB, letter to Georges Duthuit, August 22, 1948; cited in Labrusse, "Beckett et la peinture" 672). See Labrusse on Beckett and the van Velde "affaire" (as Beckett referred to it): 677–80.

83. Conversation of LO with Louis le Brocquy that took place in Paris, May 25, 1996; letter from Louis le Brocquy to LO dated May 27, 1996; Anne Madden le Brocquy, *Seeing His Way* (Dublin: Gill and Macmillan, 1994), 215.

84. "Nous ne parlons pas de la même chose, Bram et moi, il me semble. Il veut vaincre, il y revient tout le temps. Et ces splendeurs où j'entends l'hymne de l'être fonçant à rebours et libre enfin dans les quartiers interdits, ce sont peut-être des splendeurs comme tant d'autres, rapport à l'espèce bien sûr, celle de la corde tendue où l'on se vautre" (SB, letter to Georges Duthuit, early in 1949?; cited in Labrusse, "Beckett et la peinture" 679).

85. "Mais je commence à penser qu'il est trop tard et que ce sera jusqu'à la fin ces formidables tentatives de rétablissement vers une cime furieusement rêvée, et que ce sera chez lui (Bram) jusqu'à la fin la seule beauté de l'effort et de l'échec, au lieu de celle tellement calme et même gaie, dont j'ai la prétention de me laisser hanter" (March 2, 1949; cited in Labrusse, "Beckett et la peinture" 679).

86. Labrusse, "Beckett et la peinture" 680.

87. This kinship, often reduced to the supposed despair of their art, resides more in the uncertain relation of emotional and artistic despondency to the painting and writing in question. This passage from a letter by painter Pierre Alechinsky is telling: "Bram van Velde, Samuel Beckett, Jacques Putman et moi, avons fait ensemble le voyage de retour Berne-Paris en voiture au moment de la rétrospective Bram à la Kunsthalle, j'étais au volant et par une sorte de timidité (j'avais trente ans) m'étais mis à siffloter les thèmes on ne peut plus désespérés du quatuor 'La jeune fille et la mort'—manière absurde de garder à part moi que l'art de BvV est moins désespéré qu'il ne paraît, n'est pas désespéré du tout . . . Je ne possédais pas encore mes arguments, fort simples d'ailleurs: c'est *avant* et *après* que Bram était désespéré, jamais *pendant* les trop brefs et rares moments où il peignait" [Bram van Velde, Samuel Beckett, Jacques Putman, and I together made the return trip from Bern to Paris by car at the time of the Bram retrospective at the Kunsthalle. I was at the wheel and began softly whistling the utterly hopeless themes of the quartet "La Jeune fille et la mort"—an absurd way of keeping to myself that Bram van Velde's art is less despairing than it appears, is not despairing at all . . . I had not yet formulated my argument, a rather simple one more-

over: It is *before* and *after* that Bram despaired, never *during* the brief and rare moments when he painted].

As a point of information potentially useful with regard to sources, I cite an additional excerpt from this letter: "Comme un écho, peut-être un boomerang ou mon délire (cf. *Pale fire*, de Nabokov), ma surprise plus tard de retrouver ce déchirant Shubert-là sur la bande sonore de 'Tous ceux qui tombent'" (Like an echo, perhaps a boomerang or my delirium (cf. *Pale Fire* by Nabokov), my surprise at later finding this anguishing Shubert on the soundtrack of "All That Fall") (letter from Pierre Alechinsky to LO, August 12, 1995).

88. Claire Stoullig, "Bram van Velde, un certain état de la fortune critique," catalogue *Bram van Velde*; cited in Labrusse, "Beckett et la peinture" 677.

89. "Tout le mal que je pense du rôle que j'ai joué dans l'histoire van Velde" (SB, letter to Georges Duthuit, May 26, 1949; cited in Labrusse, "Beckett et la peinture" 677).

This same integrity may, in fact, have been responsible for, among other things, Beckett's not having disapproved of Ruby Cohn's ommission of Duthuit's name from the *Three Dialogues* title in *Disjecta*, a situation she now intends to rectify in the next edition of that volume. As I suggest in the article cited in n. 59, a reverse form of generosity may well have been at play in his taking full credit for what he considered unworthy of an attribution shared with his friend.

90. "J'ai lu aussi sur la peinture, avec vos notes, mais n'ai rien pu y ajouter. Je crois que c'est le côté descriptif qui m'a paralysé, ou plutôt qui ne m'a pas déparalysé" (SB, letter to Georges Duthuit, March 1, 1949; cited in Labrusse, "Beckett et la peinture" 673).

91. "La définition de l'artiste comme celui qui ne cesse d'être *devant*" (SB, letter to Georges Duthuit, March 9, 1949, in Mason, *Bram van Velde* 46.

92. "Je profite d'un instant (passager) de lucidité pour te dire que je crois voir ce qui nous sépare, ce sur quoi nous finissons toujours par buter, après bien des locutions inutiles. C'est l'opposition possible-impossible, richesse-pauvreté, possession-privation, etc. etc. A ce point de vue les Italiens, Matisse, Tal Coat et tutti quanti sont dans le même sac, en chanvre supérieur, du côté de ceux qui, ayant, veulent encore, et, pouvant, davantage. Davantage de quoi? Ni de beauté, ni de vérité, d'accord, si tu veux, ce n'est pas sûr, ce sont des concepts fourre-tout, mais d'un rapport soi-le reste qui autrefois s'exprimait en termes de beauté et de vérité et qui maintenant cherche d'autres répondants, et ne les trouve pas, malgré des airs voulus de capharnaüm, vide et périclitation" (SB, letter to Georges Duthuit, June 9, 1949; cited in Labrusse in "Hiver 1949: Tal-Coat entre Georges Duthuit et Samuel Beckett," in *Tal Coat devant l'image*, ed. Claire Stoullig et al., exhibition catalogue [Geneva: Musées d'Art et d'Histoire, 1997], 110).

93. "Tu opposes un temps quotidien, utilitaire, à un temps vital, de tripes, d'effort privilégié, le vrai. Tout ça revient à vouloir sauver une forme d'expression qui n'est pas viable. Vouloir qu'elle le soit, travailler pour qu'elle le soit, lui en donner l'air, c'est donner dans la même pléthore que depuis toujours, dans la même comédie. Apoplectique, pétant des artères, comme Cézanne, comme van Gogh, voilà où il en est, le pâle Tal Coat, et où en serait Masson, s'il le pouvait. Pas la peine de parler de détails. Existe-t-il, peut-il exister, ou non, une peinture pauvre, inutile sans camouflage, incapable de l'image quelle qu'elle soit, dont

l'obligation ne cherche pas à se justifier?" (SB, letter to Georges Duthuit, June 9, 1949; cited in Labrusse, "Hiver 1949" 111).

94. SB, "Three Dialogues" 102, 103, 125.

95. SB, "La Peinture des van Velde" 118.

96. SB, "Three Dialogues" 124–25.

97. SB, "Three Dialogues" 110.

98. Harvey 415, 417, 418.

99. "Une telle densité, c'est à dire simplicité, d'être, que seule l'éruption peut en avoir raison, y apporter le mouvement, en soulevant tout d'un bloc" (SB, letter to Georges Duthuit, March 9, 1949, in Mason, *Bram van Velde* 46–47).

100. Cohn, foreword to *Disjecta* 10.

101. SB, *Dream of Fair to Middling Women* (New York: Arcade Publishing, 1992), 138–39.

102. SB, "An Imaginative Work!" 90.

103. SB, "Intercessions by Denis Devlin" 91.

104. Harvey 419.

105. G. W. F. Hegel, *Aesthetics;* cited in Danto, *Philosophical Disenfranchisement of Art* 135.

106. Charles Juliet, *Conversations with Samuel Beckett and Bram van Velde,* trans. Janey Tucker (Leiden: Academic Press, 1995), 165.

107. Conversation between LO and le Brocquy, May 25, 1996.

108. Harvey 435.

109. "Je ne veux rien prouver [. . .]" (SB, letter to Georges Duthuit, March 9, 1949, in Mason, *Bram van Velde* 47).

110. SB, "Three Dialogues" 126. As art critic Jacques Putnam reminds us, with this segment of the "Three Dialogues" we are no longer even "in the recognized sphere of painting" at all (Samuel Beckett, Georges Duthuit, and Jacques Putnam, *Bram van Velde,* trans. Olive Classe and Samuel Beckett [New York: Grove Press, 1960], 27–28).

111. Daniel Albright, *Representation and the Imagination* (Chicago: University of Chicago Press, 1981), 162.

112. "Voici où nous en sommes, ou plutôt où je feins de me tenir solidement, ce qui n'est pas du tout le cas, afin de pousser la dialectique aussi loin que possible, simple question d'article à faire. Tu verras à la fin que je suis nullement borné à ma position" (undated letter of Georges Duthuit to SB).

113. "Cette malheureuse composition, qu'on m'a arrachée à coups de lèche, à une époque où déjà je me foutais de Geer comme de mon dernier suspensoir, je ne l'ai ni sous la main ni dans la tête. Je crois seulement me rappeler que je me suis laissé aller, afin d'en finir plus vite, à une antithèse dont je suis le premier à goûter toute l'absurdité, tout en lui reconnaissant une certaine valeur explicative, ce qui est loin de me consoler" (SB, letter to Georges Duthuit, May 26, 1949, Duthuit Archives).

114. Cited in Anne d'Harnoncourt, intro., *Marcel Duchamp,* ed. Anne d'Harnoncourt and Kynaston McShine (New York: Museum of Modern Art, 1973), 38.

115. H. Porter Abbott, *Beckett Writing Beckett* (Ithaca: Cornell University Press, 1996), 60.

Chapter 4

1. Most notably, by Eugene F. Kaelin, *The Unhappy Consciousness: The Poetic Plight of Samuel Beckett* (Dordrecht: D. Reidel, 1981); and Lance St. John Butler, *Samuel Beckett and the Meaning of Being* (London: Macmillan, 1984).

2. Stanton B. Garner Jr., *Bodied Spaces* (Ithaca: Cornell University Press, 1994), offers an excellent overview of the deconstructive criticism, as it appears in Steven Connor, *Samuel Beckett: Repetition, Theory, and Text* (Oxford: Basil Blackwell, 1988); Lance St. John Butler and Robin J. Davis, eds., *Rethinking Beckett: A Collection of Critical Essays* (London: Macmillan, 1990); Thomas Trezise, *Into the Breach: Samuel Beckett and the Ends of Literature* (Princeton: Princeton University Press, 1990); and others. See Garner, *Bodied Spaces* 18–26.

3. Deirdre Bair makes much of Geulincx's impact on Beckett, particularly as far as the writing of *Murphy* is concerned (*Samuel Beckett* [New York and London: Harcourt Brace Jovanovich, 1980], 91–92). Hugh Kenner devotes an entire chapter to Geulincx's influence in *Samuel Beckett: A Critical Study* (Berkeley and Los Angeles: University of California Press, 1968), while Anthony Cronin attests to how difficult it is to assess (*Samuel Beckett: The Last Modernist* [New York: HarperCollins, 1997], 230). Knowlson stresses Beckett's fascination with the philosopher and situates the connections with *Murphy* in the context of the writer's own statements on his reading of him (*Damned to Fame* [New York: Simon and Schuster, 1996], 206–7).

4. Knowlson, *Damned to Fame* 248, 271.

5. From a 1961 interview with Gabriel D'Aubarède; cited in Locatelli 14.

6. Raymond Federman and John Fletcher report in their bibliography, *Samuel Beckett: His Works and His Critics* (Berkeley: University of California Press, 1970), as follows: "In reply to the question, 'Why did you submit *L'Expulsé* to *Fontaine* and *Suite* to *Temps Modernes* in 1946? Had you any contacts with the editors?' Mr. Beckett writes: 'I knew Sartre but not Max-Pol Fouchet . . . at the time'" (49). And Deirdre Bair, in *Simone de Beauvoir: A Biography* (New York: Summit Books, 1990), quotes her subject thus: "[Beckett] never liked Sartre and thought we were both out of touch with modern literature. It gave him pleasure to extend his dislike to me" (346).

7. In a letter addressed to LO on August 5, 1995, Simone Merleau-Ponty, the philosopher's wife, wrote the following:

Je ne sais pas si Beckett et mon mari se sont connus à l'E.N.S., mais ce dont je suis sûre, c'est qu'il n'y a pas eu de vraies relations entre eux au cours des années pendant lesquelles j'ai vécu avec mon mari, depuis la guerre jusqu'à sa mort en 1953. Pas de rencontres suivies, pas d'échanges amicaux, pas de correspondance écrite . . . Mon mari connaissait certainement l'oeuvre de Beckett, il a y plusieurs livres de lui dans la bibliothèque, mais je n'ai pas trouvé de notes de lectures dans ses papiers.

[I don't know if Beckett and my husband knew each other at the Ecole Normale Supérieure, but of what I am sure is that there was no real relationship between them during the years I lived with my husband, from the war until

his death in 1953. No regular meetings, no friendly exchanges, no written correspondence . . . My husband certainly knew Beckett's work, there are several of his books in the library, but I have not found notes from his readings in his papers.] (Translation mine)

Jean Beaufret, the well-known Heidegger specialist, was at the ENS when Beckett was there. It is possible that Merleau-Ponty became known to Beckett through Beaufret, with whom Beckett maintained a close friendship. This, however, is undocumented and, given the Merleau-Ponty's student status at the time, would presumably not be of great significance as far as my present purposes are concerned.

8. It was not only from Mme Merleau-Ponty that I learned of her husband's knowledge of Beckett's work but from John Calder, Beckett's British publisher, as well. It was also Calder who, in March 1997, spoke to me of the friendship between Merleau-Ponty and Duthuit.

9. Knowlson, *Damned to Fame* 122 (undated letter from Beckett to Tom MacGreevy; Knowlson gives July 1930 as the probable date).

10. Knowlson, *Damned to Fame* 248 (letter to Tom MacGreevy, Sept. 21, 1937).

11. SB, letter to Axel Kaun, 170.

12. St. John Butler, *Samuel Beckett* 89.

13. Merleau-Ponty, "An Unpublished Text by Maurice Merleau-Ponty: A Prospectus of His Work," trans. Arleen B. Dallery, in *The Primacy of Perception,* ed. James Edie (Evanston: Northwestern University Press, 1964), 3.

14. Merleau-Ponty, *Primacy of Perception* 42.

15. Garner 28.

16. SB, "La Peinture des van Velde" 132.

17. Georges Godin and Michaël La Chance, *Beckett* (Quebec: Le Castor Astral, 1994), 67.

18. Cf. Gary B. Madison, "Did Merleau-Ponty Have a Theory of Perception?" in *Merleau-Ponty: Hermeneutics and Postmodernism,* ed. Thomas W. Busch and Shaun Gallagher (Albany: State University of New York Press, 1992), 86.

19. Madison, "Did Merleau-Ponty Have a Theory of Perception?" 88.

20. Merleau-Ponty, "Unpublished Text by Maurice Merleau-Ponty" 3.

21. Merleau-Ponty, *Phenomenology of Perception,* trans. Colin Smith (London: Routledge and Kegan Paul, 1962), 407; cited in Madison 88.

22. Cf. Michael B. Smith, "Merleau-Ponty's Aesthetics," in *The Merleau-Ponty Aesthetics Reader,* ed. Galen A. Johnson (Evanston: Northwestern University Press, 1993), 194.

23. Beckett, "Three Dialogues" 101–2.

24. SB, "For Avigdor Arikha," *Disjecta* 152.

25. Smith, "Merleau-Ponty's Aesthetics" 208.

26. I am grateful to Ruby Cohn for identifying Gautama as another title for Buddha. Buddha's real name was Siddhartha Gautama.

27. SB, "Henri Hayden, homme-peintre," *Disjecta* 146.

28. I do not refer to truth here in the Enlightenment sense of what is empirically demonstrable but in the Greek sense of *aletheia*.

29. SB, "Humanistic Quietism," *Disjecta* 69.

30. Notebook 2, November 15, 1936; cited in Knowlson, *Damned to Fame* 222.

31. Cronin, *Samuel Beckett* 147.

32. Sidney Feshbach, "'Recognize Me if You Can': About Samuel Beckett's 'Whoroscope,'" forthcoming publication. This is by far the most comprehensive study of Beckett's poem undertaken to date.

33. SB, "Recent Irish Poetry," *Disjecta* 70.

34. SB, "The Essential and the Incidental," *Disjecta* 82.

35. Cited in Madison 88.

36. SB, "Peintres de l'empêchement" 136.

37. SB, "La Peinture des van Velde" 130.

38. Merleau-Ponty, *Phenomenology of Perception* 150–51; cited in Helen Fletcher Thompson, "From Metaphor to Meaning: Sartre, Merleau-Ponty and the Subject of Sight," in *Analecta Husserliana*, ed. Marlies Kronegger and Anna-Teresa Tymieniecka (Dordrecht: Kluwer Academic Publishers, 1994), 42:194.

39. Merleau-Ponty, *Phenomenology of Perception* 320; cited in Thompson, "From Metaphor to Matter" 195.

40. Eyal Amiran, "Figuring the Mind: Totality and Displacement in Beckett's Fiction," *Journal of Beckett Studies* (Spring 1992): 46.

41. Hugh J. Silverman, "Between Merleau-Ponty and Postmodernism," in Busch and Gallagher, *Merleau-Ponty* 140.

42. SB, *Ill Seen Ill Said, Nohow On* (London: Calder Publications, 1992), 73.

43. See Antoinette Weber-Caflisch, "Lumière de Bram van Velde sur Beckett," in Mason, *Bram van Velde* 277.

44. SB, "Three Dialogues" 125.

45. "Ce n'est pas le rapport avec tel ou tel ordre de vis-à-vis qu'il refuse, mais l'état d'être en rapport tout court et sans plus, l'état d'être devant" (SB, letter to Georges Duthuit, in Mason, *Bram van Velde* 46).

46. "Quoi que je dise, j'aurai l'air de l'enfermer à nouveau dans une relation. Si je dis qu'il peint l'impossibilité de peindre, la privation de rapport, d'objet, de sujet, j'ai l'air de le mettre en rapport avec cette impossibilité, avec cette privation, devant elle. Il est dedans, est-ce la même chose? Il les est, plutôt, et elles sont lui, d'une façon pleine, et peut-il y avoir des rapports dans l'indivisible? Pleine? Indivisible? Evidemment pas. Ça vit quand même. Mais dans une telle densité, c'est-à-dire simplicité, d'être, que seule l'éruption peut en avoir raison, y apporter le mouvement, en soulevant tout d'un bloc" (SB, letter to Georges Duthuit, in Mason, *Bram van Velde* 46–47).

47. I take my inspiration here from Jacques Garelli's excellent essay "'Il y a le monde'" *Esprit* 6 (June 1982): 113–23.

48. Merleau-Ponty, *The Visible and the Invisible*, trans. Alphonso Lingis (Evanston: Northwestern University Pres, 1968), 113.

49. Merleau-Ponty, "Cézanne's Doubt," in Johnson, *Merleau-Ponty Aesthetics Reader* 65, 63.

50. Merleau-Ponty, "Cézanne's Doubt" 67.

51. Merleau-Ponty, "Cézanne's Doubt" 68.

52. Merleau-Ponty, "Cézanne's Doubt" 67.

53. Merleau-Ponty, "Indirect Language and the Voices of Silence" 80.

54. Merleau-Ponty, "Indirect Language and the Voices of Silence" 82.

55. Merleau-Ponty, "Eye and Mind" 131.

56. SB, letter to Tom MacGreevy, September 8, 1934; cited in Knowlson, *Damned to Fame* 187.

57. SB, "MacGreevy on Yeats" 97, 96.

58. SB, letter to Axel Kaun, 172.

59. Rupert Wood, "An Endgame of Aesthetics: Beckett as Essayist," in *The Cambridge Companion to Beckett*, ed. John Pilling (Cambridge: Cambridge University Press, 1994), 13.

60. Ontical inquiry is distinguished from ontological inquiry in its concern with entities and the facts that relate to them as opposed to Being.

61. Merleau-Ponty, "Indirect Language and the Voices of Silence" 79.

62. Merleau-Ponty, "Indirect Language and the Voices of Silence" 80.

63. Merleau-Ponty, "Indirect Language and the Voices of Silence" 83–84.

64. Merleau-Ponty, "Indirect Language and the Voices of Silence" 79.

65. SB, letter to Tom MacGreevy, September 8, 1934; cited in Knowlson, *Damned to Fame* 188.

66. Merleau-Ponty, "Indirect Language and the Voices of Silence" 80.

67. Merleau-Ponty, "Eye and Mind" 132.

68. Merleau-Ponty, "Eye and Mind" 130.

69. Merleau-Ponty, "Eye and Mind" 142.

70. SB, letter to Tom MacGreevy; cited in Knowlson, *Damned to Fame* 188.

71. Merleau-Ponty, "Cézanne's Doubt" 68.

72. SB, "Hommage to Jack B. Yeats," *Disjecta* 149.

73. Merleau-Ponty, "Indirect Language and the Voices of Silence" 103.

74. SB, letter to Tom MacGreevy; September 8, 1934, TCD Library.

75. Merleau-Ponty, "Indirect Language and the Voices of Silence" 116.

76. SB, "Three Dialogues" 125.

77. Merleau-Ponty, "Eye and Mind" 149.

78. "Il peut donc se détourner du visible immédiat sans que cela tire à conséquence" (SB, letter to Georges Duthuit, March 9, 1949, in Mason, *Bram van Velde* 45).

79. Merleau-Ponty, "Indirect Language and the Voices of Silence" 116.

80. SB, letter to Axel Kaun, 172.

81. SB, letter to Georges Duthuit, March 9, 1949, in Mason, *Bram van Velde* 46.

82. "Je ne vois pas du tout comment un travail pareil peut accrocher des considérations sur le temps et l'espace, ni pourquoi, dans ces toiles qui nous font grâce de ces catégories, on serait tenu de les remettre, sous des espèces plus riantes que celles familières de la division, extensibilité, compressibilité, mensurabilité, etc., à l'infini" (SB, letter to Georges Duthuit, in Mason, *Bram van Velde* 47).

83. Avigdor Arikha related to me in a conversation at the Marlborough

Gallery in New York (May 14, 1996) that literature and visual art for Beckett were like oil and water. Similarly, James Lord notes that Beckett told him, "I've never felt that painting or sculpture can express the same thing as literature. I don't see any parallel between the two arts" (Lord, *Some Remarkable Men* [New York: Farrar, Straus and Giroux, 1996], 289). And the following extract from a letter Beckett wrote to Duthuit apropos of the set for *Godot* makes the point again:

On a fait du décor de ballet et de théâtre, à leur grand dommage je crois, une annexe de la peinture. C'est du Wagnerisme. Moi je ne crois pas à la collaboration des arts, je veux un théâtre réduit à ses propres moyens, parole et jeu, sans peinture et sans musique, sans agréments. C'est là du protestantisme si tu veux, on est ce qu'on est. Il faut que le décor sorte du texte, sans y ajouter. Quant à la commodité visuelle des spectateurs, je la mets là où tu devines. Crois-tu vraiment qu'on puisse écouter devant un décor de Bram, ou voir autre chose que lui?

[Ballet and theater set design have been appropriated, at a great loss to them, I believe, to painting. This is Wagnerianism. For myself, I do not believe in the collaboration of the arts, I want a theater reduced to its own means, words and acting, without painting and without music, without amenities. This is a sort of Protestantism, if you want, we are what we are. The set must emanate from the text, without any addition. As for the visual commodity of the spectators, you know what you can do with that. Do you really believe that we can listen before a set by Bram, or see anything other than that?] (Cited in Rémi Labrusse, "Beckett et la peinture: le témoignage d'une correspondance inédite," *Critique* [Aug.–Sept. 1990]: 676)

84. Cited in Smith, "Merleau-Ponty's Aesthetics" 205.

85. Merleau-Ponty, "Eye and Mind" 132.

86. Alain Robbe-Grillet, *For a New Novel,* trans. Richard Howard (New York: Grove Press, 1965), 19.

87. Juliet, *Conversations with Samuel Beckett and Bram van Velde* 165.

88. Knowlson, *Damned to Fame* 249.

89. Knowlson, *Damned to Fame* 697n.

90. Knowlson, *Damned to Fame* 368.

91. SB, letter to Tom MacGreevy, March 27, 1949, TCD Library.

92. SB, "Three Dialogues" 125.

93. "Je ne peux plus écrire de façon suivie sur Bram ni sur n'importe quoi. Je ne peux pas écrire *sur*" (SB, letter to Georges Duthuit, March 9, 1949, in Mason, *Bram van Velde* 47–48.

94. Letter to Axel Kaun, 172.

Chapter 5

1. G. W. F. Hegel, *The Philosophy of Fine Art,* trans. F. P. B. Osmaston (New York: Hacker Art Books, 1975), 1:117.

2. Jean Hagstrum, *The Sister Arts* (Chicago: University of Chicago Press, 1958), xxii.

3. Martin Esslin, "Towards the Zero of Language," in *Beckett's Later Fiction and Drama*, ed. James Acheson and Kateryna Arthur (Houndsmills, Basingsyoke, and London: Macmillan, 1987), 35.

4. Jessica Prinz, "Resonant Images: Beckett and German Expressionism," in *Samuel Beckett and the Arts: Music, Visual Arts, and Non-Print Media*, ed. Lois Oppenheim (New York: Garland, 1999), 153.

5. Ruby Cohn, *Just Play: Beckett's Theater* (Princeton: Princeton University Press, 1980), 31; cited in Prinz, "Resonant Images and German Expressionism" 153.

6. Esslin, "Towards the Zero of Language" 35.

7. Enoch Brater, *Beyond Minimalism* (New York: Oxford University Press, 1987), 37. See also Stanton Garner Jr.'s chapter "(Dis)figuring Space" in *Bodied Spaces* 52–86.

8. For discussion of the role of the Beckett director, see my book *Directing Beckett* (Ann Arbor: University of Michigan Press, 1994).

9. Esslin, "Towards the Zero of Language" 47; cited in Prinz, "Resonant Images: Beckett and German Expressionism" 153.

10. Billie Whitelaw, *Billie Whitelaw . . . Who He?* (New York: St. Martin's Press, 1995), 144–45.

11. Daniel Albright, "Beckett as Marsyas," in Oppenheim, *Samuel Beckett and the Arts* 28.

12. SB, "Three Dialogues" 123.

13. *Vogue*, December 1969, 210; cited in Albright, "Beckett as Marsyas" 47.

14. Knowlson, *Damned to Fame* 187.

15. For Knowlson's demythification of the collaboration that was *Le Kid*, see *Damned to Fame* 125–28. For an excellent appreciation of German Expressionism and Beckett, particularly with regard to the shorter plays, see Prinz's essay "Resonant Images: Beckett and German Expressionism."

16. Cf. Albright's description of the reversal: "Expression is painful, important, irrepressible, murderous; it would be best to be silent, but that is too difficult. The only alternative [. . .] is to make speech out of the evasion of the obligation to express. This evasion bears witness to the sacredness of what it evades" (Daniel Albright, *Representation and the Imagination* [Chicago: University of Chicago Press, 1981], 156).

17. Knowlson, *Damned to Fame* 126.

18. SB, *Imagination Dead Imagine, Collected Shorter Prose, 1945–1980* (London: John Calder, 1986), 145.

19. SB, *Lessness, Collected Shorter Prose, 1945–1980* 153.

20. For an excellent discussion of Beckett's teleplay aesthetic as "peephole art," see "*Eh Joe* and the Peephole Aesthetic," *Samuel Beckett Today/Aujourd'hui* 4 (1955): 53–64.

21. Locatelli, *Unwording the World* 87.

22. See Ruby Cohn, *Samuel Beckett: The Comic Gamut* (New Brunswick: Rutgers University Press, 1962), 103.

23. See, for example, Knowlson's discussion of *Happy Days,* in which he reminds us of the partially buried figures in the final frames of Luis Buñuel's 1928 film, *Un Chien andalou,* noting that this was "the kind of avant-garde film that Beckett went to see during his Ecole Normale days," and of a photograph by Angus McBean of Frances Day that Beckett may or may not have seen. (It appeared in 1938 in the review *The Fleet's Lit Up* and shows the actress, buried to her waist, "posed with a mirror held in another's hand" [*Damned to Fame* 425]). See also Enoch Brater's insightful commentaries on the original *Endgame,* directed by Blin in collaboration with the playwright "on a skull-like set, where the two windows served as 'eyes' " and on the resemblance of Eye in *Film* and Mouth in *Not I* to the Buñuel film ("Dada, Surrealism, and the Genesis of *Not I,*" *Modern Drama* 18, no. 1 [Mar. 1975]: 51, 53–54). In "Unswamping a Backwater: On Samuel Beckett's *Film*" Sidney Feshbach makes interesting connections with Magritte and, perhaps more important, with Georges Bataille, whose *Histoire de l'Oeil* (1928) "was discussed in 'The Metaphor of the Eye' by Roland Barthes in 1963, the year of the script for *Film*" (*Samuel Beckett and the Arts: Music, Fine Arts, and Non-Print Media,* ed. Oppenheim, 346).

24. SB, *Watt* 246.

25. For an excellent analysis of this "soundscape," see Marjorie Perloff, "The Silence That Is Not Silence: Acoustic Art in Samuel Beckett's *Embers,*" in Oppenheim, *Samuel Beckett and the Arts* 247–68.

26. Perloff, "Silence That Is Not Silence" 249.

27. My discussion of figurality is indebted to Daniel Albright's insights expressed both in the section on Beckett in *Representation and the Imagination* and an e-mail, dated July 21, 1997, to the author.

28. Perloff, "Silence That Is Not Silence" 253.

29. Albright, *Representation and the Imagination* 170.

30. SB, *Watt* 226.

31. SB, *Watt* 231.

32. E. H. Gombrich, *Art and Illusion* (Princeton: Princeton University Press, 1969), 298.

33. SB, *Stirrings Still* n.p.

34. Gyorgy Kepes, *Language of Vision* (Chicago: Paul Theobald and Co., 1967), 15. This discussion is inspired by Kepes's explanation of the visual process in his chapter on plastic organization (15–64).

35. Cohn, *Samuel Beckett* 167.

36. Kepes 36.

37. Kepes 46.

38. SB, *Dream of Fair to Middling Women* 167.

39. Cited in Mercier 119.

40. SB, *More Pricks than Kicks* 176.

41. SB, *Dream of Fair to Middling Women* 178–79.

42. SB, *More Pricks than Kicks* 180.

43. McMillan, "Samuel Beckett and the Visual Arts" 33. McMillan identifies what Beckett calls *The Lances* as Velasquez's *Surrender of Breda.*

44. SB, "Love and Lethe," *More Pricks than Kicks* 87.

45. SB, *Dream of Fair to Middling Women* 116.

46. SB, *Murphy* 84. The Happy Tomb has been described by McMillan as depicting "the dead as a seated figure enticed by young girls to rejoin the living" ("Samuel Beckett and the Visual Arts" 32).

47. SB, *Murphy* 251.

48. Cf. Mercier 120. Also, McMillan points to Beckett's embarrassment, at times, over the pervasiveness in his work of the "visual forms and techniques and allusions to works of art" ("Samuel Beckett and the Visual Arts" 32).

49. Mercier 91–95.

50. Knowlson, *Damned to Fame* 342, 238, 520, 583, 599.

51. Knowlson, *Damned to Fame* 583.

52. Wendy Steiner, *The Colors of Rhetoric* (Chicago: University of Chicago Press, 1982), 41.

53. Mary Ann Caws, *The Art of Interference* (Princeton: Princeton University Press, 1989), 240.

54. SB, "Dante and the Lobster," *More Pricks than Kicks* 9.

55. H. Porter Abbott, "Samuel Beckett and the Arts of Time: Painting, Music, Narrative," in Oppenheim, *Samuel Beckett and the Arts* 15. This essay is an excellent analysis of the "intimate binding" of Beckett's narrative with music and painting.

56. I am indebted here to Tamar Yacobi, who remarkably argues these points in "Pictorial Models and Narrative Ekphrasis" (*Poetics Today* 16, no. 4 [Winter 1995]: 599–649). I was delighted to discover this essay after completing the brief commentary on *Stirrings Still* in the preceding pages, for she too maintains that the whole of art may be a visual model of ekphrasis and that this figure may play a distinctly narrative role. The notion that ekphrasis may cover several or the totality of an artist's works is from Gisbert Kranz, *Das Bildgedicht: Theorie, Lexikon, Bibliographie*, 3 vols. Literatur und Leben, n. s., 23 (Cologne: Böhlau, 1981), 377ff. It is cited in Yacobi 602. The term *antinarrative* is Yacobi's and appears on p. 622 of her essay.

57. SB, *Murphy* 63.

58. W. J. T. Mitchell discusses the fetichized object in ekphrastic poetry in "Space, Ideology, and Literary Representation," *Poetics Today* 10, no. 1 (Spring 1989): 91–92.

59. The simultaneous operation of ekphrasis and ordinary figures of speech was the subject of "The Ekphrastic Figure of Speech," a paper presented by Tamar Yacobi at the International Association of Word and Image Studies, Trinity College Dublin, August 1996.

60. Heath Lees, "'Watt': Music, Tuning and Tonality," *Journal of Beckett Studies* 9 (1984): 23.

61. SB, *Watt* 251.

62. W. J. T. Mitchell, "On Poems on Pictures: Ekphrasis and the Other," *Poetics Today* special issue on "Literature and Art," ed. Wendy Steiner, 10 (1989); cited in Caws, *Art of Interference* 6.

63. SB, *Watt* 127.

64. Galen A. Johnson, "Ontology and Painting: 'Eye and Mind,'" in *The Merleau-Ponty Aesthetics Reader*, ed. Galen A. Johnson (Evanston: Northwestern University Press, 1993), 52.

65. SB, *Watt* 127.

66. Jane Alison Hale, *The Broken Window* (West Lafayette, IN: Purdue University Press, 1987), 47.

67. Stanley Cavell, *Must We Mean What We Say?* (New York: Scribner, 1969), 152; cited in H. Porter Abbott, *The Fiction of Samuel Beckett* (Berkeley: University of California Press, 1973), 9–10.

68. Abbott, *Fiction of Samuel Beckett* 10.

69. Cited in Prinz, "Resonant Images: Beckett and German Expressionism" 153.

70. Bennett Simon, *Tragic Drama and the Family: From Aeschylus to Beckett* (New Haven: Yale University Press, 1988), 235.

71. Knowlson, *Damned to Fame* 220.

72. McMillan, "Samuel Beckett and the Visual Arts" 31–32.

73. *Krapp's Last Tape, Collected Shorter Plays of Samuel Beckett* 60. Beckett expressed the same idea in 1931 when he wrote in his essay on Proust, roughly half of which is devoted directly to a discussion of memory, "At any given moment our total soul, in spite of its rich balance-sheet, has only a fictitious value. Its assets are never completely realisable" (*Proust* [London: Calder and Boyars, 1970], 41).

74. SB, *Ohio Impromptu, Collected Shorter Plays of Samuel Beckett* 286.

75. John Erickson, "Self-Objectification and Preservation in Beckett's *Krapp's Last Tape*," in Smith, *World of Samuel Beckett* 185.

76. Knowlson, *Damned to Fame* 525.

77. SB, *Murphy* 251.

78. SB, *A Piece of Monologue* 266.

79. Lawrence Graver, "Homage to the Dark Lady," in *Women in Beckett*, ed. Linda Ben-Zvi (Urbana: University of Illinois Press, 1990), 148.

80. See Cronin, *Samuel Beckett* 16–17.

81. Knowlson, *Damned to Fame* 589.

82. Wilfred R. Bion (1897–1979), an important psychoanalytic thinker associated with the Tavistock Clinic in London, treated Beckett in 1934–35. Though it was not until after World War II that Bion more fully articulated his thinking on object-relations issues, according to Bennett Simon, he "must have been struggling both to articulate his personal issues and to understand the nature of early defects in object-relations—early issues around closeness and its dangers—at the same time he encountered Beckett, who probably presented such issues in 'pure culture'" (*Tragic Drama and the Family* 241).

Bion, incidentally, who would himself (in 1946) become her patient, was influenced in the late 1930s and 1940s by the thinking of Melanie Klein (Simon 238). Perhaps Klein's work had already begun to impact Bion's when Beckett was in treatment with him. (Being Viennese, she came to London via Berlin in 1929.) Not only would her theories of infancy have had relevance for Beckett's therapy, but her thinking on artistic creation could have been significant as well. For Klein maintained (in her 1937 article "Love, Guilt, and Reparation") that the writer is motivated precisely by the "desire to rediscover the mother of the early days, whom [he] has lost actually or in [his] feelings" (cited in Graver 148).

83. Abbott, *Beckett Writing Beckett* 108.

84. Shira Wolosky, "The Negative Way Negated: Samuel Beckett's *Texts for Nothing*," *New Literary History* 22 (Winter 1991): 227; cited in Abbott, *Beckett Writing Beckett* 108.

85. Brater, *Beyond Minimalism* ix.

86. SB, "Three Dialogues" 121.

87. They collaborated on the set for the 1961 Odéon Theater's revival of *Waiting for Godot* in Paris.

88. James Lord, *Giacometti: A Biography* (New York: Farrar, Straus and Giroux, 1985), 33.

89. James Lord, *A Giacometti Portrait* (New York: Farrar, Straus and Giroux, 1965), 26; cited by Neubauer in "Alberto Giacometti's Fantasies and Object Representation," in *Fantasy, Myth, and Reality,* ed. Harold P. Blum, Yale Kramer, Arlene K. Richards, and Arnold D. Richards (Madison, CN: International Universities Press, 1988), 188.

90. Most notably by Matti Megged in *Dialogue in the Void: Beckett and Giacometti* and Reinhold Hohl in *Alberto Giacometti* (New York: Abrams, 1971).

91. Peter B. Neubauer, "Albert Giacometti's Fantasies and Object Representation," in Blum et al., *Fantasy, Myth, and Reality* 189.

92. Beckett's later disembodiments of face (*That Time*) and mouth (*Not I*) will be similarly suspended in the dark.

93. From "Le Rêve, le sphinx et la mort de T"; cited in Hohl, *Alberto Giacometti* 206.

94. Cited in Megged 40. For more on Giacometti's effort to "bridge the gap between reality and art" and the desire to "[discover] anew the ways in which reality might be grasped and shaped by art," see Megged 38–40.

95. I cite, in this regard, the Unnamable's exclamatory "what an eye" and "This eye, curious how this eye invites inspection" (*The Unnamable* 11, 122).

96. David Sylvester, *Looking at Giacometti* (New York: Henry Holt, 1994), 36.

97. Sylvester 22.

98. Cited in Sylvester 25.

99. It was Neubauer's identification of the disturbance in Giacometti that made me consider the possibility with regard to Beckett. So similar were the sublimatory and compensatory devices in their work that it seemed only reasonable to look further at the possibility that a comparable dysfunction was operative in Beckett.

100. Lord 165.

101. Merleau-Ponty, *Phenomenology of Perception* 349.

102. Jean-Paul Sartre, "The Paintings of Giacometti," *Situations,* trans. Benita Eisler (New York: George Braziller, 1965), 177.

103. Sartre 178–79.

104. Sartre 180.

105. SB, *Waiting for Godot* 42b.

106. Sartre 190–91.

107. Cited in Sylvester 94.

108. Sylvester 83.

109. Hohl, *Alberto Giacometti* 172.
110. Lord 428.

Chapter 6

1. William Burroughs, "Beckett and Proust," *Review of Contemporary Fiction* 7, no. 2 (Summer 1987): 28.

2. I am grateful to Sidney Feshbach for his insights into the historical limitations of the controversy as expressed in a conversation of March 27, 1998.

3. Cited in Ann Cremin in "Friend Game," *ARTnews* (May 1985): 85–86.

4. Merleau-Ponty, "Eye and Mind" 138.

5. Merleau-Ponty, "Eye and Mind" 123–24.

6. *Proust* 74; *Disjecta* 90. For further discussion of allegory, see Marius Buning, "Allegory's Double Bookkeeping: The Case of Samuel Beckett," *Samuel Beckett Today/Aujourd'hui*, no. 1 (Amsterdam: Rodopi, 1992), 69–78.

7. *Tractatus*, 2.172; cited in W. J. T. Mitchell, *Iconology: Image, Text, Ideology* (Chicago: University of Chicago Press, 1986), 39.

8. *Proust* 75.

9. Cf. Carolyn Van Dyke, *The Fiction of Truth: Structures of Meaning in Narrative and Dramatic Allegory* (Ithaca: Cornell University Press, 1985), 27.

10. Paul de Man, *Blindness and Insight* (Minneapolis: University of Minnesota Press, 1983), 34, 35. It should be noted, however, that Merleau-Ponty had already broadened his conception of plastic form to include the literary while en route to "Eye and Mind." Though publication of *La Prose du Monde* was posthumous, "Indirect Language and the Voices of Silence" was written as its third chapter (and additional parts of the book correspond exquisitely with Beckett's creative and critical practice). *La Prose du Monde* was edited and published by Claude Lefort in 1969 (Paris: Gallimard). Speculation about why the work remained unfinished is varied. For a brief overview of the question, see Galen A. Johnson, *The Merleau-Ponty Aesthetics Reader*, 378n. 1. It is worth noting with Johnson, moreover, that "during the middle period of his career, Merleau-Ponty was working on a general theory of expression that would elaborate a philosophy of art and language and extend it into a general philosophy of culture and history" (Johnson 22).

11. Erwin Panofsky, "Iconography and Iconology: An Introduction to the Study of Renaissance Art," *Meaning in the Visual Arts* (New York: Doubleday, 1955), 26, 32; rptd. from *Studies in Iconology* (1939).

12. W. J. T. Mitchell, *Iconology: Image, Text, Ideology* (Chicago: University of Chicago Press, 1986), 1, 5.

13. Mieke Bal, *Reading Rembrandt* (Cambridge: Cambridge University Press, 1991), 214.

14. Beckett and Lessing is a subject well worth investigating, but space prevents it here. On the basis of "Le Monde et le Pantalon" Antoinette Weber-Caflisch situates Beckett clearly within the Lessing tradition (*Bram van Velde: 1895–1981*, catalogue ed. Rainer Michael Mason [Geneva: Musée RATH, 1996], 281n. 14), and there is certainly other evidence (still mostly anecdotal and epistolary) to support that view as well. At the same time, however, in a letter to

Duthuit dated March 9, 1949, Beckett wrote specifically of the temporal relations of painting, arguing along lines antithetical to Lessing's notion of stasis in that art. In any case, we know from the German diaries of Beckett's interest in Lessing's thought: As Knowlson tells us, "While in Brunswick, Beckett took the opportunity to go by train to nearby Wolfenbüttel where he visited the house of the dramatist Lessing and the Augusta Bibliotek, where Lessing was librarian from 1770 to 1781. He bought from a local bookshop a complete set of Lessing, which he had posted directly to his home in Foxrock" (*Damned to Fame* 226).

15. Cf. W. J. T. Mitchell 5–6, 158.

16. Renée Riese Hubert, "From an Abandoned Work: The Encounter of Samuel Beckett and Max Ernst," in *Beckett Translating / Translating Beckett*, ed. Alan Warren Friedman, Charles Rossman, and Dina Sherzer (University Park: Pennsylvania State University Press, 1987), 199.

17. Rainer Michael Mason, interview with Jérôme Zanetta, *Scènes Magazine* 87 (1985): 68.

18. Avigdor Arikha, "Le Nuage rouge," in Mason, *Bram van Velde* 236; translation mine.

19. "Une Rhétorique de l'irrationnel se bâtit devant nous," undated fragment by Georges Duthuit, Duthuit Archives.

20. "Le Rapport pèse à Beckett. Il le suffoque," undated fragment by Georges Duthuit, Duthuit Archives.

21. Lois Gordon, *The World of Samuel Beckett: 1906–1946* (New Haven: Yale University Press, 1996), 88.

22. See Gordon S. Armstrong, *Samuel Beckett, W. B. Yeats, and Jack Yeats: Images and Words* (Lewisburg: Bucknell University Press, 1990), 11, 50, 64, 70.

23. SB, *Disjecta* 149. It is interesting to note that another quality they shared was an obsession with memory. Hilary Pyle observes that "memory began to impress [Yeats] as an artistic implement [. . .] from about 1900, when he painted the large watercolour *Memory Harbour*." Yeats cultivated his memory by recording for some two decades in a series of small notebooks spot sketches that were used to inspire oil paintings or figure in them thematically. Even as the precise technique came to be employed more sporadically, the emphasis on memory would continue as a source of ideas for his art until the end of his life (*Jack B. Yeats in the National Gallery of Ireland* [Dublin: National Gallery of Ireland, 1986], xv–xvi). Beckett's own preoccupation with remembrance has, of course, already been cited.

24. SB, *Disjecta* 146, 150.

25. Cited in my book *Directing Beckett* 15.

26. SB, *Fizzles* (New York: Grove Press, 1976), 37–39.

27. Marjorie Perloff, *The Poetics of Indeterminacy: Rimbaud to Cage* (Princeton: Princeton University Press, 1981), 202–4.

28. Mitchell, *Iconology* 5.

29. See Perloff 205.

30. Georg Baselitz, lecture delivered in Munich, November 8, 1992; rptd. in Diane Waldman, *Georg Baselitz* (New York: Guggenheim Museum Publications, 1995), 238.

31. Samuel Beckett and Georg Baselitz, *Bing*, trans. Elmar Tophoven (Cologne: Galerie Michael Werner, 1991). Includes twenty-four etchings and one woodcut by Baselitz (in German).

32. Baselitz studied, in particular, Jurgis Baltrusaitis's 1955 *Anamorphoses ou Perspectives Curieuses* (Waldman 20).

33. Cited in Waldman 71.

34. Enoch Brater, *The Drama in the Text* (New York and London: Oxford University Press, 1994), 91.

35. See Brater, *Drama in the Text* 91.

36. SB, *Bing, Têtes-Mortes* (Paris: Les Editions de Minuit, 1967), 64, 61, 62.

37. SB, *The Lost Ones* (New York: Grove Weidenfeld, 1972), 7.

38. Abbott, *Beckett Writing Beckett* 137.

39. SB, *The Lost Ones* 13, 16.

40. The first English editions of *The Lost Ones* contain an error in the dimensions given for the cylinder. Beckett tried to correct the mistake for the 1972 Grove Press edition, but he was too late in his notification to the publisher. Reprintings of the text did not remedy the discrepancy, and it was not until the New Overbrook publication with Charles Klabunde's illustrations in 1984 that we had a definitive edition.

41. Samuel Beckett and Charles Klabunde, *The Lost Ones* (Stamford, CN: New Overbrook Press, 1984): 250 numbered copies and 60 artist's proofs, signed by author and artist.

42. Cited in publicity material for the book.

43. Arikha wrote in a letter to me dated May 21, 1998, that "the six colour-etchings belong to the brief period of regression into abstraction which happened in early 1968."

44. Samuel Beckett and Avigdor Arikha, *L'Issue* (Paris: Georges Visat, 1968): 6 color aquatints, 154 copies.

45. Arikha also illustrated *Oh les beaux jours* with a series of brush and ink drawings done from life (the artist's wife posed as Winnie and Arikha as Willy) for a special edition by Les Prix Nobel. (Unfortunately, the images were reproduced in color instead of the original black and white.) *Malone* was illustrated by him for the same edition. In 1957 he produced six pen and ink drawings for the Minuit edition of *Nouvelles et textes pour rien* of the following year. Additionally, he designed the set of the 1984 Alvin Epstein-directed *Endgame* at the Samuel Beckett Theater in New York.

46. Samuel Beckett and Avigdor Arikha, *The North* (London: Enitharmon Press, 1972): 137 copies.

47. SB, *The Lost Ones* 56.

48. Samuel Beckett and Robert Ryman, *Nohow On* (New York: Limited Editions Club, 1989): 550 numbered copies, signed by author and artist. Beckett's narratives are reprinted here and follow the same pagination as the Calder Publications (London, 1989) edition.

49. SB, *Company* 12, 18, 41, 49.

50. SB, *Ill Seen Ill Said* 59, 80, 88.

51. SB, *Worstward Ho* 117.

52. Telephone interview with Ryman, June 23, 1998.

53. For an interesting discussion of the realist/minimalist combination, see Breon Mitchell, "Six Degrees of Separation: Beckett and the *Livre d'Artiste*," in Oppenheim, *Samuel Beckett and the Arts* 176–79.

54. SB, *Nohow On* 28–29.

55. Mitchell, "Six Degrees of Separation" 178.

56. SB, *Nohow On* 72, 80–81.

57. Shiff met with Beckett in Paris to suggest Ryman for an illustrated edition of *Ill Seen Ill Said*. Forewarned by John Calder that the author might be inclined toward a somewhat catholic taste, Shiff began by discussing artists of the London School (Francis Bacon, Lucien Freud, and so on), though he originally had Ryman in mind. Expanding the project to include the other two novels, Beckett overcame his initial hesitation to have the works illustrated, agreed to Ryman, though he was unfamiliar with his work, and, later, was enormously pleased with the special edition Ryman and Shiff produced (telephone interview with Shiff, June 23, 1998).

58. "Tout le drame se situera donc dans cette geôle du rapport et de l'espace limité, limitant, de l'homme" (from unpaginated and undated typescript documents of Georges Duthuit held in the Duthuit Archives).

59. SB, letter to Georges Duthuit; March 2, 1949.

60. See Samuel Beckett, Georges Duthuit, and Jacques Putnam, *Bram van Velde* 20, 32, 52.

61. "Ils nous recommandent de nous attacher au protoplasme plutôt qu'aux individus qui en proviennent. Adultes, revenez dans l'ovule initial d'où sortit l'organisme constitué. Reblotissez-vous [sic] dans ce halo indifférencié où l'on ne distingue ni dedans ni dehors" (Duthuit Archives).

62. SB, "Three Dialogues" 110–11.

63. Letter from SB to Jasper Johns, March 25, 1974.

64. Letter from Arikha to LO, December 29, 1994.

65. Duncan Thomson claims the original text dates to the 1950s (*Arikha* [London: Phaidon Press, 1994], 64); the Grove Press edition of *Fizzles* gives 1960 as the approximate date (*Fizzles* [New York: Grove Press, 1976], front jacket flap); while Deirdre Bair notes that the collection of prose pieces that make up the 1976 publication of *Foirades* (Paris: Minuit) dates "mostly from the late 1960s and the early 1970s" (*Samuel Beckett* [New York: Harcourt Brace Jovanovitch, 1978], 638–39). Beckett's reordering of the pieces contained in *Pour finir encore et autres foirades* and *Fizzles* would account for these discrepancies.

66. French text: reprinted in "Un Livre de Samuel Beckett et Avigdor Arikha: 'au loin un oiseau.'" *Revue de l'art* 44 (1979): 103; English translation: "Afar a Bird," Fizzle 3, in *Fizzles* (New York: Grove Press, 1976), 25.

67. Thompson 64.

68. Conversation with Arikha at the Marlborough Gallery in New York, May 14, 1996.

69. Paul Valéry, *Pièces sur l'art* (Paris: Gallimard, 1934), 143; cited in Caws, *Art of Interference* 196.

70. SB, *Fizzles* 26–27.

71. Thomson 64.

72. Thomson 103.

73. SB, *Fizzles* 26–27.

74. *Foirades/Fizzles* (New York: Petersburg Press, 1976) was published in an edition of 250 signed copies. In a letter to Johns dated February 7, 1974, Beckett explains the title: "The Shorter Oxford Dictionary defines fizzle as follows: 1. The action of breaking wind quietly; the action of hissing or sputtering. 2. A failure or fiasco."

75. The project was the idea of Vera Lindsay (once married to John Russell, whom Johns knew). She approached both Beckett (through his agent) and Johns in 1972 and was offered the rights to the manuscript of *Waiting for Godot*. Johns, however, would only work with a previously unpublished text, and, following an initial meeting between the two artists in Paris in 1973, Beckett began forwarding English translations of the "fizzles" to Johns. In conversation with me in 1995 Paul Cornwall-Jones, publisher of the illustrated edition, mused that it "wasn't really a collaboration, while it was a perfectly legitimate collaboration."

76. The only etchings that do not derive from *Untitled, 1972* are the numerals that precede each of the five sections.

77. In an interview with Roberta Bernstein, Johns, himself, attested to an "intuitive" connection with Beckett and even claimed that "in some odd way there are occasional overlappings of images" ("An Interview with Jasper Johns," *Fragments: Incompletion and Discontinuity*, ed. Lawrence D. Kritzman [New York: New York Literary Forum, 1981], 286–87). It cannot be said, however, that Beckett felt anything more than respect for Johns's work.

78. The details of the collaboration were provided by Paul Cornwall-Jones, of Petersburg Press, in conversation with me in 1995 and are confirmed by Roberta Bernstein in "Johns and Beckett: *Foirades/Fizzles*," *Print Collector's Newsletter* 7 (Nov.–Dec. 1976): 141–45.

79. The layout of the book is described in detail by Bernstein (1976: 143) and by Johns in an unpublished interview with Anne Hindry, dated January 9, 1989.

80. Letter from SB to Jasper Johns, March 25, 1974.

81. Richard S. Field, "The Making of *Foirades/Fizzles*," in *Foirades/Fizzles: Echo and Allusion in the Art of Jasper Johns* (Los Angeles: Wight Art Gallery, University of California, Los Angeles, 1987), 116.

82. This is the fourth in the differently numbered Grove Press edition, where it appears on p. 31.

83. See Charles Juliet, *Conversations with Samuel Beckett and Bram van Velde*, trans. Janey Tucker (Leiden: Academic Press, 1995), 158.

84. See, for example, James Cuno, "Voices and Mirrors / Echoes and Allusions: Jasper Johns's *Untitled, 1972*," *Foirades/Fizzles* 222. This remark appears in Vivien Raynor, "Jasper Johns" (interview) *Art News* 72 (Mar. 1973): 22; cited in Cuno 221.

85. Jessica Prinz, "*Foirades/Fizzles*/Beckett/Johns," *Contemporary Literature* 21, no. 3 (1980): 495.

86. See Prinz 506.

87. Perloff, *Poetics of Indeterminacy* 210.

88. "Fizzle 5" of the illustrated edition is "Fizzle 2" of the Grove Press publication, where this quote appears on pp. 19–20.

89. Letter from Louis le Brocquy to LO, January 3, 1995.

90. Le Brocquy also illustrated Thomas Kinsella's *Táin* and James Joyce's *Dubliners*. In an artist's note accompanying the latter he wrote, regarding Joyce's work: "Here also, I believe, consequent drawings should be induced to grow spontaneously and even physically—marks in printer's ink—from the matter of the text itself. Here again, I hope, it is as shadows thrown by the text that they derive their substance" (limited edition [Dublin: Dolmen Press, 1986]; hardback and paperback editions [Dublin: Lilliput Press, 1992]).

91. The term is Anne Madden's, used in *Seeing His Way* (Dublin: Gill and Macmillan, 1994), 269, to describe the drawings of Beckett made by le Brocquy (her husband) for *Stirrings Still*.

92. *Stirrings Still* (New York: Blue Moon, 1988), n.p.

93. Robert Scanlan, review of *Stirrings Still*, in *Harvard Book Review*, nos. 11–12 (Winter and Spring books 1989): 1.

94. Cf. Madden 37.

95. *Stirrings Still* n.p.

96. Cited in Madden 262. As Madden wrote with regard to le Brocquy's work for the Gate Theatre's *Waiting for Godot*, "The lighting of the set, Louis felt, should reveal the tree, the stone, the twilight only when they were referred to in the play; as they came into the minds of the players" (262).

97. *Stirrings Still* n.p.

98. *Beginning to End: A Selection from the Works of Samuel Beckett*, adapted by Samuel Beckett and Jack MacGowran (New York: Gotham Book Mart, 1988): 300 numbered copies signed by author and artist and 26 lettered signed copies. Gorey also illustrated *All Stange Away* (New York: Gotham Book Mart, 1976): 200 numbered copies, 26 signed copies, with 16 cut and altered vintage wood engravings.

99. Gorey is perhaps best known for his logos for the PBS television series *Mystery!* and the many book covers and newspaper illustrations he has produced during the course of his career. He has also turned out a great many very small hand-lettered word and image books driven by a keen sense of mystery and humor.

100. Telephone interview with Gorey, May 27, 1998.

101. See, in particular, Ruby Cohn, "Ghosting through Beckett," in Buning and Oppenheim, *Beckett in the 1990s* 3–4.

102. SB, *Beginning to End* (originally from "From an Abandoned Work") 10.

103. Stephen Schiff, "Edward Gorey and the Tao of Nonsense," *The New Yorker*, November 9, 1992, n.p.

104. Charles Klabunde, "Statement on *The Lost Ones*," *Review of Contemporary Fiction* (Summer 1987): 160.

105. Initially, he was opposed. When George Reavey suggested in 1935 that *Echo's Bones* appear in an illustrated edition, for example, Beckett refused. His reputation solidly established, however, he not only allowed his work to appear in special editions illustrated by several different artists but supported their efforts. (See Breon Mitchell, "Six Degrees of Separation: Beckett and the *Livre d'Artiste*," in Oppenheim, *Samuel Beckett and the Arts* 173.) One exception,

however, is to be noted: When Luigi Majno proposed, subsequent to *Still,* another M'Arte Edizione, this time with illustrations by Michel Folon, Beckett declined, saying, "There have been too many special editions" (letter from SB to Majno, April 29, 1974).

106. Mitchell, "Six Degrees of Separation" 191.

107. Samuel Beckett and William Stanley Hayter, *Still* (Milan: M'Arte Edizione, 1974): 160 numbered or lettered signed copies. This was the first publication of Beckett's text.

108. Hayter recalled, many years after the 1974 publication, telling Luigi Majno, publisher of M'Arte Edizione, that he "would not dream of approaching Sam" and that the publisher "would be in a better position to do so" (Cremin 87). Knowlson corroborates this in *Damned to Fame* (524). Majno's recollection, however, differs: When he and his daughter, both close friends of the artist, discussed with Hayter "the possibility of a book with his own work and an important text, [Hayter] mentioned that he would contact 'Sam.' And so he did." Following that, Majno claims, he met with Beckett in Paris, where, after some hesitation, Beckett handed over the manuscript and the book took shape (letter from Luigi Majno to Lois More Overbeck and Martha Fehsenfeld, 28 August, 1995).

109. Letter from Désirée Hayter to LO, July 9, 1996.

110. Related by Majno to Overbeck and Fehsenfeld, March 2, 1995, in a response to several queries by them.

111. Brater, *Drama in the Text* 72, 70.

112. Peter Black and Désirée Moorhead, *The Prints of Stanley William Hayter* (Mount Kisco, NY: Mayer Bell Ltd., 1992), 30.

113. Knowlson, *Damned to Fame* 525; cited in Mitchell, "Six Degrees of Separation" 182.

114. McMillan, "Samuel Beckett and the Visual Arts" 44.

115. I borrow this term from Martin Jay, as cited by Thomas Seifrid in "Gazing on Life's Page: Perspectival Vision in Tolstoy," *PMLA* 113, no. 3 (May 1998): 437.

116. Robert P. Fletcher, "Visual Thinking and the Picture Story in *The History of Henry Esmond*," *PMLA* 113, no. 3 (May 1998): 381.

117. Bruno Latour, *We Have Never Been Modern*, trans. Catherine Porter (Cambridge: Harvard University Press, 1993), 137.

118. Sidney Feshbach, "Recognize Me if You Can: About Samuel Beckett's 'Whoroscope,'" forthcoming.

119. SB, *The Unnamable* 78.

Selected Bibliography

Abbott, H. Porter. "Samuel Beckett and the Arts of Time: Printing, Music, Narrative." In *Samuel Beckett and the Arts: Music, Visual Arts, and Non-Print Media*, ed. Lois Oppenheim. New York: Garland Publishing, 1999.

———. *Beckett Writing Beckett*. Ithaca: Cornell University Press, 1996.

———. "Late Modernism: Samuel Beckett and the Art of the Oeuvre." In *Around the Absurd*, ed. Enoch Brater and Ruby Cohn. Ann Arbor: University of Michigan Press, 1990.

Acheson, James. *Samuel Beckett's Artistic Theory and Practice*. London: Macmillan, 1997.

Albright, Daniel. *Representation and the Imagination*. Chicago: University of Chicago, 1981.

Amiran, Eyal. "Figuring the Mind: Totality and Displacement in Beckett's Fiction." *Journal of Beckett Studies* (Spring 1992): 39–54.

Arikha. Texts by Richard Channin, André Fermigier, Robert Hughes, Jane Livingston, Barbara Rose, and Samuel Beckett. Interviews by Barbara Rose, Joseph Shannon, and Maurice Tuchman. Paris: Hermann; and London: Thames and Hudson, 1985.

Arikha, Avigdor. "Un livre de Samuel Beckett et Avigdor Arikha: 'Au loin un oiseau.'" *Revue de l'Art* 44 (1979): 103.

Armstrong, Gordon S. *Samuel Beckett, W. B. Yeats, and Jack Yeats: Images and Words*. Lewisburg: Bucknell University Press, 1990.

Ashton, Dore. *About Rothko*. New York: Da Capo Press, 1996.

Bair, Deirdre. *Simone de Beauvoir: A Biography*. New York: Summit Books, 1990.

———. *Samuel Beckett: A Biography*. New York and London: Harcourt Brace Jovanovich, 1978.

Bal, Mieke. *Reading Rembrandt*. Cambridge: Cambridge University Press, 1991.

Beckett, Samuel, and Avigdor Arikha. *Au loin un oiseau*. New York: Double Elephant Press, 1973.

———. *The North*. London: Enitharmon Press, 1972.

———. *L'Issue*. Paris: Georges Visat, 1968.

Beckett, Samuel, and Georg Baselitz. *Bing*, trans. Elmar Tophoven. Cologne: Galerie Michael Werner, 1991.

Beckett, Samuel, and Edward Gorey. *Beginning to End: A Selection from the*

Works of Samuel Beckett, adapted by Samuel Beckett and Jack Mac-
Gowran. New York: Gotham Book Mart, 1988.

———. *All Strange Away.* New York: Gotham Book Mart, 1976.

Beckett, Samuel, and William Stanley Hayter. *Still.* Milan: M'Arte Edizione, 1974.

Beckett, Samuel, and Jasper Johns. *Foirades/Fizzles.* New York: Petersburg Press,
1976.

Beckett, Samuel, and Charles Klabunde. *The Lost Ones.* Stamford, CN: New
Overbrook Press, 1984.

Beckett, Samuel, and Louis le Brocquy. *Stirrings Still.* New York: Blue Moon
Books; and London: John Calder, 1988.

Beckett, Samuel, and Robert Ryman. *Nohow On.* New York: Limited Editions
Club, 1989.

Begam, Richard. *Samuel Beckett and the End of Modernity.* Stanford: Stanford
University Press, 1996.

Beja, Morris, S. E. Gontarski, and Pierre Astier, eds. *Samuel Beckett: Humanistic
Perspectives.* Columbus: Ohio State University Press, 1983.

Bernstein, Roberta. "Johns and Beckett: *Foirades/Fizzles.*" *Print Collector's
Newsletter* (Nov.–Dec. 1976): 141–45.

Bersani, Leo, and Ulysse Dutoit. *Acts of Impoverishment.* Cambridge: Harvard
University Press, 1993.

Black, Peter, and Désirée Moorhead. *The Prints of Stanley William Hayter.*
Mount Kisco, NY: Mayer Bell Limited, 1992.

Blau, Herbert. "The Oversight of Ceaseless Eyes." In *Around the Absurd,* ed.
Enoch Brater and Ruby Cohn. Ann Arbor: University of Michigan Press,
1990.

Bram van Velde. Texts by Georges Duthuit, Jacques Putnam, and Samuel Beck-
ett. New York: Grove Press, 1960.

Brater, Enoch. *The Drama in the Text.* New York: Oxford, 1994.

———. *Beyond Minimalism.* New York: Oxford, 1987.

———. "Dada, Surrealism, and the Genesis of *Not I.*" *Modern Drama* 18 (1975):
49–59.

Buning, Marius, and Lois Oppenheim. *Beckett in the 1990s.* Amsterdam: Rodopi,
1993.

Bush, Andrew. "The Expanding Eye: The Allegory of Forgetting in Johns and
Beckett." In *Foirades/Fizzles: Echo and Allusion in the Art of Jasper Johns.*
Los Angeles: Wight Art Gallery, University of California, Los Angeles, 1987.

Busch, Thomas W., and Shaun Gallagher, eds. *Merleau-Ponty: Hermeneutics and
Postmodernism.* Albany: SUNY Press, 1992.

Butler, Lance St. John. *Samuel Beckett and the Meaning of Being.* New York: St.
Martin's Press, 1984.

Büttner, Gottfried. *Samuel Beckett's Novel* Watt. trans. Joseph P. Dolan. Philadel-
phia: University of Pennsylvania Press, 1984.

Casanova, Pascale. *Beckett l'abstracteur.* Paris: Seuil, 1997.

Caws, Mary Ann. *The Art of Interference: Stressed Readings in Verbal and Visual
Texts.* Princeton: Princeton University Press, 1989.

Cohn, Ruby. "Ghosting through Beckett." In *Beckett in the 1990s.* Amsterdam:
Rodopi, 1993.

———. *Just Play: Beckett's Theater*. Princeton: Princeton University Press, 1980.

———. *Samuel Beckett: The Comic Gamut*. New Brunswick: Rutgers University Press, 1962.

———, ed. *Disjecta*. New York: Grove Press, 1984.

Cremin, Ann. "Friend Game." *ARTnews* (May 1985): 82–89.

Cronin, Anthony. *Samuel Beckett: The Last Modernist*. New York: Harper-Collins, 1996.

Cuno, James. "Voices and Mirrors / Echoes and Allusions: Jasper Johns's *Untitled, 1972*." In *Foirades/Fizzles: Echo and Allusion in the Art of Jasper Johns*. Los Angeles: Wight Art Gallery, University of California, Los Angeles, 1987.

Danto, Arthur. *The Philosophical Disenfranchisement of Art*. New York: Columbia University Press, 1986.

———. *The Transfiguration of the Commonplace*. Cambridge: Harvard University Press, 1981.

Docherty, Thomas, ed. *Postmodernism: A Reader*. New York: Columbia University Press, 1993.

Escoubas, Eliane. *Art et Phénomenologie (La Part de l'Oeil 7)*, 1991.

Esslin, Martin, "Towards the Zero of Language." In *Beckett's Later Fiction and Drama*, ed. James Acheson and Kateryna Arthur. Houndsmills, Basingstoke, and London: Macmillan, 1987.

———. *The Theatre of the Absurd*. New York: Doubleday, 1961.

Feshbach, Sidney. "Marcel Duchamp or Being Taken for a Ride: Duchamp was a Cubist, a Mechanomorphist, a Dadaist, a Surrealist, a Conceptualist, a Modernist, a Post-Modernist—and None of the Above." *James Joyce Quarterly* 26, no. 4 (1989): 557–58.

Field, Richard S. "The Making of *Foirades/Fizzles*." In *Foirades/Fizzles: Echo and Allusion in the Art of Jasper Johns*. Los Angeles: Wight Art Gallery, University of California, Los Angeles, 1987.

Friedman, Alan Warren, Charles Rossman, and Dina Sherzer, eds. *Beckett Translating / Translating Beckett*. University Park: Pennsylvania State University Press, 1987.

Garelli, Jacques. *Rythmes et mondes*. Grenoble: Jérôme Millon, 1991.

———. "Il y a le monde." *Esprit* 6 (June 1982): 113–23.

Garner, Stanton B., Jr. *Bodied Spaces*. Ithaca: Cornell University Press, 1994.

Godin, Georges, and Michaël La Chance. *Beckett*. Quebec: Le Castor Astral, 1994.

Gombrich, E. H. *Art and Illusion*. Princeton: Princeton University Press, 1969.

Gontarski, S. E. "Revising Himself: Performance as Text in Samuel Beckett's Theater." N.d., n.p.

Gordon, Lois. *The World of Samuel Beckett: 1906–1946*. New Haven: Yale University Press, 1996.

Hagberg, Garry. "Linguistic and Artistic Relations: Five Questions." *New Novel Review* 3 (1996): 9–22.

Hagstrum, Jean. *The Sister Arts*. Chicago: University of Chicago Press, 1958.

Harrington, John P. "Samuel Beckett's Art Criticism and the Literary Uses of Critical Circumstance." *Contemporary Literature* 21 (1980): 331–48.

Harvey, Lawrence E. *Samuel Beckett: Poet and Critic.* Princeton: Princeton University Press, 1970.

Hauck, Gerhard. *Reductionism in Drama and the Theatre: The Case of Samuel Beckett.* Potomac, MD: Scripta Humanistica, 1992.

Hegel, G. W. F. *Aesthetics: Lectures on Fine Arts.* Trans. T. M. Knox. Oxford: Oxford University Press, 1975.

———. *The Philosophy of Fine Art.* Trans. F. P. B. Osmaston. New York: Hacker Art Books, 1975.

Heidegger, Martin. "The Origin of the Work of Art." *Poetry, Language, Thought,* trans. Albert Hofstadter. New York: Harper and Row, 1971.

Hohl, Reinhold. *Alberto Giacometti.* New York: Abrams, 1971.

Johnson, Galen A., ed. *The Merleau-Ponty Aesthetics Reader.* Evanston: Northwestern University Press, 1993.

Jones, Alan. "Beckett and His Friends: A Writer among the Artists." *Arts Magazine* 66 (1991): 27–28.

Juliet, Charles. *Conversations with Samuel Beckett and Bram van Velde.* Trans. Janey Tucker. Leiden: Academic Press, 1995.

Kalb, Jonathan. *Beckett in Performance.* Cambridge: Cambridge University Press, 1989.

Kepes, Gyorgy. *Language of Vision.* Chicago: Paul Theobald and Co., 1967.

Knowlson, James. *Damned to Fame.* New York: Simon and Schuster, 1996.

———. *Light and Darkness in the Theatre of Samuel Beckett.* London: Turret Books, 1972.

Knowlson, James, and John Pilling. *Frescoes of the Skull: The Later Prose and Drama of Samuel Beckett.* New York: Grove Press, 1980.

Krance, Charles. "Traces of Transtextual Confluence and Bilingual Genesis: *A Piece of Monologue* and *Solo* for Openers." In *Beckett in the 1990s.* Amsterdam: Rodopi, 1993.

Labrusse, Rémi. "Hiver 1949: Tal-Coat entre Georges Duthuit et Samuel Beckett." In *Tal Coat Devant l'Image,* ed. Claire Stoullig et al. Geneva: Musée d'Art et d'Histoire, 1997.

———. "Beckett et la peinture: le témoignage d'une correspondance inédite." *Critique* (Aug.–Sept. 1990): 670–80.

Lake, Carlton, ed. *No Symbols Where None Intended.* Austin: Harry Ransom Humanities Research Center, University of Texas at Austin, 1984.

Latour, Bruno. *We Have Never Been Modern.* Trans. Catherine Porter. Cambridge: Harvard University Press, 1993.

Locatelli, Carla. *Unwording the World.* Philadelphia: University of Pennsylvania Press, 1990.

Lord, James. *Giacometti: A Biography.* New York: Farrar, Straus and Giroux, 1985.

———. *A Giacometti Portrait.* New York: Farrar, Straus and Giroux, 1965.

Lyotard, Jean-François. "Answering the Question: What Is Postmodernism?" In *Postmodernism: A Reader,* ed. Thomas Docherty. New York: Columbia University Press, 1993.

Madden, Anne. *Seeing His Way.* Dublin: Gill and Macmillan, 1994.

Mason, Rainer Michael, ed. *Bram van Velde: 1895–1981*. Geneva: Musée RATH, 1996.

McMillan, Dougald. "Samuel Beckett and the Embarrassment of Allegory." In *On Beckett: Essays and Criticism*, ed. S. E. Gontarski. New York: Grove Press, 1986.

McMillan, Dougald, and Martha Fehsenfeld. *Beckett in the Theatre*. London: John Calder, 1988.

McParland, Brenda, et al., eds. *Louis le Brocquy: Paintings, 1939–1996*. Dublin: Irish Museum of Modern Art, 1996.

Megged, Matti. *Dialogue in the Void*. New York: Lumen Books, 1985.

Mercier, Vivian. *Beckett/Beckett*. New York: Oxford, 1977.

Merleau-Ponty, Maurice. *La Prose du monde*. Paris: Gallimard, 1969.

———. *Résumés de cours (College de France, 1952–1960)*. Paris: Gallimard, 1968.

———. *Le Visible et l'invisible*. Paris: Gallimard, 1964.

———. *The Primacy of Perception*, ed. James Edie. Evanston, IL: Northwestern University Press, 1964.

———. *Phenomenology of Perception*, trans. Colin Smith. London: Routledge and Kegan Paul, 1962.

Mitchell, Breon. "Six Degrees of Separation: Beckett and the *Livre d'Artiste*." In *Samuel Beckett and the Arts: Music, Visual Arts, and Non-Print Media*, ed. Lois Oppenheim. New York: Garland Publishing, 1999.

———. "The Secret Life of the Book: The *Livre d'Artiste* and the Act of Reading." In *Conjunctions: Verbal-Visual Relations*, ed. Laurie Edson. San Diego: San Diego State University Press, 1996.

———. "Samuel Beckett and the Postmodern Controversy." In *Exploring Postmodernism*, ed. Matei Calinescu and Douwe Fokkema. Amsterdam and Philadelphia: John Benjamins, 1990.

Mitchell, W. J. T. "Space, Ideology, and Literary Representation." *Poetics Today* 10 (1989): 91–102.

———. *Iconology: Image, Text, Ideology*. Chicago: University of Chicago Press, 1986.

Neubauer, Peter B. "Alberto Giacometti's Fantasies and Object Representation." In *Fantasy, Myth, and Reality*, ed. Harold P. Blum et al. Madison, CT: International Universities Press, 1988.

Norris, Christopher. *What's Wrong with Postmodernism: Critical Theory and the Ends of Philosophy*. Baltimore: Johns Hopkins University Press, 1990.

Oppenheim, Lois. *Directing Beckett*. Ann Arbor: University of Michigan Press, 1994.

———, ed. *Samuel Beckett and the Arts: Music, Visual Arts, and Non-Print Media*. New York: Garland Publishing, 1999.

Orton, Fred. "Present, the Scene of . . . Selves, the Occasion of . . . Ruses." In *Foirades/Fizzles: Echo and Allusion in the Art of Jasper Johns*. Los Angeles: Wight Art Gallery, University of California, Los Angeles, 1987.

Perloff, Marjorie. "The Silence That Is Not Silence: Acoustic Art in Samuel Beckett's *Embers*." In *Samuel Beckett and the Arts: Music, Visual Arts, and Non-Print Media*, ed. Lois Oppenheim. New York: Garland Publishing, 1999.

———. *Postmodern Genres*. Norman: University of Oklahoma Press, 1988.

———. *The Poetics of Indeterminacy: Rimbaud to Cage*. Princeton: Princeton University Press, 1981.

Pilling, John. "*Foirades/Fizzles*/Beckett/Johns." *Contemporary Literature* 21 (1980): 480–510.

———. *Samuel Beckett*. London: Routledge and Kegan Paul, 1976.

———, ed. *The Cambridge Companion to Beckett*. Cambridge: Cambridge University Press, 1994.

Prinz, Jessica. "Resonant Images: Beckett and German Expressionism." In *Samuel Beckett and the Arts: Music, Visual Arts, and Non-Print Media*, ed. Lois Oppenheim. New York: Garland Publishing, 1999.

———. *Art Discourse / Discourse in Art*. New Brunswick: Rutgers University Press, 1991.

Pyle, Hilary. *Jack B. Yeats in the National Gallery of Ireland*. Dublin: National Gallery of Ireland, 1986.

Read, David. "Artistic Theory in the Work of Samuel Beckett." *Journal of Beckett Studies* 8 (1982): 7–22.

Rollins, Mark, ed. *Danto and His Critics*. Cambridge, MA: Basil Blackwell Ltd., 1993.

Ross, Stephen David, ed. *Art and Its Significance*. Albany: SUNY Press, 1994.

Sartre, Jean-Paul. "The Paintings of Giacometti." *Situations*, trans. Benita Eisler. New York: George Braziller, 1965.

Schiff, Stephen. "Edward Gorey and the Tao of Nonsense." *The New Yorker*, November 9, 1992.

Schloss, Carol. "*Foirades/Fizzles:* Variations on a Past Image." *Journal of Modern Literature* 12 (1985): 153–68.

Shiff, Richard. "Anamorphosis: Jasper Johns." In *Foirades/Fizzles: Echo and Allusion in the Art of Jasper Johns*. Los Angeles: Wight Art Gallery, University of California, Los Angeles, 1987.

Silverman, Hugh J. "Between Merleau-Ponty and Postmodernism." In *Merleau-Ponty: Hermeneutics and Postmodernism*, ed. Thomas W. Busch and Shaun Gallagher. Albany: SUNY Press, 1992.

Simon, Bennett. *Tragic Drama and the Family: From Aeschylus to Beckett*. New Haven: Yale University Press, 1988.

Smith, Joseph H., ed. *The World of Samuel Beckett*. Baltimore: Johns Hopkins University Press, 1991.

Soutif, Daniel. "Flight into Whiteness: Bram van Velde." *ARTFORUM* (Summer 1990): 150–53.

Steiner, Wendy. *Pictures of Romance: Form against Context in Painting and Literature*. Chicago: University of Chicago Press, 1988.

———. *The Colors of Rhetoric*. Chicago: University of Chicago Press, 1982.

Sylvester, David. *Looking at Giaocometti*. New York: Henry Holt, 1994.

Taminiaux, Jacques. *Poetics, Speculation, and Judgment: The Shadows of the Work of Art from Kant to Phenomenology*. Ed. and trans. Michael Gendre. Albany: SUNY Press, 1993.

Thomson, Duncan. *Arikha*. London: Phaidon Press, 1994.

Tompkins, Calvin. *Duchamp*. New York: Henry Holt, 1996.

Waldman, Diane. *Georg Baselitz*. New York: Guggenheim Museum Publications, 1995.

Walker, Dorothy, ed. *Louis le Brocquy: Images, Single and Multiple, 1957–1990*. Yomiuri Shimbun / The Japan Association of Art Museums, 1991.

———. *Louis le Brocquy*. Dublin: Ward River Press, 1981.

Watt, Steven. *Postmodern/Drama: Reading the Contemporary Stage*. Ann Arbor: University of Michigan Press, 1998.

Weber-Caflisch, Antoinette. *Chacun son dépeupleur*. Paris: Les Editions de Minuit, 1994.

Wider, Kathleen. *The Bodily Nature of Consciousness: Sartre and Contemporary Philosophy of Mind*. Ithaca: Cornell University Press, 1997.

Wood, Rupert. "An Endgame of Aesthetics: Beckett as Essayist." In *The Cambridge Companion to Beckett*, ed. John Pilling. Cambridge: Cambridge University Press, 1994.

Yacobi, Tamar. "Pictorial Models and Narrative Ekphrasis." *Poetics Today* 16 (1995): 599–649.

Zinman, Toby. "*Eh Joe* and the Peephole Aesthetic." *Samuel Beckett Today/Aujourd'hui* 4 (1955): 53–64.

Index